DEDALUS EUROPE 1992
– editor Aysha Rafaele

*the Black Cauldron*

D1514469

Funded by the Danish
Literature Information
Centre

Arts Council Funded

Translated from the Danish by W. Glyn Jones

# *The Black Cauldron*

# William Heinesen

Dedalus/Hippocrene

Published in the UK by Dedalus Ltd,
Langford Lodge, St Judith's Lane, Sawtry, Cambs, PE17 5XE

UK ISBN 0 946626 97 9

Published in the USA by Hippocrene Books Inc,
171, Madison Avenue, New York, NY 10016
US ISBN 0 7818 0000 5

Distributed in Canada by Marginal Distribution,
Unit 103, 277 George Street North, Peterborough, Ontario, KJ9 3G9

First published in Denmark as Den Sorte Gryde in 1949
First English edition 1992

Den Sorte Gryde copyright © William Heinesen 1949
Translation copyright © Dedalus 1992

Printed in England by Billings & Sons Ltd,
Hylton Road, Worcester, WR2 5JU

A C.I.P. listing for this title is available on request.

The cover picture is a painting from William Heinesen reproduced by courtesy of Mrs
Heinesen and Emil Thomsen. The painting is on p57 of Fra billedmagerens værksted
published by Emil Thomsen-Tórshavn 1980. This book offers the largest selection of
William Heinesen's paintings so far published in book form.

# DEDALUS EUROPE 1992

At the end of 1992 the 12 Member States of the EEC will inaugurate an open market which Dedalus is celebrating with a major programme of new translations from the 8 languages of the EEC. The new translations will reflect the whole range of Dedalus' publishing programme: classics, literary fantasy and contemporary fiction.

*From Danish:*

The Black Cauldron - William Heinesen
The Dedalus Book of Danish Literature - editor W. Glyn Jones

*From Dutch:*

The Dedalus Book of Dutch Fantasy - editor Richard Huijing

*From Dutch/French:*

The Dedalus Book of Belgian Fantasy - editor Richard Huijing

*From French:*

The Devil in Love - Jacques Cazotte
Angels of Perversity - Remy de Gourmont
The Dedalus Book of French Fantasy - editor Christine Donougher
The Book of Nights - Sylvie Germain
Le Calvaire - Octave Mirbeau
Smarra & Trilby - Charles Nodier
Monsieur Venus - Rachilde

*From German:*

The Angel of the West Window - Gustav Meyrink
The Green Face - Gustav Meyrink
The Weird, the Wonderful & the Fantastic: Gustav Meyrink's Golden Treasury – editor Maurice Raraty
The Dedalus Book of Austrian Fantasy: the Meyrink Years 1890-1930 - editor Mike Mitchell
The Dedalus Book of German Fantasy: the Romantics and Beyond - editor Maurice Raraty
The Architect of Ruins - Herbert Rosendorfer

*From Greek:*

The History of a Vendetta - Yorgi Yatromanolakis

*From Italian:*

Senso (and other stories) - Camillo Boito

*From Portuguese:*

The Mandarin - Eça de Queiroz
The Reliquary - Eça de Queiroz

*From Spanish:*

The Dedalus Book of Spanish Fantasy - editor A. R. Tulloch

Further titles will be announced shortly.

Dedalus would like to thank The Danish Literature Information Centre in Copenhagen and The Arts Council of Great Britain for making this publication possible, with especial thanks to Lise Bostrup and Antonia Byatt.

# THE AUTHOR

**William Heinesen** occupied a unique position in twentieth-century Scandinavian letters. He was born in Tórshavn in the Faroe Islands in 1900, the son of a Danish mother and Faroese father, and was equally at home in both languages. He went to study in Denmark at the age of 16, but later returned to his native islands, where he remained until his death in 1991.

Heinesen was one of five writers born in the Faroes between 1900 and 1902 who raised Faroese literature to the level of general European writing by the mid-twentieth century. More than any of the others, he managed to combine his love of the Faroes with a universality that made him accessible to readers of many nationalities. There is no need to know Tórshavn to understand the themes and conflict in his work, though many is the Tórshavn citizen who can be recognised in it. He combines cosmic vision with humour, biting criticism of self-seeking with warmth and sympathetic understanding. Even the Opperman of *The Black Cauldron* is not entirely evil.

Heinesen was on several occasions said to be among the authors being considered seriously for the Nobel Prize, and he was the candidate proposed by the Danish Society of Authors for many years. That he did not receive it (he was awarded almost every conceivable other prize) may have been his own fault; he wrote to the Nobel Committee to tell them he did not want it! He believed that if the Prize were to go to a Faroese citizen, then it should be to one who actually wrote in Faroese – something he did not do, as he felt that Danish offered him a greater inventive freedom.

Although internationally known as a poet and novelist, Heinesen is equally famous in the Faroe Islands as an artist.

His paintings range from large-scale murals in public build-ings, through oils to pen sketches and caricatures, and in his final years he spent much of his time on collages. He was a competent musician, too, the composer of many choral and chamber works, and of the tone poem *Norske Løve* (The Lion of Norway) which in the early 1980s was broadcast by the BBC.

W. Glyn Jones

# THE TRANSLATOR

W. Glyn Jones read Modern Languages at Pembroke College Cambridge, with Danish as his principal language. After studying at the universities of Copenhagen and Århus he completed his doctoral thesis at Cambridge. He taught at various universities in England and Scandinavia before becoming Professor of Scandinavian Studies at Newcastle University. Since 1986 he has been Professor of Scandinavian Studies at the University of East Anglia. He has written widely on aspects of Scandinavian literature including studies of Johannes Jørgensen, Tove Jansson and William Heinesen, and a *History of Denmark*. He is the co-author with his wife Kirsten Gade of a *Danish Grammar* and the new *Blue Guide* to Denmark. They are currently working on producing a *Colloquial Danish* for Routledge. W. Glyn Jones' many translations from Danish include *The Fairy Tale of My Life* by Hans Christian Andersen and *Seneca* by Villy Sørensen.

# I

## 1

Serpent Fjord is a long inlet stretching into the island deep between lofty grassy fells. At the bottom it opens into the broad pool officially called Kingsport, but in everyday parlance simply known as *The Cauldron*. The sea is always smooth in there, and safer anchorage cannot be found. There it lies tucked away like a womb deep inside the island, a fruitful, teeming uterine passage in the midst of the desolate ocean, a favoured spot amidst the ravages of war, a haven for weary seamen, a refuge for déracinés and refugees, a breeding ground for religious sects, a cosy nest for profiteers of every kind.

Here it is that Solomon Olsen has his home; he is said to be the richest man in the country, though many are of the opinion that M. W. Opperman is not far from catching up with him. And there are other citizens of importance: Consul Tarnowius, Stefan Sveinsson and J. F. Schibbye's widow. Olivarius Tunstein deserves a mention as well: he began by hiring an old sand-pump dredger to export fish, and now he is the owner of the huge and lucrative cutter the Gratitude. Then there is Inspector Joab Hansen's sister Masa, the owner of the biggest retail store in town.

But Opperman stands out among the whole bunch. He is legendary. His reputation is not based principally on his shipping and fishing company; he only owns a couple of small cutters, whereas a Solomon Olsen has a whole fleet including schooners and trawlers. No, it is his wholesale business that has rightly made Opperman famous. Only a few years ago he was a quite ordinary travelling salesman, and now he runs a wholesale business in the grand style. Despite war and want this man has been extraordinarily

successful in procuring even the scarcest of goods, and there is hardly a tradesman in the entire country with whom he does not have some profitable connection. In addition to this he is the owner of the Bells of Victory restaurant, a major shareholder in the Flora Danica margarine factory, the North Pole Cold Storage Plant, the Congo Steam Laundry, the Vesuvius Machine Shop and the Angelica Bog Fox Farm; moreover, he is Portuguese Consul and Chairman of the Employers' Association. And he is constantly expanding his activities, erecting new buildings and appointing new staff.

As a person, Opperman is something of a mystery, but he is by no means unpopular; he is affable with everyone, not arrogant like Consul Tarnowius, curt like J. F. Schibbye's widow or sectarian and self-righteous like Solomon Olsen. But of course he has his faults and his comical sides. He speaks a language known to no man, and there are many who find his manner somewhat effeminate. But more than almost anyone else Opperman has one excellent quality: he never loses his temper. You can call him what you like – soft or sly, old-maidish or ruthless, stick-in-the-mud or loose-liver, even lecher and murderer – as some indeed have done: he will always disarm you with his quiet, forgiving, one might almost say fond smile, his Mona Lisa smile, as Mr Heimdal the bookseller, himself a great lover of the arts, has facetiously described it.

The new office and warehouse that Opperman has had built and recently taken into use is the work of the bookseller's young architect son, Rafael Heimdal, designed in the most up-to-date style in concrete and glass. He has economised on nothing; there is plenty of light and air and heat here, a lift, a toilet and a rubbish chute, an air-raid shelter, kitchen and cafeteria for the employees, comfortable offices with plenty of space, and cosy inner rooms furnished with Chesterfield chairs for visitors and customers to sit at their ease. Here, too, there is what is called a *news bureau*, a kind of waiting room or whatever, where Opperman's employees can go and listen to the news and stimu-

late their intellects with good reading. The benches lining the walls in the news bureau are covered in red oilcloth, and the long polished tables are strewn with copies of *Picture Post*, *Life* and other illustrated periodicals and price lists laid out for general use. On the walls there are advertisements and pictures illustrating the progress of the war, explosions, sinking ships, aeroplanes shot down in flames, ruined cities, maimed women and children, maps and statistics and portraits of Churchill, Roosevelt, Stalin and General Smuts. These comfortable rooms, with an entrance from the street and giving direct access to the air-raid shelter in the cellar, Opperman has generously placed at the disposal of anyone desirous of resting and relaxing, discussing current affairs and generally feeling at home; for whatever else Opperman might or might not be, he is a democrat through and through, and he never misses an opportunity to show this in practice.

For instance, he is totally indifferent to social status, eschewing the company of Consul Tarnowius, Doctor Tønnesen, Mr. de Fine Licht the pharmacist, Villefrance the bank manager, Ingerslev the director of the telegraph office, and other so-called leading people. But he is fond of the company of quite ordinary men and women and of the non-commissioned ranks; he has employed people of doubt-ful reputation like Black Betsy and the infamous Frøja Tørnkrona, and indeed he does not even turn away in disgust from drunks like Selimsson the photographer or down-at-heel scholars like the Icelandic researcher Engilbert Thomsen; he gives them all a forbearing smile and takes them into his employment.

Indeed, Opperman is a friend of the people. Nor does he forget widows and the fatherless. For instance, the young bard Bergthor Ørnberg came to see him yesterday to ask for a contribution to a newly-formed association with the object of helping children in distress, the offspring of sailors killed in the war; without hesitation Opperman put a cheque for 15,000 kroner on the table, earnestly pleading at the same time that no mention should be made of his

name in connection with it. Bergthor was speechless and said he could make no promises. On the contrary, he went straight up to Mr. Skælling, the newspaper editor, with the splendid news, and this morning The News has a front page article in bold lettering telling of Opperman's magnificent gesture. This is all the more remarkable as even Solomon Olsen himself has only thought fit to support this noble cause to the tune of 2000 kroner, while Stefan Sveinsson only has 500 to his name; those of Consul Tarnowius and J. F. Schibbye's widow are nowhere to be seen on the list of subscribers.

Little wonder that the name of Opperman is on everyone's lips. Old Ole the Post, who is delivering the newspaper in the slowly awakening town sees all lips curling round the syllable *op*. "Op, op, Opperman," he mutters a little crabbily but inoffensively to himself. Ole is one of those who say little, but at times the adulation of the great figures and their English pounds becomes too much for him. Pounds and endless pounds . . . pounds and war, pounds and war.

Down in the harbour a newly-arrived ship is docking. It is Opperman's Manuela, skippered by young Ivar Berghammer from Angelica Cottage. And there comes Opperman himself. Ole's mouth contorts, but then he has to stop for a moment and savour the picture of this man whose name is on everyone's lips. Opperman is dressed in his checked summer suit, small but elegant; he is carrying his white cane and sporting an artificial red flower in his button hole. His upper lip is marked with a thin black moustache and the well-known kindly smile. There are those who say that he is a Portuguese. Others maintain that his mother came from Mexico and his father from Hamburg, but that he was born in London. Yet others argue that he is English born and bred. "No concern of mine," thinks Ole as he turns away and vigorously ejects a stream from his chewing tobacco. "As far as I'm concerned he can be from the Dodecanese or Ivigtut or Timbuktoo. They're all confounded foreigners, the whole lot of them: Consul Tarnow-

ius is Danish, Stefan Sveinsson's Icelandic, Schibbye's widow's from Bornholm, Villefranche the bank manager's a Jew, Doctor Tønnesen's a Jute, and Pastor Fleisch comes from Ringkøbing. There's folk from every country conceivable in the Cauldron here: Tørnkrona the tailor's Swedish, Selimsson the photographer's Finnish, Batt the smith's father was a Scot, and the pharmacist's wife is from Antwerp. And Mrs. Opperman was born in Frederiksted on St. Croix. Then there's that Italian sculptor Schiaparelli. And Miss Schwartz in the pharmacy is supposed to be Polish. Not to mention all the new flotsam that's been washed up by the war – soldiers, refugees and wrecks, spies, blacks and muslims. And what about those three queer lodgers of Mrs. Lundegaard's: Thygesen and Myklebust – always as drunk as lords – and that curious Icelandic tramp Engilbert Thomsen."

But Thygesen and Myklebust are probably fundamentally decent men. It was heartbreaking to see their emotion the other day when Ole delivered their wretched Red Cross letters . . . Those two tough men sobbed like schoolgirls, whether from sorrow or joy. They were both well under the influence, and Ole the Post was given an enormous glass of *snaps*. And Myklebust stuffed a whole bottle of Ainslie into his jacket.

Ole stops in front of Mrs. Lundegaard's little private hotel. A creel full of offal is standing on a packing case near the entrance to the kitchen. The sounds of a guitar and a deep unsteady voice can be heard coming from the attic; it is Thygesen; he is very musical. Mrs. Lundegaard takes her newspaper and pouts her mouth for her "Opperman". And now the Icelandic researcher appears, chewing away at something, shabbily dressed, long-haired, pale and unshaven, but big and strong and with a sort of melancholy omniscient smile in his brown eyes. He is in a good mood and nods good morning as he lifts the heavy creel and puts the sackcloth straps around his forehead to steady it as he carries it off on his back.

Ole remembers he has a letter for Liva Berghammer, the

lass from Angelica Cottage. He fishes it out and asks the Icelander to do him a favour and take it with him as he is going that way in any case. Engilbert stuffs the letter under his jersey and moves slowly up the hillside.

It is said of Engilbert Thomsen that he is a visionary, and that he believes in trolls and witches, sprites and mermaids. Others maintain he is a spy. He can't really be a nice person to have under your roof, but Mrs. Lundegaard always speaks of him with as much respect as she would of an archbishop. Oh well, when all is said and done, she's a lonely widow in her mid-thirties, and the huge Icelander is a man in the prime of life. In general Ole the Post is inclined to feel a little envious of Mrs. Lundegaard's three lodgers. They must live a very comfortable life here, for Mrs. Lundegaard's benevolence knows no bounds; there is an abundance here of good food and drink. Ole himself never crosses the threshold of the hotel without Mrs. Lundegaard putting her cigar box and the little flower-covered *snaps* bottle on the kitchen table. He shakes himself in elated anticipation as he turns around in the doorway and rids his mouth of the morning's well-worn chewing tobacco.

# 2

Meanwhile, Engilbert Thomsen was plodding on, stepping out up the green hillside with his heavy burden of meat destined for Opperman's foxes.

High up on the slope he rested a while and looked down over a village just discernible through a milky membrane of haze and smoke rising from its chimneys. Life was beginning to bubble and boil down there round the black pool of water; there were the sounds of dogs barking and cocks crowing, of lorries groaning and hooting, motors spluttering, bagpipes twittering, cranes complaining, hammer blows resounding from Solomon Olsen's slipway. Then one of the armed trawlers let off steam with an earsplitting rush like the hiss of a gigantic goose. The fells hissed back in return. The Cauldron was boiling over in a motley of sound.

Engilbert had but a smile for all this commotion with which the improvident citizens of today feel compelled to surround themselves. He viewed with patronizing contempt these complacent slaves of Mammon who knew only the crass everyday life this side of the great Curtain. He himself was moving in an entirely different direction: up, up towards the lofty plane of knowledge and spiritual liberation. But it cost him struggle and trouble and an unending and painful battle to conquer his own base desires, an eternal crusade against the irksome fetters binding him to the world of the senses. . . those evil, pallid octopus tentacles constantly seeking to enfold him and hold him fast.

Engilbert got up, yawning long and thoughtfully as he once more shouldered the basket of whale meat. The path up to the Angelica Bog where Opperman's fox farm was situated was quite difficult, but once he reached the top, it was as though he were placed totally outside the undifferentiated world of reality; the village disappeared from sight,

and there was nothing but sky and sea, lonesome fells and huge isolated boulders which, according to legend, were populated by subterranean spirits.

Indeed, Engilbert knew this from his own experience. One afternoon, he had with his own eyes seen a female face peering out of the crack in a cleft boulder up there, and on another occasion he had heard giggling and laughter from a deep cavern between some towering boulders. It was the place known as the Troll Child's Cave. Engilbert wouldn't have minded getting closer to these giggling creatures; he delighted in all strange phenomena and was not afraid, except insofar as his path upwards towards his supreme objective of spiritual perfection in the deity might be made more difficult.

The haze grew denser, and for a time Engilbert found himself in a thick grey mist. But up at the Angelica Bog the sun was breaking through; the wind was carrying with it scudding wisps of cloud which fluttered past one after another like bird spirits. There were real birds amongst them, too, crows and gulls, attracted by the smell of meat. And suddenly the sun emerged . . . a strange sun, breaking through the haze in the shape of a blood-red cross surrounded by two translucent circles in rainbow colours. He stretched out his arms towards this strange sign and, caught in overwhelming emotion, whispered "Logos! Logos! Can it be you?"

All this lasted no more than a second, and then the sun assumed its customary circular shape once more. And a moment later everything was once more engulfed in swirling mist.

Engilbert was lost in profound wonderment. Could it really be the symbol of Logos that had revealed itself to him to give him strength and courage to continue his struggle? Or was it merely some magic, some illusion seeking to deceive him?

For that matter, anything could happen up there in the Angelica Bog. . . Supernatural forces were at play. Restless shadowy spirits roamed about up here working their magic.

Here wandered the ghosts of the two odious women Unn and Ura who poisoned their husbands so as undisturbed to go on fornicating with a mountain spirit, and here, too, it was that a farmer called Aasmund did combat throughout a whole winter's night with the spherical monster Hundrik, who sought to roll him into the ground and only gave up when Aasmund guessed his name. And here, too, lay the murky Hell Water Pool, which was said to be bottomless. Hell Water was one of those mysterious lakes in which visions were sometimes to be seen. It was here that an old shepherd saw a reflection of the great fire of Moscow in 1812.

Engilbert had learned all this from old Elias of Angelica Cottage. On his way to and from the fox farm every day he would often stop and have a chat with Elias at this tiny cottage lying far off the beaten track under the Angelica Outcrop. Elias, the owner, was a sickly little man who was prone to asthma and frequent attacks of epilepsy, but otherwise agreeable enough and quite talkative.

Engilbert felt irresistibly drawn to Angelica Cottage and those who lived there for other and quite different reasons, too. Elias' daughters were indeed unusual. Thomea, the eldest, had a face covered with whiskers and was – at least according to Mrs. Lundegaard – in possession of occult powers; and the youngest, a half-grown girl, was not quite right in the head. Then there was Liva, like Engilbert in Opperman's employment. A lovely creature in every respect. But she, too, was a little odd, for she was a follower of the mad baker, Simon, a devotee of his fire and brimstone sect. And there was a fourth daughter who was no longer at home; she lived in Ørevík at the mouth of the fjord and was said recently to have been widowed by the war. Then there was Ivar, the son, who was in command of Opperman's Manuela. The family in Angelica Cottage used to live in great poverty, but as a skipper, Ivar was now making a good income.

Engilbert remembered the letter for Liva, and took it out so as not to forget to deliver it on his way down. The

mist was again lifting, and the sun rising pure and fresh in the sky, surrounded by hosts of harmless little fleecy clouds. The fox furs in Opperman's cages darted about like lightning. Engilbert shouldered the creel and set off downhill.

In the yard in front of Angelica Cottage a little group of people were bent over something lying on the ground. Engilbert immediately guessed that it was Elias having one of his attacks. He hurried over. Yes indeed, it was Elias stretched out on the ground in convulsions. He was a pitiful sight, fragile and hollow-chested and with his scrawny hands pressed up under his chin as though he was trying to push his own head off his body. There was a wooden spoon in his froth-covered mouth. Liva and Thomea were watching his movements. Alfhild, the mentally deficient youngest daughter, was sitting on her own and playing with some snail shells, totally indifferent to all the fuss around her.

Engilbert wanted to be useful, and squatted down beside Thomea. Secretly and greedily he observed the three women. Despite her whiskers Thomea was not unfeminine; she was big and strong with a voluptuous figure like that of a young heifer. Liva too, a pretty girl, had a dark shadow across her upper lip, and both sisters had heavy black eyebrows. Thomea's eyebrows met, the sign of a werewolf. It gave him a curious tingling sensation to have this whiskered girl so close to him. . . he trembled under the influence of the powerful magnetic current emanating from her person and making the talisman on his chest burn as though glowing with heat.

But then Elias suddenly uttered a hoarse wail, his eyes began to roll and show the whites; his body tensed upwards in a bow so that the back of his head and his heels almost seemed to be all that was touching the ground. . . and then it fell back; but now his arms and legs began to flail wildly, and this insignificant and inoffensive little man hit out in all directions with all the violence of a hooligan, howling and threatening those around him like one possessed. Liva received a blow to the side and got up, clenching her teeth

in pain. Engilbert stepped across and took her place and set about helping Thomea to keep her ungovernable father under control.

In time the sick man fell calm; the attack was over for this time. Engilbert helped the two girls to get him indoors and laid out in the alcove bed in the living room. There he lay, pale and wasted like a corpse, and with splashes of blood around his sunken mouth.

As Engilbert looked around in the tiny living room he saw its woodwork was scrubbed white. A carefully prepared sheepskin lay in front of the alcoves; the ceiling and one wall were almost hidden by ivy leaves, but in the midst of the greenery a space had been cleared for an enlarged photograph of Elias's late wife. It was a little faint, but it was still possible to see that the woman from Angelica Cottage had been dark-haired, with heavy eyebrows like her daughters.

Engilbert remembered the letter again. . . Surely he couldn't have lost it in all that kerfuffle. No, there it was up his sleeve; he took it out, smoothed it over and handed it to Liva. She snatched the crumpled envelope from him and turned away with it. He noticed that she put it to her lips before putting it in her bosom. Then she hurried out into the kitchen and began to arrange her hair in front of the mirror.

Engilbert turned to Thomea and said, in an intimate, low voice: "You know remedies for so many things – don't you know one for your father's illness?"

The girl looked away and shook her head. He felt an almost irresistible desire to come closer to her and win her confidence, but she was taciturn and unapproachable, difficult to get on speaking terms with. He shook hands with her as he left. He succeeded in capturing her glance, a strange, devastating look that went right through him.

Engilbert accompanied Liva part way down the path, but she was in a hurry and had to take a short cut across the fields so as not to be late in Opperman's office.

"Good-bye, Engilbert," she waved. "And thank you for all your help, and for the letter."

He followed her cheerful tripping figure until she disappeared behind a hill. He could still sense the horny scent of the two downy girls from Angelica Cottage and still had a powerful feeling of being under the influence of Thomea – there was an itch and twitching in one ear and on his chest where his talisman was hanging. And at the same time he felt with a mixture of sensual delight and horror how his desire for the hairy girl was growing into lust. There was no mistaking it: mysterious and dangerous forces were at work, forces which must be opposed at any price because they originated in evil and sought to rob him of the spiritual gains which he had made over the past six months, and to force him into fresh degradation.

This great, bewitching woman was doubtless in league with these sinister powers of darkness which sought to waylay his soul on its way to the light.

"Be steadfast, be steadfast," he whispered to himself and through his jersey he pressed his talisman close to his heart.

# 3

Once she was left to her own devices, Liva stopped, took out the letter, and with her eyes closed raised the envelope to her lips. It was from Johan. Although unwilling to admit as much, she dreaded reading it, for suppose he were worse, or perhaps even wrote to say that they had given up hope. She wouldn't open it until later when she could take her time and read it without risk of being disturbed. She slipped it back into her dress. Then she looked upwards and sighed long and audibly.

Johan had been in her thoughts all morning, for it was the second of August, the anniversary of that awful day when the Gratitude came back with seven survivors from the Albatross, the big schooner from Sandefjord that had been sunk off Shetland.

Only twelve months! It seemed like years since that disastrous morning when Johan came home unexpectedly with pneumonia after being shipwrecked and drifting helplessly for four days in the lifeboat from the Albatross. Those harrowing days as he lay in the hospital hovering between life and death. That unforgettable time of joy and gratitude when he had recovered and regained his strength sufficiently to sit outside in the sunshine. And then once more the distress of the relapse, when tuberculosis forced him back into the sanatorium in Østervaag. The separation. The hope. Until that, too, became precarious.

And although it was this misfortune that had opened her eyes and brought her to Jesus, she could not yet conceive that Johan, her burly, self-confident Johan, really lay there incurably ill, confined to a hospital ward along with a crowd of other pitiful creatures coughing their hearts out.

She had twice made the journey to the capital to see her fiancé. He was able to sit up in bed and was of course in a way the Johan she had always known, despite his indoor pallor and skinny hands yellow as straw. The thought of

those waxen hands was enough to force a silent scream deep down inside her. There lay her Johan, slowly withering away. Her big, strong, self-assured Johan. Her sole consolation was that he, too, in this dreadful time of trial had found grace and redemption, and that in a brief while they would both be united in that other world that knows no end.

Near the bridge across the Storaa river Liva stopped for a moment and glanced quickly at the half-finished concrete house down by the river mouth, the house intended for her and Johan. It was a nice house, impressive even. But it was without windows and doors, nothing but an empty shell. And it would never be finished. But what did that matter? Better to have an indestructible house in the land everlasting.

"Ah, my Lord and Creator," sighed Liva, and hurried on across the bridge. The world was racked with misfortune and terrible events. Just think of the Evening Star that struck a mine on its way to England and sank with all hands. Her brother-in-law Oluf, Magdalena's husband, was among those who perished then, a strong, healthy man with a wife and three children. And Simon the baker lost his two sons, Erik and Hans; they were no more than seventeen and nineteen years old. Aye, a lot of ships were going down these days, leaving widows and orphans behind. And the war raged on with no end in sight; the time of evil and waste was come upon the world.

The memory of other misfortunes and sombre events passed through her mind. She almost derived a certain consolation from them now that the last days, bringing the end of human life, were approaching and the great hour of judgement was at hand. There was Opperman's wife, lying incurably ill in her attic room. And Benedikt Isaksen's five children, all carried off within a single year by galloping consumption. Alas, such was life: death and misfortune threatened at every turn. But a lamp had been lit, a mighty lamp – lit in the midst of gloom and despair, lighting the way for all who would open their eyes.

All that mattered was to hold tight on to this lamp, always keeping it with you in your thoughts and never letting anyone snatch it from you – in the words of the hymn:

> Take hold your lamp, oh timid heart,
> It lights the way so clear,
> Bids evil from this world depart,
> For now the night is near.

She hummed the tune to herself; it was a wistful melody with a long refrain twisting and twining, urging, admonishing:

> For now the night is near,
> For now the night is near,
> Take hold your lamp, oh timid heart,
> For now the night is near.

Liva became aware of a little group of people in summer clothes coming towards her along the road. It was the young shipowner Poul Schibbye, together with Olsen's lanky son Spurgeon and a third man who was a stranger to her.

"Now what have we here, the darkest rose in the world," shouted Poul Schibbye, gaily approaching Liva with his arms held out wide as though to embrace her. "How are you, my flower? How do you get on with Croesus down there?"

"Fine, Pjølle," said Liva, making to hurry on, but Poul Schibbye stopped her and took her hand.

"Aye, you know the Rose of Stambul, of course?" he said by way of introduction. "Liva and I are bound by unbreakable bonds; we were baptised and confirmed in the same water, and we should have been married in it, but she didn't want to. . . Fancy, she turned me down. Isn't that right, Liva?"

"Yes, Pjølle," said Liva, unable to help a smile.

Pjølle contorted his fleshy face and surrendered himself to a feigned sob. He threw himself on his knees at Liva's feet and clutched her hand to his cheek.

"That's enough, Pjølle," she scolded, freeing herself and blushing; she smiled apologetically at Spurgeon and the stranger.

"No, you are in a hurry, Liva", said Pjølle, getting up. "Well, then, fare thee well, in the name of God, and give my regards to Chiang Kai-shek, and God bless you, my own little ducksie."

"Aye, isn't she a delight?" he said, turning round to watch her go. "She's the one I ought to have had. And now she's gone and joined the *Bun Sect*! Lost to the world."

"Yes, but she gave you a sweet smile, Pjølle", said Spurgeon.

"She loves me."

Poul Schibbye tossed his walking stick up in the air like a spear and caught it again. "I'm still her Romeo. That was pretty obvious, wasn't it, Spurgeon?"

He waltzed around a turn, cooing and sobbing gently, with his hand on his heart: "She lo-ves me."

# 4

As Engilbert left the steep path leading to Angelica Cottage and stepped out on to the road, he was met by a strange sight: two young seamen were approaching along the road, singing at the top of their voices and pushing a large, fully-laden handcart in front of them. It was Angelica Ivar and his friend Frederik. On top of the load, staring around with melancholy eyes, sat – a monkey.

The men blocked Engilbert's path and offered him a welcoming drink. As he held up the bottle in greeting, Ivar was singing in a subdued, fervent tone:

> All flesh, it is but grass,
> The prophets all did say,
> This earthly life will pass,
> Whenever comes the day.

Engilbert put the bottle to his mouth and took a hefty swig of the aromatic liquor tasting of angelica. "I'll give you a hand if you like," he said.

They pushed the cart a little way up the path, as far as it would go, and then each of them shouldered part of the load. Thomea and Alfhild came to meet them. The seamen put down their heavy sacks, and in transports of joy at their return Alfhild threw herself at her brother and Frederik, smothering them in kisses and caresses. Frederik offered Thomea a drink from his flask, and to his amazement Engilbert noticed that she took a hefty swig.

Ivar was more than a little tipsy. A blissful smile lit up his weary eyes, and he broke into song. The lad from Angelica Cottage was a big, muscular chap, dark and with a strong growth of hair like Thomea. Frederik appeared to have drunk less. He told of their journey home: on this occasion it had been unusually difficult, and off the Orkneys their ship had been attacked by a whole two planes at the

same time; they had lavished no fewer than seven bombs on the little boat, but they had all missed. But then the beasts had taken to their machine guns and shot at them like mad things; the wheelhouse had been riddled full of holes like a sieve and the sandbags torn to shreds. But then a British fighter had turned up, and the two marauders had made off with their tails between their legs.

> They struck with might, they struck with zeal,
> Like gallant knights at play,
> Bright flashed the blades of shining steel
> When sword met sword that day.

So sang Ivar. He put Alfhild down, swung his sack up on his shoulder and made a clumsy attempt to dance the steps of the ancient ballad as he moved on:

> So tight he clasped his jewelled hilt,
> The blood burst from his vein,
> So quick the mortal blow he dealt,
> He cleft his foe in twain.

Thomea went down to the cart to help carry their belongings. Alfhild walked along with her brother, boundlessly happy; Engilbert observed her in amazement, for the crazy girl was behaving less like Ivar's sister than a young girl-friend madly in love with him. Her brother had difficulty in keeping her at bay.

Frederik had the monkey on his shoulder; it sat wiping its snout and looked as though it was weeping. Alfhild was afraid of it and clung on to Ivar.

"He'll not hurt you," Frederik assured her. "He's so sweet-tempered, and happy as the day is long. Look, he's smiling again now."

Finally, the entire load was under cover. The three men settled down in the grass outside the house while Thomea prepared the meal. It was party food; eggs and tasty biscuits, meat, herring and some elegant tiny cream cheeses

in silver paper, and there were no fewer than five crates of beer in little red tins. Another box contained clothing, and there was *akvavit* in a third. The bags contained flour, corn and concentrates for the animals. Then there was a box with brooches and finery and a curious little xylophone to play tunes on with a wooden mallet. Alfhild had a wine-coloured necklace of glass beads around her neck and was sitting in ecstasy running her lips over the shining beads.

Ivar and Frederik laced their coffee with gin and stretched out ravenously for the food. Engilbert, too, made free with the splendid repast, meanwhile eyeing Thomea as she went to and fro.

After the meal the two seamen were overcome by drowsiness and wandered outside to have a nap in the sunshine in front of the barn. The monkey clambered up on the gable end of the barn and sat there staring into space like some strange figurehead on a ship.

Engilbert could not remember where he had left the empty creel. Thomea helped him to look for it. For a moment he was alone with her behind the barn; he took her hand and said in an earnest voice: "Why do you pursue me, woman?"

She tore herself away and turned towards him with a wild look in her eyes and her mouth open ready to scream. He sought to calm her down and said in a tone at once hushed but warm: "Let's be friends, Thomea. Come, we must talk."

The girl disappeared without replying. Engilbert felt as though he was cocooned, enclosed in the silvery curtain of a powerful magnetic field; every pore in his body was tingling, and he sensed how he was being drawn to this mountain temptress, this massive she-calf. There was a crackling sensation in his body, as though he had been eating fibre glass, and he could long feel her eyes fixed like clamps on the back of his head as he wandered down the path.

Half way down the hill he met a young woman with three small children. She was humbly dressed, with her

youngest child in her arms and a bundle of clothes on her back. Engilbert realised that this must be Elias's second daughter, Magdalena, who had been married in Ørevík, and whose husband had been lost on the Evening Star. There was no mistaking the similarity between her and the other sisters. Only she was fairer, with a reddish cast to her black hair. Engilbert nodded to her in friendly fashion, as though he knew her; she looked surprised, but returned the greeting.

Engilbert felt heavy and drowsy from the *akvavit*, and had no desire to go down into the village. He longed to go back to the Angelica Bog, was drawn in that direction as though by strong electrical forces; his feet were heavy, but he could not resist, and he decided to obey this call and abandon any thought of working for Opperman for today. He quickly turned around and returned across the fields. It was one of those infrequent days when the sun was shining brilliantly. He was overcome by an irresistible drowsiness; he flung himself down into the heather and felt the irresistible hold of sleep dragging him down into its depths.

Thomea went to meet Magdalena. "It's about time you came, too," she said.

"I didn't want to be a burden on you," said Magdalena. "But now I've got the insurance money for Oluf . . . ten thousand kroner! So I'm all right now."

Magdalena tossed her head. She put down the bundle of clothes on the ground. "Aye, Thomea," she said, "these are strange times, a time of life and a time of death – what are we to make of it? There is suffering and sorrow everywhere you look, and danger and misfortune - but then vast amounts of money are pouring into the country, and there are plenty of hungry mouths being fed when all's said and done."

Thomea turned to the children and touched their clothes. "Now we'll see about something to eat for you," she said in a kindly voice.

Before long Magdalena and her children were seated on benches around the kitchen table. Magdalena's eyes took

on a warm glow at the sight of all that unaccustomed food. She took a bottle of gin, stroked it lovingly and poured herself a drink. "Heavens, what a wonderful sight," she whispered. The children ate with a ferocious appetite, at the same time looking in amazement first at Thomea and then at Alfhild, who was sitting in a corner by herself, knocking out tunes on the xylophone.

After the meal Magdalena lit a cigarette and helped Thomea to clear the table. She hummed happily as she dried the plates. But suddenly she sat down on the bench and hid her face in her wet hands. It was over in a moment, then she got up again, tossed her head and exclaimed: "No, Thomea, it's not that I'm going around hanging my head, don't think that. But sometimes I can't help thinking that it was me who got Oluf to sail on the Evening Star. He really didn't want to. He was really rather a timid soul, you know. He never wanted to go to sea, least of all just now, of course. But what was there for him to do at home? He simply hung around, and we just had to make a serious effort to make a living, seeing as how expensive everything is. . ."

Magdalena stared out into space and sighed.

"And to be honest, Oluf could often irritate me. I could always get a little work on the farm, but it didn't bring in much. Then, when I came home tired out there he'd be, just reading the newspaper and had hardly done anything all day – and hadn't tried to get any work either. 'Cause it was his nature just to sit and dream, lost in his own thoughts."

Again Magdalena tossed her head: "So you can understand that in a way it was my fault that he finally pulled himself together. And then it had to end with him being killed on his first trip."

"Aye, it had to end like that, Lena," Thomea sounded dispirited as she repeated Magdalena's words. Then she sat and pondered.

Magdalena set about the washing-up again. But suddenly she turned fiercely towards her sister and said: "You should

see about getting rid of all those hairs on your face, Thomea! Honestly, you'd be a different person without them."

Thomea looked at her in hurt and dismay. Magdalena went over to her and took her sister's arm to comfort her. "You *must* do it," she said. "I'll help you. There's a good hairdresser here, and she can manage that sort of thing in a jiffy. We can *afford* it, lass. We're not going to be done out of things any longer, are we?"

"I don't know," said Thomea uncertainly, with a sad smile. She sighed and looked affectionately at her sister.

Alfhild had gathered a host of dandelion flowers and was forming them into a wreath. It was for Ivar. When it was finished she went across to where her brother and Frederik lay asleep. She took a piece of straw and tickled Ivar's ear, but he did not wake up. Then she tried to open his eyes, but the lids closed again. She smoothed his thick hair and fixed the wreath firmly to it.

About midday Ivar awoke and got up shivering. The shadow from the barn had just reached the spot where he had been lying in the grass. Frederik still lay in sunshine, snoring. The monkey was at his feet.

Ivar went over to the little brook to the north of the house to quench his thirst. Everlastingly unconcerned, the limpid water was running between the clean-scoured boulders and tiny untouched islands of sand, and had the secure taste of the land. The day was wonderfully mild and peaceful. Down by the quayside in the harbour several ships, one of them his own Manuela, lay side by side. Over on the other side of the pool stood Solomon Olsen's pink warehouses, standing out against the grey mountain side. A proper little village had grown up there recently, with quays and ships, slipways and camouflaged oil tanks. Solomon always had luck on his side, his ships received top prices for their cargoes, and not a single one had so far been damaged. And it was the same with Opperman, Mrs. Schibbye, Tarnowius and all the others. They were all in full flower, earning vast sums on their transit trade in Icelandic fish. Aye, life was good and secure here.

Frederik had awoken and was standing stretching. When he saw Ivar approaching he burst out laughing and shouted: "What the hell have you been dressing yourself up in?"

"Me?", said Ivar. He put his hand to his head and discovered the wreath, but he put it back on his head with a smile. "Alfhild's been up to her tricks, of course."

"Sshh," said Frederik suddenly, looking up at the sky. "I'm sure I can hear a plane."

They both listened. The distant drone of an aeroplane could now be clearly heard, and the sirens began to wail ominously out on the point.

"There it is," Frederik pointed up at the sky. "Up over Urefjeld."

"Yes." Now Ivar, too, could see the tiny dark spot in the sky above the mountain. It grew, took on the shape of a cross, and the drone increased. The anti-aircraft guns bayed in deafening cacophony, and white smoke buds blossomed against the blue of the sky.

"It's flying over," said Frederik.

The machine moved northwards and disappeared. But shortly afterwards it returned, flying very high, and scarcely visible any more. Again the guns started thundering for all they were worth, and the echoes thrown back by the mountains sounded like raucous laughter mingled with moans and high-pitched shrieks.

"Look over there," shouted Ivar. A column of water was rising from the calm surface of the bay, only a few feet from one of the trawlers lying at anchor there, followed by another, just off the jetty. And suddenly a column of smoke rose from the quayside. One of the ships had been hit by a bomb.

The two seamen exchanged glances and set off running down the hillside.

Ivar was quicker off the mark and led the way. He could hear Frederik calling, but was too impatient to stop.

"Ivar!" Frederik shouted again.

Ivar stopped and turned round, irritated: "Well, what the hell is it . . . what do you want?"

"The wreath!" Frederik shouted.

Ivar could not contain a short laugh. He snatched Alfhild's wreath from his head, laid it carefully on the grass, and ran on down the hill.

# 5

It was not the Manuela that had been hit, but Schibbye's Fulda. Flames and smoke were swirling all over the big, grey-painted ship. It had been hit in the prow, and seamen and dockers were busy moving the other ships from the jetty to prevent the fire from spreading; others were trying to put out the flames; a group of men and boys came rushing along dragging a fire hose. A few figures, enveloped in wet sacking, were running to and fro on the burning ship in an effort to salvage valuable equipment and get it ashore.

The Fulda was not the only ship to be damaged. Those anchored closest to it had caught it, too, and the buildings near the jetty had had all their windows blown in. Old Mrs. Schibbye was standing in her smoke-filled office staring out through a shattered window. Blood was flowing from one of her cheeks. On the floor behind her lay a jagged lump of blackened metal that had been hurled in through the window. Mrs. Schibbye was in high spirits; her big, nubbly face was twisted in a smile, and she seemed almost to be thoroughly enjoying herself. Now and then she directed a stream of fierce utterances mixed with embittered cries from the window: "Ah, the swine! Swine, I say. Keep at it, my lads. It's too good a ship to lose for so little. Remember, it's bread and butter to all of us. What'll we do if we've no ship? But it's too late. We can't get on top of that fire, and in any case the ship's sinking, any fool can see that. We'll get the insurance, but what the hell's the good of that? No one ever grew fat on insurance money. And where am I going to find a new ship at a bloody time like this? Keep at it, lads. No, we're too late. The battle's lost. The battle's lost."

Mrs. Schibbye burst into a flood of tears. She turned towards Lydersen, her head clerk, who was occupying his usual place, as white as a sheet and trembling uncontrollably

like a dog after a cold shower: "Lydersen! Have you seen that piece of shrapnel? The thunderbolt! Just look at it, there it is. It came flying in through the window . . . so close it grazed my face. I was supposed to be murdered. Do you understand?"

Overcome by her emotions she caught hold of the little clerk by both his shoulders and shook him vehemently. "Murdered, you understand . . . *murdered*! I was supposed to be stone dead on the floor here! That's what those swine were after. But there was someone stronger than them. . ."

Mrs. Schibbye turned round and opened a wall cabinet. She took out half a bottle of cognac and poured it out into two tumblers. "Look, Lydersen! Medicine!"

The head clerk clutched his glass convulsively and emptied it at one go. Mrs. Schibbye turned back to the window. "The ship's lost," she said, and her flushed face contracted in pain; for a second she looked almost beautiful. But then she became hard again, like burnished copper, and shouted triumphantly: "Death had to take its teeth out of my throat, though, Lydersen, Death had to let go."

"Yes," the head clerk confirmed, with a wan smile.

"Hey, where the bloody hell's my son got to?" Mrs. Schibbye suddenly shouted. "Is Pjølle still down in the cellar shivering like a puppy? *You* stayed at your post, Lydersen. I'll remember that."

Mrs. Schibbye suddenly scowled and nudged her head clerk hard on the shoulder, adding quickly: "Has anyone else been hurt, I wonder, Lydersen? Has anyone been killed? Let's go down and find out."

Lydersen turned scarlet; his eyes were brimming over.

"Your cheek's bleeding, ma'am," he said. "Hadn't you better let the doctor have a look?"

"To Hell with him," said Mrs. Schibbye. "Where's my cap? Oh well, I can do without that, too."

Lydersen suddenly showed his prominent teeth in a sickly, foolish smile which he tried to conceal behind his drooping moustache. Mrs. Schibbye burst into a loud laugh; she went on for a long time, but then it developed

into a kind of sombre, menacing, threatening howl: "Oh, oh, the Fulda was a good ship. She brought a lot of money back. She brought blessings and happiness every time she came . . . to great and small. She fed a lot of mouths. Oh, oh. . . . !"

Liva had been standing for a long time down on the quayside, lost in the sight of the burning, sinking ship. But she could hardly neglect her work in this way any longer. She tore herself away and pushed through the crowd of people.

There was not a soul to be seen in Opperman's warehouse. The door to the office was ajar; Liva glanced in and saw Opperman at his desk, busy filing some papers. He had obviously not been concerned at what had happened. Heavens above, how calmly he was taking everything . . . already hard at work, why, he was even humming a tune to himself and appeared to be well pleased! As for Liva, she was still trembling and felt weak in all her joints.

As she drew back from the door she chanced to brush against a tall pile of shoe boxes, so that it tipped over and collapsed on to the floor with a great clatter. She made a feverish effort to collect the boxes and stack them as before. Opperman didn't come out of his office, strangely enough, though he must have heard the din. Only when everything was more or less in place again did he appear in the door; his face was red; he smiled and beckoned to Liva. "Aha, so it's you? Come in here a moment."

Liva got up, somewhat surprised, and went into the office. Opperman took her by the hand, bowed slightly and invited her to sit on the sofa. Only now did she realise that he was drunk, or at least very tipsy. His tie was askew, as was his mouth, and there was a weary, mawkish look in his eyes. He put a long-stemmed green glass on the table in front of the sofa and filled it from a conical bottle with a cross on the label. Liva made to get up and go, but he held her back; giving her a searching look, he said plaintively: "Oh, Liva. Confused day, very confused! You also need pick-me-up, Liva!"

"No, thank you, I don't want anything," said Liva uneasily.

"Just little drop?"

"No, thank you."

"Oh, then I have alone."

He poured himself a glass and emptied it, smiled vaguely and shook his head a little. Suddenly a cunning look came into his eyes; he went across and took hold of both her hands. She got up in confusion, and found herself standing close up against him.

"Oh, Liva, you give me little kiss today?" he pleaded.

Liva resisted, but she could hardly refrain from laughing at Opperman. She felt neither anger nor fear . . . a drunken man was a drunken man. Only it was pretty humiliating for Opperman that he had had too much to drink simply from fear. . .

"No, no, Liva," he said. "I not ask for kiss, for you a nice, good girl, you engaged and religious girl. No, it just I feel so lonely."

He sighed, made a weary gesture, and went on plaintively: "Everyone want Opperman's money, no one want him himself; all want wages, want tax, want gifts to public works. Some simply take money . . . and no one say anything, for Opperman never protest, never make example of people, never. But I value you high, Liva, you are so beautiful. I value, too, your brother, he do me great service, he also get good rate. No, you misunderstand me, Liva, you not fond of me, I not trouble you . . . I give you beautiful coat, lovely reefer. You like? Not shoes, either? Not underclothes, Liva, fine silk?"

Liva shook her head and could not suppress a smile. But now the door to the outer office opened, and Amanda, Mrs. Opperman's old maid, put her head inside. Opperman looked irritated as he turned round. "What now, Amanda? You not see I busy? I tell this girl what to do."

He turned to Liva and appeared to scold her: "I hear all right you upset shoe boxes; you behave like little child. You upset everything, knock over, no use."

Liva blushed scarlet and hurried out of the office. Opperman sent her a warm, melancholy glance.

The bombed ship was doomed. By late morning the fire had successfully been brought under control, but the ship was letting in vast quantities of water, and the pumping equipment had been destroyed. There was nothing for it but to tow the hulk in to the head of the bay and beach it.

At dusk the quays were still full of people talking in groups and discussing the day's sombre events. Another ship lost, and this time it had happened right in front of their noses, without anyone being able to do anything to stop it. But as though by a miracle, the misfortune had cost no lives. They would hardly be as lucky next time.

There was a great deal of coming and going in Mrs. Schibbye's home; friends and relatives came to ask how she was and to cheer her up after the catastrophe. She was flushed the colour of roast beef, with two strips of plaster across her cheek. The blackened piece of shrapnel lay on a piece of wrapping paper on the middle of the dining room table; she seemed unable to tear herself away from it, and kept glancing at it triumphantly, as though it was a dangerous wild animal that she had managed to bring down.

"If it had been even half an inch closer, you'd have been coming to my funeral," she laughed, the gold chain with the great medallion chinking as her breast heaved.

"Aye, aye, what times these are," sighed Nikodemus Skælling, who had come to glean some information for his newspaper. "We who had our best years before 1914, we can scarcely conceive that civilised life can be so brutally crushed in this way."

He added emotionally: "Don't you agree, Mrs. Schibbye -- those good old *antediluvian* days when Kaiser Wilhelm tended his moustache and the whole world hummed the Luxembourg Waltz . . . ?"

Mrs. Schibbye laughed silently. "Days and days," she said. "Have you ever known anyone sing the praises of the present, Mr. Skælling? No, for everyone always goes on

about the present. No, 'Those *were* the days', you know. But even so, I would say that the roughest days I have known were just before this war. Good God. We were all on our arses. It was a dreadful time, wasn't it Pjølle?"

She nudged her son and went on in the same mocking tone: "It was a terrible job negotiating terms with creditors, eh, running from pillar to post and asking for mercy and time to pay – wasn't it, Pjølle? Cross your heart, wasn't it almost worse than the war? Aren't I right? The war came almost as a relief, that's the truth of the matter. It was like a shower of rain over the desert. Not only for us, but for the whole country."

Pjølle shrugged his shoulders, glanced at Mr. Skælling and said with a rueful smile: "Damned if I know what's worst."

Mrs. Schibbye rubbed her nose in recollection while she excitedly rocked to and fro in her chair: "I'll never forget the first time the Fulda had sold its catch in Aberdeen and I got a telegram telling me the stupendous price. I thought of those words, whoever it was who said them: 'You woke up one morning and were famous!' 60,000 kroner net profit. It was incredible . . . after having been as hard up as we really were after the Spanish Civil War had ruined the market for dried cod. Yes, I must admit the Fulda was a good investment - what do you think we've earned on it, Pjølle?"

Pjølle had a crafty look in his eyes. He shook his head as he took a sip from his glass. "How the hell should I know? Five hundred per cent?"

"What on earth are you talking about, you fool? That's nowhere near. Your health, Mr. Skælling."

Mrs. Schibbye gave a short laugh and shuffled elatedly, but she immediately composed herself and looked serious again, adding as she thoughtfully refilled Mr. Skælling's glass: "But of course, touch wood. How long is all this splendour going to last? It seems the ships are all disappearing, one after another. Sometimes two at a time. There'll be none left in the end, and then we shall be in a pretty mess."

Mr. Skælling was noticeably flushed when he arrived home for supper shortly afterwards.

"Good Lord! It's obvious where you've been," his wife laughed. "How has she taken it?"

"Like a man, of course," Mr. Skælling laughed. "Thank goodness, I saw my opportunity to sidle off before she drank me quite under the table. Oh, but never mind, Maja . . . It's people like Mrs. Schibbye we need at this difficult time, strong, determined folk who don't lose their heads but remain at their post whatever befalls."

# 6

One of the few not to have seen or heard anything of the air raid was Engilbert Thomsen. On the other hand, however, he had been undergoing another strange experience. It started with his falling into a sudden and unconscionably deep sleep and dreaming that he was fighting with a horse, a short, ungainly, very shaggy horse that was trying to bite out his heart – a task in which, moreover, it finally succeeded, though without causing him any pain or other injury; using its long teeth it ripped his blackish red heart out and disappeared with it. Long after it had vanished from sight he could hear it cachinnating in the distance.

Darkness was falling when he awoke. He remembered his dream and had a distinct feeling that some spell had been cast on him. He felt as though something alien had entered into him so that he was no longer quite himself. But he had retained all his understanding and powers of observation, and now he was very curious to see what else would happen.

Poised above the jagged black horizon a dark red moon was sinking. Hell Water lay like a pool of blood; he went down to it and gazed into its mirror-like surface, and there he could clearly see the shaggy little horse that had taken his heart; it was galloping off and disappearing into the distance, and through the din from the fox cages he could hear an almost human laugh issuing from it. Then he saw other strange visions in the waters of the lake: a flock of red sheep wandered in, whatever that signified, and then other animals appeared: a huge cow with long horns, and two smaller cows, and then some animal with six legs. But it was even more bizarre once the moon had gone down, for then he could make out shapes like human beings, nebulous and bluish-green, twisting in a slow dance across the surface of the lake; he could see their pale hands and faces, but he was not afraid of them.

Finally the figures glided out into the darkness, and the lake lay black and forsaken. For a long time Engilbert sat deep in thought. He felt a great urge to go over to Angelica Cottage and find Thomea. He would go to her and simply say: "Here I am, Thomea. Why have you cast a spell on me so I see visions? I am in your power – what more will you do now?"

Up in Angelica Cottage the grown-ups were gathered at supper. A floral cloth was spread on the table, and there was a brand-new paraffin lamp to provide the light. The children and Alfhild had gone to bed. Old Elias lay awake in his alcove. He had been washed and given a clean shirt and lay staring into the room with tired, wondering eyes. Thomea took out the map of Europe so that Ivar could show them how the war was progressing.

"Aye, aye," Elias said. "But there's a long way to go yet. At least another winter. Don't you think so, Ivar?"

Yes, Ivar, too, thought it would take another winter.

"But winter can be a bad time," the old man shook his head. "Bad for you, Ivar. Gales and darkness, no lamps, no lighthouses. I don't know how you manage."

"The darkness is our best friend," said Ivar with his mouth full. "And storms the next best."

Elias smiled despondently: "Foolish the man who decries fair weather," he said. "So the old proverb doesn't hold any longer. It's a topsy-turvy old world. God help us."

After supper the seamen lit their pipes. They sat for a while and chatted with Elias while the womenfolk went to and fro. Frederik took out a bottle of wine and poured it out liberally in glasses and cups. Magdalena drained her glass in a single gulp and did her best to persuade Liva to taste the wine, too. "A glass of port won't do you any harm," she said. "Do let's have a bit of creature comfort." She refilled Thomea's and her own glasses, lit another cigarette and blissfully exhaled the smoke. Liva maintained a stubborn refusal – she neither smoked nor drank. Magdalena had had both *snaps* and beer with her meal, and her eyes were becoming glazed.

"You're lucky here, you lot," she laughed merrily. "Heavens above, but you're lucky. You ought to appreciate it a bit more. Over in Ørevík last year's whale meat was about all you could buy – and that had gone off. Do you think we ever got a smell of beer or *snaps* or wine? No, it was off to bed at nine o'clock every evening and then up at six again for the next day's grind. And even then you were slaving away for others for next to no money. Cheers, Frederik."

"Cheers, Magdalena," Frederik gratefully returned the greeting.

Magdalena bent down and whispered in his ear: "I like you a lot, lad . . . you don't say much but you're nice to be near."

Magdalena sat down beside Liva and put an arm round her shoulders.

"And you've gone and joined the *sect*," she said in a reproachful tone.

But suddenly she took her sister's hand and clutched it to her cheek. She whispered fervently: "Liva . . . you're not angry with me, are you? I'm just talking a lot of nonsense, aren't I? I know you're going through it . . . perhaps more than I've ever done, you with that brooding nature of yours. Poor kid, poor kid."

Magdalena sighed and got up. "Ugh, this place is so thick with smoke I can hardly breathe. I think I'll go outside and have some fresh air."

Before long Ivar and Frederik took their leave. They had to go back to their ship. It was a dark evening, and there was no moon. Half way down the hillside they stopped for a moment and had a dram from a hip flask.

Ivar said in a low voice, "You know, Frederik, . . . being on dry land . . . in the dark. It's good for the soul, isn't it?"

"Yes, it's good for the soul," came Frederik's reply from the darkness.

Liva still had her unopened letter on her.

She hadn't wanted to open it until she could be undisturbed, but now she couldn't wait any longer. She took her pocket torch and clambered in through the gable end of the barn. Here, right up under the ridge of the roof, with her heart hammering with anxiety, she opened her letter.

As soon as she saw Johan's familiar handwriting and the final words, "Yours for ever", she burst into tears and had to put the letter down for a moment. But then she steeled herself and read it. Yes, it was as she had feared, perhaps not quite so bad, but almost. Johan was still running a temperature and had to stay in bed, and there was some question of an operation – though he had to "get up enough strength" first.

She switched off the torch and stayed in the pitch-dark barn until she began to shiver with cold.

Engilbert had carried out his decision to take the bull by the horns and go straight to Thomea. He would not complain or ask her to lift the spell, only talk to her and come to an understanding with her. He respected the strange girl's mighty knowledge of the occult, and although he had now had a taste of her mysterious powers, he was not afraid of her.

Like all other houses, Angelica Cottage lay in total darkness; the only glimmer of light to be seen came from the north-facing cowshed window. It would be very convenient if it turned out to be Thomea out there in the cowshed, so he could meet her out there on her own. He peered in through the crack of light. Yes, it was her. She was milking a creamy grey cow; her thick black hair looked doubly black against the cow's light belly. Her arms were tanned a dark brown, as were her bare legs. There she sat, brown and black and with an abundance of hair, and an overwhelming desire arose again in Engilbert's breast and took away his breath. He waited until Thomea had finished milking, and then he suddenly opened the door and went inside.

"Sshh, Thomea," he said hoarsely. "I must talk to you. Something strange has happened to me today. You must help me, Thomea."

Thomea got up quickly and stared at him, open-mouthed.

"I'll go again straight away," whispered Engilbert. "Just one word, Thomea. But no one must see us. . ."

He went across and extinguished the lamp, but while he was doing this Thomea saw her opportunity to slip out. He heard her utter a little stifled whine as she opened the door. It was amazing that this big strange woman could move so quickly. Engilbert felt flustered. Aha, perhaps there was magic at play here, too. He groped his way around the dark stable to find the door, and in the darkness he again glimpsed the thick-set little horse that had eaten his heart. At last he found his way out. But out in the open it was just as pitch dark, with not a star to be seen, not a glimmer of light from the blacked-out village. Finally he located his creel behind the stable and swung it on his back. He felt tired and weary, and hungry and thirsty, too – he'd better see about getting home.

That was easier said than done, however. He picked his way step by step along the narrow, uneven path. Far below him the darkness was seething with the din of machines, the hooting of horns, the sound of hammer blows, the barking of dogs and singing of all kinds. But suddenly a great, slightly luminous figure sprang out of the darkness, the figure of a woman wearing a grey scarf, and if he was not very much mistaken it was Thomea. He paused. The figure paused, too, but then suddenly vanished. And now he could hear light footsteps on the path behind him, and a voice calling his name. It was Liva.

"You're out late this evening, Engilbert," she said as she shone her torch down on the path. The beam fell on a cluster of grey boulders looking for all the world like a group of women huddled with their heads together.

"Liva," said Engilbert. "Do you know your sister Thomea can work magic?"

"Of course," replied Liva as though sharing a joke. "She knows all kinds of ways of treating warts and tooth-ache and nightmares."

"That's nothing," said Engilbert. "But, Liva . . . she's done something to me so that I keep falling into a magic sleep and having visions."

And then he quickly added: "Not that I'm reproaching her, Liva, don't think that for a minute."

"No, of course," said Liva. "It must be lovely to have visions."

"Perhaps not exactly lovely," said Engilbert. "Though interesting, I must admit. But I'll be coming up one day soon to talk to her about it. I think I can learn something from her, and perhaps she might be able to learn a thing or two from me, because I've had some experiences, too, Liva."

"Yes, do come, Engilbert, you're always welcome."

Engilbert was close to Liva on the narrow path, and he caught the scent of her skin and her hair. He sighed and said: "Liva, you are so beautiful. And what about Opperman . . . is he head over heels with you? And how do you manage to keep clear of the soldiers, Liva?"

His hand fumbled for hers in the darkness; he caught hold of her arm, pressed it and said in an emotional voice: "You are doing right, Liva, you're keeping to the straight and narrow path, you're a steadfast lass in spite of all the temptations lying in wait. Promise me you'll go on like that, my dear; I'm talking to you as a fatherly friend."

Engilbert gripped her arm more tightly. Suddenly he stopped, threw down the creel and fell on his knees before her, flinging both his arms round her knees.

"Stop it, Engilbert. What are you doing?" she said.

"I am kneeling before you," said Engilbert. "For you are beautiful and pure, steadfast and wise, and I am only a poor, striving soul. Don't be afraid of me, Liva. I give you my blessing."

He suddenly pressed his face firmly against her lap, got up quickly and picked up the creel, held her hand tight and

said in an anguished voice: "Goodbye, Liva, you my young life, may bright spirits guard your path now and to all eternity! Wish me well, too, Liva; it will give me strength on my way . . . !"

"May Jesus be your shield and your defence," said Liva. It sounded like an invocation in all its earnestness. Liva disappeared into the darkness. Engilbert remained there for a moment, feeling refreshed by the young voice wishing him well.

Liva went down to the mouth of the river. She was on the verge of tears as she held Johan's letter to her cheek. "O Lord God . . . Johan, Johan," she whispered, "My darling, my poor dear." She did not switch on her torch, but groped her way forward to the half completed house and with a sigh went in through the unfinished doorway into the cellar. There she stood for a while amidst the acrid smell of mould and cement. Tears forced their way through her closed eyelids, and she allowed them to flow, but she made no sound.

There was a rustling sound in the darkness, cats, she supposed, or perhaps rats scuttling about. No, there was someone there. Now she clearly heard the sounds of breathing and a brief giggle, followed by a "Sshh!" A couple of lovers, presumably. Lovers in this house of sorrow. Aye, why not, life had to go on. But it was scandalous nevertheless, scandalous. She flushed with indignation; she tiptoed out again, walked some way up along the river bank and sat down sobbing in the grass. A light flickered in one of the unglazed window niches down there. Someone was lighting a cigarette.

Liva felt a dark desire to give in to her sorrow; she pictured to herself Johan's emaciated face and his straw-coloured hands. Before long – perhaps next year, perhaps even this year – he would be dead. She saw herself, dressed in black, walking behind the coffin, and she heard the pastor's words: "For dust thou art . . ."

And then, what?

All that was left was to wait until Jesus took mercy on

her and relieved her of her sufferings. But that could take a long time. Alas, her wait might last a whole lifetime, and wouldn't she finally forget Johan, then? No, never, never. But at the very end, when she had grown old? But she wouldn't grow old. The world wouldn't grow old. The last days were approaching, that was her hope, and that had become her firm belief. The waiting would not be long. And who knew, perhaps she would die before Johan. She felt an urge to pray to God that it might be so. Or even better: that he would let them both die at the same time.

She had talked to Simon the baker about these things. You must not think so much about your earthly love, he had said. Of course he was right. But they were harsh words. It was as though there was no place for them in her thoughts, no room for them in her heart. For she did not care to be where Johan was not. She wanted to stand before her Judge and Saviour arm in arm with Johan. Together they would humbly bow before His everlasting altar, and He would unite them for all time. It was indeed strange to think of. But in any case it was beyond human understanding.

Liva had an uneasy feeling that at the bottom of her heart she bore Simon something of a grudge. It was wrong of her, it was ungrateful of her towards the man who had given her the faith of the mustard seed, the most priceless gift anyone could have, indeed the one thing needful. She would seek his counsel openly and honestly, as she was wont. He would understand and forgive her. She pictured to herself his calm, gaunt face with its unflinching gaze. Simon was different from all other people, he was stronger, truer, totally filled with God's spirit and justice.

Someone lit another cigarette down in the ruin. Once more her breast was filled with resentment. What she ought to do was to dash down and turn the impudent lovers out. Yet that would merely be foolish. But at least she could go down to River Cottage to see Sigrun and ask whether she had ever seen the like. Sigrun would back her

49

up all she could. But no. Liva preferred to imagine that it was a young couple out together for the first time. The young man was in love and embarrassed, and lighting one cigarette after another was all he could think of . . .

She got up with a shudder. She felt the need to go down to River Cottage and have a talk to Johan's sister. Sigrun was a peculiar woman in many ways, and you could often get mad with her, but this evening it might be a good thing to be stirred up a little.

Sigrun was not at home. Her brother, Jens Ferdinand, was in the kitchen polishing his shoes. He looked as though he had just washed and spruced himself up. It suited Jens Ferdinand to be in his best clothes. His face was really quite handsome, more handsome than his brother Johan's, though with that trace of stiffness in his features that was characteristic of a hunchback. But his voice was not distorted, as was so often also the case with hunchbacks. Jens Ferdinand's voice was deep and firm.

"Good evening, Liva. Come in. Sigrun will be here shortly."

Jens Ferdinand grasped her hand and held it in his own for a long time. He smelled strongly of alcohol, and his handsome dark brown eyes were a little bloodshot.

"It's lovely to see you, Liva," he said lingeringly. "Lovely. Yes, honestly, who else has a future sister-in-law like you?"

His voice trembled slightly, and his mouth betrayed emotion: "You . . . you are the most entrancing sight on earth, Liva. Yes, I'm calling things by their proper name, because I've had just a drop too much to drink this evening. You're the sort of person who deserves to be worshipped, yes, by God you do . . . every man must worship a girl like you. But . . . why have you joined the bun sect, Liva? I was terribly sorry to hear you'd started going there. What do you want with those stupid people, Liva? They mean you no good, believe me, they're simply out to get their hands on you. They're a self-indulgent bunch, that's what they are, but they go about it in such an

underhand way ... they love each other in Jesus ...
cunning, isn't it ... revolting. No, don't be angry, Liva.
Oh, all right, go on. You just get mad with me because
I've had a drop too much and I'm saying what I think. I
won't say another word now, Liva. I didn't intend to upset
you."

"I'm not angry with you, Jens Ferdinand," said Liva.
"And you mustn't think I bother about what you say. You
should come and hear Simon yourself ... I think that
would give you something else to think about."

Jens Ferdinand nodded. "Liva," he said warmly. "I
know I'm only a worthless wretch at the side of you."

He stretched out his hand to her again. "Well, I'll be off
now, off on my lonely way. My life is wasted and unblest
... yes, it is; I best know that myself ... the world's a
miserable hole in general, a stinking slaughter-house. And
then in the midst of it all I come across a creature like you
... ! What the hell am I to make of it, then? What am I to
say? Perhaps life's not so bad after all? So we ought to be
content."

Jens Ferdinand heaved a deep sigh, and tears came to his
eyes. "Yes, I'm drunk, Liva, that's why I'm talking like
this, you must forgive me ... Well, that sounds like
Sigrun coming ... so I'll be off. Goodbye, Liva, goodbye,
goodbye."

Liva gave a wan smile and shook her head. But suddenly
he felt her hand on his head and heard her whisper: "May
Jesus Christ keep thee, my poor dear."

He gave her a contrite look.

There was the sound of quick footsteps on the gravel
outside. It was Sigrun coming home. She had a brief
altercation with her brother in the hall; Liva heard her call
him a weakling and a disgrace to the family.

"Good evening, Liva," she said cheerfully as she entered
the kitchen. "You should just know what *I*'ve been through
this evening. Lord! Well, as I was coming home from the
telephone exchange two drunken sailors went for me and
tore my dress. Just look ... what *do* you think! The collar's

51

loose, two buttons missing, the breast pocket torn half off, my belt split. It was only two young lads, but they were both after me . . . *me*, a woman of thirty-three. I'm going straight down to Captain Gilgud tomorrow morning to complain and demand compensation for my dress. You'll see, Liva!"

Sigrun sat down, quite out of breath. She sat staring into space; her eyes were dry, and Liva noticed the tiny warm wrinkles beneath them. She went on: "God in heaven, they were a brazen pair, the fools, Liva. I can't tell you how they carried on. Luckily I couldn't understand what they were saying. A couple of greenhorns, they were. Oh, but sit down, Liva, and have a bite of food if you're hungry. How are you getting on, by the way? Do they leave you in peace? And what about Opperman? He's a smart little man, isn't he?"

Sigrun took a couple of steps across the floor, imitating Opperman's mincing gait. It was very lifelike, and she managed to copy Opperman's loose neck and mawkish arm movements.

"And the girls fall even for him," fumed Sigrun. "And he isn't even in uniform. But he's foreign, and that's the most important thing."

She went on as she laid plates on the table: "Now there's going to be a wedding again, a double wedding. Old Mathiasen the teacher. His two daughters are getting married – they've landed a sergeant each. I can't see why they bother. Anna from the slipway office is already a widow. . . Yes, her husband was killed in Italy. She's just been told. And Rita, the girl who sold tickets in the cinema, she's been widowed, too. And by the way, remember fat Astrid? Well, she's really fat now, there's no mistaking that – and it's with an old NCO – he's already a grandfather and heaven knows what else besides. They've managed that one all right, haven't they. And her with a father as has stood preaching in Capernaum chapel for generations, warning young people not to give in to temptation – what am I saying, God forgive me. But they don't do things in

small measures these days, you must admit . . . war and air raids, death and misfortune – nothing makes any difference. Do sit down, Liva. And now your sister Magdalena's come home, I hear. With three children. And she wasn't even married for a full three years. And they're all going to live up in your house. Good heavens. Aye, as long as Ivar's at sea, it'll be all right. But what if he gets himself killed, Liva? Then you've got problems. Oh, do sit down, my dear, and have a bite to eat."

"No, thank you, I've had supper," said Liva.

Sigrun had put a little food on the table and poured herself a cup of tea. She sat at the little drop-leaf table and began to eat.

"Magdalena was always such a nice girl," she said. "But she was ever so irresponsible. One man one day, another the next, and she was engaged at least twice before she married Oluf. And they do say that the eldest daughter isn't his."

Liva closed her eyes tight. She knew this old story. But it wasn't fair of Sigrun to bring it up again now that Magadelena had come home a widow.

Sigrun ate with a will and washed down her food with scalding, strong tea. A brooch bearing the emblem of the Christian Youth Association could be seen shining on her blouse.

"By the way, we've got an amazing case in the Association," she said, lowering her voice to a confiding tone. "A dreadful case. It doesn't matter if I tell you, Liva, 'cause unfortunately it's all over the village. Perhaps you've already heard it? Yes, it's Consul Tarnowius' daughter Borghild. Yes, what do you think? She's got herself into trouble, and she doesn't even know who the father is, for she only knows his first name, and the wretch has buzzed off – and besides, she's probably had more than one. . . !"

Sigrun's mouth tightened, and she shook her head as she poured out a fresh cup of tea. "And we'd been preaching to her and doing our best to keep a hold on her. That's why her father sent her to us, you know. And he gave the

Association five hundred kroner so that we'd do our very best. But it was no use; the girl was impossible; she went straight from our meetings into sin, out into the slough. But she's got it from Tarnowius himself, for he was an old rake before he got married. It's *inherited* Liva. Original sin. The sins of the fathers shall be visited upon the children."

Sigrun went on as she ate: "Hey, your brother Ivar was gloriously drunk this evening. I just caught a glimpse of him together with Frederik – they were on their way up to Marselius' dance hall. Of course! They must have their dance, even if the world is falling apart! They've got to dance and drink and – whore, yes, why not use the right word?"

Sigrun savoured the nasty little word for a moment, and the warm wrinkles appeared again under her eyes. Then she took on a serious air. "If only Ivar can keep his temper and not get into a fight, as he so often does. And if only he doesn't get my poor brother mixed up in the trouble he causes. Because Jens Ferdinand has started *slipping* . . . you saw him yourself, didn't you? He still looks all right, of course, but he's not been to the printing works today at all, and if he gets into bad company, he can go on like this for weeks. And that's more than his bad heart can stand. And he suffers something dreadful afterwards."

Suddenly, Sigrun took hold of Liva's hand; her voice became sad and reproachful. "And what about you, Liva? I don't understand why you've started going along with Simon and that rabble. I really can't forgive you for it. You ought to consider yourself too good for that, my girl. He's so self-righteous, so censorious, he thinks he's the only possessor of eternal truth, yes, by God that's what he thinks. You can't be saved nowadays except in his lousy little baker's shop. But it'll not last for long, you'll see, because he doesn't do anything these days, he's not working as a baker any longer. So you'll see, he'll end on the parish or in clink or in the loony bin."

"You do go on," said Liva suddenly, drawing back her hand. "You're like an automatic tooth-pick, you pick at everything."

Sigrun looked up in surprise.

"Well, I mean . . . I actually came with bad news this evening," said Liva.

Sigrun put down her knife and fork and laid her head on one side. "Is it . . . Johan?"

Liva took out the letter, but quickly returned it to her bosom.

"He's going to have an operation," she said. "When he's got up enough strength for it."

"God help us." Sigrun came to a standstill and left her cup untouched. "An operation's one of the last things they try."

"Yes, I suppose it is," said Liva. She quickly turned round and left without saying goodbye.

"Liva," shouted Sigrun after her. "Oh, my God, Liva. . ."

Liva followed the coastal road towards the village; she was biting her lip as she went, and had a salt taste in her mouth. A pungent smell of fermenting seaweed swept in from the shore; she breathed in its scent, which reminded her of the time which was even now almost of the distant past, when the house was being built and she used to go down there together with Johan, full of plans for the future.

From the village she could hear the usual confusion of noises, a woven tapestry of song and surging dissonance in which the steady tramp from Marselius' dance hall as it were established the basic pattern.

She drifted slowly in towards the village and passed Capernaum, the free church meeting house. The big building stood dark and bulky in the damp evening, apparently deserted, but inside full of light and resounding to the music of the harmonium. She stopped for a moment and listened. Then she hurried on. It was getting on for nine o'clock, and from almost all the houses along the road she could hear the dull tones of London's Big Ben. Then they came to an end, to be followed by the news. From out of the darkness came the sound of hammer blows and the hiss

of machinery from Solomon Olsen's slipway, and from one of the ships singing and the jolly tones of a harmonica could be heard. From the barracks, too, came the sound of singing and shouting to the accompanying drone of the bagpipes. It was Friday evening, payday and drinking day for the soldiers and for the seamen the evening for dancing. And issuing from the depths of all this confused din could be heard the steady tramp of feet dancing the traditional ring dance in Marselius' dance hall.

She turned up the main road; the ballad sounded closer at hand now; they were dancing to the ancient ballad of the Battle of Roncevalles, so it was presumably Ivar leading it, for it was his favourite, and he was one of the best ballad leaders in the Serpent Fjord.

But now the ballad was suddenly drowned by a different kind of song – the high-pitched, entreating sound of a hymn, to violin accompaniment. She recognised Simon's voice; it was he and his followers, they had taken up position on the tiny square in front of the entrance to the dance hall. She crossed over to them and joined the little group, and suddenly she felt how everything was falling into place. This was where she belonged; she felt secure as though on an island in a tumultuous sea. When the hymn came to an end Simon stepped forward and began to preach. She could not concentrate her thoughts on his words, but his voice made her feel happy and safe.

There was a throng of people in the dance hall. When the blackout curtain at the door was pushed aside the dancing assembly could be glimpsed slowly moving forwards through the dusty, smoke-filled room. The crowds of people outside were in constant motion, and scarcely anyone cared to stop to listen to the baker's message. Here and there faces could briefly be glimpsed in the light from pocket torches: seamen, soldiers and girls. There were two very dark-skinned merchant sailors among them, their faces were the colour of tarnished metal – they must have been Indians or Arabs. Suddenly she saw her sister Magdalena's face illuminated in a brief flash. Magdalena

down here in the village – already this evening? She was confused and felt a slight pain in her breast. She closed her eyes and made an effort to concentrate on Simon's words.

They were stern words, words that hurt, words about the punishment which we bring down on our own heads through our sinful acts and thoughtless behaviour, and about the great hour that is approaching when the Lord shall reveal Himself in the clouds and strike the nations with terror and divide the sheep from the goats. We must follow the example of the wise virgins and have our lamps ready.

"My lamp is ready," called a voice from the darkness, and a powerful beam of light was turned on the baker's face. Simon stared straight into the light, calm and unconcerned; his sharp profile stood out in the darkness like a paper cutting, only suddenly to disappear again, but his voice continued to sound in the darkness, mildly admonitory in tone, but fundamentally inexorable.

# 7

Ivar was leading the dance. He was one of the few to be entirely at home in the rambling ballad; the verses poured from his mouth as from an inexhaustible well; his weather-beaten and weary face shone with sweat, and he was plagued by a heavy thirst. When they finally reached the end of the ballad he broke out of the chain and made his way in to the bar. Here, too, there was a crush; the long benches around the grubby table were packed tight with beer-drinking seamen and soldiers, but they willingly made room for Ivar, and a generous hand filled his glass with beer and *snaps*.

"Just listen to Jens Ferdinand, he's making a political speech," someone nudged him.

Ivar turned round and saw Jens Ferdinand, the hunch-backed typographer, standing on a bench, brandishing a long, grey hand in the smoke-filled air. His eyes stood out black in his ashen face. Jens Ferdinand was having one of his big evenings; it had been happening pretty often just recently, but otherwise he was usually a quiet, shy man. But then, suddenly this came over him; he got drunk and intoned mighty speeches to the people. Now he was standing there, his mouth flowing over with fine words of the sort you see in print; they confused his ordinary listeners like a wad of foreign banknotes, but in general people understood what he was getting at; a few nodded and agreed with him, others laughed and found the eager little man amusing, while others again were angry, threatened him and told him to go to Hell. Jens Ferdinand spoke with the zeal of a missionary, but the contents of his speech were not exactly pious.

It was the war he was going on about this time . . . the war, the only aim of which was to exploit and sacrifice innocent people so that a handful of millionaires in the different countries concerned could extend their influence

even more . . . gamblers, armament makers, factory owners and speculators. "It's for their sakes that people are being slaughtered in their millions," he cried. "We're not fighting for our native land. They cry native land just to entice ignorant people into their trap. And it's not a scrap different here in the Faroe Islands; no, it's just the same, for here, too, it's a tiny clique of rich speculators, a mere handful of influential men seeking to grow yet more influential on the basis of other people's danger and death! That's who we're dying for . . . in the name of our native land. . . !"

"Well, at least, no one's going to think of killing you, Jens Ferdinand," someone countered. "You're all right, you little worm."

"Aye, did you ever hear the like?" someone else shouted. "Just listen to that bolshevik running down our best folk."

The voice was that of a tall young man in a chequered sports suit and wearing heavy horn-rimmed spectacles. It was Bergthor Ørnberg, known to some as "the bard". Bergthor was Solomon Olsen's book-keeper and chairman of the youth movement known as "Forward".

"Lickspittle", snarled the typographer scornfully.

"Do you mean me, you . . . you . . . !"

Bergthor turned threateningly towards him.

"No, no!" wailed old Marselius, the publican. He was standing fidgeting nervously. "Jens Ferdinand's drunk and doesn't know what he's saying. Let's have no trouble, be good, honest men! Who's bothered about a nonentity like him?"

The little typographer was dragged down from the bench; the man sitting beside him pushed a brimming glass in front of him: "Here, now get this drunk, and shut up."

He went on in a protective tone and addressed himself to the whole gathering: "Jens Ferdinand's bloody well the brightest chap in this place, he'd outweigh any five school-teachers put together."

Jens Ferdinand emptied his glass in a single draught. "That's right," shouted Marselius gaily, rubbing his thin goatee beard. "That's right. Let's all enjoy ourselves together."

But it was not long before things again went wrong between the typographer and the bard. They were having a furious row when Bergthor suddenly pointed a finger at the hunchback and shouted: "They say you're a spy. Do you know? Who the hell are you spying for, you'd better tell us straight away."

But now Ivar got up and shook Bergthor vigorously by the shoulder: "Who the bloody Hell says he's a spy? Except you, you bum-sucker! You watch out, and remember you're not surrounded by the girls in Solomon Olsen's office now!"

Bergthor uttered a sound somewhere between a laugh and a roar: "Just listen to him, the Count of Acacia Cottage! Has it gone to your head now you've been put in command of Opperman's rotten little tub?"

Ivar clenched his teeth. He turned half away and said quietly, but distinctly: "If you want to say anything else, come outside for a moment, and if you daren't, then sit down and shut up."

Bergthor lit a cigarette and blew out the smoke scornfully.

"Who the devil do you think you are?" he said. "Go back to Acacia Cottage and play Mussolini there, you'll have a better audience there."

"No, no, no!" shouted Marselius on the point of tears. "We don't want any brawls in here, I said."

"There isn't going to be a brawl," said Ivar. He turned calmly towards Bergthor and said: "Are you coming outside or not?"

Bergthor took another pull at his cigarette, looked around with a laugh and said: "Why, have you got a message from Marshall Badoglio?"

Several of the men laughed. Ivar breathed heavily. But suddenly he lost control of himself, thumped the grinning Bergthor in the chest and knocked him to the ground.

"No, no, no!" wailed Marselius, tearing at his beard.

"Well done, Ivar," shouted Poul Strøm. "That stay-at-home was asking for a bloody nose. But let that be enough."

Poul Strøm, the skipper of Solomon Olsen's trawler Magnus Heinason, was a man of great repute, and a giant to behold. His words were always taken seriously, for he never lost his composure. But Ivar's fury would not abate. Everything went black before his eyes, he bared his tattooed lower arm threateningly.

"Just you come on!" he fumed.

"Grab him!" screamed Marselius. "Get hold of him! He's out of his mind. Shut the door into the dance hall!"

"All right, Ivar," said Poul Strøm in an effort to soothe him. "Come over here and sit down and have a beer, mate."

Ivar peered at him through unseeing eyes and approached him with his elbow raised behind. Marselius took flight and tripped over a chair leg. He wailed plaintively: "Do get hold of him, one of you . . . please! He might kill somebody."

Ivar felt himself grasped from behind. He turned round quick as lightning and hit out, lowered his head like a charging bull and rushed at a clump of hands and fists, striking out at random, pale and with tightly closed mouth. Once more he was grabbed from behind and brought half way to the ground, but he got to his feet again, stumbled against a table, and felt a dull pain in his side, which made him even more furious. He caught hold of a bottle and hurled it along the table, smashing glasses and bottles alike. His ears were ringing to the sound of an immense number of voices singing the turbulent ballad of the Battle of Roncevalles; he felt himself being lifted from the ground and kicked, but he managed to battle his way free again, clutched a chair and swung it threateningly in the air.

"Where's Frederik?" someone shouted. "Frederik's the only one who can calm him down."

"We'll bloody well get him under control," said Poul Strøm, flinging off his jacket. "Right! At him again before he does some damage with that chair!"

Ivar bared his teeth in a lunatic smile, took a couple of steps forward and swung the chair against the ceiling,

smashing the lamp in the process. For a moment the bar was pitch dark, but soon torches appeared from all sides, all directed at Ivar, whose face contorted in the sharp light, while, dazzled, he swung the chair about him.

It took some time to get him tethered, but finally they managed to force him down on the floor and hold his arms and legs tight. He was pale, and groaned through tightly closed lips; there was froth in the corners of his mouth, and a trickle of blood was issuing from his nose. Marselius had fetched a lamp from the kitchen and put it on the bar. Bergthor Ørnberg, too, was bleeding from his nose and mouth; he had a cut on the upper part of his jaw, and his glasses had been smashed. A couple of other men, too, bore signs of the struggle, but no serious damage had been done. The darkened room was quiet; the scant light from the kitchen lamp was reflected in the broken glass strewn over the floor and tables. It was past midnight; the dancing had come to an end, and the men's voices were subdued. They were debating whether it would be necessary to bind Ivar.

"No, nonsense," said Poul Strøm. "The spark's gone out of him. Let's see about getting him back aboard his ship."

He bent down and took hold of Ivar by the upper arm. "I suppose you can manage on your own, can't you? We've got to get you on board. Come on!"

But now a heavy knock was heard on the door. It was the police, the inspector himself and two constables. Bergthor Ørnberg appeared behind them, holding a hand-kerchief up to his swollen mouth.

"Well, now you can see what it looks like in here," he said. "Lamp smashed, furniture ruined, men beaten up. . . it's a wonder there's no more serious damage. And there's the culprit. And there's Jens Ferdinand Hermansen, the man who started the trouble."

"No, you did that yourself," said Poul Strøm.

Bergthor took the handkerchief from his mouth and stepped over to the inspector. "Look, Joab Hansen, you can see for yourself. I demand that he should be held responsible and punished so it can be a lesson to him."

"Yes, he's dangerous," said the inspector curtly. "Get the handcuffs, Magnussen."

Joab Hansen cast a disapproving glance at the assembly. His brown eyes were slightly askew in his face, and one was bigger than the other. His tight lips moved as though he were chewing on something.

Ivar lay with his eyes closed. His hand fell down limply when the officer raised it, and he offered no resistance. But what now . . . there was the sudden ring of metal against the wall. Ivar had grabbed the handcuffs and hurled them away, and the next moment he was on his feet again. He was again grasped from behind, but he tore himself free, stumbled across towards Joab Hansen and shoved him so violently that he toppled over.

"Oh God!" shouted Marselius in despair. "He's even gone for the representatives of the law. Oh no, that this should happen under my roof."

Ivar had managed to jump up on to the bar, and here he stood, dangerous to behold, grinding his teeth and ready for battle, once more gripped by fury and looking as though he were about to leap like a tiger into the body of the room.

"Take it easy," Poul Strøm exhorted. He went and stood in front of Ivar and said sternly: "Now you're not going to do any more daft things, Ivar. Do you understand? Or are you going to make a complete fool of yourself and end up in clink?"

One of the officers made use of the opportunity to creep behind the bar; he had a rope in his hand. But suddenly Ivar kicked out at the kitchen lamp and launched himself from the bar. There was a shout from the darkness: "Here, I've got him, I'm holding him! Let go, you bugger!" The torches came out again, and their beams shone in confusion in all directions. No one knew where Ivar had got to. The inspector's peremptory voice rang out: "Watch the exit. Don't let him get away!" The torches were trained on the door. It was wide open. They were not long left in doubt that Ivar had escaped.

"It was Jens Ferdinand who let him out," yelled Bergthor. "I saw him do it."

Now Marselius arrived with two candles. His hands were trembling uncontrollably.

"After him!" shouted Joab Hansen. "We must get him at any price! I'll get help from the military if necessary."

"Aye, do what you can, men," groaned Marselius. "Don't let there be a murder in this village . . . things are bad enough as it is . . . show yourselves to be men, and God be with you . . . !"

"Don't just stand there shouting, Marselius," said Joab Hansen. "Lend me a mirror, quick."

Marselius fetched a mirror, and the inspector went across to the light with it.

"Oh, I can see now," said Marselius in a voice breaking with rage and sympathy. "Joab Hansen's got his forehead hurt."

"It's only a lump," said Joab Hansen. "But I wouldn't have got off as lightly if I'd fallen against the stove."

"It's a dreadful lump," said Marselius, pathetically clacking his tongue. "Wait a moment, and I'll fetch a cold compress."

Ivar had made no attempt to hide; he was on board his ship. They found him there, sitting on the edge of his bunk in an unlocked cabin. He had been badly knocked about, his thick black hair was plastered to his skull, and blood was streaming down his forehead and cheeks. Frederik's monkey was suspended from the ceiling, pulling faces at him.

Magnus Magnussen, better known as Big Magnus, was a decent and somewhat ponderous policeman. He found a jug of water and set about wiping Ivar's face. The blood was coming from a gash right across the top of his head.

"You'd better lie down, Ivar," said Magnus. "While I fetch the first aid box."

Ivar found a half full bottle of gin in the cabinet above the bunk and took a gulp. Then he lay down. The corners of his mouth turned down in a weary, sullen smile. Others

arrived now, and he heard Joab Hansen's unruffled, but slightly scornful voice: "Oh, it's a good thing he ended up here. Search him for weapons. And you'll keep guard, Magnussen. And never mind about coddling him so much."

Big Magnus had found a bottle of antiseptic, which he was sprinkling on the wound in Ivar's head. Luckily, it was only a superficial cut. He took his time.

"You've got yourself in a mess now, Ivar," he said.

Ivar fell into a light sleep. He dreamt they were dancing up on the deck. It was again the fiery old ballad about the Battle of Roncevalles that was being sung. It slowly died away, and in the silence he heard the sound of an aeroplane. He bounded up from the bunk, but was forced back again by strong hands.

"The machine gun," he shouted. "Let me get at those devils and shoot them down."

"You're having a nightmare," said Magnus. "There's no aeroplane. Now then, Ivar, let's have no more nonsense."

Ivar lay down heavily in the bunk again and dozed off once more.

Frederik returned at about two o'clock in the morning. He had been out with a girl he knew and had no idea of what had happened. Big Magnus let him into the cabin. The monkey jumped down from the ceiling and crouched on Frederik's shoulder. In a low voice Magnus put Frederik in the picture. Frederik shook his head. "This can be a serious business. I ought to have stayed with him, then it might never have happened. It's the second time in a week this has come over him. But what the devil are we to say . . . ?"

He sat down on the edge of the bunk and took the monkey on his knee.

"It's a rotten life, this, Magnus," he said. "A rotten life. We've hardly had a wink of sleep for days."

"What do you mean, it's the second time?" asked Magnus.

"Well, something similar happened in Aberdeen last

Saturday. He'd had too much to drink then, too, and then there was something about a girl."

Frederik stroked the monkey's neck. He went on in a confidential tone: "Well, you see, Ivar doesn't really bother with girls, he's very reserved. But then he went mad keen on a certain one . . . she was only sixteen or seventeen, and he was determined to get engaged to her - he'd even bought a ring and I don't know what. But when he went to visit her on Saturday, there was another chap with her. So what did he do? — He started beating him up. But the girl wouldn't have any more to do with Ivar and told him to go to blazes, and that, Magnus, was more than he could take. He's only twenty-five, and he's never had anything to do with women, as far as I know. After that he went to a pub and drank himself silly and picked a fight with some foreign sailors, and if I hadn't dragged him out there's no knowing what might have come of it, because the laws down there are very strict now there's a war on."

"No, that sort of thing's a real mess," said the policeman, mournfully contemplating his huge, idle hands. "A real mess. But just you lie down, Frederik. I'm staying here in any case."

Frederik took a bottle and two glasses out of the drawer under his bunk. "Have a drink to keep you going," he said. "What do you think they'll do, Magnus?"

The policeman rubbed his hairy nose, looked away and shrugged his shoulders: "It depends on *Opperman*. He can arrange everything, of course, if he wants to. And I don't think he'll let Ivar down."

# 8

Engilbert was awakened by an ear-splitting cock crow, and when he opened his eyes he saw a black cockerel perched on the foot of his bed. He didn't really believe in that cockerel, but expected it to dissolve like a figure in a dream. However, it stayed there and was obviously real enough, clucking quietly away like an offended hen, turning its head from side to side in a brief jerking rhythm and showing the white of its eyes. And now it was flapping its wings again and crowing with a wide open beak with such force that it resounded in the spring base of the iron bedstead. Yes, it was a real cockerel all right. It had clearly come in through the open window.

It was half past six on a still, overcast morning. Engilbert left the cockerel alone and lay for a while longer. He had had a restless night. He had dreamt he was roaming about in the Angelica Bog . . . there, there had been several suns in the sky, one of them coal black, and a funeral procession had emerged from Hell Water. He had also been in one of the great boulders up there: four powerful, sunburned women had been sitting in it, naked and their entire bodies covered with hair. His dream still felt like reality, and he thought excitedly of the four enormous women and would have liked to get to know them better.

In the next room Thygesen, the Danish butler, was greeting the morning with a song. Thygesen was one of those rescued from the big steamship, the Lesseps, that had been torpedoed south of the islands in 1940, and since then he had hung on here at Mrs. Lundegaard's together with Myklebust, the Norwegian refugee. Thygesen was never really drunk, but always slightly intoxicated, and as soon as he had had the first drink of the day, he burst into song, accompanying himself on the guitar.

Myklebust laughed in approval; his voice was still rusty at this early hour, and he sounded like a steamer unsuccess-

fully trying to sound its siren. These two strange men haunted Mrs. Lundegaard's big attic. Myklebust was a wealthy shipowner; his fleet was sailing for the British. He himself had no need to do anything, and in addition he could well afford to keep Thygesen. Their days passed in gentle boozing and pointless chatter and song. Occasionally, when the weather was good, they could be seen out on the fjord, fooling about in the "Gokstad Ship", that ridiculous and grotesquely over-constructed Viking ship with the red-striped sail, that Myklebust had bought from the mad shipbuilder Markus.

Engilbert failed to understand how they could be bothered carrying on like this day in and day out. Neither of them was young; both had grown-up children, and both had plenty of worries and sorrows. Thygesen's only son, who had been a saboteur in Copenhagen, was said to have been taken by the Germans. Myklebust had been in danger of his life and forced to flee together with his youngest son, while it seemed that the remainder of his family had gone over to the enemy. That son was now in the British Navy. Both Thygesen and Myklebust had on several occasions sought to volunteer for service, but nothing ever came of it, for they were too old to be of use.

The cockerel flapped its wings, but instead of crowing it produced a tiny, feeble hiss, as though it were making an attempt to speak. Now it hopped down on to the floor, and then up on to the window ledge. It was almost as though it were inviting Engilbert to get up and go out. All right, perhaps he could look forward to yet another strange experience on this new day. Though it was unlikely to be anything good. He had an agonising presentiment of immense difficulties mounting on his path. Ghastly temptations lay in wait for him. Mean and malevolent powers sought to rob him of the spiritual benefits which he had so laboriously harvested over the past six months.

Perhaps he ought to go and consult Stefan Sveinson's wife, Svava. She was a woman of rare wisdom and knowledge; indeed in the opinion of some she was close on being a spiritual leader of great eminence.

The cockerel remained on the window sill while Engilbert dressed. It seemed to nod to him and wink knowingly as he pulled his jersey over his head. When he finally got the jersey on, the cockerel had disappeared.

Inspector Joab Hansen sat over his lunch while considering what to do with Ivar. There was no reason why that puppy should not be put well and truly in his place, with a three month gaol sentence which in effect would ruin him for the rest of his life. Yet, on the other hand, there was no reason why the entire affair could not be dealt with by a small fine and an apology to that bloody-minded so-and-so Bergthor Ørnberg.

"Consul Opperman's here to see you," the maid announced.

Joab Hansen drained his cup of coffee reflectively. Opperman's visit today had not caught him unawares. The two men shook hands and glanced furtively at each other, each weighing up the other. Of course, it was about Ivar. The Manuela was supposed to have left that very evening, and there was no time to be lost; fish prices were on their way up, and there was a particularly good telegraphic offer of a cargo from the Westman Islands. So it was important not to waste any time, and Opperman was coming now to ask the inspector to do him the favour of dropping, or at least delaying, charges against Ivar.

The inspector replied in a firm, clear voice, but with a dubious little twinkle in the corner of his eye: "It can't be delayed as matters stand, Opperman. We are just going to have to send your skipper to Tórshavn under police escort. It will simply be demanded of me."

Opperman blinked quite impassively at Joab Hansen and tapped him gently on the shoulder: "Oh, Hansen. We know each other, eh? Clever business people stick together. You do me favour, I do you favour. I give your shop best chance, I give good discount, long credit . . ."

"My sister's shop," the inspector corrected him.

"Your sister's shop," Opperman agreed. "I save her big delivery of lovely cottons, it go like hot cakes, I reserve her lovely new shoes no one else can get, lovely chocolate biscuits, very scarce. We talk it over, Hansen, oh it will be great advantage. I always give you advantage and knockdown price."

The inspector chewed away meditatively. "Now a wholesaler in the capital has been fined 200,000 kroner for cheating the Price Control Commission," he said, giving Opperman a quizzical sideways glance.

"I know," smiled Opperman nonchalantly. "He behave very foolish. Make supplier write false invoice and then both share profit. Oh, very foolish, very cheeky."

"Yes, it pays better to stay on good terms with the Price Control Commission," Joab Hansen commented; a cruel line emerged at the root of his nose as he said this. "You're very good friends, you and the Price Control Commissioner, aren't you, Opperman, eh?"

Opperman looked down and gave a hearty laugh. "Yes, Inspector, the Price Control Commissioner such a nice man, he tell so many amusing things. He tell me you are his very good friend."

Opperman suddenly looked up, and the two men exchanged a quick glance.

"We could talk of so many things," said Opperman. "Shall we talk, shall we keep quiet? Eh, Inspector, shall we keep quiet?"

The inspector looked at his watch and whistled softly: "Oh! I've a lot to do, Opperman. But now . . . as for that poor fool Ivar Berghammer, you know well enough that I personally don't wish to harm anyone . . . !"

"Oh," said Opperman, rubbing his hands in ardent encouragement: "It pay you well, Hansen! People say: That man Hansen, he has good warm heart, he means well by everybody."

"I haven't promised anything yet," said the inspector. "I can't promise anything."

Opperman totally ignored the remark. "And we always

get round Bergthor," he said with a smile. "We just give him little support for National Youth Association."

The two men shook hands once more and exchanged a few indifferent remarks about this and that without quite looking each other in the eye.

But now there was another knock on the door. It was the old headmaster, Verlandsen. He was bare-headed and his eyes were flashing eagerly behind his thick lenses: "Aye, that was quite a to-do with Ivar last night, eh . . . ? What are you going to do about it, Joab Hansen?"

The inspector glanced at his watch and murmured something about assault and bodily harm.

Verlandsen bared his huge brown teeth amidst his white beard. "Are you going to have him punished, Joab? Well, I suppose it doesn't concern me, really, but . . . you've both been my pupils, haven't you, and I know Ivar well. He's a good lad at heart; it's that confounded drink that's responsible for all this. And then all these dangerous trips through the war zone. And I know you, too, Joab, and know that you . . ."

"Aye, yes, I had quite a mauling myself," said the inspector. "But of course, far be it from me to want personal revenge. Though what I can officially condone is quite another matter."

Verlandsen inclined his huge ram's head: "Ivar went too far and acted like an ass — that's quite clear. I'm not defending his actions, Joab Hansen. But if he's punished now, it will be a disgrace not only to him but to the rest of us, too, and most of all to his old father and his sisters. He's Elias's only son. And just look how he's managed to get the whole family on its feet, Joab. They're doing well up there at Angelica Cottage now; they're well off, thanks to that brave lad. Aren't I right, Joab? Just think back on how poor they used to be, even suffering hardship at times, and yet it wasn't their fault, for they've always been hard workers. And if all that's going to be ruined just because . . ."

A sarcastic smile flickered on the policeman's lips as he chewed on the idea. He shrugged his shoulders.

71

"Joab Hansen," said the old teacher earnestly, touching the neckline of Joab Hansen's waistcoat with his index finger. "Consider what's at risk. And remember that you yourself are a prosperous man with no financial worries, for your business is doing well, and that's a good and happy thing. But think of those people up at Angelica Cottage and take pity on them, Joab, if there is any way you can."

"Yes, all right, all right, Mr. Verlandsen," said the policeman, shuffling a little. "It's very nice of you to plead for him. But that shop you're talking about isn't mine, it's my sister Masa's. No, but I don't want to harm anybody, of course I don't, and you know that as well as I do. But I can't promise anything definite. However, since you're so concerned with the matter, you could see about getting hold of Bergthor Ørnberg yourself and getting him to agree. I'm sure he's got a great respect for you. Do that, and you'll be doing a good deed."

Verlandsen grasped the inspector's hand and shook it violently. The old man was moved, he swallowed hard as he left, nodding, but without opening his mouth. The inspector was inclined to feel a certain emotion himself. "I certainly don't want to harm anybody," he murmured to himself, and he fingered the bump on his forehead.

Mr. Verlandsen immediately hurried across to Solomon Olsen's office to find young Ørnberg. Bergthor was another of his former pupils. He had always been a stubborn lad, quite a difficult character, but he was sure he would be able to persuade him. In any case, there was no time to be lost. Mr. Verlandsen looked at his watch as he turned the corner near Masa Hansen's shop. He failed to notice a new grey car driving fast down the main road, and was almost run down. He had to grab the bumper on the car as it braked hard, and was carried a few yards along the road. He dropped his glasses in the process. The car stopped, and a tall man jumped out and embraced him. Without his glasses, the old teacher could not see who it was, but by his voice and the fact that he spoke Danish, he could hear it must be Erik Tarnowius.

"Oh, it's all right, it doesn't matter," said Verlandsen. "No damage done. No, of course it wasn't your fault, it was me, clumsy old fool that I am. I wasn't looking where I was going, for I'll never get used to all this modern traffic."

The Consul had meanwhile found Verlandsen's glasses. They were undamaged. He forced the old man into his car and drove him to his destination on the other side of the inlet, once more shaking the old teacher's hand with a thousand and one apologies. Then he settled back at the steering wheel with a sigh of relief.

"Good Lord, that could have been an absolutely dreadful accident," he thought. "It would have been far, far worse than *the other thing*. Properly speaking, the other thing could hardly be called an accident."

But it was not exactly anything to rejoice over, either. Never mind, perhaps matters were going to sort themselves out now. He was the son of a factory owner, according to Captain Gilgud.

The Consul drove to the edge of the road down by the water, where he stopped for a moment while he lit a cigar. He opened the window and let the fresh breeze from the bay blow in.

Ah yes, it looked very much as though some arrangement could be made, thanks to that incomparable Captain Gilgud. It could be arranged. It could be arranged. He had made up his mind. He would keep his wife in the dark, at least until everything was cut and dried. And as for Borghild herself, there should be no great problem now she had been *worn down*. He would talk to her in private. It would be all right.

The Consul reached out for the starter, but changed his mind and lapsed into reflection again for a moment. He needed a little time to gain his breath.

He had not yet recovered from the shock he received when Maria, in despair, confided to him that their sixteen-year-old daughter had got herself pregnant, and that she didn't even know who the seducer was. It looked hopeless

73

at first. An absolutely dreadful scandal. But once the first
sense of paralysis had passed he had taken the bull by the
horns; he had gone to his good friend, Captain Gilgud, and
had confided in him. It was first and foremost a matter of
getting the father identified. Tarnowius had cherished a last
secret hope that the young man might after all be found
and perhaps even turn out to be a suitable match. Merely
to get the girl married would in any case be an enormous
relief.

It had been a humiliating task. But Gilgud, that incompa-
rable man, had naturally shown the greatest understanding
and revealed himself to be a true friend. But unfortunately,
the thorough and discreet enquiries he had instigated had
not led to any result. Borghild had been unable to give any
information about her seducer other than that he was a
young soldier whom she had been together with only on
one single occasion and not seen since, and that his name
was Charles. That was a slender basis indeed for identifica-
tion. There were naturally dozens of young soldiers with
this quite everyday name, and to have the girl confronted
with them all so that she could point out the right one,
would be an embarrassing and in all probability fruitless
way of going about things. The right Charles might have
left, or he could simply deny any knowledge of the matter;
or even if he confessed, he might turn out to be married
already; or perhaps he was a scoundrel who would only
bring misfortune to the girl if she were to marry him.

But then, as though by a miracle, Gilgud had found a
young man from the Medical Corps who was willing to
marry the girl. He was only a private soldier, but not
simply any Tom, Dick or Harry, for the young man was
the son of a factory owner, and the Captain knew him
personally and could give his word of honour that he was
highly respectable in every way.

It also carried some weight that the young man boasted
the almost unbelievably magnificent name of Charles
Gordon.

So there was, properly speaking, no risk entailed. At the

very worst the couple could have a divorce later if it should turn out not to work. Moreover, this Gordon was due to leave soon, and heaven alone knew whether they would ever see him again.

Such was the state of affairs after the confidential discussion Consul Tarnowius had had that morning with Captain Gilgud. "It's as exciting as in a film," Gilgud had remarked as they left each other, and there was indeed something in that. It was merely a pity that it was a film in which Tarnowius was playing a leading role. But thank God for that miracle-man Gilgud! Tarnowius would go home now and take his daughter out for a spin and let her know what he had decided.

Charles Gordon was not the son of a factory-owner, but of a modest nurseryman who occasionally also produced a little marmalade. All that about a factory-owner was something that Captain Gilgud had made up for some reason or other. But it was not actually the Captain who had suggested to him that he should marry the seduced girl; it was his own idea, and he had had a good deal of trouble persuading the Captain that he meant what he said.

Afterwards, he had also had some difficulty in explaining to himself how it had happened. He knew nothing of this girl except that the Captain had, in all discretion, shown him her photograph. There were no ulterior motives, for Gilgud had told him nothing of the girl's family background. Neither was it because he was too soft, as the Captain seemed to believe. A kind of desire for adventure? But you could have erotic adventures in different and better ways than by accepting the paternity of other people's children.

No, the fact is that despite your twenty-four years you have never yet dared to approach a girl in the usual way, he acknowledged cynically, as he bounced along beside Captain Gilgud in the little army car. Besides, you've never had time, he went on. You've been too busy with your piano playing and your music. And you've had neither the time nor the courage as a soldier, either. You've

75

always preferred to play the piano for that music fiend Gilgud, or to listen to gramophone records and discuss music with Harrington and Horace Young, the two musicians. So this is just a caprice, an adventure, perhaps happiness, perhaps a witches' sabbath. Capriccio, he could hear Harrington's eager voice ringing in his ears. Presto. Capriccio furioso. And suddenly he could not help laughing. He saw, too, that Captain Gilgud was fighting with the help of his cigar to suppress a smile. They turned away from each other until it was past, and the Captain said: "It's a serious matter, Gordon. It is *fate*."

The car stopped in front of a big new house of gritty cement, quite a little mansion, built in a sort of home–spun Moorish style, pale pink in colour like a baby's bottom, with a balcony overlooking the water and a veranda or bathing jetty, or whatever it was supposed to be. And there was a garden full of sweet-smelling autumn flowers in well-tended beds among flagged paths. A large, well-trained alsatian approached them warily. Charles Gordon felt a little uncomfortable, but at the same time as though transported to some Eastern adventure. There was a throbbing in his temples as he followed the Captain up the broad flight of steps laid with imitation marble tiles. The Califf was off on an adventure.

Borghild Tarnowius, standing on a stool, was keeping an apprehensive eye on him from the little Gothic bathroom window. No, it was definitely not him, but of course she knew that beforehand. The real Charles was an entirely different type. This man was dark and slim, almost delicate. He looked so distinguished, far more distinguished than that thick-set, rubicund Captain Gilgud.

The other Charles was nowhere near as cultivated, he looked more like a curly-haired boy scout. It was Rebecca, the maid, who had brought them together. She had had one of his mates, a red-haired lad. They had all four been out in the fields and lain there smoking cigarettes, and she had seen how Rebecca had surrendered herself to her boy, and she had followed suit; it had all happened so quickly

because she was afraid of being late home. Afterwards, Rebecca had grumbled at her and told her she was a fool for not taking more care. Since then she hadn't seen anything of Charles, but Rebecca had discovered that he had been sent to Italy, and that in any case he was married and had two children. So that was the end of that. Since then Borghild had secretly met other soldiers and been out in the fields with them, too, but she had been more careful and not given herself to them as she had to Charles. That was something she had regretted once it turned out that things had gone wrong first time after all.

Borghild jumped down from the stool; she felt a little bewildered; she could hardly understand anything of what was going on. She went downstairs and tidied her hair in front of the mirror. Good heavens above, how strange everything had turned out. So now she was to be *sold*. She felt delicious waves of excitement coursing through her body, and was on the verge of tears, but she kept a grip on herself. Rather be sold than put under the control of the principal of the Christian Fellowship and be forced to listen to the hypocritical admonishments issuing from her and her parents.

Charles Gordon had been introduced to Consul Tarnowius and, to his own surprise, heard himself reel off a solemn apology. The words came as of their own accord and arranged themselves in an exquisite posy: he profoundly regretted the lapse of which he was guilty; it was inconsiderate and unforgivable, but he would never so much as think of fleeing from his responsibilities. And so on and so forth. The Consul had been confused, but at the same time actually moved, and Captain Gilgud had stood in amazement, until he had suddenly bounced up and said in a stern voice: "What is all this nonsense, Gordon? Are you out of your mind?"

Charles fell into a confused silence and looked down like a repentant sinner. He had a tingling feeling of unreality . . . it was like standing masked on a stage, acting the part of someone else, only suddenly to hear your own real name bawled at you from the auditorium.

"I thought we should let the young people have the opportunity to talk to each other in private," the Consul said to the Captain. "And then my wife will be along shortly."

He took Gordon by the arm and led him into the adjoining room. "Just wait here a moment," he said. "My daughter will be coming."

Charles felt taken aback at suddenly finding himself left on his own. The tension was almost intolerable. He heard the Consul opening bottles of lemonade in the next room. He cast an anguished look around the big room. It was full of valuable old-fashioned furniture, and no expense had been spared. A huge ebony grand piano was standing in the corner. He was overcome by the urge to sit down and play something or other, some turbulent piece like Chopin's Study Opus 25 No 10 in B flat minor. But now his wife-to-be appeared from between the door curtains. Good heavens, how young she was. She was very much on edge and glanced around excitedly, but without looking him in the eye. Her hair was chestnut, and she wore a dress that looked almost as though it were made of lilac-grey mother-of-pearl. She was biting her lower lip and breathing nervously through trembling nostrils. Suddenly, her lower jaw dropped, and she gasped for breath.

Charles felt totally at her mercy. He was not in command of the situation, he was trembling and felt a nervous toothache in his back teeth. . . . That confounded old shyness when confronted with a woman overwhelmed him in tempestuous waves of remorse and blushes of shame; he couldn't go through with this idiotic comedy, he felt completely worn out. Like a disconsolate schoolboy realising he is about to fail an examination, he moved as in a trance and held out a hand to the young woman.

"I well understand you are angry," he managed to stammer. "I beg your forgiveness."

Borghild shook hands with him helplessly, still without looking at him. He felt the warmth of her body and smelt the scent of her hair, and suddenly she looked up at him

with her dark blue eyes and awoke an immense desire in him. He wanted to embrace her, but she took him aside, led him to a shaded corner of the room, and there took both his hands and looked into his eyes. Her mouth was open; she shook her head in silent wonderment while she tightly clasped his hands.

# 9

Frederik stood smoking outside Joab Hansen's house while he waited for Ivar to return. Ivar was in the office for questioning, or whatever it was. Bergthor Ørnberg was in there, too, and so were Marselius and a couple of other men. Frederik was very concerned to know what they would do with Ivar. Now Marselius came out on the steps, red-faced and fumbling meditatively with his goatee beard. Before long Bergthor's smooth bespectacled face appeared; he swept back his sleeve, looked at his wrist watch, and hurried off.

At last Ivar came. He stopped half way down the steps and lit a cigarette, flicking the match away with a sullen gesture and slowly inhaling the smoke. He looked worn out and unconcerned.

"Well?" asked Frederik.

Ivar took his time.

"I got a fine," he said. "And then they wanted me to apologise and promise to behave better in future. But that I refused. Bergthor hadn't lost any teeth as far as I could see. But I offered to pay him 500 kroner for pain and suffering, and they went along with that. Marselius wanted 1000 kroner, but Hansen got him down to 200. He said that the whole of Marselius's set-up was illegal in any case, and then Marselius replied that so were a lot of other things. And the inspector shut up at that."

Ivar's lips curled down in a sarcastic smile: "And then, when those two monkeys had gone, Joab Hansen says: 'Now I've just about made myself a criminal for your sake, Ivar; just to *spare* you; you know, you could have got three months or more in gaol for getting rough with the police.' 'All right, what do I owe you?' I ask. 'Nothing,' he says. 'You don't owe me anything.' So I gave him all I had got left on me, a bit more than 500 kroner. He shouted out that he'd said he didn't want anything, but I could hear how pleased he was by the tone of his voice."

Ivar gulped down the smoke and blew it out with a short sigh: "I don't give a damn for any of them. It was Joab Hansen himself who ought to be in the cooler. And Opperman and the whole crowd of them. I'm sick of it all. The war and the whole lot. Ugh!"

They went on board the Manuela.

Lying on the floor down in the dark cabin they found something that looked like a bundle of dirty rags. It was Jens Ferdinand the typographer, dead drunk and breathing noisily through his mouth.

"Poor devil," said Ivar. "Come on, we'll put him up in the bunk for a bit, and then we can get him home when it goes dark."

Ivar unscrewed the top of a bottle of Cluny.

"I'm just dying to get away from this bloody hulk," he said. "I ought to have a big ship. A trawler for example. An armed trawler. Or a torpedo boat."

Frederik laughed, but Ivar became serious: "I damned well ought. Why do we have to flap about in these hopeless old tubs? Surely the Faroe Islands are in the war. It's a lot of bloody humbug that we're supposed to be neutral. We've been hijacked, turned into slaves, as Jens Ferdinand says. And he's right. We think we're being paid pretty well, but there are others getting five times, even ten times, as much just for staying at home and giving us orders. Opperman's taxed on a net income of 175,000 kroner, but Joab Hansen swears he makes at least three times as much in his wholesale business in addition to what he earns on his two tubs. And Solomon Olsen's a million-aire several times over. Oh well, that's no concern of mine."

Frederik felt a little despondent. It was not like Ivar to talk in this way. He had changed recently. Since that affair with the girl in Aberdeen. He could obviously not get over it. Frederik tried to think of something encouraging to say.

"I suppose the war'll be over one day," he said.

"What then?"

Ivar yawned. His yawn ended in a sullen grin, and he started humming to himself:

> All flesh, it is but grass,
> The prophets all did say,
> This earthly life will pass,
> whenever comes the day.

Frederik breathed a sigh of relief. That was more like Ivar. He was his old self again.

Ivar rubbed his eyes and said sulkily: "I don't think life ashore's good for us, Frederik. It weakens you. I felt it as soon as I left the ship this time. I was all weak at the ankles. I was scared. I was suddenly scared! *S*cared of the sea, scared of the Germans. And when I saw those men working for the British, building the new road across the isthmus I was envious of them because they have their work on dry land, and still earn good money. No, it's not good for us to be in port, Frederik, we lose our strength . . . like fish out of water."

Ivar stood up straight and stretched his arms. "But a dram's good for you, even so," he said and gave Frederik a benign look.

He broke into song again:

> A fiery dram, a glass of ale
> Our loyal friends shall be,
> Where'er we go, where'er we sail
> All o'er the rolling sea.

Frederik joined in the refrain. Yes, Ivar was his old self again after all. He was all right again now.

Frederik hesitated and seemed ill at ease: "By the way, Ivar, I met my half-uncle today, you know, the watch-maker, and he asked me to go round to see him this evening at six o'clock. He'd got something important he wanted to talk about. I managed to get out of him that he wants to lease a ship, and I have a feeling that if we can

agree on things he wants me to skipper it. Well, I don't know, but . . . suppose that's what it is, Ivar?"

"You go and have a talk to him," said Ivar. "Pontus the Clock has plenty of money, and it would be like him to fancy gambling a bit. Besides, he's half daft and he needs someone else to do his thinking for him. Aye, Frederik, if you get the chance, then take it; you'd be crazy not to. But don't make any promises before you're sure he's not up to tricks and that you're not going to be swindled."

They both got up and went out on deck.

The sharp smell in Pontus Andreasen's watch and fancy goods shop put Frederik off; there was a curious ingratiating, feminine scent emanating from the pink perfumed cotton wool in the boxes Pontus used to package his brooches. It brought with it memories of confirmations and engagements. And in Pontus's little office there was the acrid smell of paraffin stove and medicine.

Frederik could still hear Ivar's words ringing in his ears: "Make sure he's not up to tricks." He listened cautiously to what the watchmaker had to say as he chewed away at his dead cigar. Yes, Pontus was half daft. He had the gold bug. Frederik felt a little sorry for his old half-uncle, this man who had spent half a century toddling around in his little jeweller's shop, and now was suddenly overcome with a desire to be a shipowner and wholesaler. He had always wanted to have a go at this, explained Pontus, but his wife had been very much against it, for she was of a cautious and timid nature. But since she had passed to a better world last summer there was nothing more to hold him back. He had money, over 100,000 kroner. And admittedly, there weren't any ships for sale at the moment, but there would be sooner or later. For the time being he had leased a schooner for two trips.

"What schooner's that?" asked Frederik.

"It's the Admiral, belongs to Thæus Mortensen from Sandefjord."

Frederik looked upwards and breathed in deeply. "The

Admiral," he said, and nodded. "That's a big ship. But it's an old hulk. I suppose you realise, Pontus, that it's over fifty years old. But otherwise they say it's not a bad ship. Though for some reason or other it's never been a lucky ship. As far as I know, Thæus has only ever lost money on it, and if he didn't have his other two ships, there's no knowing where he'd be. How much does he want?"

"A lot," said Pontus, rubbing his striped thighs. Pontus always wore a black jacket and striped trousers. "A lot. Twenty thousand a month."

"Then you'll be lucky if you break even," said Frederik.

Pontus's face contorted ready for a sneeze, but he managed to prevent the explosion before it occurred. Frederik recalled this from earlier days; Pontus had always been bothered with sneezing, and he was an expert at stifling a sneeze before it came into the open.

"I'm not interested in *breaking even*," Frederik, he said. "It's got to give a profit. A big profit. If they've not had any luck with it so far it's because they've always had that impossible brother of Thæus's, Luke, as its skipper. It's Luke that's unlucky, not the ship. I know Luke only too well, he's far too old and cautious by nature, and he's daft into the bargain, Frederik. They can all get round him and kid him into believing anything they want. I'm a sly old fox; I know people, believe me. But I believe in you young folk, Frederik. It's lads like you and the chap from Angelica Cottage who bring the money in. It's true! Just think on that the other skippers Thæus has are all young men. It's like the Spitfire pilots, they're only young men, too. It's only Luke who's old and incompetent. The ship's good enough. Aye, I know there's supposed to be a ghost on board. . . !"

Pontus's long, broad front teeth were bared in a smile beneath whiskers so stiff they looked as though they were frozen; he did, indeed, look like an old fox. An unpleasant light was flickering in his yellow eyes. Scratching himself violently at the back of his neck, he added: "I know it'll work, Frederik. I've already got a splendid offer from

Stefan Sveinsson. The Admiral's going to get first look in at Effersfjord provided I'll sail thirty fish workers up there as passengers. You know there's a terrible shortage of labour up there. The ship will get straight into the quayside and get the best cargo. Sveinsson has given me his solemn promise. He's a fine man."

The watchmaker leaned forward as he got up, and stuck his thumbs into the armholes of his well-worn waistcoat. "But I'm glad you're producing all your objections, Frederik, that's what it should be like. Let's hear all the pros and cons. Not that it'll make any difference; I've made up my mind. I'm not a young man any more, and I'm a widower, without children. I can't take my money into the grave with me, and I don't want my in-laws to get their hands on it. But you're related to me, too, Frederik. No . . . I've said enough. But now I'm determined to have a flutter. Why should I sit here alone and twiddle my thumbs when I *have* money to take a chance with?"

Pontus sat down again, wriggled his chair closer to Frederik's and suppressed another sneeze. "You know," he said in a low voice, "I've been *dying* to gamble in fish ever since the war began. I've missed out on one chance after another, just for the sake of peace and quiet. You know what Kathrine was like and you know what a terror she could be. It's infuriated me no end to see even men without a penny to their names growing rich on fishing. Just look at a man like Consul Tarnowius – he used to be on the verge of bankruptcy, and now he's rolling in money, so much so that he's been able to build himself a palace! With towers and a swimming pool and a palm court and the lot! Or what about Olivarius Tunstein, that wretched cobbler – he owns the Gratitude now. And he started by hiring a worn-out old suction dredger."

"Yes, I don't know how he managed it," admitted Frederik.

"How? It was criminal. But so are so many other things, and people get away with anything and everything, for there's no respect for law and order any longer in this

country, or anywhere else in the world for that matter. So Olivarius managed to pull it off and made a packet out of it. All you need is nerve and determination."

"But that was when you could rely on market prices," Frederik protested. "Things are a bit different now. There's more fish on the market. People are more interested in quality. Solomon Olsen made a big loss the other day on the Kitty; it took a cargo of saithe to Aberdeen. There was nothing wrong with the fish, but there was just no market for black-jacks, and the whole lot went for a song. . ."

"Yes, but the Kitty," exclaimed Pontus, pointing his index finger triumphantly. "The Kitty's got Ludvig Næss as its skipper, and he's an old 'un of fifty-nine. What did I just say?"

"The Kitty's had many a good trip," said Frederik pensively.

Pontus moved his chair back to the desk. His face was flushed, and the hairs projecting from his big nose moved to and fro indecisively. But suddenly he tossed his head and gave Frederik an icy, disdainful look: "I see; you're obviously not interested. Good Lord. If you're happy as leading seaman on Opperman's filthy little tub, then for God's sake stay leading seaman. There are dozens of others who'll be all over me to get a chance on the Admiral."

Frederik flushed. "I've not said I won't, Pontus," he said. "I'll let you know this evening."

"Thank you so much, that's extraordinarily kind of you," said Pontus, getting up and executing a stiff little bow.

Frederik got up, too. He tried to look Pontus in the eye. But the little man turned away from him and said in a biting tone: "Listen, Frederik, you needn't bother to come back. No, that you don't, you conceited fool."

Frederik shook his head. "All right, but . . . I didn't want to tempt providence, Pontus."

Pontus suddenly swung round. His eyes were screwed tight with contempt, and his front teeth were bared. "I

knew you were a cissy, Frederik," he snapped. "I just wanted to give you a chance, seeing we're related. But now you've lost your opportunity like the simpleton that you are. Do you see?"

"Don't take it like that, Pontus," said Frederik with a little smile.

But Frederik's composure simply made the old man even more furious. He kicked open the office door and drove out Frederik as though he were a steer. The shop was still filled with the oppressive, acrid smell of crowded parlours and sweating ring fingers.

# 10

Engilbert had had another remarkable and disturbing experience. It had occurred early in the day up in the Angelica Bog. As usual, it was misty here, and today the mist was so dense that Engilbert lost all sense of direction and looked for the fox farm in the totally wrong place. Then, when he started off for home again, he could not find a part of the hillside sloping downwards. Whichever way he turned it seemed to lead upwards. Finally, he sat down on a stone to collect his thoughts – and it was then things started happening. A little way off the figure of a woman appeared in silhouette through the mist, a woman carrying a peat basket on her back. She was big-boned and supple, rather like Thomea, and at first he was sure it was she and called out to her. The woman paused, but then continued on her way, without hurrying.

Engilbert called out again. The figure stopped once more. But then she was swallowed up in the mist.

He swung his creel up on his back and hurried towards the spot where the figure had appeared. "Thomea," he shouted. He was convinced it was the girl from Angelica Cottage, and that the approaches he had made to her the previous day must have provoked her to come up here in the hope of meeting him. Perhaps she had seen him when he was on his way up and had invented some errand up there in the bog. The Angelica Cottage folk had their peat up there.

Before long he caught sight of her again; the mist lifted a little, and there, in a lighter patch, he glimpsed her smoke-grey figure; but she seemed to be on a higher plane, as though she had detached herself from the earth and was hovering there in the mist. He called out. The figure stopped and was once more on the ground; he thought she beckoned to him and he had to admit to feeling a little mystified. It was Thomea, and yet it was not Thomea.

Perhaps it was a wood spirit. Suddenly she broke into a run, and he set off in pursuit. He got so close to her that he could hear her breathing, but then, suddenly, she vanished.

"Thomea," he called gently. "You've nothing to fear from me. Why do you run away?"

She must have hidden somewhere nearby. He shouted again: "Hallo! Whoever you are!"

There was no answer. No sound except the lapping and trickling of the water in the bog. The mist became thicker, and he had no idea where he was; there were a lot of big, mossy boulders here, and the ground was damp; here and there there were murky little pools between patches of venomous-looking quagmire. He started searching among the boulders and came across the black entrance to a cave yawning between two cliffs as high as houses. He peered in, reached in with his arm; it was a sizable cave, perhaps the one they called the Troll Child's Cave. Yes, now he suddenly recognised it: it was the Troll Child's Cave. He shuddered, overcome with a mixture of lust, fear and bad conscience.

"Thomea, or whoever you are," he said cheerfully and soothingly. "What are you hiding for?"

He put down his creel and groped his way uneasily into the cave. It was big and wet, with water dripping from the roof and trickling across the floor. She was there. Suddenly he had her in his arms and was aware of her warmth and the smoky fragrance of her clothes. She complained gently, but made no serious resistance. He could not distinguish her features here in the darkness; his hands explored her face. Yes, they were Thomea's features; this was Thomea, a real, living being. He went on to explore her neck and breast, grasped her hands and thrust her arms aside; then he forced her down in the slime on the floor of the cave. She moaned and made more determined resistance, forced her knee up in his abdomen, exerted her elbows until she succeeded in extricating one hand and forcing it up against his chin. She was strong, this woman, but with a great effort Engilbert managed to tether her free hand. A wild

desire had surged through him; he pressed her deeper and deeper into the mud, forced her knee aside and thrust his foam-covered tongue in between her lips and teeth. She part groaned, part whimpered, pressed her elbows down into the mud and managed to raise herself a little; but he was too strong for her, he grunted in triumph as he once more pressed her down in the squelching mud.

But suddenly he felt a sharp pain in his tongue. He let out a howl, but he smothered it in a roar of laughter: "Are you biting me, you devil? I'll teach you." By way of punishment he struck her at the temple and once more sought her mouth, but now she bit him again, and now it was as though she was biting to save her life, her teeth sank into his lower lip; she bit like a terrified mare, ruthlessly, until she drew blood. He howled with pain, lost hold of her wrists, felt a merciless blow from her knee against his abdomen which left him gasping for breath.

And suddenly he was overwhelmed by an undefinable fear; he felt weak, was on the point of tears, let her throw him aside without offering any resistance, hoped to the bottom of his soul that this monster would leave him in peace, while, to his horror, he realised that she had not had enough: he felt her furious fingers in his hair, she thrust his face down in the mud, kneed him in the side, rolled him over in the muddy cave. No Christian woman could behave in this way . . . they were the actions of some evil troll. It suddenly became clear to him that he had been tricked by some power with evil intent, tempted into some snare of mortification. Never in his life had he been exposed to anything so demeaning. He had a nightmarish feeling of being paralysed, of being unable to escape from this alien creature. Then he felt her demonic fury moderate. She released her grip on his hair; her fingers glided down over his cheek, it was almost as though she were caressing him. Yes . . . with a mixture of fear and amazement he felt that she was caressing him now, and her breathing told him she was weeping. It was uncanny . . . the troll woman was weeping and carrying on, but only for show, of

course; he suspected she might be up to new tricks, but suddenly he regained his strength, got up with a start and crawled like some four-legged creature out of the cave, fled for his life and realised he was running downhill.

He did not stop until he reached the fence to the outfield. Here he sat down for a moment. He was soaked in mud and sweat; half-congealed blood and spittle trailed down his chest like a beard; his hands and feet were trembling. There was a little stream nearby; he took off his jersey, rinsed and rubbed it in the clear water and wiped the blood and grime from his face.

Heavens above! What on earth had been going on? He started reflecting, as he ran his wounded tongue over his swollen lower lip. He had an empty, cold feeling in the midriff, as though his heart had been torn from his body, leaving behind a cavity oozing with mud.

The talisman! He clutched feverishly at his chest. It was gone.

Trembling, he started rummaging through his clothing. No, it was not there. The talisman was nowhere to be found. It had vanished.

Shivering with cold, Engilbert climbed the fence and set off homewards across the stubbly infield. He was full of regret and torment, but also of wonderment. Never in his life had he experienced anything so remarkable. Powerful forces had been at play. But perhaps they had not been evil forces. Perhaps it had been meant as a test, though if it had, he had failed and received his well-deserved punishment.

Suppose he went home now, changed his clothes and tidied himself up a little, and then went over to Stefan Sveinsson's to confide in his wife, Svava. She was a shrewd woman, so perhaps he should simply tell her the whole story and ask her advice. He was desperately in need of real company and yearned to hear educated people speaking a real, intelligible language, better and nobler than the one he was exposed to otherwise, that troll-like pseudo-Norwegian tongue of the Faroe Islands. Not to mention Opperman's double Dutch or Thygesen's and Myklebust's

drunken gobbledygook. He longed to be together with his own people, people moved by reason.

Madame Svava was taking a bath, but she sent him a message that she would be down in twenty minutes, and the maid showed Engilbert into the sitting room and asked him to take a seat while he waited. Stefan Sveinsson was in England on business.

Engilbert looked around the beautiful room with its vast leather chairs and gleaming mahogany furniture. Einar Jónsson's world-famous sculpture "Mother Earth" was standing on the harmonium, surrounded by a large collection of photographs in gold frames; dignified, distinguished portraits, all of them. First of all there was Stefan himself, a man of rare good looks in white tie and tails, fair-haired and adorned with a full moustache and gentle, blue eyes. Next to him there as a photograph of his wife, a youthful study of a dark-haired Svava, quite unlike the pure white-haired woman she now was. Her regal, silvery hair was really far more beautiful now.

Then there were photographs of their children, their son, Bjørn, who was in the Embassy, and their daughters Rosa and Viola, who were in America. Rosa, the elder of the two, was a famous porcelain painter and Viola was married to a millionaire who had made his money in pins. And there were portraits of Svava's parents, a sturdy parson and his wife, and of Stefan's father, Svein Stefansson, a factory-owner, a powerful man in the land and a poet at the same time.

Engilbert had seen all these portraits before, and Stefan himself had carefully explained who figured on them all.

Now he turned to the huge painting of Vatnajøkull hanging on the wall at the end of the room, a dazzling sight, the sulphurous blue volcano outlined against a sky covered with storm clouds, with the surging river in the foreground. Aye, he could not help longing to get back to Iceland, the land of fire and ice, the strangest land in the world. And, at the moment, the most fortunate land in the

92

world. There was no war, no hunger or misery, everything was in full flower, in heavy, ripe flower; everything the sea and land could produce was fetching top prices; England and America were actually vying with each other to pay them. Money was flowing like lava from a crater; the prices were high: a cigar could easily cost 25 kroner, a bottle of *snaps* sometimes as much as 500, but that did not matter, for all wages and incomes were correspondingly high, and unemployment was unknown; indeed there was a shortage of labour for the vast new buildings that were springing up everywhere. It was stupendous merely to think of it. And here Engilbert himself was working as a simple labourer in foreign parts, an assistant to Opperman, looking after his foxes. . .

Not that Engilbert felt either regret or resentment. He was not one of the great men of commerce; he was a simple researcher, engrossed in the things of the spirit; he was satisfied with his lot. Even as a young yogi he had seen through the machinery of society; he knew that it was nothing but a *shell,* the hard, necessary, indispensable shell around an obscure, enigmatic centre, a core hidden from the light of day, and yet the most important thing of all simply because it encompassed death and life and eternity within itself.

But now Madame Svava entered the room. For a moment he felt completely dazzled by her tall radiant figure. She was dressed in a yellow Japanese kimono with bronze ornamentation, and her shimmering white frizzy hair poured down over her shoulders and her back. She was bathed in fragrance like a bed of sweet-smelling flowers. Her white wrists and fingers sparkled with rings and bracelets, and her smiling teeth, too, shone with gold.

Aye, beautiful she certainly was, Svava, despite her fifty years; there were no wrinkles in her face, and her cheeks were red and tulip-like, like those of a young girl. Strangely enough, her wide, arched eyebrows had not turned white like her hair; the original black hue was still to be seen, as it was in her eyelashes. Madame Svava was a woman of the

world, and those who knew no better would have put her age at certainly no more than thirty-five.

Engilbert had the strange feeling of having crumpled up deep down within himself, and he scarcely any longer wanted to hear what Svava had to say about the remarkable things he was experiencing. He suddenly thought it was all so loathsome. But she helped him to get going. With a cheerful twinkle in her eyes she asked him to tell her all about his progress in the occult, and after drinking a couple of glasses of strong green liqueur he warmed up and opened his heart to her.

Madame Svava nodded in a mysterious fashion, but she was not impressed; nothing took her by surprise; it was almost as though she knew beforehand what he was going to say. And so she probably did, for she was one of those few chosen ones upon whom Fate had bestowed the gift of second sight. Nor was it of any avail to try to hide anything or employ mild circumlocutions – smiling earnestly, she was constantly on the alert.

"So at no time did you have your full will with her up there in the cave?", she asked.

"No," said Engilbert.

Madame Svava pinched her eyes and looked at him through her black lashes: "So there was no orgasm, either? You understand what I mean?"

"Yes," Engilbert gave a serious nod. "I understand what you mean. No, there was no orgasm, not physically, at any rate, though perhaps spiritually, for when she rolled me over in the mud I felt limp, completely worn out."

"This is very interesting," said Madame Svava, opening her eyes. She looked pensive. "Do you know, Engilbert, I think I will *tell your fortune*. I think that that is the way to discover more than we know now."

Engilbert felt himself beginning to tremble. He was already profoundly in her power, and this made him uneasy. Did Svava mean him well? That was the question. She was reputed to be an incomparable friend to her friends, but spiteful and wicked in hounding her enemies.

Some maintained that her arts had attracted the fury and hatred of leading theologians, and that this was one of the reasons why Stefan had taken her away from her native Iceland and settled her securely in this island fortress out in the ocean.

Madame Svava leaned forward a little, held both her delicate hands up to her face and sat for a moment rocking to and fro. Then she got up, opened a drawer in a bureau and took out a chestnut coloured ring of plaited hair. She sat down in her chair again and placed the ring on her lap. Engilbert was now trembling so much that he had to grit his teeth to prevent them from chattering. He stared at her lap, which was clearly outlined through the light silk cloth. The ring seemed strangely immodest – it was presumably plaited when she was in her dark-haired youth. He felt she was staring at him.

"Look at me, Engilbert," she said in a low voice. "No, not at the plait. Look me in the eye."

As he met her gaze it was at first as though his head was swimming, but then he accustomed himself to it and felt a certain repose in it. It was as though he was surrendering to an invincible but benevolent power.

"One, two, three, four, five," she began to count, right up to thirty-six. "You will soon be thirty-six, Engilbert," she said. "Either this month or next."

"The second of next month," he said.

"You have two sisters," she continued.

Engilbert opened his mouth to reply, but she was there first: "One of them is dead, yes, now I see, she died very young. She was called . . . Nora?"

"Naomi," he whispered.

"Yes, right, Naomi. Such an unusual name. And, Engilbert, you have two, three, or perhaps more children. Three, I see. With two different women."

"Two with one and one with the other," Engilbert corrected her. He noticed that he had begun to sweat profusely. "I have four altogether," he said.

"Yes, four," she confirmed. "The first woman has married since."

95

"Yes, she married an American."

"The other one is unmarried."

"Yes."

"But then there's a third," she continued. She sighed as though saddened by this.

Sweat was pouring down Engilbert's brow and cheeks, and his tongue and lower lip were burning.

"There is a third," repeated Madame Svava. "I can't really make it out. She is very young. Have you a child with her as well, Engilbert? It is not clear to me. You needn't be ashamed of telling me, Engilbert."

"I don't know," he said. "I don't know. I'm not aware of it."

"But it was for her sake that you . . . went abroad, Engilbert. That you came here."

Engilbert shook his head gently. "Yes," he said.

"I can tell you that she has had a daughter since you left, and that this child has been christened Engilbjørg."

Engilbert groaned weakly and rocked to and fro in his chair.

"Hush," Svava admonished him. "Now there is something very strange. Sit completely still. Close your eyes."

He closed his eyes and felt the light movement of her finger tips over his forehead. He felt almost anaesthetised by the perfume on her dress and skin.

"Open your eyes," she commanded. She was sitting in her chair facing him, and the ring of hair lay in the same position on her lap.

"No," she said. "I can't see anything clearly. You will be going on a long journey, I think. There is a woman who is pursuing you in her thoughts day and night."

Engilbert broke into a dry sob and seemed to swallow.

"Is she stronger than you?" he managed to say.

Madame Svava was silent.

"Am I under a spell?" Engilbert asked in a hollow voice.

It was some time before Madame Svava replied. At last she said tersely: "The powers are doing battle for you, Engilbert. I cannot say more."

"Will you help me?" he breathed.

She did not reply to the question, but said with a little smile: "You are a well-read man, Engilbert. Do you remember where these lines come from:

> I know yet a tenth:
> Whenever I see
> Witches playing on high
> I can send them astray
> So they lose their own skins,
> Their longing for home."

"Ljóðatal from the Hávamál," Engilbert hurried to answer.

"Correct."

Engilbert blushed slightly; their eyes met; he felt overwhelmed and could not help recalling how, as a young boy, he had for the first time met and reciprocated the glance of a woman in love.

He got up and grasped her hand, pressed it to his lips, kissed it deliriously, kissed her wrists and the naked arm in the wide sleeve.

"You are terribly worked up, Engilbert," she said tenderly. "Look, have a glass of this. I'll add a few drops of something that will do you good."

She fetched a small medicine bottle and measured seven drops into the liqueur glass.

"Now, Engilbert," she said. Her voice was kindly, almost merry. "Just drink this, and then go home and have a sleep. And now I want to give you something. Look."

She started examining the ring of hair, turning it over and round, and twice putting it to her lips. Then she drew a long, dark hair out of it and handed it to Engilbert.

"Keep this. Carry it on you. It will help you far better than your other talisman."

Engilbert thanked her emotionally. He twisted the hair carefully around his little finger and placed his finger to his lips in silent adoration. Then he emptied the glass, sighed

97

deeply and said: "Thank you, Madame Svava, I thank you from the very bottom of my heart. You know I can never repay you, much as I would wish I could."

He felt weak at the knees, and like one intoxicated he stumbled out of the door and down the soft-carpeted staircase.

"Now they are battling for your soul, Engilbert," he said to himself.

On his way home he went in to Pontus's shop and bought a tiny purse made of some pearly material, and fitted with a fastener. Then, in Masa Hansen's shop he bought a piece of string which he cut into three and plaited together. He fastened the purse to this. He would always carry it on his chest. He unravelled Madame Svava's hair. It coiled itself together like a tiny snake snuggling down in its nest.

# 11

Throughout the day the clouds had hung in great swirls down over the mountains. By mid afternoon the wind had dropped, and the mist settled thick and clammy over the village and the bay. The Manuela was now almost ready to sail; the bullet-riddled wheel house had been repaired and furnished with a double layer of sandbags. The ship had been stocked with provision, and the machine gun serviced and tested by men who knew their job. Ivar had been on board all day; he was reluctant to go ashore, and had asked Frederik to go up to Angelica Cottage and take leave on his behalf.

"I don't like showing myself after that damned affair last night," he said.

"I know, but you ought to go with me even so," Frederik maintained. "I think your father and sisters will be terribly disappointed if you don't come. Besides, it's so foggy that there's not a soul will recognise you."

The upshot was that they both went. Ivar took a bottle of gin. Before turning off the road and starting up the tiny path leading to Angelica Cottage they took a swig. The air was filled with minute drops that settled like flour on their jerseys. The path shone with potentilla and dandelions. In one place there was also a patch of big marguerites. Ivar pulled one of them and fanned his nose with the wet, elastic petals.

"These flowers," he said, twisting his mouth in a rueful smile, "these flowers have grown here as long as I can remember. And the tansies there. We used to pick those as children."

"Yes," said Frederik. "Plants like those die off each winter - but what the hell, they come again. They'll perhaps still be there in a hundred years. . ."

Frederik felt animated by the hefty drink, and he started telling of the girl he had been with the previous night. She

was a singularly bright girl; she had read several books, and she had also told him something he hadn't known before: that ravens and puffins could live to be over a hundred and that somewhere or other in the hot lands there was a bird that entered a fire every time it grew old and allowed itself to be burned, whereupon it took on a new shape and became young again.

"That's the phoenix," said Ivar.

"Yes, that's it, that was what it was called," confirmed Frederik. "So you've heard of it, too."

"Yes, but I don't think you can really take much notice of that story, Frederik," said Ivar with a smile.

"Aye, maybe it was a load of rubbish. Perhaps she was making a fool of me," admitted Frederik. "I couldn't make her out. I've never been able to keep a girl; they never take me seriously. Is there something a bit ridiculous about me, Ivar? Is that what it is?"

"Yes," said Ivar, flinging down the marguerite. "Girls see all men as being stupid and ridiculous."

He turned towards Frederik and said scornfully: "Most women are *harpies*. All they want is praise and flattery and money. They're not interested in anything but themselves."

Now the hipped turf roof of Angelica Cottage emerged from the mist. The damp air smelled heavily of smoke.

"You know, they're not all harpies," said Frederik reflectively. "There's good stuff among them, too. You'll find yourself one some day. Forget that one in Aberdeen; she wasn't your type any way."

The family in Angelica Cottage had just sat down for their evening meal, but now the girls got up to make room for the seamen. "No, we've had our supper, we don't need anything," said Ivar. "We've just come to say goodbye before leaving, and we haven't much time."

He held out his hand to his father, but was immediately almost knocked over backwards by Alfhild who had flung both her arms around his neck. He laughed as he tried to push his sister off, but it was in vain; the girl clung tight to him and whispered something in his ear.

"No, you can't come," said Ivar. "Not until the war's over. Then we'll all go up in an aeroplane and fly right up to the North Pole."

"Now, Alfhild," scolded Magdalena, pulling her sister away. "Say goodbye properly to Ivar and Frederik and stop hanging all over them like that. See, here are your chimes. Play something for us."

Alfhild laughed and slapped Magdalena's bottom, but then she grabbed her chimes and stretched out on the floor with them.

Ivar and Frederik were not allowed to go before they had had a cup of coffee. Ivar poured a *snaps* for his father. The old man sipped it slowly; he held the glass gingerly and took great care not to spill a single drop, and with every sip he breathed a wish for thousandfold good fortune and then called down Christ's blessing and grace on them.

Ivar watched him impatiently. His father had always been like this, tender, delicate, almost womanish, full of pious apologies, excessively grateful for little things. Ivar could not help thinking of his mother, whom he clearly remembered, although he had only been five years old when she died: she was the opposite of her husband, big-boned and tough, mannish in temperament, kind and patient with her children, but taciturn and bitter when confronting strangers. Aye, his parents had been very different in nature and background; his father had come from poor stock, his mother from an affluent farming family. Yet despite this their married life had been happy, and they had left behind them the achievement of a lifetime: they had cleared the virgin land under the outcrop known as the Angelica Wall, where there was now a potato patch, meadows and a small herd of cattle. A peaceful locality, well hidden from the world, aye, merciful heavens, a happy place, a paradise to look back on when you were out there on the sea.

Ivar took hold of his glass and emptied it. He felt a light touch on his shoulder and turned round. It was Liva. She bent down and whispered: "Come with me a

moment, Ivar, there's something I so much want to say to you."

He got up and followed his sister outside. Liva looked away from him and said in a low voice: "You must forgive me, Ivar . . . I've been wanting to talk to you all the time, but I've not dared, for I don't know how you'll take it . . . but I'm so worried about you, Ivar, and I pray so often that all shall be well for you and that you might turn to Jesus before it's too late. But don't wait until it's too late, Ivar. For the hour is nigh now, and we must be ready always and have our lamps lit. No, listen to me, Ivar; I *must* talk to you. You must turn to Him who alone can light our way out of the everlasting darkness to come. Do you hear? I don't want us to be parted for all eternity when the hour comes. I can't bear that thought. . ."

She took hold of his hand, and a firm, alien ring crept into her voice: "Ivar, surrender to your Saviour, believe in Him Who has suffered death for us so that we may not perish."

Ivar gave Simon the baker a vexed thought: that crazy fool, now he had completely turned Liva's head, kind, well-meaning Liva. He pressed his sister's hand in return and said calmly: "You don't need to be anxious on my behalf, Liva. Come on, we'll go inside again."

"You mustn't be angry," said Liva. "I had to say it, I didn't want to neglect what God demanded of me. I'll always pray for you and Frederik, and for all of you. . ."

Ivar gave her a comradely nudge with his elbow. "We'll work it out, old girl," he laughed. Liva, too, had to laugh. She took his arm, and they went inside again.

Frederik had refilled the glasses, but now they had to go and they drank to their departure. Liva and Magdalena went down the path with the two men, all four walking arm in arm. The moon was up, hovering in the murky, misty air like a pale old jellyfish. Magdalena was a little giddy from the wine and kissed her brother and Frederik as she took her leave. Once more she took their hands, executed a few dance steps and sang:

Then fare you well, beloved friends.
To God we now commend you.
His gentle solace never ends
And He will ever tend you.

The others joined in the refrain from the old seamen's ballad:

Fare ye well, now I must leave,
But I'll be back one day.

Ivar and Frederik walked on in silence. Frederik was supporting himself on Ivar's arm; contrary to his custom, he had had a drop too much and was not entirely steady on his feet. As they approached the cemetery Ivar increased his speed. He was hoping that for once Frederik would forget to visit it. Frederik had the habit of taking leave of his parents' grave every time he went to sea, and thanks to an old misunderstanding, it had become the custom that Ivar should accompany him. And so it was this time, too. It was impossible to prevent it, for the road skirted the cemetery. Frederik was determined to stop at the gate; he stood there with a curious stoop, as though weary.

They filed up the long avenue of stunted trees which emerged one after another in the veiled moonlight, and they were swathed in the cemetery's melancholy aroma of withered flowers. Ivar could not for the life of him stand this smell, and it was almost with glee that he surrendered to the thought that he could look forward to ending his days at sea and so be spared lying here among sorrowing doves and glass-covered curlicues.

There was only grass and a small moss-grown memorial stone to adorn Frederik's parents' grave. Frederik bent forward and mumbled some short piece of which Ivar as usual only caught the words: "eternal rest". Then it was over, and they hurried out again. The trees lining the path reappeared in the mist, one by one, like sentries standing there to confirm that Frederik had carried out his idiotic

duty. Only when he had shut the gate did Frederik straighten up and become himself again.

On the foredeck of the Manuela a group of men could be seen. It looked like the crews from several ships, and some of the men appeared to be kneeling. Ivar and Frederik could clearly hear Opperman's voice: "Oh no, it is hopeless, he is quite dead."

"What the hell's going on?" murmured Ivar.

"The monkey," Frederik burst out. He dashed on ahead.

Yes, it was the monkey. It lay rolled up on the deck, as stiff as a dried swab, stone dead.

Then something totally unusual happened: Frederik started storming and raging like a slave driver and using words which no one ever expected to hear coming from his mouth. He swung the stiff animal's corpse in the air as though threatening to batter the onlookers with it, and he openly accused the cook of having poisoned it.

"You could never stand him, Elieser, that's what it is, for you're a creature of the Devil, for all your Christian claptrap. You've given him rat poison or some other bloody concoction, that's what you've done, you bugger . . . you begrudged me him, even though he brought luck to the whole ship."

No one spoke out against him. They were all taken aback to see the peaceful leading seaman go berserk. They simply let him go on venting his fury; no one was glad the monkey was dead; it had been popular with them all. The cook bent his head and sighed. He knew perfectly well that he had not given the poor beast anything bad to eat, and Frederik would come to accept that later, once they could talk it over in peace and quiet.

When no one sought to contradict him, Frederik's torrent of words died away, and now Opperman's voice rang out loud and clear, speaking as it were on behalf of all those present: "You buy new monkey, Frederik. I pleased to pay."

There was a sound of sniggering and suppressed laughter at these words, and this reawakened Frederik's fury. Fuming,

he turned towards Opperman: "It's not everything in this world that can be bought for money, *Mr.* Opperman."

Opperman smiled and was about to say something, but Frederik got in first; the words were hurled from his lips like stones from a catapult: "Shut up, you scruffy cur, you foreign swine, you swindler, you womaniser. Do you understand what I say, you little rat? Get ashore with you, you've no right on this ship with honest men."

A howl of laughter, offensive but inevitable, arose at this. Like an avalanche, it started quite gently, with a few splutters here and there, but it quickly rose to a roar, and indeed some of the younger ones present laughed and howled uncontrollably. Ivar glanced at Opperman, and to his amazement saw that he, too, was laughing. He was not the least bit upset; Frederik, on the other hand, was decidedly offended, indeed deeply hurt. He uttered a sound almost like a sob and forced his way through the crowd with the dead monkey under his arm. Those nearest to him stopped laughing, and gradually the tumult subsided.

"Oh, dreadfully angry," said Opperman. "Shame for Frederik, poor Frederik, lose his darling monkey."

For the first time in his life Ivar felt a certain admiration for Opperman. Anyone else would inevitably have made a fool of himself in such circumstances; they would have boiled over and acted intemperately in one way or another. But it appeared that Opperman was not like that. No, there he stood, little and ridiculously dressed up to the nines among a crowd of seamen in their working clothes, and expressing sincere pity for the man who had just been heaping abuse on him.

Soon afterwards the Manuela cast off and put out to sea in the silent, fluffy, damp darkness.

# 12

The misty autumn night, haunted by sleepy moonlight, lies like a protoplasm over the village, an indefinable *something*, filled with torment.

Jens Ferdinand has awakened from his deep intoxicated sleep, he notices in dull despair that retribution is upon him. Like the boy in the fairy tale, he has presumed to open the door to the innermost, forbidden room in the castle, the place where oblivion's sacred jewel lies hidden, but now the sinful yearning for a forbidden bliss has left him, and the hour of retribution has arrived. There is something merciless and uncompromising within him, something that is demanding vengeance and exacting payment.

The situation is a familiar one, but it can most certainly not be suffered with rationality and resignation; it is appallingly new every time ... the potential for suffering is inexhaustible; the demons of retribution are in fine fettle, and their inventiveness knows no bounds. Indeed, in their very knavishness they are somehow admirable. They effect disintegration; they disrupt all sense of time and space; they divide consciousness against itself: you are no longer a single person, you are two or more, you have eight eyes like a spider.

If you doze off for a moment the demons have it all their own way. Yet even that is preferable to the sharp needle of wakefulness nagging in the back of your head.

He is lying in his own bed; he knows that by the familiar sound of the springs. But at the same time he is lying on the floor of a vast crypt, and round about in the darkness he can sense the multifarious sound of great crowds moving about impatiently ... at sea, on land and in the air, as Churchill says.

If only he could gather together his arms and legs, which are being trampled underfoot by all these millions

of alien beings . . .! If only he could get his eyes under control and and stop them squinting, unite them into a single whole!

He hears a shout in the darkness: "This is what we expect of you." And suddenly he understands that in his capacity of a thinking and comprehending being he is the object of devotion. He gathers himself for an almighty effort and shouts, while the juices of life rise in him: "My suffering is but a tiny fragment of the totality of suffering in the world, of the phenomenal suffering and misery of this age. Like someone suffering from meningitis, humanity itself lies on its couch of pain, crippled to the depths of its soul and a prey to the demons."

"Heil! Heil!" resounds the applause like a horde of wild horses galloping across an arena of iron.

But then he hears irritated voices: "Out with that misery, that hunchback, that spider!" And so they go on. And he has to suffer it.

But her hand in your hair . . . ? Whose hand? And suddenly he knows: Liva's distant but warm smile and that young voice of hers, sad, unsuspecting and infinitely kind: . . . "I'm not angry with you . . . May Jesus Christ keep thee, my poor dear."

So Liva is smiling at you? I'll stake everything, everything on that smile — see here, my crippled heart, take it, fry it, eat it in the name of God, and may it do you good, amen. . . !

And then the most iniquitous of all iniquities: Powerful alien arms grasp her from behind and throw her to the ground. There is the sound of laughter, coarse and lusting; he leaps up and to his horror sees Death himself having his will with her. And with a shriek he awakens and feels the long, painful needle of consciousness pricking him.

# II

## 1

One windy moonlight night at the end of September Solomon Olsen's trawler, the Magnus Heinason steered in through the bay. Its flag was at half mast, and when it came within hailing distance of the quayside there was a call to those ashore with the request that they should send for the ambulance. It arrived just as the ship docked; two stretchers were passed in over the gunwhale; a wounded man was put on one and carried out to the waiting ambulance, which quickly moved off. The other stretcher was slowly lifted ashore, while the harbour folk and the seamen bared their heads.

The body was that of the young skipper of the Manuela, Ivar Berghammer. The crew climbed ashore and grouped silently around the stretcher. They spoke in low voices, as though so as not to waken the dead man. The Magnus Heinason had found the Manuela's lifeboat with six survivors eighteen nautical miles south west of the island. They had all been suffering badly from exposure after drifting for two days. One of them, a seventeen-year-old from Sandefjord had been wounded in the shoulder. The skipper had been killed on board the Manuela, his chest torn apart by machine gun fire. An enemy aircraft had attacked the ship one morning at dawn, not bombing it, but strafing and setting it ablaze.

Frederik, the leading seaman, had his arm in a sling, but it was nothing serious, just a minor flesh wound in the lower part of the arm. Poul Strøm, the trawler's captain, had cleaned it and bandaged it.

The ambulance returned; the stretcher with Ivar's body was lifted into it, and the ambulance disappeared into the

night. Soon afterwards the trawler put out again; they were in a hurry, on their way from Iceland to Scotland with a valuable cargo of frozen fish, and they had not originally intended putting ashore on the way.

Of the five survivors from the Manuela, only one, Sylverius, was married; the others were young lads, and three of them lived in other villages. Sylverius suggested that they should all go home with him and have a warm meal. Someone had fetched his wife, and she was standing there, white as a sheet, holding his arm; the others looked away from the young couple and let them have their reunion in peace. Before long the three men went off with them. Frederik, however, upset and restless, preferred to be left alone and stayed behind on the windswept quayside. The windows in Solomon Olsen's warehouse on the other side of the bay were glittering in the moonlight, and the shadows of huge clouds were driving across the mountain sides. It was just after two o'clock.

Frederik was at a loss as to what he should do. Opperman and Ivar's family had to be told of the tragedy, that was certain. But ought he to waken people up in the middle of the night with such bad news? He was the obvious person to undertake the task, and he had promised to do so. It was another of those many trials one had to face. Nevertheless, he felt most inclined to drag it out as long as he decently could, perhaps until five o'clock. Then, at least, it would be morning. To turn up in the middle of the night and shock people up with the news of a tragedy struck him as little short of an act of murder.

Frederik prepared to spend a few hours alone. He decided to go for a walk and exercise his stiff limbs. He could go up to the cemetery. That seemed to be the most suitable place just now. Then he would go down to the hospital and enquire about Henrik, the wounded man from Sande-fjord, and try to discover what arrangements were being made for Ivar's funeral. For the time being, the stretcher had been placed in the hospital mortuary.

The town was grey and inert in the bleak night, but it

was not silent; there were the muffled sounds of work from Solomon Olsen's slipway, while voices and even a little music could be heard here and there. When Frederik passed Opperman's warehouse he could see through a chink in the black-out curtains that there was a light on in the office. He went closer and listened; yes, he could hear voices. They were speaking English. Frederik decided to cut short the agony and knock on the door with his awful message. He took a deep breath and shook his head. It was disgraceful that he had behaved so outrageously and heaped abuse on Opperman the last time they had met; he felt ashamed when he thought how calmly Opperman had taken it. And he felt it as a kind of punishment, a just punishment, that he was now condemned to be the one to tell Opperman that his ship had been lost. That was what you got for your arrogance – forced to eat the cabbage that you yourself had spat in, as the old play had it.

Frederik felt insignificant and superfluous. He had had this feeling ever since the catastrophe. He felt it was all a gross misunderstanding on the part of fate. It was quite wrong, absolutely ridiculous, that it was Ivar who should be dead and that he, Frederik, had survived. He had not yet shed a single tear over Ivar, but the dryness he felt within was burning the soul out of him.

Now the door to Opperman's reception room opened, and a couple of army officers emerged on to the steps. Behind them came Pjølle Schibbye, puffing away power-fully at his cigar. Opperman remained standing in the doorway, rubbing his hands and smiling so broadly that his teeth could be seen flashing in the moonlight. Frederik waited until the others had disappeared, and then he went and knocked at the door. Best to get it over and done with.

Opperman was flushed and a little tipsy and smelled of whisky. "Pliss come in," he said. "You want borrow bottle? Oh, I see it is Frederik. . .? But where Frederik come from now in middle of night? The Manuela. . . ?"

Frederik leaned against the doorpost. He was holding his

bonnet in his hand. In a flat voice and looking down he told Opperman what had happened. Opperman put all five fingers of his hand to his mouth, "Dreadful," he said. "Dreadful."

He pulled Frederik inside and forced him down in a chair. He remained standing himself, wringing his hands and standing askew; his mouth was twisted as though he were about to vomit, open so that the well-tended teeth could be seen.

"Oh Lord and God," he said. "Shot in the chest? Dead on the spot? Oh, bad, bad."

Opperman put his hands on his stomach: "Yes, that war, it cost many young lives, Frederik. That is certain."

Opperman had tears in his eyes. He pushed a glass across to Frederik and filled it. His voice was forced: "We must accept it with patience, Frederik," he said. "We must gather strength to bear our suffering, like all other people in this war. Think of people hit in air raids everywhere, no homes, cold, hungry, dreadful."

Opperman loosened his tie and opened his shirt. He was sweating. "Oh, dreadful," he repeated. "And naturally I not sleep this night. Just lie thinking of that ship, of Ivar dead, dreadful."

He seated himself and took a great gulp from his glass, then sat staring at the floor for a moment. The delicate wrinkles on his forehead made him look like a melancholy old woman.

But suddenly he got up. A smile was dawning around his eyes. He raised his head, suddenly adopted an upright, almost manly, stance, and held out his hand to Frederik. Frederik could scarcely refuse to shake hands with him.

"Well. He died for his native land, Frederik," said Opperman, in a voice as though addressing an auditorium. "All you who sail go to war for native land like real soldiers. And we who own ships, we risk everything and lose much money for common good. Yes, this is how men die and suffer throughout all world, in blood and sweat and tears . . . for victory of justice."

He looked deep into Frederik's eyes and repeated: "Yes, for victory of justice in this dreadful war. In time. In time, Frederik. Through suffering to victory."

They emptied their glasses. Frederik felt that it was time to go. Opperman showed him to the door, and he shook hands with him once more.

It was not yet three o'clock. Frederik drifted haphazardly out into the moonlit night; he hung around the hospital for a long time, peering into the deserted courtyard, and finally going into it and taking up position in a corner until either a nurse or Benedikt Isaksen the porter turned up. Yes, there was Benedikt. His scrawny figure was a strange sight in the moonlight; he was bare-headed and bald like Death himself. He drew the back of his hand across his nose and wiped away a drop.

Frederik went across to speak to him. Benedikt was not a talkative person, but he said what had to be said. The wounded man was in bad shape, but he was expected to recover, for he was young and strong. Nothing had been done with Ivar's body as yet. It was still in the morgue together with the body of a girl who had died of diphtheria.

"I'll take you in, if you like," Benedikt suggested.

Frederik followed him like a sleepwalker. The mortuary was bathed in subdued moonlight. There was a strong smell of carbolic. He saw the two stretchers, both covered with sheets. Benedikt drew aside the sheet covering Ivar so that the face became visible. Frederik stared at the silvery features which were completely unrecognisable; he could not understand why he should be standing here looking at them; there was no sense in it. The porter said nothing; he took an empty stretcher that was leaning up against the wall, and put it over his shoulder, and then they went out into the moonlight again, and Frederik took his leave.

He felt drained and sick, and he remembered the old seamen's song: "All flesh, it is but grass". He thought of his childhood spent in the little house by the shore, of his mother, whom he could dimly remember, and his father who lay ill with consumption for many years before he

finally passed away, and his brother Anton, who died in the same year as his father. Frederik was fourteen then and had just left elementary school. He remembered the empty house, and how it was pulled down because of the danger of infection. The timber was used for a new bridge over the river, and for a long time he thought he could recognise the familiar old smell of his home whenever he walked across the bridge.

Then he lived for a year up in Angelica Cottage before going to sea as a ship's boy on the cutter, the Spurn, together with his old playmate Ivar. After that he and Ivar had stayed together and been inseparable friends. It was Ivar who had urged him to study at the home trade college. And when, two years ago, Ivar was made skipper of Opperman's ship, Frederik had gone with him as leading seaman. It had been a difficult time, but a good time. He always felt he was standing in the midst of events when at Ivar's side. Things happened there, that was where things went on. Nothing could hold Ivar back when he had made up his mind to do something, and he kowtowed to no one. Frederik proudly remembered how Ivar had once put his foot down with an Icelandic fisher dealer; at first he said he would take him to court, but then he threatened him with his bare fists, because the Icelander had tried to foist a badly frozen cargo of fish on them.

Frederik had reached the cemetery and stopped at the gate, peering up through a stunted avenue disappearing in the withered grass. There was a forlorn and desolate smell; most of the leaves had fallen from the trees and lay in piles along the side of the avenue and between the graves. He bared his head and opened the gate, but once inside he changed his mind and went out again. He would be here soon enough to attend Ivar's funeral. He hurried on.

"All flesh, it is but grass." Again the words rang in his ears.

Frederik followed the hillside until he reached the path leading up to Angelica Cottage. It was still only just turned three. He would not waken anyone yet. He glanced up at

the little outlying cottage under the Wall, asleep and unsuspecting in the uneasy moonlight.

Frederik strolled back to the town. He felt drawn to return to the hospital. Not that there was anything he could do there. But it was simply that he had grown accustomed to being near Ivar. If only he could have talked things over with Ivar tonight.

There was a light in the boiler room in the cellar. Frederik went across and looked through a crack in the black-out curtain. Benedikt was sitting on a packing case in the middle of the room; the light caught his shining cranium and bony face, and his deep eye sockets almost seemed to be empty. He was deep in thought.

Frederik went into the boiler room, feeling a desperate need to talk to someone. Benedikt gave him a mournful, understanding look.

"Ivar was a fine young man," he said. "He could be a bit hasty, like when he beat up Bergthor and the Inspector, but that was only when he was drunk. He was all right otherwise. And he was a good son to his father, and a good brother to his sisters, and a good friend to you, Frederik."

Frederik nodded. "Yes, indeed he was, Benedikt."

The porter gave a long sigh and cleared his voice. Then he slowly raised his head, and, seeking to catch Frederik's eye, said: "But how was it between Ivar and Jesus? You must know, Frederik, because you were always together with him. Had he received grace and redemption through Jesus Christ? Was he a believer, Frederik?"

"Yes, he certainly was," replied Frederik, and repeated: "He most certainly was. He just never talked about it."

"But you did have prayers or prayer meetings on board?" continued Benedikt.

"No, not really," Frederik hesitated a little. "I would sometimes read a prayer aloud on Sundays and holy days, and then a few of us would sing a hymn. Ivar didn't mind."

"Didn't mind?" asked the porter, looking up cautiously. "Could he have anything against your worshipping your God and Saviour?"

115

"No, he didn't mind. That's exactly what I said."

"No, I should think not, having anything against the one thing needful." The porter shook his bone-white head in silent wonderment.

"He didn't mind it at all," Frederik repeated.

"No, because if he had had anything against it," continued Benedikt obstinately, "he would have been no better than one who offends one of these little ones. And then it would be better for him that a millstone. . ."

Benedikt swallowed the rest of his sentence and backed away like one who realises that it is better to be silent. Frederik felt a kind of resentment on Ivar's behalf and asked: "That a millstone what. . ."

"Were hanged about his neck!" Benedikt exploded.

"Why should it be hanged about his neck?" asked Frederik, affecting not to understand in order to take his revenge on Benedikt. The porter was a member of Simon the baker's sect. The bun sect as it was called.

Benedikt got up, and with averted gaze and the voice of a preacher said: "Were hanged about his neck, and that he were drowned in the depth of the sea. Don't you know the Scriptures, Frederik?"

Turning towards Frederik he added: "My words were not aimed purely at Ivar; they were meant to apply in general to all those who scorn their fellow men for worshipping their God."

"He never scorned them for it," said Frederik.

"That's good, Frederik," said Benedikt. "That's *good*. But it's not *enough*. He in whom the spirit does not reside is dead even though he be alive."

"Where do those words come from?" asked Frederik.

"They were my own words. Or they were inspired in me. And he who has the light of the spirit burning within him, he continues to live, even though he be dead. They were my own words, too, Frederik."

"And whosoever shall exalt himself shall be abased?" said Frederik. "They weren't my words; they were from the Bible itself."

"I'm not exalting myself, if that's what you mean," said Benedikt, in a wavering tone. "Far be it from me, poor sinner that I am, to want to exalt myself. On the contrary, I try to abase myself as best I can and with the beneficient help of Christ. No, there aren't many who really make an effort to abase themselves as much as I do. Here I go, Frederik, emptying spitoons and cleaning bedpans and washing corpses; my job's degrading in every respect. But that's only because I know He has said: 'He that is greatest among you, let him be as the younger; and he that is chief, as he that doth serve.'"

"So you really do want to be great in one way or another?" asked Frederik. He could not get away from the porter's arrogance in doubting Ivar's faith.

Benedikt flared up again. Once more he was standing in such a position that his eye sockets looked as though they were empty. His voice took on an urgent, harsh tone: "I want to be great in Jesus. That's what I want, Frederik. And that's what you ought to make an effort to become, too. For what shall it profit a man, if he shall gain the whole world, and lose his own soul?"

Frederik looked at his watch. "No, I only meant that even if Ivar didn't wear his faith on his jersey like a medal for heroism, he was in that respect as good a man as both you and I."

Benedikt uttered a long sigh, and his watery eyes suddenly became visible in their sockets.

The thought struck Frederik that the porter was a sorely tried man, left alone in the world after tuberculosis ravaged his home and robbed him of his entire family. Was it to be wondered at if this cruel fate had turned his head a little?

"Goodbye, Benedikt," he said gently. "And thank you for letting me stay here while I waited."

"Goodbye," came the answer. "And may Jesus Christ Himself fill your lamp with oil so that you be not lost in the darkness of damnation."

It was five o'clock by now. The moon was low in the

western sky and in the east there were the first signs of dawn. Frederik had sat down on a corner-post by the road leading to the hospital; he had been rapt in thought, and the prospect of going up to Angelica Cottage with the news of Ivar's death suddenly seemed an almost insuperable task. He felt there was something perfidious in his being safe and sound, while Ivar was obliterated for ever, no longer of use as anything but food for the worms under the ground. He was reminded of the words: O my Father, if it be possible, take this cup from me. But at this he became even more ashamed of himself . . . was he sitting here and thoughtlessly actually comparing himself with Him in the Garden of Gethsemane? Alas, had he but been a man of the spirit and able to say a word of comfort to those left behind. But that was not his nature; pious words would sound ridiculous coming from his lips; he could not suddenly appear as anything other than the old, familiar Frederik, Ivar's leading seaman and companion. It was no use playing the pastor or evangelist.

But of course, he could go up to the pastor and get him to accompany him. Fancy not thinking of that before. Pastor Fleisch would surely do him that service with pleasure; he was an amenable chap.

Frederik went up to the parsonage and knocked at the door. Yes, Pastor Fleisch told the maid to ask Frederik to wait a moment, and he would come.

The pastor's sitting room reminded Frederik of a shop, with countless shelves and display cabinets tightly packed with all kinds of trinkets, watches, photographs and rare stones and crystals. On the walls there were pictures from Jutland, Pastor Fleisch's home. Two enlarged photographs of the pastor himself and his late wife hung over the sofa. Pastor Fleisch was an elderly man, white haired and round, and with a Vandyke beard. His eyes were perhaps a little ferrety. He was said to be a very wealthy man, but he also had a certain reputation for his charitable works. On the other hand it offended some people that he was never averse to striking a good bargain. During the course of the

war he had bought two houses which he had then sold again at a good profit. And he had made money out of the contents of one of them, too.

But perhaps it was not really for the sake of personal gain that he struck these bargains; at all events, a good deal of the profit went to charity. Not only did Pastor Fleisch lend a helping hand to the poor; he also loaned young people money for their education, and it was well known that he had helped Mr. Lillevig, the grocer in Sandefjord, to get his business on a firm basis by investing money in his ship. They had both profited from this, for it was a lucky ship and it did well.

Pastor Fleisch came down from the attic and shook hands with Frederik. His face was still puffed with sleep, and he was without a collar. His white hair stood up like a brush. He stroked his beard and looked into a corner while Frederik told him his errand. There was no emotion to be seen on his flushed face; he looked at his watch and said: "All right, Frederik Poulsen, but then we had better get off at once so that no one else gets there before us."

He disappeared for a moment and returned wearing a clean collar, a black overcoat and a bowler hat. They set off. Portly as he was, he was a good walker, and the climb up to the cottage was no problem to him – he had a good pair of lungs. He discussed markets and fish prices with Frederik as they walked along, and he was as well informed as a proper merchant. It struck Frederik that it almost seemed not to have dawned on the pastor how distressing their errand was, and he was not far from regretting that he had not decided to come alone after all.

It was almost six o'clock by the time they reached Angelica Cottage. Smoke was rising from the chimney, so someone was up. As they drew nearer, they could hear voices. It seemed to Frederik that some of them belonged to outsiders. And suddenly he thought he could hear Opperman's voice.

"That can't be right," he thought. But yes, it was Opperman. He was standing in the hall with his hat in his

hand and was just about to go. Frederik felt embarrassed that Opperman had got there before him, but at the same time it was almost a relief to him.

"Oh, Pastor Fleisch," said Opperman, holding out a gloved hand. Pastor Fleisch shook hands with him and drew him aside. The two men spoke together in low voices. Frederik could hear that it was something about insurance. He went out into the kitchen. Liva and Magdalena, both half dressed, were weeping profusely; they took Frederik's hand as though in their sleep. Elias was sitting over by the fire; he was not weeping, but he was staring vacantly before him, and there was a glazed, numb look in his eyes. He took Frederik's hand in both his and held it for a long time, and it was as though this despairing grip released something in Frederik's breast; he could no longer keep the tears back; wave after wave of hopeless grief surged through him; he withdrew to the hall and stood there with his forehead against the wall, doing his best to suppress a paroxysm of weeping. He heard Pastor Fleisch speaking as though reading aloud from a book. Yes, he was indeed reading; Frederik could hear him turning a page. It took a long time. It was as though Pastor Fleisch was keen to demonstrate that he was with them heart and soul. And the sermon was followed by a long prayer. Then, at last, it was over. The pastor shook hands with all present and wished God's comfort and blessing on them. Frederik, too, was shaken by the hand. He was not able to collect his thoughts sufficiently to thank Pastor Fleisch for his trouble. He stayed behind in the hall, drained of all thought, completely numbed, staring at a knot in the unpainted wall.

# 2

The news of the Manuela's and Ivar's death spread quickly through the town and across the fjord, and it was not long before flags were to be seen flying at half mast everywhere.

Mr. Nikodemus Skælling, the editor of the local newspaper, quickly set about writing a few words to mark the sombre event; from a purely technical point of view it came at the right time, sad as it was, for he was short of material; in the last issue he had had to fill a whole page with a translation, an article from the Reader's Digest on the famine in Russia resulting from the ridiculous revolution of 1918 and Nansen's magnificent efforts to secure international aid. But his readers had not been interested, and Heimdal, the bookseller, had asked him sarcastically in the club yesterday evening whether the paper would not soon be publishing the latest on Napoleon's retreat from Moscow. "Oh, come now," came the reply, and Mr. Skælling explained to Heimdal the real reason for his printing the American article on the Russian famine. The great defeat inflicted on the Germans on the Eastern Front was filling everyone with enthusiasm for the Russians, so it was only reasonable to remind them that the objects of their adulation were still a horde of bolsheviks, unquestioning devotees of those two Asians Lenin and Stalin.

Mr. Skælling was somewhat at a loss as to how to refer to the dead skipper. Only recently, Ivar Berghammer had attracted unfavourable attention to himself as a rowdy, and he had been a somewhat troublesome type in general. However, the fact that he came of a poor family and had worked his way up was actually rather commendable. Mr. Skælling was not one of those who kowtowed to the plutocracy; on the contrary, as the son of an intelligent and honest, but, financially speaking, anything but affluent police inspector, he had worked his way up – not to

material riches, good Lord no, but at least to a social position that was not entirely insignificant. In a few months' time, when old Verlandsen, the headmaster, reached retiring age, Mr. Skælling, who was his deputy, would replace him, assuming there was any justice in the world. Moreover, he was Chairman of the Conservative Association, Deputy Chairman of the Town Council, a member of the Price Control Commision, Secretary of the Employers' and Shipowners' Association, and an honorary member of the Serpent Fjord Sports Association, and it was purely and simply on account of the war that he had not been knighted – he had the Governor's own word for that.

Yes, he had his strengths, and moreover he could write. As a political correspondent, Mr. Skælling had acquired a good reputation in the Danish conservative press, and here in the Faroes, too, his writing was highly regarded, at least by the few connoisseurs whose opinion was of any significance.

Nor should the *memorial mound* be forgotten – that aesthetically pleasing mound with the plaques commemorating those lost at sea, those men who *never came home* and were never laid to rest in consecrated ground. It had been Mr. Skælling's idea. Perhaps that had been forgotten by now, but what did that matter? It still warmed his heart every time he visited the hallowed spot and saw how the memorial plaques grew in number.

Well then . . . but back to the case of Ivar Berghammer. Irrespective of the personality of this young man, Mr. Skælling could not escape the fact that he had a deep-seated distrust of the very *type* Ivar represented. Ivar Berghammer was only one of the gradually, but disconcertingly, increasing number of more or less proletarian upstarts whom abnormal times had raised above their original station. This capricious age had released unpredictable forces which spelt danger because they knew neither roots nor culture. Yes, indeed, an age of louts and boors, an age at the mercy of the clenched fist, was already well on the way to establish-

ing itself. It was sad to think back on those untroubled days of quiet prosperity when old Consul Tarnowius sat as a respected patriarch in his office and held all the threads in his steady hand, while the fish-drying grounds overflowed with silvery white dried cod tended by busy people blessed with happy dispositions and hands that were never unoccupied . . .

But that was not the subject at this moment. Mr. Skælling reached for his telephone; he would ring to Opperman and get some information to use in his article on the tragedy at sea.

Opperman was able – as he put it – to give the dead skipper his very best recommendation. There were not many as plucky and intrepid, reliable and loyal, as Ivar had been. Mr. Skælling could hear the emotion in Opperman's voice. He made some comment, too, to the effect that Ivar had died a hero's death – a rather superficial remark. Life at sea was a profitable occupation at the moment, and if all those many sailors who unfortunately lost their lives in this crazy war could be called heroes, the gallery of heroes thus created would be endless. The term had to be limited to those who sacrificed their lives in seeking to save others or in furthering some just cause. And sailing money home for Opperman was, of course, only an insignificant business which no one would have undertaken if not to gain some benefit in the form of a good commission.

Otherwise Mr. Skælling had nothing serious against Opperman. He was an upstart and had his weaknesses and his ridiculous side, but he was a remarkably clever man, whose heart had often been seen to be in the right place, too.

Of course, he could afford it all. But on the other hand, Opperman was in no way obliged to embark on charitable works; they were entirely voluntary, matters close to his heart. Nor was the benefaction to the orphan childen the only one to come from Opperman's hand. He had contributed to the church organ fund. And the young people's sports activities found a patron in him. In spite of all his peculiarities, it had to be admitted that Opperman was a

valuable person to have in the community. And he was a good and loyal supporter of the newspaper, with a regular advertisement on the front page, in addition to which he occasionally took the entire back page.

Mr. Skælling was sorry to think that Opperman had lost his ship. All these ships going down were a matter for general concern; their loss would sooner or later have serious repercussions as the sources of income dried up in a process which could have fateful consequences for every member of the community. Ultimately, of course, it was shipping which maintained the entire social fabric and raised the standard of living for all.

That confounded war!

And yet, on the other hand it could not be denied that it was that selfsame war that made seafaring profitable. Properly speaking, there was nothing for it but to take it philosophically. The sea giveth, and the sea taketh away.

Mr. Skælling took his fountain pen: "The sea giveth and the sea taketh away. Once more Kingsport has suffered a painful loss. Our fleet has been reduced by yet another ship, the gallant cutter, the Manuela, belonging to one of our most distinguished citizens, the well-known merchant, Consul M. W. Opperman. And this war, the scourge of the entire civilised world, demanding new and painful sacrifices in virtually every country, has claimed as tribute the life of yet another of our young men."

As always when writing obituaries, Mr. Skælling was overcome by emotion and embarked on a flight of lyricism: "It happened at first dawn, just as a new day was breaking over the war-torn and unfortunate breed of men. For the last time this young man was to behold the sunrise before wandering forth into the night eternal to join the sombre, silent ranks of fallen mariners . . ."

A tiny tear welled up in Mr. Skælling's eye. His thoughts had turned to his own son, Kaj, who was the same age as Ivar, just turned twenty-five. At one time Kaj had insisted he wanted to go to sea, but thank goodness nothing had ever come of it, and luckily he had now settled down as

124

Tarnowius's book-keeper. But supposing he had become a sailor and so, of course, either a skipper or a first mate, or at the very least a home-trade master. Suppose it had been Kaj lying there in Ivar's stead in the hospital mortuary with his chest ripped apart by a machine gun salvo!

Yes, he could vividly enter into the deep sorrow of the bereaved. It was an inspired obituary. "It's perhaps a little rhetorical," he said to the typographer, Jens Ferdinand Hermansen, when he handed him the manuscript. "But in a situation such as this one has to show generosity of heart, and Ivar Berghammer is, when all is said and done, the first civilian victim of the war at sea to be laid to rest here."

"And God grant that he may be the last," he added, withdrawing with a little sigh to his office adjoining the composing room.

The typographer ran through the article. "What the hell does that banal snob mean by showing generosity?" he muttered to himself. "But the tune's the same here as everywhere else in the world: first you squeeze the life out of the others, and then you skim off the cream for yourself; then you fall on your backside overcome by emotion because you've been so generous as to notice that they've kicked the bucket. It's the tomb of the unknown soldier all over again. To Hell with the lot of them."

There was a knock on the door. Jens Ferdinand had a shock when he turned round and saw that it was Bergthor Ørnberg.

"It's about a song, or rather a *hymn* that I would like to have printed," said Bergthor. "The Forward Youth Association's going to sing it at Ivar's funeral."

Bergthor was all seriousness and cordiality; he had put all grudges aside. He shook the typographer's ink-black hand and with a matey smile said: "We had a rather unfortunate confrontation that night at Marselius's place, Jens Ferdinand, but let it be forgotten now. In the shadow of death we all meet as friends and abandon all resentment."

He unfolded a carefully typed manuscript and laid it on the type case. "See, this is a poem I've written. It came to me this morning when I heard the news of Ivar's death. We weren't properly speaking friends, on the contrary, but as you know, I forgave Ivar for his behaviour towards me and let the matter drop. Naturally. Who wouldn't? It all happened when he was drunk."

Bergthor raised his head, his eyes shadowed with mournful pride: "But now he is dead he is no longer Ivar Berghammer the private individual; he is more, Jens Ferdinand, he is far more! For us here in the Cauldron he has become the representative of all those brave and intrepid seamen who are now risking their lives for their native land . . . all those who together constitute the foundations upon which our community is built. They show our flag in alien ports; they bring wealth to the country; they are indispensable and dear to us, and if they fall on the field of honour, Jens Ferdinand, then we will do them all the honour that we in our weakness can muster. And so the youth of this place shall sing at Ivar's graveside, while the flag flies alongside them."

Bergthor Ørnberg spoke as though he were already standing at the graveside; his breathing betrayed his exaltation, his nostrils were quivering, his upper lip was red and slightly swollen; he really looked as though he had been crying. Jens Ferdinand ran suspiciously through his poem. Yes, of course, it was a load of stilted trash, a shameless and vacuous spate of words, daft patriotic nonsense, set to a stirring Danish melody from the Romantic age.

"You've turned out a right load of trash there, all right," he said irascibly. "That doesn't do justice to Ivar's memory."

Bergthor's eyes suddenly narrowed to slits, and he failed in his attempt to smile. It was a moment or two before he could think of what to say after the shock.

"I didn't ask for your opinion," he said in a low voice. "What you think is a matter of complete indifference to me. I want that poem printed. Do you understand?"

*"Cocky little typographer,"* he added scornfully.

"You're no poet," said Jens Ferdinand brutally. "We do have real poets in this country, but *you* are not one of them. You're small fry."

Bergthor gritted his teeth and made as though to strike Jens Ferdinand, but he lowered his arm. He bent down towards the slightly built hunchback and hissed: "You chicken, you. I could crumple you up and throw you in the waste paper basket if I could be bothered."

He straightened himself up and his look became arrogant: "And in any case it's foolish of me to stand here and waste time on a minion. Where's the editor?"

He grabbed the manuscript and went and knocked on the office door. He soon returned. In an authoritative voice, and without as much as looking at the typographer, he said: "Now get a move on so it can be ready in time."

# 3

Engilbert fell into deep thought when he heard of the loss of the Manuela and the tragic fate of the lad from Angelica Cottage. He had a nagging suspicion that in some way he was partly responsible for what had happened, and he directed a silent and impotent protest at Madame Svava.

That bizarre pair of drunkards, Thygesen and Myklebust, were making a din in the attic, taking it in turn to sing lighthearted songs. Myklebust was warbling in a falsetto voice and putting on quite a show:

> I rowed my boat to Seiegrund,
> One morning awful ear-ly . . .

Engilbert banged on the wall and shouted: "Can't you keep quiet in there, you two . . . Haven't you heard about the tragedy?"

Myklebust suddenly fell silent. Before long Thygesen opened the door to Engilbert's room and looked in. His eyes showed signs of heavy drinking, but they were deadly serious. His chin was covered with week-old stubble.

"I thought you said something about a tragedy?" he asked in a subdued voice. "What has happened, Mr. Thomsen?"

Myklebust could be glimpsed in the passageway, listening attentively in the background. Engilbert explained briefly to Thygesen what had happened, adding: "So I feel we must stay quiet today and not make unnecessary noise."

"Good God," said Thygesen, turning towards Myklebust. "He says another ship's gone down, and that they've shot the skipper."

The two men tiptoed away and disappeared. Engilbert could hear them whispering and sighing in their attic. He could also hear the gurgle of their eternal bottle. Of

course, it was not long before they ceased whispering, and now Thygesen sang out in his deep bass voice. But in a subdued, almost tearful, manner. And Engilbert could hear from the melody and the words that it was some kind of funeral hymn:

> Oh wondrous moon, companion of the night
> Shine out upon my face in death forlorn.
> Smile kindly on me in my mortal plight
> And light my way o'er death's dark bourne.

Engilbert sat down heavily on his bed and started thinking the situation through.

If it really was Svava who had wrought this misfortune, then it was a terrible misunderstanding, done without his knowing, and completely at variance with what he wanted. But perhaps he had committed an unforgivably foolish act in confiding in this fellow countrywoman of his. The Icelandic spirit is totally different from that in other countries; it is dangerous and terrible, for Iceland is the land of glaciers and volcanoes, of hot springs and earthquakes, the land where people have been burned in their homes, the land of the Vøluspá prophecies. He had to think of Svava's verse about the witches playing on high. He remembered, too, that Stefan Sveinsson had once said that his wife was descended from the Norwegian king Harald Squirrelcloak's illegitimate son Erik Murt, who according to legend was supposed to have settled in Iceland; but when he was told this, Engilbert had not given a thought to the fact that in that case Svava had the blood of Erik Bloodaxe in her veins! Indeed, even worse: she was a descendant of Gunhild the Regicide! Perhaps it was from this evil and treacherous woman that she had inherited her magic powers.

And that talisman of hers that he at first had been so genuinely pleased with . . . what had it brought him except pain and trouble? Powerful it certainly was, but seemingly powerful in the wrong way. It had diverted him from the path of spiritual ascent; it had made Thomea from Angelica

Cottage submit to his will . . . the very evening after he had received it she had, as though by magic, surrendered to him with a frenzied reckless manner the likes of which he had never known before; since then he had been with her on several occasions, and she had remained just as compliant. Through her arts Svava had indeed forced the strange heavily-built girl from Angelica Cottage to her knees and made her into his obedient tool.

Nor was that all. Engilbert had discovered that his power over women in general was many times greater than before. Everywhere he went, women looked at him with passion in their eyes. Even Mrs. Lundegaard, otherwise so straightlaced, had come to him one night, and now she was like wax in his hands. And it was not only earthly women who behaved in this way; the subterranean spirits didn't hold back, either. Time after time he had been up among the boulders in the Angelica Bog and caught a glimpse of them in the dusk and heard their laughs and giggles, and time after time they had visited him in his dreams. Even Madame Svava herself had once come to him in his dreams . . . she had appeared sitting on a kind of throne covered with black moss; he had knelt at her foot, and she had stroked his hair and revealed herself to him.

Of course, all this had been strange and fascinating enough. But for his soul it had been an evil draught, a treacherous potion that had dragged him ever further down, down to a level from which he had otherwise worked his way up; indeed, he could not but wonder whether in all his life he had ever sunk deeper in the cesspool of filth, in bestial and unworthy dependence on carnal pleasures and sensuous thoughts. It was in sadness and trembling he thought back on that blissful morning up in the Angelica Bog when he had seen the sign of Logos in the clouds.

Alas, alas. Several times he had decided to turn around and begin a new ascent. But each time he failed. There was not a shadow of doubt that he had fallen prey to superior evil powers, and that Svava was in league with them. Her

intentions with him were not good. She sat on her throne of black moss and sowed her seeds of evil and lust.

He took out the little purse containing her lock of hair, and opened it.

"Release yourself from this iniquity," a voice whispered inside him. "Let the flames devour it."

But the sight of the living lock of black hair suddenly filled him with an uncontrollable desire; he twisted it round his finger and put it to his lips and once more felt electrified by its strange power. Everything went dark before his eyes; he kissed the lock madly and dissolved trembling into ecstasy, a mysterious sense of infinite well-being.

The rain had ceased, but the air was thick and misty. Frederik had been to a captain's protest together with the other four survivors from the Manuela, and he was now on his way up to Angelica Cottage. He felt tired and weak from lack of sleep and moved like a sleepwalker, devoid of all thought, scarcely aware of touching the ground. As he passed the school, a voice called out to him. It was old Verlandsen. He came out of the school gate, open-mouthed and with a sheepish look on his face; his eyes were swollen and heavy behind his thick glasses.

"Oh God, oh God, Frederik," he said. "So that was how it was to end . . . and in a way it was all my fault."

"Of course it wasn't, why on earth do you say that?" Frederik almost felt like smiling. It was just like the old man to come up with stupid remarks of this kind, however bright he was otherwise. He always maintained that he was to blame for whatever happened.

"It was my fault that you were able to sail that evening," said Verlandsen, looking Frederik in the eye. "I put in a good word for Ivar both with Joab Hansen and Bergthor Ørnberg. If I hadn't done that, Frederik, and the matter had been allowed to take its course . . ."

"Yes, but then it must surely have been God's will that it happened as it did," said Frederik, simply to say something.

Verlandsen's expression seemed to indicate he was receptive to new ideas. He shook Frederik's hand in gratitude: "Yes, Frederik, let that be our consolation and hope. For otherwise the whole affair is incomprehensible. Yet even so, I can't help thinking that I've behaved like a clumsy old fool. And it's not the first time I've had this sort of thing happen. It's often the case that you are guilty of hurting people without intending to. You think that what you're doing will be good for them, and then the opposite turns out to be the case. I don't understand it, Frederik. And now I am so old that there is not much hope I'll ever understand it. There is something called a shift in value . . . but the Lord knows I've never really had the brain to understand it. However, I must get back to my work, Frederik . . . but let's have another talk soon, my poor lad; come and have a chat, do me that kindness."

The mist had thickened now. The air was filled with swarms of dancing midges. The clumps of marguerites along the path to Angelica Cottage had still not withered entirely, and the stubble fields were light green as in the spring. There was a cheerful smell of peat smoke and coffee in the kitchen. Magdalena came out to meet Frederik; they exchanged glances and she sighed as she took his hand and patted it.

Magdalena was alone at home with her youngest daughter, who was asleep in her cradle. The other two girls were playing with Alfhild out in the yard. Elias had gone down to the hospital together with Thomea and Liva.

Frederik went over to the cradle and pulled the cover aside to reveal a tiny child's head covered with dark down. He raised his eyebrows at the sight, and for a moment was lost in thought. Good Lord, here lay a child, a tiny human child, waiting to grow up into this strange and sorrowful world that not even Verlandsen could understand. . .

"Come and have a bite to eat, Frederik," said Magdalena. "You must be terribly hungry and thirsty; no one's thought of giving you anything to keep you going, you poor thing. And aren't you awfully tired, too? And what about

your arm . . . Is there anything I can do to help you with it?"

"There's nothing wrong with my arm," said Frederik. He sat down. Magdalena laid the table. "You're almost asleep, Frederik," she said. "You look almost as though you were drunk. Look, when you've had something to eat what about having a snooze and getting some of your strength back?"

She went across to him and touched his arm. He felt her breath against his face.

"I'm not the least bit hungry, Magdalena," he said. "Only sleepy. I'd rather lie down straight away, if you don't mind."

He pulled his damp jersey off and lay down in the alcove bed, dizzy with fatigue. He felt Magdalena's hand spreading a blanket over him and caressing his head. Half asleep, he caught hold of it, and pressed it to his cheek. She got to her knees beside the alcove; he felt her mouth against his own and opened his eyes wide in amazement.

Magdalena looked at him with tears in her eyes. He took her head in his hands and kissed her, and suddenly all thought of sleep was gone; all that remained was a little dizziness.

"What is it we are doing, Magdalena?" he said tenderly, pulling her down into the alcove. It was suddenly dark in there – she had pulled the curtain to.

"We oughtn't to do this," she whispered breathlessly. "It's all wrong. You mustn't be angry with me, Frederik. I must go now . . . they could be here any moment. No, Frederik, let me go, my dear."

As though in a dream, Frederik could hear the kettle boiling on the hearth and, muffled by the distance, the laughter of children playing outside.

The mist was dispersing again; it was once more raining heavily from low clouds. Together with their father, Thomea and Liva were on their way back to Angelica Cottage. They had been visiting the hospital mortuary. The women were dressed in mourning and their faces were

half hidden behind black scarves. Elias's stiff, blue Sunday Faroese cap perched on his head like a helmet, an absurd contrast to his tired, flaccid features.

Liva felt that everyone was turning round to look at them, and that curious faces were watching them from all the windows. As they passed Opperman's house a voice called to her from the kitchen; a maid came out on the steps and beckoned to her.

"The mistress would like to talk to you," she said.

Liva started. What could Mrs. Opperman want her for?

"Just carry on," she said to Thomea. "I'll catch up with you."

Mrs. Opperman was lying in her bed in the big, light upstairs room. She was very thin, but showed none of the sickly pallor one might have expected; on the contrary, her face and arms were a dark brown. She took Liva's hand and shook it warmly.

"You poor thing," she said. "Yes, it's hard for you, Liva. I hope I haven't inconvenienced you, but I so wanted to express my sympathy. Look, do have a seat here in the easy chair for a moment if you've time."

Mrs. Opperman spoke fluent Danish. Her protruding eyes betrayed cool indifference, and made Liva feel uncomfortable. She looked around the spacious room. It was like a hospital; there was some strange apparatus bristling with electrical switches over in the corner. An adjustable mirror had been fixed on the bed head. From the window there was a view across to Opperman's offices down on the other side of the harbour. She could see Opperman himself through the window, sitting at his writing desk.

"Do take off your scarf for a moment, my dear," said Mrs. Opperman in a kindly voice. "I can't see your face at all. No, of course, if it embarrasses you, Liva ... that wasn't the intention. . ."

Liva felt Mrs. Opperman's cold seagull eyes fixed on her; it made her feel insecure, and she looked down.

"Life's a strange thing," said Mrs. Opperman. "There your brother was taken away, young and strong and with

the future before him. And here am I, still alive, but tied to this bed for the rest of my life . . . useless, no good for anything, a reject."

"But you hardly look ill at all," said Liva in order to say something. "You look so sunburnt. . ."

"Yes, it's that thing over there, the artificial sun-lamp," said Mrs. Opperman pointing to the contraption in the corner. "But it doesn't do me the least bit of good. No, I've been finished for a long time, Liva; I'm dying bit by bit. But let's talk about something else. . ."

She closed her eyes. Her huge eyelids were blackish brown, verging on blue. Liva stared at the peculiar mirror above her head. Suddenly Mrs. Opperman opened her eyes and stared intently at Liva, searching, scrutinising. Then, slowly and quite calmly, she said: "Liva, I am not at all angry with you. I simply wanted to have a proper *look* at you; that's all. You must forgive me."

"Why should you be angry with me?" asked Liva in amazement.

Mrs. Opperman looked away. She raised her eyebrows, and her mouth contorted in a mournful little smile.

"Oh, Liva," she said. "Don't let's put on an act. I know all about it. You mustn't be embarrassed with me. I've become accustomed to *that* as well as to so much else. I have had to put up with it."

"What have you put up with?" asked Liva in a whisper, flinching a little.

"My dear girl, you play your part well," smiled Mrs. Opperman.

"I don't know what you mean," said Liva, getting up.

Mrs. Opperman closed her eyes again. The smile remained hovering on her lips. She sighed. "Liva," she said. "I'm sure you'll forgive me. You've nothing to fear from me, lying here completely helpless. You'll forgive me for having my spies out. You know Amanda: she's been here for eight years and she's my only real friend. She's on my side, you know, and she's my little spy. I've got it all from her. No, don't be angry, Liva. Let's talk about it calmly."

135

"If only I knew what you think I've been doing," said Liva, looking the sick woman frankly and fearlessly in the eye. Suddenly, and contemptuously, she added: "For you can't possibly think I've had anything to do with your husband."

Mrs. Opperman still lay with her eyes closed. She nodded and said in a low voice: "Yes, Liva. I know you have. You see that mirror above my head. It can be fixed so that with the help of another mirror I have here in bed I can see out of the window. I saw the bombs fall on the Fulda. I saw the aeroplane and everything. It didn't worry me, for I'm used to death staring me in the face. But then, afterwards, I saw you and my husband down in his office. You had a drink. Remember?"

To her horror and disgust, Liva felt she was blushing scarlet. "I didn't drink anything," she said in a hollow voice.

"Well, it doesn't matter, in any case. You were alone, and I could see you standing close up to one another."

"We didn't," said Liva, shaking her head. She sat down on a stool. She felt strangely helpless.

"Well, it doesn't matter," said Mrs. Opperman without opening her eyes. "Because you went back that evening in the dusk. And that time you went in through the vestibule. And you were disguised. You had a rust-coloured bonnet on and you were bending forward as you walked. I've got good eyes, Liva. And from Amanda I know that you were together from seven to about eleven, four hours."

"That's not true, Mrs. Opperman," said Liva. "May the earth swallow me up if it's true. May misfortune strike me."

"Heaven forbid," said Mrs. Opperman. "Oh well, that was the first time I discovered what was going on between you. But later Amanda . . . yes, I'm sorry, Liva, but it does concern the man who's supposed to be my husband, doesn't it. Later, Amanda listened at the door and under the window and she heard you and Max together in the office. Several times."

Liva shook her head all the time. She was gradually realising that this pitiable woman before her was demented. She would talk to Amanda and get it all cleared up.

"Liva," said Mrs. Opperman. "Come here, let me shake hands with you again, and then go home. You are young, you are poor, but you might perhaps become a rich wife . . . if you can hold on to him. And if you can stand him."

Mrs. Opperman raised her huge eyebrows and gently shook her head. Then, in a low voice, she added: "For he is dreadful. Dreadful. He may not be an evil man, Liva, for at times he can be so kind and nice. Perhaps he is more like an unreasonable spoilt child. He does terrible damage, he tears things apart, and then he regrets it afterwards. Oh, he has done me so much harm, Liva. And he has torn so much apart for me. Perhaps not everyone would have survived it. I've been almost out of my mind, too. I have, really. I am not religious, Liva, but many's the time I've thought that if Satan exists, then he is called Max Opperman. But bit by bit I suppose I've learned to deal with him. For he has to be treated like a child. In a way he is not so much evil as childish."

Mrs. Opperman gave Liva a sideways glance. There was a little smile in the corner of her eye, and she said warmly, as though speaking in confidence: "He's not a real *man*, Liva. I suppose you know that yourself, although you're so young. In any case, you'll discover it sooner or later. As a woman you'll find no satisfaction in that poor devil. You'll see. But he's wealthy, and if you become his wife, you'll be a wealthy woman. No, Liva, don't be angry. We're talking to each other as friends, aren't we?"

"Yes," replied Liva in order to put an end to it. "But I must go now, Mrs. Opperman. Good-bye."

"Come again, my dear," said Mrs. Opperman. "Promise?"

Liva made no reply. She felt confused and sickened and had broken out in a sweat. Down in the kitchen she came across Amanda on her way up with coffee and cakes on a tray. "Wait a moment," said the old maid, opening the

door to the sitting room. "Here, sit here a moment, and I'll be back presently."

Liva remained in the doorway. Her heart was beating wildly. The big, light room was opulently furnished, shining with well-polished mahogany; the deep armchairs were enormous, the size of bulls, and they were upholstered in some material with a bronze sheen. Standing against the wall at the end of the room there was a big harmonium with a double row of stops, and the walls were covered with paintings in broad gilt frames. And the bound books in the big bookcase in the corner glittered with gold, and standing under a glass cover on top of the bookcase there was a clock of gold beaten as fine as lace. The door to a side room was surmounted with an embroidered biblical text and the words: God Bless Our Home. It was indeed an imposing room. But it seemed not to be used much, for it smelt enclosed like a storeroom. There were several photographs on the harmonium; one of them was a wedding photograph of Opperman and his wife; she was beautiful in her white silk dress and with a myrtle wreath in her frizzy hair. The bridegroom was wearing a dress coat and holding a pair of starched white gloves in his hand. His smile was the one she knew of old, and in general Opperman had not altered very much during the eight years he had been married. The bride was a little taller than the groom.

Amanda returned. "Why are you standing here?" she asked. "Do come into the sitting room."

Liva looked imploringly at the old maid and touched her hand. "Amanda," she said. "I didn't know that Mrs. Opperman was . . . confused. I mean that she rambles a little. Doesn't she, Amanda? She's mad, isn't she?"

Amanda opened her eyes wide, and her lips contracted into a tiny circle. "Mad? No, she's ill in a different way, but there's nothing wrong with her mind. No, Mrs. Opperman is really very bright, very intelligent."

Everything turned black before Liva's eyes. She pulled herself together and said severely: "Then what's all this

nonsense she's talking about me and Opperman? And what about you? Because you're supposed to have seen and heard us together, and God in Heaven knows it's not true. Do you understand me, Amanda? It is *not true*, I say."

Amanda turned away a little, recoiling slightly as though afraid of being hit. She muttered something, clearly enough for Liva to hear it: "No, it's not a lie, it's certainly not a lie. I've seen it all. And Opperman's not denied it, either. And the mistress is both brighter and more intelligent than the two of us together..."

"It *is* a lie," whispered Liva and repeated it in a loud voice that resounded through the hall and staircase: "It is a lie. I'll make Opperman swear that what you say is a lie. I'll have you in court for your evil gossip, you'll see."

Amanda had gone over to the kitchen door and stood holding the handle; there was a tiny canny smile playing in the corner of her eye, but she avoided looking at Liva, and kept on muttering as though talking to herself: "Opperman... yes, of course, he'll back you up, good Lord, of course he will... But the mistress is neither daft nor mad, I'll guarantee that, and she isn't even angry with you, 'cause that's what she's like."

Liva moved across to the old maid, grasped her limp hand and forced her to look her in the eye.

"Don't you understand how terrible and shameful this is for me?" she asked in a subdued voice. "I'm engaged to be married. I've never had anything to do with anyone except my fiancé. I have had *nothing* to do with Opperman, Amanda, nothing, nothing. You mustn't ruin everything for me with your gossip. My fiancé might hear it, and then what? He might die from it, Amanda, because he's seriously ill. Don't you see what a terrible sin that would be?"

Liva's voice grew more and more imploring and appealing: "You must believe what I say, Amanda. You must help me. You must get Mrs. Opperman to see that it is all a misunderstanding. Do you hear? It must be someone else you've heard in with Opperman in the evenings. I'll get to the bottom of it, Amanda. Will you believe me then, if I get to the bottom of it?"

Terrified, Amanda sought to drag her hand free. Suddenly Liva let go, and the old maid quickly slipped into the kitchen and closed the door behind her. Liva could hear her muttering and scolding to herself in there. Then Mrs. Opperman's voice rang out from the bedroom: "Amanda. Come here immediately."

Liva picked up her scarf, which had fallen to the ground. Hesitantly, she stepped out into the rain. Now she recalled Mrs. Opperman's words: "You had a rust-coloured bonnet on that evening." Frøja Tørnkrona from the restaurant usually wore a rust-coloured bonnet. It might be Frøja Tørnkrona who was meeting Opperman in secret. Of course it was Frøja. She would go with anyone.

Liva decided to go back and try to make Amanda see that it was not her but Frøja who had been meeting Opperman. But the maid was nowhere to be seen. She was presumably up in the bedroom with the mistress. Yes, now she could hear them talking to each other up there; she could hear Amanda's excited voice. She would not go up. She stood for a long time in the hall and heard them whispering up there. And all of a sudden she felt herself gripped by fury. With all her strength she shouted up the staircase: "They're all lies. They're all lies. I'll have all three of you in court."

Then she went out in the rain again; once more things went black before her eyes. How could she put an end to this nightmare? She felt a need to confide in someone who could understand her. Magdalena, for instance. Or Simon. Or Opperman himself . . . Yes, why not go across to him now and demand an explanation, force him to confess to his wife and Amanda that it was Frøja Tørnkrona who was paying visits to him in the evening.

She hurried down to Opperman's office and found him alone. He got up from his desk and came towards her.

"Oh, Liva," he said in a kindly voice. "You come here? You remember you have time off today and until funeral is over? But, oh, you are so dreadfully sorrowful, Liva. You speak to me?"

She knocked his outstretched hand away and said hoarsely: "I have just been up to see your wife. She's accusing me of having an affair with you. I won't put up with it. It's Frøja or someone else who's having an affair with you. You've got to admit it, Opperman. I'll force you to admit it."

Opperman glanced at Liva; she was terribly pale; her eyebrows and black eyelashes looked as though she had put too much make-up on them. He bent over his desk and fiddled with some papers. His hands were trembling. "My dear, my dear," he said tonelessly. Finally he sat down, took a paper knife and sat for a moment rocking it between his fingers.

"Liva," he said at last. "You have good conscience. People with nothing to fear have good conscience. The truth will out. Frøja run restaurant The Bells of Victory; Frøja often come here in evening when she has better time, for she always very busy. I often talk to Frøja about important things; she always like to talk. She not my girl-friend, Liva. I not have girl-friend. I know Amanda watch, oh, very suspicious, tells tales also to my wife. And my wife become so over-nervous, poor thing, she always lie hopelessly sick, she think I always unfaithful to her. First with one, then with another, oh, many before you. I am so used to her talk, I now am almost immune. She quickly forget it again. And Amanda very stupid. Oh, I just say her: Amanda, I tell military you lie and you will be shot with gun, then she very afraid and say: oh, I not mean it. . ."

He put the paper knife down and sighed a little. "Oh, that nasty make-believe, Liva. You take no notice. Rely on me, I see to it."

Liva felt calmer. Opperman looked at her impassively. "Pity you bothered by that foolish chatter," he said. "You have worse things to think of. But I will see to all, Liva. Just go home, do not think. Good conscience the best pillow. You must not be angry, dear child, not worry. I take all on myself. Oh, I very sorry about it for you."

"I'm giving in my notice," said Liva. "I can't work here any more."

Opperman got up and started wringing his hands. "Oh no, Liva. Not too hasty. No, no. Think about it till day after tomorrow . . . you see everything be OK. Dear Liva, not go. You come here day after tomorrow, then you have changed mind."

Liva felt relieved when she was once more out in the rain and on her way home. She thought of Mrs. Opperman's words: he is dreadful, but he may not be an evil man, but rather like a spoiled child. And fundamentally, she was right, too, in saying that Opperman could be so good and kind, so friendly and helpful.

How on earth could she understand him. Or her. Though perhaps she was a little easier to understand. How could she really be any different, lying there, unoccupied and helpless, and with that strange, unfathomable husband. Liva decided she would pay the poor woman another visit after the funeral and get her to renounce her suspicions. Both for her own sake and for Liva's. And then she would keep the job with Opperman. She could not afford to give up such a well-paid job now that Ivar was no more.

# 4

The sun was shining, and there was a slight frost on the day of the funeral. Opperman and his staff had been at work decorating the church since early in the morning. The altar and pulpit were draped in black, and black bows and festoons were fixed all round the walls and on the doors to the pews. Stands and flower holders decked with palms and luxuriant foliage plants had been placed in the chancel, and garlands of evergreens and rust-coloured dead leaves had been draped round the altar rail. No expense had been spared; the chancel had the appearance of a lush garden.

All the kind souls in the town had assisted Opperman, first and foremost children and young people from the Christian Youth Association, under the expert guidance of Sigrun, Liva's future sister-in-law. The coffin, standing on its catafalque at the entrance to the chancel, was hidden beneath a wealth of flowers and wreaths, and a row of other wreaths lined the aisle.

The church was filled to overflowing; some wore uniform, the rest were in mourning, and even the porch was crowded. The organ sounded different from usual; it was being played by a young English soldier – Consul Tarnowius's son-in-law, actually – and he could at times make it sound like a veritable storm. Mr. Verlandsen, the teacher, had gathered a choir of schoolchildren and former pupils, with whom he had practised the hymns. The male voice choir from the garrison was there, too; they did not join in the Faroese hymns but remained ready for the later part of the ceremony.

Mr. Nikodemus Skælling, the editor, had found himself a good place up in the organ loft, where he had a good view of everything going on.

"Good Lord, isn't it splendid," whispered Mrs. Skælling. "It's almost too much of a good thing, don't you think so, Nikodemus?"

143

Mr. Skælling made no reply, though he was quietly thinking that when old Consul Tarnowius had been laid to rest ten or twelve years ago the ceremony had also been marked by a certain splendour, but it could in no way be compared with this. And yet the old Consul had been an influential man, the director of a firm with a great number of branches; moreover, he owned a whole fleet of fishing vessels and employed large numbers of men, women and children. Indeed, the entire fjord community lived off his firm.

And Mr. Skælling could not but think of his own father's funeral . . . quite respectable, quite respectable, though the mourners were not numerous, and there was no pomp and circumstance, no wealth of flowers, no choir. But on the other hand there was the quiet sadness of loyal hearts – while this was a showpiece organised by Opperman. Why, in one sense it was ridiculous, profoundly ridiculous. Mr. Skælling wondered what form his own funeral would take when the time came. Or his wife's.

He took his wife's hand, and she leaned against him, overcome by the solemnity of the occasion.

"Look, even the ships hanging from the roof are draped in black," she whispered.

"Yes, and that's quite a good bit of symbolism, really. It's as if it were in memory of the ships lost in the war."

Mr. Skælling felt moved by his own words, and he held his breath for a moment. In his newspaper report of the ceremony he would bring this up.

"Solomon Olsen and his wife and son are here, too," whispered Mrs. Skælling. "And the Schibbyes and the Tarnowius's. And Doctor Tønnesen and his son. And the pharmacist and his wife, and the Villefranches and the postmaster and family, and Stefan Sveinsson and his wife . . . heavens, just look how she's made up, Nikodemus; what *do* you think of that? And all the officers. Captain Gilgud in dress uniform."

"Of course," said the editor. "Of course. This is no ordinary funeral, this is a memorial ceremony, Maja. It is the *funeral of the unknown soldier*."

He again felt moved by his own words, and swallowed slightly. That idea of the unknown soldier was another he would work into his newspaper report. That was how the whole thing should be seen, of course. The ceremony was more for a cause than for a single individual. The person was a secondary matter.

"What do you think the people from Angelica Cottage will say to all the honour we're showing them?" whispered Mrs. Skælling.

Her husband shrugged his shoulders. "It'll be worse for them if it goes to their heads. But I wouldn't be all that surprised if it did."

"No, nor me. But heavens above . . . Nikodemus!"

She grabbed her husband's arm and shook it violently.

"What on earth is it, woman?" he asked and in his fright he forgot to keep his voice low.

A couple of discordant cries could be heard coming from the chancel . . . it sounded for all the world as though someone was shouting "robbers and murderers". . . and down by the entrance to the chancel, just in front of the coffin, something or other was going on. It was difficult to see what, but it looked a little as though someone had fainted.

"It's probably only someone with heart trouble," Mr. Skælling reassured her.

"No, it isn't, Nikodemus," his wife declared breathlessly. "For it's Hermansen, the typographer. I saw it myself. He stepped out in front of the coffin and wanted to make a speech . . . but then they overpowered him. Look, they're taking him out now. He's drunk, Nikodemus. Oh, how dreadful!"

Mr. Skælling was speechless. He quietly shook his head and involuntarily folded his hands. A wave of murmurs ran through the church as the drunken typographer was led out into the sacristy by the sacristan and sexton. He offered only slight resistance, but in the doorway he turned round with a brief, penetrating cry. Then the sacristan pushed him hard in the side, and he could be heard falling down the short flight of steps.

"Serves him right," someone said inadvertently in a loud voice, and a few sounds of amusement interspersed the murmuring to be heard on all sides.

"What was that he shouted?" Mr. Skælling asked in a whisper.

"Serves him right," his wife whispered back to him. She was very upset and had tears in her eyes.

"No, Hermansen, I mean," her husband corrected her in an irritated tone. "What was it he shouted before he fell down the stairs? Was it *Heil*?"

"*False piety*," his wife whispered in his ear.

The editor recoiled a little, and then he whispered back: "I'm afraid there's something in that, Maja."

"Yes, but the other things he said, they were so dreadful," she whispered. "Robbers and murderers. Here, in the church. I can't understand how they allowed him to come in that condition."

"Yes, it was unfortunate, very unfortunate," nodded her editor husband.

It was as though the inappropriate murmurings refused to subside. But now Pastor Fleisch stepped forward at the entrance to the chancel, and suddenly there was such a silence that the clock mechanism could be heard up in the tower. The editor raised his eyebrows and settled down with an expression of suffering on his face. It was best to arm yourself against the irritations you knew were to come.

Yes, of course. The usual trite comments. "The evil times in which we live." "The difficult conditions at sea." Of course! "Our daily bread." Hm. And then, suddenly: "Daniel in the lions' den." Yes, why not. A typical stunt. "The lions did not touch him". Oh, didn't they, though? "And the men who plough the salt waves in this age in which we live, they, too, are sent like Daniel into the lions' den. But they are only weak human beings; they have no prophetic powers; they cannot calm the lions, but they fall victim to the raging of the wild beasts." Oh! "But not a sparrow shall fall to the earth without . . ."

God help us, what a muddle!

"And this young man was perhaps spared far worse things . . ."

To sum up: God sends His helpless and unprophetical creatures into the lions' den to spare them worse fates. Thank you, Pastor Fleisch, thank you!

And then the embarrassing, melancholy words to the bereaved family. All their sorrows and trials. The father's ill health. And then a hopelessly rambling digression to the effect that Christ healed an epileptic. The mother's death from cancer. And the youngest daughter to whom God had denied understanding, but who nevertheless was perhaps happier than many of us others. What magnificent taste! I wonder if he'll get on to the eldest daughter's hairy face now? Oh, apparently not, after all.

And then, finally, a ramshackle, disjointed finish, full of repetitions and without a trace of inventiveness. And when you think what could have been said on such an occasion. The tomb of the unknown soldier! The miniature ships adorned with crape, mourning the loss of their bigger brethren out there on the merciless ocean. Thank you very much, Pastor Fleisch; I'll give you Beta minus minus for that.

"What a beautiful address," whispered Mrs. Skælling.

Her husband moved a little away from her. He sighed. Now the English choir began to sing a hymn. "Abide with me". Then the schoolchildren followed with "Praise to God for His good works".

Then the coffin was slowly borne out by seamen wearing blue braided serge and carrying their shiny-brimmed caps in their free hands. Johannes Ellingsgaard, the skipper of Opperman's other ship, the Griseldis, was one of the bearers, walking in front together with Frederik. Sylverius and the other survivors from the Manuela also helped carry the coffin. Slowly the church was emptied. The Englishman at the organ raged away with yet another tempestuous piece. Johan Sebastian Bach. Gregersen, the local organist, was standing behind him staring in polite astonishment at the intricate music.

Never had Kingsport seen a bigger funeral cortège. It stretched virtually from the church at the head of the bay right out to the cemetery on the other side of the river. It would be no exaggeration to say that the whole of Serpent Fjord, everyone with legs to walk on, was taking part in the procession. Here were all the schoolchildren and all the young people from the Christian Youth Association as well as the national association, Forward. Here were farmers in their silver-buttoned national dress and helmet-like bonnets; and farmers' wives and women of the people in their black dresses and scarfs, seamen in shiny-peaked caps, ship owners and merchants in heavy overcoats and with gloved hands, officers and other ranks in their finest uniforms. There were even several top hats to be seen: the bank manager, the pharmacist, Stefan Sveinsson. But not Doctor Tønnesen, the old stick-in-the-mud – he was wearing an ordinary grey hat. Opperman, of course, was wearing a shining top hat. He led the cortège as though he were one of the bereaved. The sisters from Angelica Cottage wore old-fashioned black headscarfs which almost hid their faces. Their father looked miserable, walking along like a sleepwalker; his eyes were lifeless, his arms and age-blackened hands hung limply at his side.

Mr. Nikodemus Skælling and his wife found themselves in a bad position in the thick of the crowd; they could move neither forwards nor backwards, and they could see nothing but the black backs of those standing immediately in front of them. They were actually even being pushed from behind by members of the Forward Youth Association, who simply *had* to get to the graveside. Mr. Skælling chided the eager young people, but there was no stopping them; they were polite but determined ; they had to gather at the graveside to sing Bergthor Ørnberg's song. Soon an avenue was opened through the crowd, and the editor and his wife took advantage of the opportunity to find themselves a better position. In the end they managed to get right up to the graveside. Here, the youth club members were congregated, their white sheets of paper standing out

amidst the surrounding black; all the young people were watching Bergthor's elated face. The bard was wearing national costume.

"The puppy," whispered Mr. Skælling to his wife.

He turned around and looked in a different direction. The leafless bushes and trees in the cemetery displayed their shiny silver branches in the pale frosty sunshine. A group of intrepid marguerites stood to attention with their fresh, springy flowers. He could see the breath rising from the singing schoolchildren's mouths; the air was filled with human breath and the smell of their clothes, occasionally with a touch of perfume or naphthalene or hymnbook leather. Suddenly there came a strong smell of alcohol. Mr. Skælling discovered that it was emanating from Thygesen, the Danish butler, who was standing singing behind him. It had to be admitted that, drunkard as he was, he had a beautiful, clear singing voice; indeed there was a strangely moving tone of anguish in his singing. Myklebust, the Norwegian shipowner, was standing beside him; he was not singing, but his big, wrinkled face was contorted. Good Lord, he was actually weeping.

Finally the strains of the long hymn died away. Then all heads were bared as the three spadefuls of earth fell on the lid of the coffin and produced the familiar hollow sound of irrevocability. Myklebust was sniffing uncontrollably; the big-boned foreigner was clearly the only person who could not keep his feelings under control. Actually, it was catching, and Mr. Skælling himself felt a tear in his eye . . . it came from the prayer's words about the daily bread. Give us this day our daily bread! Aye, there was plenty of that these days, but it was at the cost of human lives and human happiness. He would write that in his little article on this great and remarkable funeral. Though perhaps it would sound a little provocative, almost socialistic. It would be grist to the mill of that nasty little typographer Jens Ferdinand. And perhaps to Doctor Tønnesen's as well, for it was said that he had some, let us say: piquant, almost bolshevik views on society. And that despite his being the

149

son of a professor. No when all was said and done, the sailors were not the only ones to be securing the daily bread for the community; the *shipowners* who risked their ships and their money very definitely played an important role, and ultimately it was, paradoxically, *the war* that could be thanked for the plentiful supply of daily bread with which the community had been blessed in recent years. One man's meat, another man's poison, as the old proverb had it, and this was indeed the case, the implacable, fundamental law of life . . .

Now Bergthor Ǿrnberg stepped forward. Was that slob really going to speak at the graveside as well? That really was a bit thick. The newspaper would definitely have to protest at it.

A greeting and an expression of gratitude from the young people. Oh well, that wasn't entirely unreasonable. "The man whom we today have laid to rest in the soil of his native land was in the peak of his youth." True, true. "War is war and it seeks its victims among the young and the strong; all around us on battlefields all over the world - on land, at sea and in the air – countless young men are at this moment falling for the cause to which they have dedicated their lives: the struggle for their native lands! So, too, it was with him. He fell for his country. The young people will always remember him as the hero he was. We do homage to his memory."

It could be worse, thought Mr. Skælling. At least it was brief. Ǿrnberg was after all better as a speaker than as a poet. For the song which followed was pretty awful, far too bombastic to be acceptable; not a single opportunity or reference was left out . . . Viking blood, the Nordic spirit, Sigurd who slew the Dragon and freed the Gold . . . the whole lot was amateurish and devoid of style, and then, at the end, it gave way to tear-dripping sentimentality and was in any case totally unauthentic in content: "He found a watery grave in the foaming sea!" Good heavens above, man, he didn't drown, he was shot, but that simplest of all facts had been carelessly sacrificed on the altar of rhyme.

And then, finally, as the icing on the cake, came the words:

> For we all take part in that wild play,
> Today it was he, but tomorrow maybe me.

As though there were any danger that Ørnberg himself, a book-keeper . . . !

And yet . . . why not, in fact? This unfortunate war profoundly affected the civilian population as well, so for that matter . . . ! Mr. Skælling shuddered as though ill at ease and breathed deeply.

While the last verse was being recited a certain sign of movement had been observable in the crowd; people were putting their heads together and opening their eyes wide.

"What's going on?" asked Mrs. Skælling anxiously. "It's not an aeroplane, is it?"

"No, it's not an aeroplane," replied her husband looking at her with raised eyebrows. "It's *the baker*! He obviously intends to say something as well. The whole thing's turning into a piece of popular entertainment."

All eyes were turned towards Simon the baker, who had taken up position on a mound to the left of the Youth Association choir.

"He's standing on a grave," whispered Mrs. Skælling.

"Yes, yes, so he is," replied her husband nervously. "It seems anything goes."

"Benedikt from the hospital's there, as well," said Mrs. Skælling. "Do you think he's going to speak, too?"

Benedikt had placed himself to the right of the baker. Some of Simon's followers could be seen behind them, women of the people, a couple of curious seedy individuals, Schiaparelli the sculptor, the down-at-the-heels photographer Selimsson, the silver-bearded boat-builder Markus, whom everyone knew to be a lunatic. Selimsson had a violin case under his arm.

Now the baker uncovered his thick mop of fair hair. He just wanted to say a few words on this occasion – not that much had not already been said and sung. But yet, too

little had also been said. Too little, too little. *The Word* had not been heard. *The Word* demanded to be heard, *the Word* could not be suppressed; if it was not heard in one way, it would be heard in another, as was God's will.

Simon paused for a moment. Then he straightened up and said in a loud invocatory voice: "Behold, He cometh with clouds, and every eye shall see Him, and all kindreds of the earth shall wail because of Him. Thus spake St. John the Evangelist. Know this also, that in the last days perilous times shall come, says St. Paul the Apostle. For men shall be lovers of their own selves, covetous, boasters, proud, blasphemers, disobedient to parents, unthankful, unholy, without natural affection, trucebreakers, false accusers, incontinent, fierce, despisers of those that are good, traitors, heady, highminded, lovers of pleasures more than lovers of God, having a form of godliness, but denying the power thereof."

"Quite a list," whispered Mr. Skælling. His voice was trembling a little. The baker's words had a powerful effect on those gathered there; people were quite literally standing open-mouthed.

"Lovers of pleasures more than lovers of God," repeated the baker. "Having a form of godliness, but denying the power thereof. Yes, thus it is written, and how terribly true it is. But let me not force myself on you: let the Word speak, the living, true, undying Word, which is as salt and seasoning."

Mr. Skælling had caught a glimpse of Solomon Olsen; the outline of the tall, heavily-built man and his even bigger son Spurgeon were just visible behind a bush. It was irritating not to be able to distinguish their features clearly. The editor secretly hoped they might feel stung by the baker's reference to the greedy who have the appearance of godliness.

"Know, all of you gathered here today," continued Simon. "God comes from Teman, and the Holy One from mount Paran, Selah. His glory covers the heavens, and the earth is full of his praise. And His brightness is as the light;

152

He has horns coming out of His hand, and there is the hiding of His power. Before Him goes the pestilence, and burning coals go forth at His feet. He stands and measures the earth; He beholds and drives asunder the nations; and the everlasting mountains are scattered, the perpetual hills do bow; His ways are everlasting . . . The sun and moon stand still in their habitation; at the light of his arrows they go, and at the shining of His glittering spear."

"*Selah!*" shouted a powerful voice suddenly. It was not that of the baker, but of Benedikt. "*Selah!*" other voices joined in. "*Selah!*" shrilled a woman's voice, a lowly voice, that of Black Betsy. And "*Selah!*" echoed the mad boat-builder in frantic ecstasy.

Mrs. Skælling started involuntarily at the sound of the strange word. Her husband took her arm and murmured: "The cheek of it."

A sense of unease spread through the assembly; faces turned upwards, fingers pointed, and a piercing shriek was heard from one of the women.

"Heavens, what on earth is this?" shouted Mr. Skælling. His wife shook his arm: "There's an aeroplane, Nikodemus. Come on, come on, we'd better get out . . ."

Now Mr. Skælling, too, could hear the drone of the motor, increasing in volume; he grabbed his wife's hand, and they rushed headlong across the graves. Everywhere around them people were on the move; from the most crowded part of the assemblage there was another hysterical shriek, and now the wail of the air raid sirens filled the air. There was a great crush down by the gate; several women had totally lost control of themselves and were weeping and wailing; one of them had fainted in the arms of Doctor Tønnesen.

"There, there," shouted Mr. Skælling in an effort to calm them. "There is no reason for panic, none at all."

His teeth were chattering as he looked round for his wife, who had disappeared in the throng; he had not been able to hold her back, and now she might get herself hurt, perhaps even crushed to death or trampled underfoot; it

153

was not at all nice, all this. A shot was heard, echoing ferociously in the mountains; then more shots made the ground tremble beneath them. The anti-aircraft guns thundered like huge baying hounds of heaven. From up by the graveside fragments of the baker's apocalyptic speech occasionally penetrated the din. And then this idiotic *Selah!*

Within very few minutes the cemetery was almost emptied of people; the only ones remaining were a little group made up of Ivar's closest relatives, the pastor, Frederik and the seven other seamen who had been pall bearers. Then there was Simon, who was still speaking, and his pale disciple Benedikt together with Schiaparelli the sculptor, Selimsson the photographer and finally Thygesen and Myklebust and the Swedish tailor Tørnkrona, who was looking for his hat. The noise from the aeroplane was dying away; the anti-aircraft defences fired another few shots, and then they, too, fell silent. And finally even the baker's speech came to an end; he took out a handkerchief and wiped his perspiring brow beneath the bushy hair. He was still in a state of deep excitement; he could plainly be heard breathing through his nostrils, and his eyes were flashing like lightning.

"They *fled!*" he said. "And that was just from things of this world, powers that only kill the body. How much greater will be their terror when God's own trumpets resound. When the kings of the earth, and the great men, and the rich men, and the chief captains, and the mighty men, and every bondman, and every free man, hide themselves in the dens and in the rocks of the mountains. And they said to the mountains and rocks, Fall on us, and hide us from the face of Him that sitteth on the throne, and from the wrath of the Lamb. For the great day of His wrath is come, and who shall be able to stand?"

This last question was directed straight at Pastor Fleisch. The parson shook his head and passed it by: "No, who can withstand? But . . . but . . . we've still one more hymn left, for we'd agreed to sing 'Now take we all our leave'. It was you, Frederik Poulsen, who was keen to have that hymn sung as a farewell, wasn't it?"

154

Frederik blushed and picked at his sleeve. "Yes, it was. But now . . ."

"Yes, no, we'll sing it," said the pastor and launched into it.

Pastor Fleisch's singing voice was not impressive, but Thygesen joined in and came to his aid, and Selimsson quickly tuned his violin and joined in with the melody. Myklebust again burst into tears, and Mr. Tørnkrona the tailor, who had finally discovered his hat and returned to the graveside, also wept like a child.

And then the funeral was over. Pastor Fleisch said goodbye to the mourners, and Simon and Benedikt shook hands as they left.

Johannes Ellingsgaard, the skipper of the Griseldis, had been up in the far corner of the cemetery, from where there was a view of the harbour and the bay; he wanted to see whether any damage had been done to the ships. "No, I think it's all right," he said, as he came back.

"Oh, it was really much disturbance," commented Opperman, who had turned up again. "First the baker, then air raid."

Vigorously shaking the hand of Ivar's father, he added: "But attendance was very big, oh, all sorrow much over Ivar. All remember this funeral for long time."

Opperman was pale and emotional. There was a strong, spicy aroma about him. Turning to Liva, he went on: "See, all those visiting cards on the wreaths; we pick them off later in memory; there are so many, so many."

The family from Angelica Cottage remained for a little while by the graveside together with Frederik and the other pall bearers. Then they slowly began to move off. Magdalena and Frederik took Elias between them, each holding him by the arm; the old man was trembling violently and could scarcely support himself.

"Oh, poor," said Opperman. "He undergo great suffering."

A little man with his hat in his hand was standing

outside the entrance to the cemetery; it was Pontus Andreasen, the watchmaker. He greeted the company deferentially, and beckoned Frederik aside. Liva took her father's arm meanwhile.

"I'm sorry, Frederik," said Pontus. "But I simply had to talk to you; it's about a very important matter . . . You don't bear me a grudge for what happened last time, not if I know you? No, I thought not. But you'd better come home with me so we can talk in peace and quiet, Frederik. Or if it's not convenient now, then come later, but you must come today, for we mustn't wait too long."

Frederik promised to go later.

Pontus was dressed in a peculiar style; he was wearing an old-fashioned tight-waisted coat and black gloves, and carrying a silver-topped ebony walking stick.

"I must say your friend was given a magnificent funeral," he said. "But he'd deserved it. Aye, we must respect his memory. And I'll see you later, my dear Frederik."

The watchmaker took off one glove and shook hands heartily with Frederik. "We'll come to some arrangement, all right, Frederik; this time nothing shall come between us."

# 5

Throughout the funeral proceedings Frederik had remained close to Magdalena; he had stood beside her at the graveside, and they had held hands tight during the air raid. His feelings were aroused, and he felt restless at the thought of her; he had no greater desire than to hold on to this young widow and be with her, marry her – but he could understand from her that she did not feel the same about him. He was tormented by the fear that one day she might impetuously and thoughtlessly give herself to someone else as she had to him. It distressed him, too, that here on the very day of Ivar's funeral he was unable to rid himself of the desire for this woman. But that was how it was: everything else seemed irrelevant, and he had been incapable of thinking of anything but Magdalena.

According to old rural custom a table had been laid for a funeral meal up in Angelica Cottage; it looked festive and beautiful, with a white tablecloth and lighted candles, and the family had made sure that the food was the best available. The seamen were silent, helping themselves only modestly to the food and to the *snaps* which had been poured out for them. Nor did Opperman say much, either, but he smiled amiably and sadly to everyone and stroked the heads of Magdalena's daughters. After the meal he fetched a big packet of caramels and sweets from his overcoat pocket. The children flocked around him in delight; Alfhild, who had otherwise stayed in a corner on her own, busy dressing a doll, also came across to Opperman and stood quivering in anticipation.

"Oh, big child, she too," smiled Opperman, giving her a block of nut chocolate. "You like sweets?"

Alfhild looked up in delight as she bit into the delicious chocolate. One, two, three – and it was all gone, and she was kneeling before Opperman's chair with plaintive eyes.

"Oh, nothing left now," said Opperman. "But you have more later. I have lot more at home."

"Alfhild," scolded Magdalena. "Do leave Opperman alone."

Her sister gave her an indignant look and laid her head amorously against Opperman's cheek. He stroked her arm, and she made to sit on his knee, but now Magdalena took hold of her and drew her aside.

"Oh, poor," said Opperman piteously. "She very like sweets and cuddling, eh? She is only a child."

Johannes Ellingsgaard looked at his watch. "I think I'll just say thank you for your hospitality, and then I'd better get off. We're sailing tonight, and there's still a lot to be done."

The other seamen, too, broke up and took their leave. Frederik also got up, saying he would go down with the others. He pulled Magdalena aside a little, pressed her hand tight and whispered: "I'll be back later. Can we meet?"

She nodded.

"I go, too," said Opperman. "But first I say my best thank you for hospitality and friendship."

"We're the ones to say thank you," said Elias, gripping his hand. "Thank you, Opperman, for your great help and consolation. Thank you all for your support and kindness. May God repay you for your trouble and kindness."

Shaking his head, he added: "But it's been too much; it was such a great honour, aye, it was more than we could have dreamt of; if poor Ivar had only known . . . that his funeral would be such a grand affair."

"Oh, rubbish," said Opperman, shaking the old man's icy hand. "But by the way, Liva. I think of visiting cards. Perhaps you go with me, and then we pick them now and you take them home with you?"

"All right," replied Liva. She felt she had been taken unawares, and a sense of weariness and resentment welled up in her. How tiresome it was; she couldn't stand any more of this nonsense with Opperman, that importunate, indeterminable, silly and yet curiously artful man. She could not see why she could not go down to fetch those cards from the cemetery alone or together with her sisters,

without Opperman having to get mixed up in that, too. But on the other hand, he was her boss, of course, and she was accustomed to doing as he wanted.

"I talk with my wife," said Opperman in a confidential tone as they walked together down along the path. "She understand nothing, oh, she is so completely obdurate. She just imagine that, you know . . ."

Liva felt herself blushing deeply. She looked away without replying.

"Yes, so meaningless, so ridiculous," Opperman went on. "Amanda say it your voice, not Frøja's. I say I swear, but they just laugh: you swear? You swear lie. Oh, it was so obdurate. . ."

"Yes, but I won't put up with it," Liva suddenly blurted out. She felt nothing but icy antagonism towards Opperman.

He sighed: "No, I understand so good, you poor thing. But I say to Frøja: you say it was you. But Frøja would say nothing, she not get mixed up, she say."

"I don't care a hang about your Frøja or any of it," shouted Liva, turning fuming towards Opperman. "I'm giving you my notice. There, it's all over. I won't have any more to do with any of you. You're all crazy, the whole lot of you."

"No, Liva," protested Opperman despondently. "Not take it like that, I so upset at it. You think this funny for me?"

"Yes, that's exactly what I do think," said Liva. "I just think it's something you enjoy . . ."

She bit her lip. She was on the verge of tears.

"Liva," said Opperman, touching her arm. "Liva, I do everything for you, do you hear? You demand what you want. Oh, it make me so much sadness. Liva, it perhaps better you leave me, but what then? Then they think it was true, for why should she go otherwise? Why?"

Liva suddenly stopped. With a penetrating look at Opperman she said quite calmly: "Will you please keep away from me, Opperman. I can cope with that problem on my

own. And we are finished with each other in every respect now. Understand?"

For a moment Opperman seemed completely flabbergasted. Then he shook his head and said: "Yes, I understand, Liva, I understand."

"*Good*," said Liva. She turned round and set off at a run across the field.

The old gravedigger and his son had almost finished filling in the grave. Liva was not in the mood for meeting anyone just now; she left the wreaths to their own devices and went up to the top corner of the cemetery, where she sat down on a bench. She felt relieved now that she was getting rid of Opperman. But when she thought of the magnificent funeral and all the trouble Opperman had gone to, she could not help feeling uncomfortable about her behaviour.

She rubbed her hands and shuddered. "That silly monkey Opperman's in love with you," she said half aloud to herself. "It's horrible."

Once more she had to think of Mrs. Opperman's words: "If you become his wife, you will become a wealthy woman." An incredibly crude thought. Mrs. Opperman knew perfectly well that she was engaged to be married. Perhaps they were simply assuming that Johan had not much longer to live, and that she had already begun to look around for another catch. The most advantageous one, of course. Opperman himself . . . and he could expect to be a widower before long.

It was ridiculous, but it was outrageous and vile, too. And then to say it like that, without wrapping it up, and on the very day Ivar was brought home dead. Yes, that woman must be very wicked. But perhaps it was that incurable illness that had made her like that. "Good heavens," thought Liva . . . "Lying like that, helpless, and knowing that you're going to die, and then being married to a man like Opperman. How can you be anything but wicked in those circumstances?"

Oh well, Opperman, for his part, must also have his

160

troubles with this sick and suspicious wife. But the silly man hadn't deserved anything else. Liva felt contempt and repugnance for both of them. It was all so nasty and hopeless.

Liva shuddered violently with cold. She would sit down this afternoon and write a long letter to Johan. She would tell him everything that had happened, including all this about Opperman. She had nothing to hide.

Or, she could go and visit Johan. Now she had given up her job there was plenty of time for that.

But she would write first. She would have to confide in him that very day.

Liva leant back, sighed deeply and shut her eyes. A merciless little voice deep down inside her said with harsh and painful clarity: "Johan will never recover. He's lying waiting to die, just like Mrs. Opperman. He *is going to die*. He's going to die, just as Ivar died. Perhaps this very year. Perhaps next year. He won't be recognisable, a dry, distorted image of what he used to be, an alien thing, like Ivar, with features and hands like brown paper, like dirty cardboard."

Death, death. The cruel word kept on ringing in her ears. Death lies in wait, death spares no one. A time of death, a time of death. Alas, there is so much to go through before we can enter into the great light and for ever be with Him who overcame death . . .

Liva shook her head and opened her eyes. Frozen graves, withered grass. Crosses and gravestones, sorrowful marble doves, white curlicues under glass covers, and "Here lie the remains of . . .." It was all strangely unreal, grey and distant and insignificant in contrast to the living light inside her. She fell to wondering. "What about myself?" she thought faintly.

Aye, here she was, twenty-three years old. She felt her heart beating; the shingle on the path crunched beneath her feet; the cold pricked her cheeks; she was alive . . . and suddenly she became aware of the seething activity in the town and harbour, the hammer blows that could be heard

every day, engines, windlasses, car horns, the barking of dogs, voices, bagpipes. She got up quickly and stretched, breathed in deeply, yawned, felt unusually hungry and thirsty and longed to set about doing something or other and becoming herself again. "Here I am," she thought again and gently shook her head as she contemplated her own situation and that of everything around her: "Here I am . . . for a short while yet, and then it'll all be over. And only then will the real life begin, the life eternal . . ."

She found Opperman standing at Ivar's grave. Yes, of course. She was not surprised. Opperman, a silly little man, a poor fool, a man of this world, in love with her, ridiculous. He was a man entirely of this world, tied to this life, a worldling and a slave of mammon. She found herself wondering how Opperman would fare in the life to come. Good God, good God.

And her thoughts went on: And what about Ivar? Yes, dear God, what about Ivar? This question had arisen in her mind several times during the last few days and nights, but she had put it aside until later. Now it was forcing itself on her, mercilessly and unrelentingly. She must go and have a serious talk to Simon about it.

The grave had been filled in. Opperman was helping the gravediggers to arrange the wreaths; he smoothed out the silken ribbons, fussy and eager, just as he was when arranging materials and ladies' stockings over in the warehouse. He was ridiculous. She could not feel angry with him. A small pile of white and black-edged cards lay in the grass. An oppressive scent of dying foliage and flowers rose from the grave. At last, all the wreaths were in place; the gravediggers took their leave and went their way. Opperman had got soil and hoar frost on his coat; he tried to knock it off, but gave up.

"Now it is beautiful grave, Liva, isn't it?" he said. She made no reply, but let him prattle on: "Oh, wondrous grave. Very wondrous. You see many other new graves, you never see so many flowers."

They parted at the entrance to the cemetery. Opperman

grasped Liva's hand, squeezed it, and said: "Oh, Liva, you not at all angry, it perhaps all become good again, for we have done no evil, we have good conscience, that the most important thing. You become cross, Liva, but you calm down again . . . yes, I see it on you. You perhaps come back again, yes? You perhaps like holiday? Go and visit your fiancé? Come back to old job?"

"No, Opperman," said Liva. "I'll not come back. But thank you for all your trouble today."

"Old job, I say," Opperman went on . . . "You not need have old job, Liva. You have new job if you want, yes you have much better job, for I value you so much, Liva, you are such clever girl, we just make mess occasionally. It easily be OK again. Oh, I see it on you Liva, you come back, you just have time to think. Goodbye. Regards to father, regards to sisters, love to children, I send them chocolate tomorrow . . . Engilbert take it with him when he go up to foxes. Dear. Dear."

Opperman's mouth twisted in pain; he had tears in his eyes.

Liva pulled her hand away in consternation. "No, Opperman," she said. "I am not coming back; I mean what I say. But you mustn't think me ungrateful. That's all I wanted to say. I mean, we don't need to part as enemies, Opperman."

"Oh, no, dear," said Opperman. "Never. Never."

He suddenly grabbed her hand and lifted it with lightning speed to his chest. "Never," he repeated imploringly.

"Let me go, man," said Liva, looking round in embarrassment. Suddenly she started and blushed scarlet . . . Simon the baker could be seen walking up the hill. He must have witnessed this ridiculous scene. What on earth must he think?

"Good bye, dearest. We meet again soon," said Opperman.

She quickly turned away from him and went to meet Simon.

"I was on my way up to see you," said the baker.

"What's that you've got there, Liva? Cards from the wreaths? What do you want with them? There's no point in keeping things like that."

"I know," said Liva. "It was Opperman who insisted on my taking them home."

Simon sighed and looked reproachful: "You surely don't need to do everything Opperman says, Liva. Leave others to grovel in front of his wealth, that is not for either you or me. He's nothing but dust in our eyes, nothing at all."

"I know, Simon," said Liva fervently. She wondered whether to throw the cards away.

"So I suppose you realise he's after you?" asked Simon.

His voice was trembling a little. Liva felt how she was blushing. The sound of Simon's voice penetrated deep into her soul and moved her. Without looking him in the eye she replied: "I have nothing more to do with Opperman. I've given up my job."

She stepped over to the roadside and threw the cards away in the ditch.

"I'm glad to hear that," said Simon in a low voice. "We need you. We can't do without you."

Liva felt warmed at those words; she took his hand. "Thank you, Simon," she said. "And I shan't let you down."

They walked together in silence for a while. Then suddenly, and in an impatient voice, Liva said: "Simon, there's something I must talk to you about. It's about Ivar. How will it be with his soul, Simon? It worries and hurts me to think of it. You know what he was like. His faith . . . it wasn't strong, Simon. Perhaps he didn't believe at all. I spoke to him about it the evening he left for the last time, but it was as though he avoided the question."

"Aye, I've wondered about that myself, Liva," said Simon. "It worries and nags me as well. And I've asked myself, too: What about Erik and Hans, my two sons who went down on the Evening Star? Aye, Erik believed, and he was a repentant sinner; it's a consolation to me to know that. In a way he reminded me of your brother, Liva; they

were both a couple of wild ones. But Hans, my elder boy, who was always so quiet and decent and such a good son to me . . . I don't know whether he had the living faith, I don't know. I go through enormous torments for his sake, Liva. And for my wife's sake as well, for Maria was taken from me at a time when I myself didn't know the miracle of salvation and the calling awaiting me. And even if I suppose she was a believer, I ask myself whether she had that living faith that fills the dead soul with imperishable warmth and inextinguishable light."

Simon sighed and his voice sounded dejected. "It is part of the cross we have to bear that we know nothing of these things," he said.

Liva turned round towards him, and they exchanged a brief, anxious glance. It disturbed her to see Simon so despondent; it was only a couple of hours since his words had resounded with thunderous intensity at the graveside.

He sighed and lowered his voice. "It is part of the cross we have to bear," he repeated. "But we can hope. We have the word of the Scriptures that the risen Christ descended into Hell and spoke to the spirits imprisoned there. But we know nothing for certain. We don't know anything about ourselves, either, Liva. We don't know what dreadful temptations have their abode in our bodies. But the Scriptures know, Liva. The Scriptures know. They often speak of it. They teach us that the great Liar, perfidious Satan, is lying in wait with his snares just when we least expect it. We can only resist him and fight, fight. Go ye into all the world, and preach the gospel to every creature. That is what the Saviour demands of us."

Once more they walked on in silence for a time. Simon's breathing was uneasy, as though he were in tumult. Suddenly, he stopped and said severely: "I might as well say this to you, Liva, for otherwise it is going to get in my way."

Liva looked at him in amazement and confusion. He returned her glance with coldness.

"You see," he said. "When I saw Opperman there

pressing your hand to his chest, I was overcome by a burning desire that came from the Devil, and which I now know I must curse and fight against. Yes, a desire for you, Liva . . . jealousy, or whatever you like to call it. Satan is the sole source of such things. Come, let us pray."

He threw himself to his knees by the roadside. Liva did likewise in some confusion; the sound of Simon's voice as he prayed and entreated went through and through her: "Tear down the webs of Satan and destroy his snares . . . let not this new infernal potion poison our souls. For, as is said: Behold, I give unto you power to tread on serpents and scorpions, and over all the power of the enemy; and nothing shall by any means hurt you."

Simon got up. His glance was stern and distant.

"Just you go home," he said. "I shall not come with you, as I had intended to do. I must be alone for a time. Go in Christ."

He quickly turned away from her and walked off.

Liva remained there, her head bowed, and her hands clutched to her mouth. It was some time before she could gather herself sufficiently to understand what had happened. But little by little she began to comprehend, and it filled her with an uneasy warmth and a deep sense of fear. She nodded timorously and stared ahead through half-closed eyes.

# 6

Frederik was curious to know what it was Pontus the watchmaker wanted of him. Was he going to offer him the Admiral again? Pontus had not been lucky with his speculations in fishing: the first trip the hired schooner had undertaken had lasted much longer than he had calculated, and the catch had not sold well; Pontus must have lost a fair amount on that. And then he had sacked Thomas Berg the skipper.

"Aye, he was a thickhead, that Thomas Berg," said Pontus. "He was too easy to fool; he was too scared to raise any objection. But then he's a teacher's son; he reads books; there's no backbone in him. And as for me, I let myself be led up the garden path ... by that blackguard Sveinsson, the worst beast I've ever in my life come across. He'd promised us the first look-in and said they'd look after us particularly well in Effersfjord, but not on your life! The Admiral had to wait a fortnight, and when it finally got in there was nothing left but rejects, half-rotten fish ... Aye, did you ever know the like? They fobbed us off with a full cargo of rotten fish; aye, they even threatened the skipper and forced him to take it, the swine, and he was daft enough to do it."

Pontus swallowed a sneeze and dried his eyes.

"And I made an enormous loss on it, Frederik. I lost 25,000 kroner. And I'll never get that money back; it's all gone into the pockets of those blasted sharks. I complained to Sveinsson, but of course he's made sure he's got his back covered, so no one can get at him; that's the first thing those blighters make sure of. And then I got in touch with Snellmann, the best solicitor in the country, and asked him to sue the cheats, but he said it was hopeless, because it was an unfortunate fact of life that foreigners always lost in Icelandic courts. There's no justice up there for anyone but an Icelander, you understand; they're gangsters, the whole lot of them."

Pontus was not angry, not even particularly worked up. He smiled ruefully and fiddled resignedly with his chafed moustache.

"Everything went wrong," he said. "I ought to have taken notice of your warning, Frederik. But we're not finished yet . . . I've got another trip left. I'm afraid, I'm afraid. I signed a contract for two trips, you know."

"It's a question of pressing on," said Frederik. "You can easily get a good cargo if you go about it the right way. And, incidentally, they're not all cheats, Pontus; there are some fine folk among them. And Stefan Sveinsson's always done us proud."

"Yes, I suppose so, Frederik," said Pontus meekly. A gentle glow was being kindled behind his glasses, and his voice became mild and imploring. "*You* know the good men and the right places, Frederik. You never had a failed trip with the Manuela, did you? What was the smallest profit you ever made?"

"Six hundred and thirty-five pounds," said Frederik. "But on that occasion we were very unfortunate, too, for we had engine trouble on the way to Scotland, and the ice didn't last out."

"There you are, there you are," smiled Pontus, showing his long teeth.

But then suddenly he became deadly serious and said, folding his hands on the desk top: "Frederik. I'm giving you the chance this time. I believe in you. You've had plenty of experience, and you've got the courage. Will you accept?"

Pontus's hands were trembling, and his silver-grey nostrils were vibrating. He could not sit still, but got up and shuffled his feet, while staring intently at Frederik. "Now, my lad. Don't let me down. You know what's at risk for me; the ship's just about ready to sail; in fact, you can leave this very evening if you like, and the market's at its very best at the moment, so there's no great risk. And whatever happens, one day you'll have to go off on your own account, won't you, Frederik, if you're going to get any-

where, for you're not thinking of hanging around ashore, are you? And if the trip's a success, we'll extend the lease. There's still a chance for us both to become rich, Frederik, but it's now or never. You'll never have a better opportunity."

"All right, then we'll try our luck," said Frederik.

Pontus grasped his hand. "I like you for that, my dear friend and kinsman," he said and sank relieved down into the chair. "I was dying to know whether you would, but I waited until after the funeral, for it's bad luck to start negotiating about important things before a funeral, you know, and I didn't want to disturb you in your sorrow, either."

"Oh, Frederik," he added in a confidential tone. "If you had any idea how difficult this last time's been for me. The tension while I've been waiting. The telegrams I've hardly dared to open. But in for a penny, in for a pound, and what's life if you don't take a risk now and then? You sailors risk your lives and your health, but we shipowners, too, put our lives and health at stake; it saps our strength, strains the heart. . . but what is it President Roosevelt says: Live life dangerously! Or maybe it wasn't him who said it, but at least he said: Keep smiling. Yes, keep smiling, Frederik. You are my good kinsman, and we're in the same boat. We'll stick together, come what may."

Delighted, Pontus swallowed another violent sneeze and got up with renewed energy. "Let's go down to the ship straight away and see about getting things ready. It's Friday tomorrow, and that's not a lucky day, so for God's sake let's get going this evening. Besides, you must know, Frederik, that there's luck in anything you undertake just after a funeral. Come on, my lad, come on."

Frederik thought of Magdalena. Pontus was right when he said it was a case of making the most of the opportunity. And Ivar used to encourage him to have a go on his own.

Frederik breathed in deeply and stretched his arms so that his elbow joints cracked.

"Yes, by God." he thought.

They went out through the shop, where the pearls and brooches were shining in their spotless display cases. There was something shining on the floor, too, a silver brooch or something that had obviously fallen out of one of the cases. Frederik bent down and picked it up. It was a little horseshoe; he gave it to Pontus, who looked as though he were trying to stifle an attack of laughter. "You found it, Frederik. I was scared stiff you wouldn't notice it. No, just you keep it; take it with you; it'll bring you luck."

Pontus's voice broke, as he added: "I put it there myself, Frederik . . . as a sign. I always look for signs wherever I go."

"And what if I hadn't spotted it?" asked Frederik in surprise. "Would you have withdrawn your offer?"

"No," said Pontus eagerly. He leant against the glass counter, and the steel-hard hairs under his nose were trembling. His hands were shaking, and his teeth chattering . . . what was wrong now?

"You're not going to be ill, are you?" asked Frederik. Pontus shook his head, but made no reply.

"Look, I'll be hanged if there isn't another horseshoe here," said Frederik. He bent down and picked it up. Pontus was again overcome by laughter and clasped the trinket in both hands. "I'll keep that one for myself, Frederik. It's made of gold, and it means twice as much good luck. And I don't think we can ask for more than that, can we, Frederik?"

"Third time pays for all," thought Frederik and deliberately started looking for the third horseshoe. There it was, over by the doormat. He gave it to Pontus. The little watchmaker was blushing scarlet; he accepted the horseshoe shyly and said quietly and with no trace of laughter: "Aye, Frederik, if we can rely on portents, then this means thrice lucky. And this horseshoe – see, it's the biggest of them all, and there's an amethyst in it. It costs sixty-three kroner, too. Look, Frederik, I want you to take it with you, and when you get aboard, fix it to the wheel. It belongs to the ship as long as the lease lasts. Understand? Fix it on well.

The Admiral has been an unlucky ship, but we're turning it into a lucky ship now. Promise?"

"Yes, I promise, Pontus," said Frederik, putting the little trinket into his pocket.

Evening had fallen before Frederik was able to return to Angelica Cottage; he had suddenly had enough to do now that he had become the skipper of the Admiral. He had consulted Johannes Ellingsgaad and the Icelandic fishing agent Stefan Sveinsson, and had decided to leave already by midnight. There was no time to be lost.

"You're jolly lucky," the Icelander had said. "You've come at the best possible time. I've got a fine cargo for you in Góðafjord, guaranteed first class fish, and the market in England will be at its best from now until Christmas. There's no doubt at all about that."

Frederik trusted Stefan Sveinsson, as Ivar had done. The sound of these encouraging words continued to ring in his ears. He was feeling somewhat overwhelmed. Admittedly, The Admiral was an old hulk, built in Ålesund in 1889, but it was certainly a far bigger ship than the Manuela had been; indeed, there was no comparison. But that meant the risk was all the greater. There was an enormous amount of money at stake; Pontus must have borrowed a vast sum.

Frederik hurried up the path to Angelica Cottage, which was shining beneath a cover of hoar frost under a starry sky. Magdalena was standing at the gate. She took his hands, and in surprise and delight he hugged her close.

"You're so warm," she said.

"I've been running. I haven't much time; I can't stay for more than a few minutes. Were you really standing here waiting for me, Magdalena? Have you been here long? Heavens, you're cold."

"What are you in such a rush for?" she asked in surprise.

"I'm sailing on the Admiral this evening."

Magdalena moved uneasily and let go his hand. "I'm sorry you're going," she said. "You could have got work ashore."

171

Frederik felt fired by her words. "Yes, but you know, I'm a sailor," he said with a little smile. "I'm not suited to hanging about on land. And we'll be back in three weeks. The Admiral's a big ship and a quick ship, Magdalena; it'll do seven knots, and the equipment's good."

"Are there guns aboard?"

"There's a machine gun."

Magdalena sighed and leant her head against his chest, caressing his hand the while. "That's not much good. Not against U-boats. Or mines. How's your arm, Frederik, is it better?"

"Yes, it's all right."

"Who's skippering the Admiral?"

There was a smile in Frederik's voice. "Well, who do you think? Guess."

Magdalena was not much in the mood for guessing.

"He's not far from you at this very moment," laughed Frederik.

"No. It can't be true." Magdalena involuntarily stepped back a little. "You?"

Frederik nodded. She looked at him wide-eyed and suddenly there was something alien in her look, as though she had never really seen him before.

"Frederik," she said, and nudged him, still staring. But suddenly she flung both her arms round his neck and again laid her head to his chest.

He kissed her and whispered in her ear: "You'll wait for me, Magdalena, won't you."

She sighed, but made no reply.

"Why are you sighing? You will marry me though, won't you? When I come home as a man who . . . as a man who can afford to build a decent house and provide for a family. What do you say, Magdalena?"

She shuffled a little and seemed to find it difficult to answer, and Frederik felt his heart beating violently. He repeated his words impatiently: "What do you say, Magdalena? Won't you? Won't you wait for me?"

She started fiddling with the lining of his collar. "My

172

dear," she said quietly, "I've got three children already. You can't start off with three children. You should have a young girl who hasn't got any children with anyone else."

"Children," said Frederik impatiently. "You know how I love children. But that's not what it is, Magdalena. You simply don't want to marry me, that's what it is."

There was almost a threatening tone to Frederik's voice: "Perhaps you've got other plans. Yes, I'm asking because I'm in a hurry. I want to know whether I can go off as a happy man or as a . . ."

"No, Frederik, you must be happy."

She sighed uneasily and added with a wan smile: "But can I make you happy, Frederik?"

He felt her mouth close to his. Why was she avoiding answering his questions. He felt unsure of Magdalena. Once more he asked her earnestly: "Then, will you wait for me? I must have an answer from you, for it means so much to me. It means all or nothing."

"Yes, but suppose you came to regret it," whispered Magdalena. "You mustn't feel tied to me, Frederik. I'll be here when you come back, and then we can talk about it again."

Frederik did not like Magdalena's reply. He put his hands on her shoulders and looked sadly into her eyes. She smiled and surrendered to him.

"You might just as well say that you'll love me for ever and never love anyone else," said Frederik at once reproachfully and imploringly.

"You are my dearest friend, Frederik," she said tenderly. "Let's see whether you feel the same when you come back. You know how quickly feelings can change."

She hastily added: "But let's go in. Then I'll go down to the ship with you."

"Will you really, Magdalena," he said, delighted. He took her by the waist and lifted her up in the air.

Magdalena and Liva accompanied Frederik back to the ship. Light snowflakes were falling, and the path was iced

over. Frederik took the two sisters by the arm. They walked in silence. The usual sound of seething activity rose up from the village; there was music, too, coming from Marselius's dance hall, where the soldiers' jazz band was playing at a dance. There was the usual throng of people outside the blacked-out entrance; pocket torches flashed here and there, faces appeared momentarily in the darkness behind rods of falling snow, mask-like faces, white and laughing.

The Admiral was ready to leave down by the quayside; its motors were throbbing. Frederik quickly took leave; Magdalena followed him to the ladder; he held her hand tight and whispered: "I don't know how to thank you, Magdalena; you've made a new man of me . . . yes, you have . . . you've given me something to live for."

The snow began to fall more thickly. Liva and Magdalena remained on the quayside until the outline of the ship had slipped out into the darkness. Magdalena was holding a corner of her scarf up to her face. Liva could hear she was battling with tears.

They walked in silence for a long time. Magdalena cleared her throat and her voice became stronger. She sighed a long: "Aye, aye."

"Doesn't Frederik remind you a bit of Oluf, my husband?" she asked suddenly. "Yes, he is a bit like him, Liva; not to look at, because he's bigger and stronger, but even so . . . And he's not as sluggish as Oluf, either. I'm terribly fond of Frederik; he's got a heart of gold, but he still reminds me of Oluf . . ."

Magdalena sighed again and was silent for a while. Then she went on: "Listen, Liva. I'd better confide in you if you can be bothered listening to me. Frederik wants me to marry him. Do you hear, Liva? But I can't marry him. Do you know why? Aye, don't eat me, Liva, I'm both embarrassed and unhappy . . . but I'm going with a soldier. I met him the very first evening I was here. All right, grumble at me, if you like. I deserve it. No one else knows about it, because we have met up in the fields, and he knows that

I've been widowed recently and that nothing must come out. Understand? Well, then, *say* something, Liva."

"Have you told him you've got three children as well?" asked Liva in a hollow voice.

"No." Magdalena's teeth were chattering a little, and she was shivering in her shawl.

"I'm so sorry about it now," she added after a while. "And besides, it's worse than what I've told you. I'd better tell you everything. Are you listening? You could at least say yes and no so I can hear you're still with me. I must talk to someone, and you can say what you like then."

"Yes," said Liva.

"This man I've told you about isn't the only one, either," continued Magdalena in a low, self-accusatory voice. "I know two. Aye, that's how bad it is, Liva."

Magdalena's voice was thick as she went on: "And Frederik . . . I've had *him* as well. And that was even on that terrible day when we heard Ivar was dead. Yes, so now you know. I seduced him. And now he wants me, he wants to marry me."

Liva took her sister by the arm.

"Magdalena," she said.

They approached the dance hall and hurried past. There were still sounds of jazz being played; the saxophones were wailing coyly and limply like children peeing on the floor for sheer devilment.

"I'm not the only one like that," Magdalena went on, her voice warming up. "Even Thomea's got someone, would you believe it? I know they're often together. And I know who it is, too; it's that Icelandic fox-keeper. What sort of a man is he, really, Liva? And he seems to want to marry her as well – at least that's what she thinks. . . Aye, I suppose it's a bit silly of me, but you know how innocent she is, even if she is twenty-six years old. And it was me that helped to get rid of all those awful hairs on her face. But that'll only last for a time; the hairdresser said that they'd come back in six months."

Magdalena suddenly shook Liva's arm. "For heavens

sake *say* something, Liva," she said impatiently. "Grumble at me. Tell me you can't stand me."

Magdalena sighed and was silent for a while. Finally, with a long, troubled sigh she said: "You don't understand me at all, do you, Liva? Because you're so good and faithful yourself. You're *good*, Liva. As for me ... I'm bad."

A moment later she added: "Do you know, when the baker was talking at the graveside ... it was almost as though every word he said applied to me. I turned icy cold with fear."

Magdalena clung tightly to her sister's arm. "Ugh ... and now winter's already here again. And there's no end in sight to the war. Is there, Liva? You're not saying anything, you're not even nodding. You're such a ... such a strange, hard person, Liva. Yes, you are. I wish I was like you and had never done any wrong, but just been good and patient. I envy you. You're like the wise virgins the baker talked about, the ones who had their bridal dresses ready and oil in their lamps. God help me and my lamp."

Magdalena laughed bitterly: "Yes, I suppose I'm not a very good virgin, Liva. No, Frederik ought to have had someone like you. What does he want with a whore with a nest full of kids already. He deserves a better fate."

They had left the town behind them. The snow had stopped falling, and the stars were shining in a cold sky.

"Let's stop here a moment," said Liva. She took both her sister's hands and said in a firm, warm voice: "Do you know what you are, Magdalena? You're a repentant sinner. You can still become one of the wise virgins. You can get oil for your lamp. If you thirst for it and pray for it."

Magdalena shook her head and smiled with her eyes closed.

"I daren't think I'm worth anything," she said. Her voice was both smiling and bitter.

"Turn to our Lord Jesus Christ," said Liva earnestly. "You must, Magdalena. That is where you will find peace and happiness to all eternity. You'll learn to realise that this

176

is only a poor resting place . . . that everything in this world is crying and screaming in despair for grace to pass redeemed into that real, eternal world, where peace and justice reign."

Liva's voice had become strange and alien. Magdalena shuddered and felt deeply ill at ease. Liva took her by the shoulders and with wide-open eyes sought to catch her eye and said in a loud, minatory voice: "You must fight, Magdalena, you must overcome all those sinful things within you. Beg your Saviour for grace. For soon, Magdalena, soon the night will come . . . soon the night will come. Good God, Magdalena, think what that means: not to have your lamp ready, but to wander around alone in the darkness to all eternity."

"Let go," pleaded Magdalena. She tore herself away from her sister's grasp and hid her face in her arms. Liva gently stroked her back and then she folded her hands and began to pray, slowly and hesitantly. Magdalena could not gather her thoughts sufficiently to follow the words of the prayer; Liva's voice sounded so·alien and deep; she could hardly recognise it, and it hurt her; it was like being at the doctor's to have a tooth out. Finally, the prayer came to an end. Amen! That word was good to hear. And now Liva's voice returned to normal; she gently shook Magdalena's clothes and said, in a tone that was almost cheerful: "You'll see, things will be better before long." She embraced Magdalena and planted a gentle kiss on her cheek, and then they went up the path, hand in hand and without exchanging another word.

# 7

And now this day, too, the day on which Ivar from Angelica Cottage was buried, must finally suffer the fate of all days: the fate of fading away into darkness. Sooner or later it will be totally forgotten, an indistinguishable layer in the vast deposit of sunken days at the bottom of the ocean of time. But for the time being it will maintain itself in people's memories. It will not immediately sink to the bottom without further ado; people will catch glimpses of it for a long time, a long time ... like a dead whale floating just below the surface, neither sinking to the bottom nor staying fully in view, kept aloft by exhalations coming from inside ...

Jens Ferdinand sees this whale come drifting along, the black, smooth fish-like body adorned with protruding, light grey lumps of gas-filled gut. In fact there are really two whales: he himself is one of them; he grinds his teeth and laughs bitterly at this latest invention of the demons of retribution, and at the same time, with a mighty effort, he works his way up to the surface.

But here he is confronted with the wicked, raised harpoon of wakefulness, and it is mercilessly planted in a back still smarting from the fall in the sacristy.

... The over-filled church, tapestried with human faces, the oppressive scent of flowers and tepid clothing, the white coffin before which he had stood and shouted his threats, powerlessly, ridiculously, and then the ignominious manner in which he had been thrown out. In grossly exaggerated dimensions he sees it all before him, and the demons are ready with their detailed close-ups from this epic film of idiocy and shame. Faces float past him, faces filled with horror, irritation, pity, disgust, amusement. Pjølle Schibbye bends over him and stifles a laugh in his hat. Inspector Joab Hansen gloats openly as he turns the chewing tobacco in his twisted mouth. Yes, they are all

gloating, more or less dishonourably, not least Bergthor Ørnberg: there he lifts his head and raises his eyebrows, while the corners of his mouth curl limply down in a surfeit of goodness, for now he is avenged.

But suddenly there is a huge close-up of Liva, unnaturally big - the black headscarf with its waffle decoration, the strong, dark hair, the pale young face, the naively folded virginal hands, the genuine pain in her eyes . . . "May Jesus Christ keep thee, my poor dear."

But then comes a yet sharper double portrait of the deacon and bell-ringer, actually two quite decent, ordinary faces, but on account of the profanation of the temple they are both devilish with anger; their eyes reflect a thirst for blood; their throats give birth to obscene and hitherto unknown wolf-like howls, but they keep control of themselves and, in deference to the discipline imposed by the church, content themselves with modest grunts. And then he rolls down those confounded steps while the congregation is like an explosive charge of suppressed amusement and *Schadenfreude*, liable to go off at any moment.

Out. Bump. Down into the depths . . . to the other mutilated fish, that double of yours, with its unnatural entrail hump. Two identical and equally disgusting deep sea monsters seeking to hide behind each other while they burrow their way down into the mud of forgetfulness on the bottom. The devils of retribution smile to each other and stick their untiring boxer's chins forward, ready with new torments.

"But I'll cheat you, you devils," he hisses. Almost weeping, he raises himself up in his bed and reaches out with a trembling hand for the bottle standing on the floor. It contains Gordon's Dry Gin, made milder with vermouth, a sure promise of a few more hours' respite before the final confrontation.

Soon things are no longer so grotesque, even if, on the other hand, there is not exactly anything to rejoice over.

The really wicked thing is that Ivar died in such a cruel way, and that this age is one that demands such appalling

sacrifice . . . to the advantage of an unscrupulous or mendacious minority of mankind. And if a drunken typographer put in an appearance in a church where a tragedy was being transformed into a farce . . . what then?

But what of Liva, that woman whom he idolised and worshipped? What of her? She was good to look at, and it was devilishly cunning that she should be so religious. Enough of that; she wasn't his; she was his brother's. Like hell she was! In spirit she was Simon the baker's mistress. That was up to them, up to them. And yet . . . if he lost *her* as well – what would be left?

Jens Ferdinand took another deep draught of the kindly, healing drink. He curled himself up on the bed and hissed through his contorted lips down into the pillow: "I love her. I love her. I've only got one life, and perhaps I'm wasting it and ruining it. But I have known what it is to fall in love, definitively, violently, terribly and impossibly in love with my mortally ill brother's fiancée, the sectarian mistress of a mad baker and religious fanatic. . .! That's an obvious handicap, old man, but . . . in short . . . bloody stupid as it may be: you *love* her."

# III

## 1

Magdalena was inclined to regret having been so unreserved in her confidences to Liva, and the whole of the following day she went around feeling nervous that her sister might try to persuade her to join Simon's congregation. Not for anything in the world would she become a member of the bun sect; she felt nothing but disgust and abhorrence for Simon and that loathsome corpse-cleaner, Benedikt, and their revivalist meetings in the grimy bakery. But when Liva came that evening and suggested that she should go along with her to a meeting she gave in without raising any objection.

It was stuffy down in the subterranean bakery. A perfectly ordinary, dirty packing case standing upright on a dais in front of the oven served as a pulpit. Along the wall and across the floor other packing cases had been placed to support the rough boards acting as benches for the congregation. It was a big, old bakery, but it was in a sad state of repair. Simon had bought it a couple of years before, but he had never taken much interest in the baker's shop, preferring to live by fishing and a little agriculture and any odd job that came along. Now the bakery was used as a meeting place for the sect. God alone knew what Simon lived on otherwise.

The two sisters sat down on one of the benches along the wall. Simon came across and shook hands with them. His handshake was firm and brief. His tall, thin figure radiated paternal harmony and benevolence; he looked almost distinguished, quite different from what Magdalena had expected.

Benedikt was standing over by the oven, his arms folded;

the light from above fell obliquely on to his bald pate, and his eyes were almost invisible in their deep sockets. There was a third person on the dais: Selimsson, the photographer, who was tuning his violin and occasionally using the back of his hand to wipe away a drip from his red nose. His hair was curly, and he was dressed in a greasy worsted suit with shiny knees and elbows. Before his conversion he had been a great drunkard and reprobate; so had Morten the shoe-maker, an infamous domestic tyrant who on more than one occasion had been arrested for maltreating his wife. Now the two of them were sitting peacefully side by side on the front bench. On his left, alone as usual, sat Tørn-krona, the tailor; Magdalena felt a little sorry for the tall, well-dressed Swede with the blond moustache: he was always alone, and everyone knew that both his wife and his two daughters were having it off with Englishmen and leaving him to his own devices. Tørnkrona stammered and was a little hard of hearing; he hardly ever opened his mouth, which made him yet more lonesome.

Immediately behind the tailor there was a round-shoul-dered little man wearing glasses, and with an untidy droop-ing moustache; it was Mrs. Schibbye's head clerk, Lydersen. After the sinking of the Fulda he had suddenly joined the bun sect. Further along the same bench sat the mad boat-builder Markus, with the long silvery beard. He was an enigmatic person, who only occasionally seemed to be deranged; otherwise he saw to his work and was said to be good at it.

Next to Markus sat Kristian the Beachman and his wife and son. Kristian was smiling, as usual; he quietly shook his head, and his great bushy eyebrows moved up and down, as though he was having difficulty in containing some overwhelming joy. The middle benches were occupied by a group of young and not-so-young girls well wrapped up in dark clothes. Black-Betsy, with her severe and wrinkled face, was one of them. The wildest tales had always been told of Betsy; she was said at one time to have been the mistress of a rich man in Copenhagen; she was believed to

be suffering from the most dreadful whore's diseases and had been in prison for a time for murdering a child, but then one day she had done an about turn and gone all religious. At first she had been a member of the Capernaum congregation, but had then followed Simon when he broke away from those more classy sectarians and started on his own.

The back bench was occupied by a group of girls; they were flushed with the heat and dared not look at each other for fear of laughing. It was quite obvious that they had come merely out of curiosity.

Jonas was distributing hymn books, and he looked intently at Magdalena. Quite unwittingly on her part, their eyes met in a manner which could almost be described as flirtatious; she blushed and quickly looked away again. Jonas was employed in Masa Hansen's shop; he had recently joined the baker's sect and undergone a conversion. He was a good-looking man, and his thick full beard went well with his fresh complexion and his kindly, fervent gaze. Magdalena could not help thinking that he bore a striking resemblance to Jesus. His loose-fitting faded raincoat, looking for all the world like some Eastern robe, made the resemblance all the more striking.

Suddenly the entire congregation bent forward as though a gust of wind had passed over them; some knelt between the rows of benches, while others leaned forward and hid their faces in their hands. Liva remained upright, merely bowing her head a little; Magdalena did likewise, bowing her head and folding her hands. She heard the baker pray in a deep, agonising, imploring voice; she could not concentrate on the words; she felt sickened and was much inclined to leave. She thought of Liva's words the previous evening about how terrible it would be to wander about in an eternal night without a lamp, and her thoughts then went to Frederik, who was at that moment sailing without lanterns in the darkness of night ... that thought was almost as terrible. And Oluf who had sailed into everlasting night in just the same way ... ! His poor dead body lay somewhere at the bottom of the sea or on some desolate

shore. Good God, how dreadful to think that he had had no lamp. And then she could not help thinking of Ivar. She regretted not wanting to see his body, but she had not dared; she was so afraid of dead bodies.

Now the baker fell silent; the prayer was ended, and the congregation began to sing:

> Take hold your lamp, oh timid heart,
> It lights the way so clear,
> Bids evil from this world depart,
> For now the night is near.

For now the night is near – those words continued to ring and resound in Magdalena's ears. Beads of cold sweat suddenly appeared on her forehead; she felt she was suffocating, cramped as though shut in a cupboard, and suddenly everything went black; an inky darkness issued from the floor and filled the entire room . . .

"I think I'm going to have to go," she said and pressed Liva's hand. They both got up.

"Let me help you." She heard Jonas's voice close to her ear. She felt herself taken by both arms and allowed herself to be led out into a little side room. It was cool in here and there was a penetrating smell of sourdough. Jonas held a glass of water up to her lips, and she drank greedily.

"Look, lie down here for a while, and you'll feel better," said Jonas. "Wait a second; you can lie on my coat, so you'll not get yourself dirty."

Magdalena soon recovered from her attack, but she was reluctant to go back into the bakery. She lay quiet.

"You just go back to the others, Liva," she said. "I'll be all right."

She could still hear the hymn from inside the bakery.

> It lights the way so clear;
> It lights the way so clear;
> Take hold your lamp, oh timid heart,
> For now the night is near.

184

Before long Jonas returned. She closed her eyes and pretended to be asleep. He gently placed his hand on her bosom and ran his fingers sensitively over both her breasts. She opened her eyes and met his gaze.

"Have faith in Jesus," he said gently.

Embarrassed, she looked away. Jonas filled her glass. As soon as he had disappeared again Magdalena got up and made her way out through a back door. She breathed a sigh of relief when she was once more standing outside in the cold under the clear starry sky.

Thomea was sitting up alone, waiting, when Magdalena arrived home. She was very agitated, and it was obvious she had been weeping. The little kitchen was warm and tidy, and the kettle was singing on the stove.

"I say, Magdalena . . ." said Thomea, getting up.

"Well, what is it?" replied Magdalena rather reluctantly. Humming to herself, she sat down and took off her shoes, and then she yawned: "Oh, I'm dog tired."

"Where's Liva?" asked Thomea. "Haven't you come home together?"

Magdalena shook her head and yawned again.

"I'm so afraid," said Thomea in a hollow voice.

"Then you ought to go and lie down."

"That Mrs. Lundegaard from the hotel has been here," said Thomea.

"Mrs. Lundegaard? What did she want?" Magdalena was suddenly interested.

Thomea sat with her head bowed and stared down at her hands. "She wanted to have a talk to me. She told me that she's going to have a baby with him."

"With Engilbert?" exclaimed Magdalena. "Good heavens."

She got up and went across and laid her hand gently and almost protectively on her sister's back. "So that's the sort he is," she said in a low voice. "Well, I've always thought he was, Thomea. A shifty piece. A real unsavoury type. But it's lucky that you . . ."

Magdalena shook her head. "I mean . . . in a way it's a good job you've found out what he's like, isn't it?"

"She said a lot more," continued Thomea; her voice was still hollow and choking. "She said that he had been . . . destroyed. Yes, that's what she said. Destroyed. She said that I'd destroyed him. She believed I'd cast a *spell* on him. Yes, that's what she said."

The two sisters stared wide-eyed at each other.

"Yes, but what does she mean cast a spell?" said Magdalena.

Involuntarily adopting a lighter tone, she added: "Do you mean to say you can perform magic, Thomea?"

"Do you think I can?" replied Thomea uneasily. She sighed.

"Well, you should know that best yourself, my dear," laughed Magdalena.

Thomea suddenly grasped her hand and squeezed it; then, in a hoarse voice she asked: "What is it to cast a spell, Magdalena? Is it to wish? I wished I could have him. I wished it. And then it happened. Is *that* casting a spell?"

"Rubbish," said Magdalena uncertainly. "As long as you've not been . . . playing around with magic. No, I don't know. I don't know anything about that kind of thing."

She tried to pull her hand away, but Thomea refused to let go. She said in a dull voice: "If I've got such a strange power as Mrs. Lundegaard says . . . and as Engilbert says . . . for he's said it so often. . . But if I've got a power like that . . ."

"Well, what then?" asked Magdalena tensely.

"Then it's something I'm not aware of. It's something about me. Do you think there is that about me, Magdalena?"

Their eyes met again, and they sat staring at each other. Suddenly Thomea's face twisted. She let go her sister's hand and bent forward in a dull, dry sob.

"Thomea," said Magdalena and shook her arm. "Of

course you can't do magic. It's a lot of rubbish. There's no such thing, is there? It's that swine that's made up the story to defend himself now he's got himself into a mess and come unstuck. Yes, anyone can see that, Thomea."

"Yes," sniffed Thomea.

"Yes, of course. And now you'd better drop the subject and think no more about it. Do you hear? Put that great oaf out of your mind, lass. Forget the dreadful man, he's nothing but a snake in the grass."

Thomea sighed again and started sobbing once more. "I don't know whether I can . . ."

"If you can what, Thomea?"

"Forget."

Magdalena leant forward and took her sister's hand. "No, poor you; I understand. He was your first one. And now he's running off like the wretch he is. . . And then he's mean enough to expose you to her scorn and put the entire blame on you. He really ought to have a good hiding, Thomea. Oh, my fingers are itching to . . . to rub his nose in his own dirt. Shall I go down and have a talk to Mrs. Lundegaard?"

Thomea shook her head. She curled up, still sobbing.

"He was here yesterday evening," she whispered in a thick voice. "Yesterday evening, while you were down at the ship with Frederik. He wanted me out in the barn. But I wouldn't. I was mourning Ivar, you know. I was terribly tired. But then he said . . . then he said so many things. He said he was down in the depths . . . down in the depths of the earth, he said. And then he said he wanted to die and be born again like a blind worm, and live like a worm in the darkness. And then, at last, he said: 'Good-bye, Thomea . . . we shall meet again in the darkness . . . for you have sunk as well, and you, too, will die . . . and perhaps we shall meet as two worms in the earth.' Yes, that's what he said."

"He's as mad as a hatter," said Magdalena in an effort to comfort her. "All Icelanders are like that, Thomea. Don't you worry. Forget him; that's all he's worth."

"I don't know," said Thomea. She crumpled up; her eyes became small and blurred, and her lips were half open.

"I wish him dead, now," she said.

"Nonsense," Magdalena tried to make light of it. "I say, Thomea," she added, without looking at her sister. "Don't say anything to Liva about this, understand? We've got enough trouble already, we don't want any more. Here she is. You'd better get to bed, my dear."

Magdalena started humming gently to herself. She went across and took the singing kettle off the hob.

"Oh, so you left, Magdalena?" said Liva.

"Yes, I couldn't stand them. It was horrible."

"That's what I thought too at first," said Liva dully.

"Ugh ... that Jonas," said Magdalena. "Don't you think he's a proper old fraud?"

"Why do you say that? No, I don't think so. You should just hear him speak. No, Magdalena, I think it's just you having nasty thoughts. But I was like that to begin with. I didn't like it at all the first time Simon kissed me."

"Kissed you?" Magdalena turned round with a smile towards her sister. "No, does he really *kiss* you, Liva? Really, on the mouth?"

"No, on my hair," said Liva unconcernedly. "Like a brother kisses a sister. Yes, at first I thought, too, that he was a ... dirty old fraud, as you put it. But that was only because I had the wrong thoughts. Now I know him and I know there's no guile in him whatever, Magdalena. Simon is a man battling for a cause. He suffers a lot, suffers terribly for the sake of Jesus Christ. I love him as a brother no, even more than that .. as ... as Mary of Bethany loved the Saviour and sat at His feet. For he is a true instrument of Jesus, he is a disciple, I *know*, Magdalena. He has helped me through the wickedest and most difficult time in my life. I can never repay him for what he's done for me."

Liva sat down. There was a deep flush on her cheeks. "And in any case, why do you think that about Jonas?" she asked.

"Because he groped me," replied Magdalena flashing a sharp look at her sister. "Is it usual down there . . . for them to paw the women's breasts like that? Is that part of the sacred ritual?"

"It must have been an accident," said Liva in amazement.

"Good heavens above," said Magdalena. "I'm not narrow-minded. Had it been at a dance, for instance, I'd think nothing of it. But *down there*! But admittedly, the filthy brute thought I'd fainted or was asleep and wouldn't notice his filthy paws . . ."

Liva had got up and was wringing her hands. "I'm terribly sorry to hear you say that, Magdalena," she said uneasily. "But I think you're mistaken. We must try to drive out the evil thoughts from our hearts. We must be *cleansed*. Even if it hurts."

Liva's voice sounded firm again. Her eyes turned hard and curiously alien. She added: "Yes, for it hurts to tear yourself away from sin. But if thine eye offend thee, pluck it out. It is better . . . it is better to meet your Saviour without eyes than to go seeing into eternal darkness."

"Liva," said Magdalena. "Don't look at me like that . . . I don't like you when you're like that. I'm afraid of you. You look really wicked and horrible."

She sat down and turned sobbing towards the wall.

"It's no good," said Liva, adding in an invocatory tone: "Pray and pray, Magdalena, until you feel that your prayer has been heard. There is no other way. It's as Simon said this evening: If we live after the flesh we shall die; but if we through the Spirit do mortify the deeds of the body, we shall live . . ." Liva could not get Magdalena's accusation against Jonas out of her mind. She was much inclined to talk to Simon about it in confidence. But in a way it felt like informing on a fellow human being and brother. Jonas had presumably given in to carnal temptation, and he might well have repented of it and prayed to Jesus for forgiveness and strength. She could not help thinking of Simon's words the day after Ivar's funeral: Tear down the

189

webs of Satan and destroy his snares . . . let not this new infernal potion poison our souls. Never as long as she lived would she forget these powerful words and the almost desperate voice in which Simon uttered them. It hurt like a burning fire in her breast to think that he, too, could allow himself to be tempted by the Devil. But he had the strength of faith with which to combat it; he was full of the light of the Word; he had immediately found the healing power and the antidote: See, I give unto you power to tread on serpions and scorpions.

Perhaps God in His mercy would also arm poor Jonas with His Word with which to defend his soul.

The following morning Liva aired these thoughts to Magdalena, but her sister simply shook her head and in general appeared to be trying to avoid her.

"You could come with me down to Simon's this evening," suggested Liva. "And then we could have a talk to him and hear what he thinks."

"I don't think there's anything to discuss," Magdalena tried to put the matter aside. "And incidentally, Thomea's not well today."

Thomea lay buried beneath her eiderdown, and the black, tousled top of her head was all that could be seen of her. She had shut herself entirely off from the world and would neither eat nor say anything. Old Elias, too, stayed in bed that day; he looked still weaker and more sallow than usual and had difficulty in speaking. Liva sat down on the edge of his alcove and read a piece of the Letter to the Galatians. She read in a loud voice so that the words could also reach Thomea and Magdalena out in the kitchen.

Liva became noticeably agitated, and her voice trembled when she reached the words: This I say then, Walk in the Spirit, and ye shall not fulfil the lust of the flesh. For the flesh lusteth against the Spirit, and the Spirit against the flesh; and these are contrary the one to the other: so that ye cannot do the things that ye would.

She paused in her reading and was lost in thought for a moment. She couldn't really understand the meaning of

the words: "so that ye cannot do the things that ye would." But then the explanation came: "And they that are Christ's have crucified the flesh with the affections and lusts".

Magdalena appeared in the doorway.

"Couldn't you lower your voice a little, Liva, when Thomea's not well," she whispered.

"Yes, of course," replied Liva and was again lost in thought. She felt tired and ill at ease. She could not pull herself together, and merely sat looking at the black letters. Could it really be thought that Jonas was not one of God's children, but the unscrupulous instrument of the Devil? If only she could get an answer to that question so that the air could be cleared again.

The answer came that evening. It was unexpected and shocking.

Benedikt had used as his text the parable of the barren fig tree. It was not a rousing address, and neither was it followed by any acts of witness. Nor was there any life in the hymn-singing. Contrary to habit, Simon sat idly, with his head bowed, occasionally stroking his forehead as though deep in burdensome thought, then sitting up and looking at the congregation. Nothing more came of it, and it looked as though it was a meeting without power or fire.

It was not until after the final hymn that Simon got up. His weary eyes sought a specific spot in the room, and he spoke in a mournful voice: "Yes, it is *you*, Jonas, it is you to whom I'm about to speak now, while we are all gathered together. It has pained me to hear of your wicked actions and your betrayal of us who trusted you. For not only have you sinned in the body . . . if only that were all! But you have committed the deadly sin of offending . . . not only *one* of these little ones, as the Saviour says, but *four* . . . aye, perhaps more, but we know of four with certainty. Three girls and a married woman. Two of them have returned to us after I talked to them and prayed together with them. But the other two will not return. You have poisoned their souls, Jonas. And you have

poisoned our work to spread knowledge of the Kingdom of God now in the eleventh hour. Because of you many will turn their backs on us together with these two souls who are now so obdurate; indeed, not only will they turn from us, but they will turn from Jesus Christ and the living Word of God. No, you shall not flee! Stop him, Benedikt; he mustn't be allowed to go. Stop him."

Jonas had made for the door, but Benedikt had taken up a position there together with Morten the shoemaker. Jonas was very pale; a confused smile trembled in his youthful apostle's beard; those closest to him drew back as though from someone infected with illness. Finally, he was left standing quite alone.

Simon took out a pocket handkerchief and, with a sigh, wiped his brow. He looked terribly weary, almost exhausted. There was a pause. Then, in a strained voice he continued: "Now I must ask you, Jonas, what you have to say in your defence. I am deeply distressed. And I have felt uncertain and perplexed. But now I know that I am doing Jesus's will . . . in the name of our almighty Lord and Master."

Jonas stood staring at his feet. Not a sound passed his lips. His hands were trembling violently. Liva turned away; she, too, had begun to tremble. All the congregation was trembling, as though in expectation of something horrifying.

"You . . . you're a filthy old swine yourself," Jonas suddenly burst out. "That's what I've got to say. And now let me get out of here. Right?"

Then he turned threateningly to Morten the shoemaker. "And as for you . . . what are you? A disgusting old beast, a malicious devil . . . you've been in prison for beating your wife. What have you got to say to that? Let me go, you swine, or I'll have the police on to you. We'll get to the bottom of this mess, I'll see to that. A crowd of bloody fools that you are. A randy crew, the whole lot of you . . . You think of nothing but getting your paws on each other. . .!"

192

Jonas's face had become totally contorted; wicked and offensive words poured from his lips; his language became more and more vulgar and profane; it was clear he had entirely lost control of himself. But not a voice was raised in protest. Simon sat in silence. Morten and Benedikt stood speechless and upright at their post by the door. All eyes were turned towards Jonas in silent horror, no one spoke against him; he was allowed to go on to the bitter end; his expressions became more and more provocative and coarse, more and more ridiculous; finally, there was nothing but explicit words for parts of the human body.

And suddenly the obscene torrent of words ceased. He looked around, his eyes rolling, and exploded in a short, ghastly, impotent laugh that ended in a long drawn out howl like that of a dog. Then he crouched down as though about to jump. But no leap came; he merely remained crouching down on the circular area that had been cleared around him, pulling the most astonishing faces in every direction. It was dreadful to behold; several of the women were battling with tears, and Tørnkrona, the tailor, hissed in a low voice: "It's awful. It's awful. He's got the Devil."

And without getting up from his crouching position, Jonas slowly turned towards the tailor, stretched out two claw-like hands towards him and hissed back: "Yes, I have Satan. See. See. I have Satan. I'm his emissary Beelzebub. I am come to sow my evil seed among you. I shall destroy you. I shall bring the darkness of Hell upon you. . . I shall . . ."

He flung open his coat and clutched at his groin.

"*Selah!*", Benedikt suddenly shouted in a loud voice, and from up where Simon was sitting came the reply: "*Selah!*" And *Selah!* the shout came also from Selimsson, the photographer, and the greying little book-keeper Lydersen sprang up on to his bench with unexpected agility and raised his arms towards the ceiling, shouting: *Selah!*

*Selah! Selah!* The room was filled with the sound, like a choir singing in unison. Liva was carried away by the

193

strange movement and added her voice to the others: *Selah! Selah!*

And then the inevitable happened. Jonas fell to the ground, as though struck by one of the many vocal arrows. He remained there, prostrate. A few convulsions ran through him; his buttocks rose and fell as he appeared to be seeking a comfortable position. His bizarre movements could not fail to remind the onlookers of an act of copulation. The shouts died down, and there was a deathly silence again, and now the fallen man, too, was quiet; his head slumped heavily forward, and his forehead struck the floor with an audible thud.

"Oh, he's dead," wailed Tørnkrona. "You die from that sort of thing."

In the ensuing breathless pause Simon began to pray, in an earnest, low voice. He prayed in gentle tones for Jonas's soul; in a humble voice he implored God to free this soul that Satan had so clearly overpowered and drawn to himself. Let Thy healing light shine upon it, and cleanse it by Thy almighty power," he prayed. "And forgive us our trespasses, as we forgive them that trespass against us. And lead us not into temptation, but deliver us from evil . . ."

When the prayer was ended, something again happened to make all faces set in speechless amazement . . . Jonas . . . Jonas slowly got up. He was grey and pale like the flour-covered floor of the bakery, and there were dark red spots of blood in his nostrils. Staggering and with trembling arms outstretched he approached Simon and knelt before him.

"Forgive me. Forgive me," he whispered, exhausted.

It was some time before Simon answered him. He stood there with his eyes closed and his hands folded. The movements visible in his face showed that he was consulting his conscience and God.

Finally, he replied in a deep and joyous voice: *Selah!*

*Selah!* replied Benedikt. *Selah! Selah!* – the words bubbled gently through the room, amazed, freed, redeemed. And the bubbling thickened of its own accord into a loud, resounding hymn:

Take hold your lamp, oh timid heart,
It lights the way so clear,
Bids evil from this world depart,
For now the night is near.

# 2

Liva was sitting on the deck of the little steamer the Kittiwake, which was chugging its way northwards through the foggy autumn morning. There were only a few passengers on board, and she was the only woman. She was up near the cargo hatch, wrapped in a thick, black blanket and resting her back against the warm funnel casing. It was Kristian the Beachman, the skipper, who had suggested this place to her and given her a bale of cotton waste to sit on. Her travelling-rug had been a gift from Opperman; he had sent it aboard to her at the last moment together with a box of sweets and a little card bearing the words: "Happy journey. Loving wishes. M. W. O."

Liva felt some relief at having got away and put the Cauldron at a distance. She was glad she had stuck to her decision, although a lot of people had tried to dissuade her on account of the dangers arising from the war. Only last week the little steamer that usually plied this route across the open sea had been attacked from the air; it had been strafed with a machine gun and had only reached port with difficulty. But after receiving Johan's last letter she had felt it was important she should visit him and talk things over with him.

The long letter she had sent to Johan immediately after Ivar's funeral had upset him. Perhaps it had been unwise of her to try to put him in the picture concerning all this trouble with Opperman and his wife. In any case, she must have expressed herself in an unfortunate way. But now, once she herself had had a talk with Johan things would presumably iron themselves out.

Liva enjoyed inhaling the fresh sea air and for a moment she felt as though outside time and back in her childhood. Occasionally you could be relieved of all worries and concerns and merely feel you were alive ... simply feel your own body, be aware of your pulse beating, of your

hair feeling cold or cool on your head . . . for a moment you could enjoy pressing your hands together and curling your toes up tight against the soles of your shoes, filling your lungs with air, yawning, as though there were nothing else but the very fact of your existence. She surrendered to this desire for reflective contentment, snuggled down in her blanket, and could not help smiling at the sudden confusion when she left this morning.

Magdalena had gone aboard with her, but then Simon the baker had turned up as well, and Magdalena had left without saying good-bye. And just as she was taking leave of Simon, Opperman's little parcel had been handed over the railings by his new errand-boy, Frits . . . Simon himself had fetched it and passed it to her without any idea of where it came from or what it contained.

And then the boat chugged out of the narrow fjord, and the houses and streets of the village slowly slipped by . . . and up on the hill in front of Masa Hansen's shop Magdalena stood waving her handkerchief . . . and there was someone else waving, too: Opperman. He was up on his roof terrace dipping his flag. Oh, it was just like him, the silly little man. And yet, you couldn't really be angry with him; he was too childish and ridiculous for that.

And then the village had disappeared in the smoke and mist of the distance and no longer seemed real; the long fjord rolled up and became invisible, and in time the coastal mountains also melted into the blue distance, and there was nothing but the chugging of the boat and the desolate ocean.

Liva amused herself by imagining that she hadn't really left, but was still going about in the now vanished village, while the girl sitting here and keeping warm in the new travelling rug was someone quite different . . . a good friend, for instance. And then, for that matter, we could pretend that it's a quite different time, she thought. Let's pretend it's three years ago. And there is Liva, and it's Sunday evening, and she is wearing her new maroon coat, looking forward to the dance that evening . . . yes, just

imagine, not the least bit bothered. And of course, what happens, but that she meets a good-looking, sturdy young man, a newly-returned mate with a weatherbeaten and perhaps rather self-assured face beneath his cap. He is together with his sister, the telephone operator, and his younger brother, who is a hunchback; Liva used to go to school with this brother, and knows him well.

"Hallo, Liva," he shouts gaily. And: "Hallo, Liva," shouts the mate. "My word, you're a big girl now and . . ." Here he used a word she didn't know: cheek or chick or something like that.

Aye, what an evening it had been. It was in March, just after sunset. A few long clouds as fine as cotton threads were visible in the cold sky . . . Who could ever forget them? Jens Ferdinand suggested that Liva should go home with them and have a cup of coffee. She felt very shy in front of the big, self-confident Johan, but filled with a kind of sweet unease. He was handsome and fun-loving and amusing; he poured out some genuine Portuguese port wine and passed round cigarettes in a silver case. There was an air of foreign ports and lands about him. He used his cigarette lighter to light the lamp. She could remember his great flickering shadow on the wall and the tattoo on his hand. What a brown and strong and safe hand it was. What a happy evening it had been. And the following days and nights. Yes, this was happiness, earthly happiness, a poor, temporal and ephemeral happiness of the kind that doesn't last, but is treacherous like quicksand . . .

Liva stared out across the grey ocean and far out to the east saw a silver streak playing on it and reflecting the sun. This was Johan's sea. What a fate for a man like him to be in a stuffy hospital ward and wait. Wait for what. For death, presumably.

Death. That little word was sharp like a splinter of glass on the tongue, but it couldn't be spat out, and neither could it be swallowed. It was simply *there*. It hurt. Nevertheless, deep down you knew better. Christ was stronger than death; He had triumphed over it and trodden it underfoot.

Earthly life was full of everlasting misunderstandings, of sin and disappointment and affliction, but life with God was pure and unsullied and lasted to all eternity. There, death had lost its sting; there, souls were united in joy and peace and praise.

Liva felt the cold air against her face and the pricking heat in her back. The sky had begun to turn a greyish red in the east, and the gulls following the boat suddenly had wings of violet. The sea, too, had turned to a downy gentle lilac shade. For a moment Liva felt thrilled with the deep, inexpressible happiness of a believer, that happiness that transcends both joy and sorrow. And deep down in her heart she felt a humble gratitude towards Simon, whose preaching had awakened her to spiritual life and in such a wondrous way given a meaning to her life, indeed to her life and her death. She felt bound to this strong man with the unbreakable bonds of the spirit. She felt proud to have been permitted to fight at his side for the Kingdom of God. At first she had been afraid of him and believed him to be hard and implacable. But it was as though she knew and understood him better after that day when she had met him on the road after the funeral and discovered that he, too, could have his moments of weakness and despondency, when it takes enormous strength of character to overcome doubt and sin and enable you to control all the wickedness within you.

Johan was up. He was sitting fully dressed in a deck chair in the corner of a small veranda, and in front of him stood an elderly nursing sister, excitedly gesticulating with her hands. Johan's cheeks and forehead were a hectic red. He was in his Sunday best and smelt of soap and brilliantine. The nurse directed an offended look at Liva and tossed her head as she withdrew. Liva guessed that it was without this nurse's approval, perhaps even without her knowledge, that Johan had got up. They were not alone. In the other corner of the veranda there was an elderly man with a dry, parchment-like face, looking around with a ferocious stare.

Johan got up and took Liva's hand. "Thank you for coming," he said. "I was worried in case anything should happen to you on the way. Did you have a good journey?"

"Yes, lovely," said Liva.

Johan bent down and started adjusting the chair. "I want the back up a bit more," he said. "Otherwise I shall almost be lying down. It's such a stupid chair. . ."

"Let me help you," said Liva. "Look, like this. Now you can sit up."

The unknown man in the corner made a sound as though he were battling against an outburst of laughter. Liva looked at him nervously, but he was sitting as before, staring ahead with piercing, protruding eyes.

"You needn't bother about him," said Johan without lowering his voice. "He always sits like that. He's not right in the head. He's old and deaf."

He spoke in a strangely monotonous tone, in short bursts. "Thank you for coming," he said again without looking her in the eye.

She moved closer and took his hand. "Dearest," she said, trying to catch his eye. "Of course, I had to come . . . so that you can see for yourself that . . ."

She shook her head with a little smile. That ridiculous affair with Opperman seemed so distant and irrelevant now. It was hardly worth wasting words on.

Johan looked away and nodded and closed his eyes. His hands were cold and damp, and under his thick mop of hair his temples were beaded with sweat.

"You don't doubt me, do you?" asked Liva, holding his hand tight.

Johan answered slowly and without opening his eyes: "I've thought so much about you, Liva, and about us two. Aye, I've not thought of anything else, day and night."

The old man in the corner was subjected to a fresh attack of laughter. Liva started involuntarily. "Johan," she whispered quickly. "Why don't you look at me?"

Johan opened his eyes, but he still avoided her gaze.

"Aren't you going to ask how I am, Liva?" he said in a low voice. "I'm a bit better. The doctor thinks I'll soon be well enough to manage that operation. And if I get over *that*, then ... ! You know, there are quite a few who've made a good recovery after that operation. And I've got faith in it, Liva. I think ... in fact I feel quite sure I'm going to get well again."

He quickly added: "You understand ... I'm saying all this to you because it's so important. I mean, it's important whether I get well again or not, isn't it? For it's not fair that you should go and wait for me if it's all going to go wrong ... I wouldn't ask that of you, Liva. You mustn't go and wait for a hopeless case."

He straightened himself up, cleared his voice rather loudly and suddenly looked her in the eye: "I'm alive, you see. I'm going to get better. I'm going to come back. You shan't regret waiting for me, Liva."

There was something threatening about Johan's voice, and there was a hard look in his eyes. The confused old man was laughing and carrying on over in his corner. Liva felt bewildered. "Johan," she said reproachfully. Johan's eyes became all the more penetrating and relentless; she couldn't stand it, and looked down.

"What are you frightened of, Liva?" he asked in a low tone, holding her hand tight.

"You don't believe me," she said in a hollow voice. "You believe that ridiculous gossip."

She bent her head and suppressed a sob. He got up with some difficulty and knelt before her chair, took both her hands and said hoarsely: "I believe in you, Liva. Do you hear? I've *got* to believe in you. And in myself, too. For otherwise it would all be hopeless. You know what it means to me to have you. It means *everything* to me."

In the recreation room behind the veranda someone was playing a harmonium. The old man got up and went in. Liva felt relieved when the strange deranged being disappeared. She leant right down and pressed her cheek against Johan's.

201

"My own dear," she said, trying to make her voice sound as unconcerned as possible. "You have no need whatever to worry. Look at me. Yes, believe me, I *can't be bothered* defending myself. I have been faithful to you throughout, and I shall go on being faithful whatever happens. Nothing can shake me, Johan. Nothing, nothing shall ever separate us. Not even death."

She took his head between her hands and in a firm voice said: "We shall go on living in Jesus Christ. Shan't we?"

Johan made no reply. Their eyes met. He was clearly affected by her words. Liva was quite composed now, and she felt that Johan, too, had begun to calm down. He sat back in his chair.

"You must forgive me for getting so worked up," he said. "But just imagine what it is like to lie here, alone, and know that you are over there at home, completely unprotected, as it were. Or at any rate: *I* can't do anything to look after you. And of course there are lots of temptations, Liva, when you're young and as good looking as you are; of course there are, and it's almost asking too much of you to . . ."

"There are no temptations for me," said Liva, getting up.

The nurse put her head round the door at this point. "Johan Hermansen. The doctor's here, and he's very angry with you for getting up."

Now the doctor's voice made itself heard, too. He appeared in the doorway: "Yes, Johan Hermansen, what's going on . . .? Oh, you've got a visitor. Yes, I see, but it's no use if you won't keep to the rules . . . especially now you're beginning . . . to make a bit of progress. We'll have to be very careful that you don't have a relapse, shan't we?"

The doctor gave Liva a disapproving look over his glasses. The nurse came and made to assist Johan up from his chair, but he got up without her help and turned towards Liva. He was very pale, and the whites of his eyes were extremely bloodshot. They exchanged looks and he held her close for a brief moment.

"I'll come again tomorrow during visiting hours," she said.

The doctor turned towards Liva. "Are you his sister, perhaps?"

"No, his fiancée."

The doctor nodded. "Oh, his fiancée. I see."

"What do you think, doctor . . . ?" Liva's voice was quite hoarse, and she could not get the rest of the sentence out.

The doctor beckoned her further into the veranda. He drew his breath a couple of times before answering. "Hm, well . . . well, your fiancé's really doing quite reasonably. Admittedly, both his lungs are affected, but I think we can save one of them. We're going to make an attempt now to stop the disease spreading . . . Do you understand? That's what this plastic operation, as it is called, aims to do. We're doing all we can. The most important thing is to keep his spirits up."

The doctor looked enquiringly at Liva: "Your fiancé's far too impatient. I think he lies there reflecting far too much. Doesn't he? He's losing his appetite with all this thinking. He's tormenting himself with something or other. We'll have to see what we can do to stop him. Don't you agree? Incidentally, have you had a tuberculin test? Oh, you're negative. Then in that case you must take care not to become infected. Your fiancé's very infectious at the moment."

The doctor was busy and had to get on. "We'll see; we'll see," he said in conclusion.

Liva spent a restless night in an overfull hostel down by the harbour. She slept on a sofa in the dining room and even had to be grateful for having a roof over her head at a time when accommodation was so short.

She got up early the next morning, had a light breakfast and walked about aimlessly in the misty streets where soldiers were marching and military trucks were driving past as they did at home. Strange to be walking about here where she didn't know a living soul. All the young women

were wearing coloured scarfs; that was obviously the fashion here.

Liva followed the road out along the shore until she could see the grey buildings of the sanatorium where Johan lay. There was a row of gulls perched on the roof. A flock of eider ducks was rocking on the sleepy waters. Liva went down to the shore and sat on a projecting rock right down by the water's edge. A girl emerged from the kitchen door of the sanatorium; she was carrying a bowl and set about feeding the hens. The gulls flew up from the roof and started circling and screeching noisily above the henhouse.

A slight drizzle began to fall. She got up and strolled back to the town, which lay engulfed in a grey mist, part drizzle, part smoke from the chimneys. The narrow, muddy streets were thronged with helmeted soldiers, some carrying gas masks, and camouflaged military vehicles.

Liva felt inordinately tired, and longed to get some sleep. It was only ten o'clock, so it was another five hours to visiting time. It began to rain heavily. She went back to the overcrowded hostel and found an unoccupied seat in a corner of the dining room. Here, surrounded by sailors drinking beer, she sat and fought with sleep. The odd meaningless word and sentence rang in her ears; for a moment she dreamt that she was sitting out in the sanatorium veranda waiting for Johan; she was staring at the bare, faded walls and the window ledges devoid of flowers and heard the old man sniggering and playing the fool. But now Johan appeared, sunburnt and ready to leave, and carrying a shiny-peaked mate's cap. "Right, we're off," he said gaily, taking her arm, and she got up with a cry of delight.

Liva awoke with a start. She felt a hand on her shoulder. It was one of the waitresses, a very young, thin girl.

"You can't sleep here," she said. "Come with me; I'll find you somewhere better."

She led Liva into a tiny dark room beside the kitchen. "Look, lie down on this bed for a while, it's mine."

"Thank you so much," said Liva. Fully dressed, she lay down on the bed and immediately fell asleep.

Liva awoke with a start; she had again been dreaming that she was waiting for Johan, but instead of her fiancé it was Opperman who appeared; he wrapped her tenderly in the black travelling rug and said: "Wait, wait, always wait."

She sprang out of bed. The little room was almost pitch dark, and the air was thick with the smell of food from the kitchen. The sound of Opperman's words was still ringing in her ears: wait, wait. It was just turned two o'clock. Thank God she had not missed visiting time... What would Johan have thought then?

The kind maid brought Liva a bowl of water and a towel so that she could wipe the sleep from her eyes. "I can get you a place to sleep tonight," she said. "It's right up under the eaves. But it's all right. I sleep up there myself sometimes. What are you here for, by the way? Have you come looking for a job?"

Liva explained her errand to her while she was doing her hair in front of a broken mirror. "Good Lord," said the other girl, clicking her tongue in sympathy. "If he's out there he must be really ill."

"He is really ill," confirmed Liva. "Heavens, but I do look bleary-eyed, and my hair's all in a mess."

"I'll give you a cup of strong coffee," said the girl. "There's time for that; it'll buck you up."

Liva gratefully swallowed the scalding drink. It tasted spicy and strong and brought a hectic glow to her cheeks.

"Ask for me when you come back," said the girl. "I'm called Martha."

"Thank you so much, Martha."

Liva hurried off. It was no longer raining. There was a rainbow hue over the long glittering road. The drone of bagpipes could be heard from a cluster of army huts up in the wet fields. Out on the point where the hospital lay the sun was shining, reflecting in the panes of the veranda. The nursing sister from yesterday was near the entrance, talking to a very pale elderly woman dressed in black. She was standing with her hand on the door handle. Liva heard her say: "But it's lovely to think that he's gone to join his

sisters who have gone before him. Just think about it like that, Mrs. Olsen." The old woman made no reply, but her upper lip trembled a little as she stared ahead through glazed eyes.

The nurse nodded to Liva as she recognised her. "Oh yes, you're Johan Hermansen's fiancée," she said in a kindly voice. "I've got a message for you from him. Do come inside. No, don't worry; there's nothing wrong. It's only . . . a letter."

She disappeared for a moment and came back with a letter. Liva opened the envelope. "My own darling," it said. "I've decided to ask you not to visit me today. I'm so happy that I saw you yesterday. I'm quite calm and confident, for I know that you are the same as always. Just have a little patience with me, just a little longer, and then everything will surely be all right. You must not be angry with me for asking you not to visit me; it's for your own sake. I don't want you to be exposed to infection here in the ward, where there are several very infectious patients. That's why I wanted to see you yesterday out there where we were. It was lovely to see you and talk to you; I can live on that for a long time. Otherwise, we can write to each other as usual. Your devoted Johan."

Liva folded the letter; the nurse gave her a searching look and took her hand. "Your fiancé is a splendid chap," she said.

She turned around to receive a new visitor; her eyes lit up in delight: "Oh, good afternoon, pastor. How nice to see you."

The pastor, a pasty man with watery brown eyes, was carrying a large bunch of flowers giving off a soothing perfume which for a moment dissipated the insipid smell of carbolic in the room. Liva was still holding the folded letter in her hand; she stood for a moment lost in thought. Flowers, she thought, of course, she would buy a big bunch of fresh flowers for Johan.

There was nothing but vegetables and potted plants to be bought in the flower shops. But Martha, the maid at the

hotel, was able to suggest a way out. She knew a lad who worked for a market gardener; all she had to do was ring him and arrange things. Liva was presented with a big bunch of flowers free of charge; indeed, the young man himself offered to take them out to the hospital. Liva fixed a little note to the bouquet. She wanted to give the helpful lad a tip, but Martha nudged her: "Don't be silly; it's good for him to use his legs." The lad looked admiringly at Martha and gave her a knowing wink.

"Is he your brother, perhaps?" asked Liva.

"No, only a young lad who goes errands for me on his bicycle," laughed Martha. She took Liva up a narrow, winding staircase. At the top there was a ladder leading up to a trapdoor in the ceiling. Martha opened the trapdoor, and they came up into a very low but light attic room. Tucked away under one of the sloping walls there was a worn mattress of seaweed, and on a tin over by the window there was an empty bottle and two dusty glasses.

"There, it's all quiet and cosy up here," said Martha. "So now you know the way. Come on downstairs now and have a bite of something. You look pretty hungry and worn out. Are things not so good with that darling boy of yours? Good Lord, you do love him, don't you?"

Martha stared at Liva, shaking her head and clearly full of sympathy. "Is he your first one? Really the only one? But what if he pops his clogs, Liva, eh? Are you simply going to be a widow dressed in black, or what? Oh, God help me, now she's blubbering. . ."

"Rubbish, I'm not blubbering."

"Yes, you are." Martha whimpered piteously and took Liva's hand. "You look just like one of those women in the films, you know, one of those that are really in love," she said tenderly. "Yes, you do, Liva. If only I'd been as good-looking as you, I'd have gone into films."

Martha yawned and patted her lips: "Well, come on and have something to eat."

Liva was not hungry.

"No, because you look as though you've been crying

your eyes out," said Martha. "But I'll bring you a cup of coffee and a piece of cake up here."

In a trice she had gone through the trapdoor and ran whistling down the stairs.

Liva went to bed early in her little attic room. She read Johan's letter again, and then she put it in her bosom and extinguished the smoking candle. In the ensuing darkness she surrendered herself to her tears. She wept and prayed until overcome by weariness and sleep. The darkness was filled with tiny flickers of light and with voices and dull sounds from the noisy building. But now there was the creaking of footsteps on the stairs, and someone pushed open the trapdoor in the floor.

"It's only me," said Martha. "Are you asleep, Liva? Could I come in to you for a while? I'm afraid there are some horrible men down in my room. They're blind drunk, and I'm sick of them . . . ugh! Now, let's light the candle; I've got a bottle of liqueur with me; you shall have a taste."

Martha poured out the thick green liquid in the dusty glasses and clicked her tongue in anticipation. "Now, that's something worth having, Liva . . . good stuff, eh? I got that bottle from an English officer I've had. I can have anything I want, you know; it's easy if you're smart. I'm only seventeen . . . but do you know how many boyfriends I've had? Thirteen!"

Martha lit a cigarette and sat down on the floor with her back to the gable end. She rocked the glass on the flat palm of her hand and whistled through her teeth.

"But I didn't give a damn for any of them," she added, curling out her lower lip. "I'd far rather have had just one like you. A real film hero like yours. It wouldn't matter if he drowned or was hopelessly ill, I'd send him flowers like you. And if he died I'd go dressed in mourning, and that would be that. I'd like that. You know, really dressed in black, in a close-fitting long dress and with a black veil and a silver cross. Cheers, Liva. Yes, I mean it; I mean every

word of it. Why should life be so soggy? I approve of elegant young widows walking behind their husbands' white coffins. That's a bit different from empty-headed girls having it off with drunken sailors and then grabbing their money, isn't it? That's no way, really, is it? No, now listen, Liva."

Martha suddenly burst into song; her voice was husky and drawling. It was a melancholy song about a drowned sailor's fiancée throwing three red roses out on to the river as it flowed to the sea:

> Three roses here I bring for you,
> A rose for each bright year
> We danced and played, were lovers true,
> Lived life with ne'er a tear.

> For three short years, a span too brief,
> This life did smile benign.
> Now fades my youthful hair with grief,
> For all this love of mine

Martha stared at the candle as she sang. Her cheeks became wet with big, shining tears. Liva looked at her open-mouthed; the words of the song reverberated within her, heavy and bitter:

> Aye, take the roses, one by one,
> And see them slowly pale.
> Although your mortal course is run,
> Our love shall never fail.

# 3

Liva was very reluctant indeed to go home as matters stood. At the very least she would have to see Johan once more before leaving; she must talk to him, hear his voice and see that he was really still alive.

She resolved at least to stay for the rest of the week and see how things went. Then, at any rate, she would be in the same town as Johan and every day she could get to know how he was.

Martha fetched a chair and a tiny rickety table up to the attic for her, and here Liva could sit undisturbed and write letters to her fiancé. She got up early, bought pen and ink and some blotting paper, a packet of envelopes and a writing pad, and she spent the entire forenoon thinking and writing. In the early afternoon she went out to the hospital to deliver the letter. As usual, there were a great many visitors; the nurse was nowhere to be seen, but there was a young orderly who took the fat letter off her and promised to pass it on.

"You couldn't just find out for me how he is today?" asked Liva. "I'll wait here at the door meanwhile."

"Just a moment," said the girl and disappeared with the letter.

Through the panes in the door leading into the day room, Liva could see into the veranda where she had sat together with Johan. There was another couple there now, a young woman having a visit from her fiancé, or her husband, or brother. There were other patients and visitors in the day room, too, and over in a corner sat the mad old man, staring wildly in the air.

Now the orderly returned, but she hurried past Liva without as much as looking at her; she seemed to be in a great hurry and must have forgotten her promise. Liva remained where she was, for she did not want to go before hearing how Johan was, and she prepared herself for a wait. She had plenty of time.

But then the nursing sister appeared at the back of the day room, with the letter in her hand. Liva recognised the big, grey envelope and for a moment she ran cold with terror . . . Why was the letter being returned to her? Why had it not been given to Johan?

The nurse took Liva by the arm and led her into a small side room; its walls were covered with a host of photographs, and there was a sharp smell of acacia leaves.

"Do sit down here a moment," said the nurse in a kind voice, pressing Liva down into a small sofa.

"Is he . . . dead?" asked Liva, suddenly feeling icily cold and calm.

The nurse nodded without making any reply. She took her time; it was a while before she said anything. She sat upright on the edge of a chair, her head bent and her hands folded.

"Yes, it's hard," she said finally. "But perhaps you didn't entertain much hope yourself? No, it was obvious to us that it was only a question of time. But then it happened far more quickly than we had imagined. We had thought he would keep going for a few months yet. He was so happy and cheerful after your visit, and yesterday evening his temperature was almost normal. But then early this morning he had a minor haemorrhage, and that finished him . . . he hadn't the strength to get over it."

There was a knock at the door; a nurse entered cautiously.

"Sister Elisabeth," she said in a low voice. "I'm sorry to disturb you, but the doctor wants you."

The sister got up; she laid a hand on Liva's shoulder. "Won't you wait here for a while; I'll be back. Would you like a glass of water? Just a moment . . ."

Liva sat there calmly. She could still not gather her thoughts and realise fully what had happened. She glimpsed the chicken run from the window. The hens were moving about restlessly; one of them, without feathers on its neck and much of its breast, looked for all the world like an elderly lady who had dolled herself up, and for a moment

Liva saw all the hens as having human faces, tiny, worn everyday faces; they were putting their heads together and talking to each other in women's voices: "Oh, so he's dead. Really? When? This morning? Did he die peacefully? Did he scream for help? For heaven's sake, say something." What an idea. But that was their affair.

The orderly she had seen first now came with a glass of water. Liva left it untouched; she was not thirsty; she was scarcely affected, simply cold and out of sorts. She started examining the photographs hanging on the wall and above Sister Elisabeth's bed . . . unknown, smiling faces. People always smiled in photographs, or at least they always looked relaxed and friendly. They didn't allow themselves to be photographed when they were upset or in distress. It would soon be a pretty miserable collection if they did.

The wall above Sister Elisabeth's bed-head was in shadow; there was a crucifix fixed to it, a yellowing ivory Saviour on a black cross. For a moment Liva fancied the tiny figure wriggled in the gloom, as though trying to alter position, and suddenly she was overcome by a powerful sense of compassion with the martyred and helpless man on the cross. She had seen crucifixes and pictures of the crucifixion many times before without feeling more than solemnity and devotion, but this time the sight gave rise to a sudden overwhelming sense of compassion with the lonely young man, the Son of Man, Who in His torment and fear had felt Himself deserted by everyone, even by God.

But now Sister Elisabeth came back; she was a little out of breath and had obviously been very busy. "Pastor Simmelhag sends his regards," she said. "He would have liked a word with you, but unfortunately he hadn't time; he had to go to an important meeting. But I told him, of course, how lonely you are here and that you are living at Hansen's Hotel . . . we agreed that it wasn't a proper place for you, and that you could easily have a bed up in the YWCA if you would like."

"No, thank you so much," said Liva. "I'm quite all right where I am now. You see, I have a good friend there, so if you don't think me impolite . . ."

"As you like," said Sister Elisabeth. "That's up to you. Do you perhaps belong to the Brethren?"

"No," said Liva. "I'm not a member of the Plymouth Brethren."

The sister looked at her wristwatch and held out her hand. "Now, it's almost four o'clock. Could you manage to come back about seven o'clock, over in the chapel? Or would you perhaps rather wait until tomorrow? You must do what suits you best. We would like to help you as far as we can."

"Thank you," said Liva. "Then I'll come back at seven o'clock."

Liva managed to steal unnoticed up to her attic. She did not want to tell the maid what had happened until later. She wanted to be quite alone at Johan's coffin.

As usual, the big wooden building was humming and throbbing with voices, the scraping of chairs, the clinking of glasses and plates. There was also some subdued singing and muffled dance steps could be heard from some distant room. Liva did not put on the light; she sat on the chair and gave in to staring at the gable window's bluish square with its black cross. She felt full of contempt for the unattractive, noisy world with its sin and filth, its misfortune and death. Indeed, it was time for the hour of redemption to strike, so that the poor, misled people of the world would finally be able to see how pointless and reprehensible it was to kick against the pricks.

Liva struck a match to see what time it was. Only half past four. She put on the light. The air was raw, and her breath rose like a blue shadow. She knelt down by her chair and folded her hands. But now there was the sound of creaking footsteps on the stairs. She quickly got up; Martha's head appeared through the trapdoor.

"When did you get back, Liva?" she asked. "Why

didn't you come and tell me that he was . . . was . . . dead? I happened to hear it from an orderly I know."

Martha took Liva's hand and looked earnestly at her. "Is it very bad, Liva?" she asked. "Is it really dreadful? Are you afraid of dead bodies? I'm not at all afraid, and I don't believe in ghosts, either."

"Martha," said Liva suddenly. "You must come to Jesus. Do you hear? You must learn to love and fear Him."

Martha gave her a surprised and distrustful look. "Now, stop it," she said, raising a deprecating hand. "You're talking like one of the Brethren. I'd no idea you were like that."

But suddenly she stepped across and embraced Liva, took her hand and pressed it to her cheek. "No, I oughtn't to be so unkind to you, Liva. Are you terribly angry with me? But I didn't know you were all religious, did I? I thought you were just ordinary. Can you forgive me, Liva? Yes, you can, for you're good. And what about me? Ugh, a dreadful harpy. I can't understand how you can put up with me. Tell me off, Liva, and tell me that I'm going to go to . . . *Hell*. Because I am."

Martha suddenly burst into tears. She drew Liva across to the mattress, forced her to sit down and pressed her head against her arm, tugged at her and sobbed: "Then show me the way to Jesus, Liva. Ask Him to come to me. I'll lie down here now; and you go over to the light and pray for me. Do you hear?"

Martha threw herself down on the mattress and buried her face in her arms. Liva began to pray. The prayer was long and urgent, and it made her feel at once calm and very strong.

Martha had sat up and was sitting staring at her.

"Is Jesus your bridegroom?" she asked in wonderment. "You talked of wearing your bridal dress."

"Yes, my wedding dress," said Liva.

"But wouldn't you really rather have your wedding with your fiancé when you meet again? Or . . . no, of course, you'd rather have Jesus Himself. But . . . perhaps

214

I'm just talking nonsense, Liva, but I just mean: what about your fiancé?"

"Yes, now you are talking dreadful nonsense," said Liva. "For of course no one can be married to Jesus; surely you must understand that. It's just the joy at meeting Him and living with Him to all eternity – it's like the joy at being united with your bridegroom. Do you understand now, Martha?"

Martha nodded. "Yes, but what about your fiancé? You'll be meeting him again. Aren't you going to be properly together again then? Or how are you going to arrange things, Liva? You can't live together without being married, for what would people say?"

"There's no question of marriage or matrimony in eternity," said Liva. "It's only a question of the union of souls in everlasting joy and happiness."

"Do you mean all souls together?"

"Yes, all souls. All redeemed souls, Martha."

Martha was silent for a moment. Then, rather downheartedly, she asked: "Only redeemed souls, then, Liva? But what about the others? Will they all be damned? That's a terrible thought really, for there might be a lot of nice people among them, don't you think? And a lot of daft ones that can't be made to understand it. Don't you think?"

Liva stared into the light. "It *is* dreadful," she said quietly. "It is absolutely dreadful. But that's how it *is*. Those who have not received the gift of grace through their faith are lost to all eternity. They will be thrown into utter darkness, where there are tears and the gnashing of teeth."

"The gnashing of teeth – what's that?" asked Martha.

"It's when you grind your teeth – like this."

They both ground their teeth. Martha's face twisted in disgust. "Do you mean they'll be tortured like that always, Liva? For all time?"

"Tortured by repentance, yes. Tormented by terrible repentance for not letting Jesus in when He knocked on the door."

"Ugh, don't look so horrible and wicked," cried Martha in horror. "Be nice, Liva, like you were before."

"I'm not wicked, my dear," said Liva in surprise.

"Yes, you are, you're wicked, because you can look really horrible; I've noticed that."

Martha began to weep again; she got up; her thin face was ugly and twisted. She went across and touched Liva's hand, cautiously and imploringly.

"Don't be wicked with me," she said. "You must help me to love Jesus. Do you hear, Liva? I must be His bride, like you. I'd so much like to love Him; I'm not interested in anyone else; I've had enough of all that, Liva. I want to be pure and lovely like you."

Liva grasped her hand. The two girls looked at each other, both smiling a little, and Martha said in a brighter tone: "Yes, like that, Liva. Now you look good again, and that's what you must always be like . . . not the other, it gets on my nerves."

It was bitterly cold later when Liva returned to the hospital. The wind had veered to the north; the air was full of tiny grains of frost, and the Northern Lights were darting across the sky. The gable ends, chimneys and naked trees in the town were outlined black and motionless against the effervescent sky.

There was a light in the little chapel, and Sister Elisabeth and a young nurse were just putting the lid on the coffin.

"You must decide for yourself whether you want to see the body," said Sister Elisabeth. "But I would almost advise you not to. It is not a beautiful corpse."

Liva wanted to see Johan's body; the lid was taken off the coffin, and Sister Elisabeth drew the white cloth aside. Liva had to take hold of herself so as not to start at the sight of the dead man's face. It was contorted and quite unrecognisable; there was nothing left here of the living Johan: the eyes, the nose, the mouth were all like those on someone she had never seen before in her life. The mouth was drawn askew to one side so that half of the front teeth were visible as though in some terrible smile; the nose was

216

huge and sharp, and the eyes had almost disappeared in bluish hollows. Only the thick dark hair was unchanged.

Liva stretched out her hand and touched the dead man's forehead; it was cold like glass. And suddenly she burst into unrestrained weeping. She could hear her own hoarse gasping; it sounded like someone with asthma, and it was difficult for her to regain her breath.

Sister Elisabeth stepped forward and took her arm. "Let's say the Lord's Prayer," she said. Liva could not collect her thoughts to take part in the prayer, but she gradually managed to control her convulsive weeping.

Liva walked slowly home; she took her time. There was nothing to hurry for. She stared up at the depths of the heavens, where the Northern Lights had gathered in an improbable wheel above her head, a vast streaming whirl-pool emitting light of many colours. She stopped and for a long time stood wrapped in the astonishing sight, and suddenly she was lost in the thought that here she stood, lonely and cold on earth, but still alive and breathing.

She went a little further away from the road, up into a tiny black patch of scrubland in the corner of a stony field. Here, shivering with cold and afraid, she knelt and prayed to God that her wait might be short.

# 4

A grey October, darkness and storm, and a continued Russian advance on the Eastern Front. Everything was sinister, sinister. What would be the end of it all? The defeat of Germany in the East was actually good enough news, but on the other hand it was not exactly a joyous sight to watch the Asian proletarian hordes pouring in across Europe. Incredible that Churchill could countenance the way in which things were developing and still not launch a second front.

There were other reasons, too, why Mr. Nikodemus Skælling could not help feeling uneasy and sometimes almost ached for the good old days before the great wars.

At home things were in a deplorable state, too; everything was developing in an unfortunate and sickening way. Sectarianism, both religious and political, was blossoming unrestrained; a new social class of upstarts and wartime speculators was stamping impatiently, eager to get at the helm. The boom had gone to the heads of such people and they had become ungovernable. Now these barbarians seriously wanted to make these islands a sovereign land in which they could do as they thought fit. There were ructions in the capital; the lawful Danish authorities were being criticised and attacked in the most impudent manner; conceited smatterers, failed students and sectarian missionaries thought themselves qualified to assume the roles of governors and judges.

This national elephantiasis had spread here to Kingsport as well; the Forward Youth Association was deeply infected, and even Solomon Olsen himself had more or less joined the rebels. It was said that he had promised to finance a new newspaper which Bergthor Ørnberg was to edit. And much good may it do them. Incidentally, it was incredibly mean-spirited of Solomon Olsen, who had a Danish knighthood.

Oh well, perhaps these boom-bubbles would burst sooner or later, and the good, healthy old conservatism which was rooted deep down in the Faroese people finally triumph.

But a far greater danger threatened from a different direction, a real pestilence that gave ample reason to sound the alarm. That was communism. The cancerous communist cell structure, which was well known to have spread over the whole world since the Bolshevik Revolution probably had its secret metastases here at home, too. Mr. Skælling had discussed this with his good friends, Heimdal the bookseller and Lindenskov the postmaster. Many of the younger social democrats were probably more or less infected. So far the social democratic party was, however, probably fairly sound on the whole; it had conformed to parliamentary forms and adopted a calm, dignified manner in harmony with social democratic traditions in other countries. You knew more or less where you were with it; the social democrat newspaper had recently printed a quite reasonable leader unambiguously emphasising that socialism was built on evolution and not revolution.

But this leader had presumably not been written without good reason. It signified a warning to the restless elements in their ranks not to become contaminated with the revolutionary disease. The heart-breaking problem was that the revolutionaries had gone underground and were working in secret. You had them close at hand without directly being able to prove it. You got their scent, that indefinable, rotten scent of game.

Yes thank you; Mr. Skælling knew that scent. He had had it close at hand. Down in the print room, to be precise. For Jens Ferdinand Hermansen, the typographer, was without doubt a revolutionary. They had his own word for it that he was bitter and opposed to the social order. And you could not accept at its face value his categorical denial of being a member of any secret organisation. At all events he was indubitably a representative of the spirit of revolt and dissolution characteristic of this age.

The episode in the church the other day told its own clear story. It was altogether too easy and unpsychological to brush it aside with the remark that it was no more than a single drunken man's happening to go berserk. It was far too *symptomatic* for that, by Jove.

The little hunchback was most certainly not an easy person to have in your employment, even if – it had to be admitted – he was in many ways a valuable man to the newspaper, for he had a brilliant mind and was untiring in his reading; he showed an amazing knowledge of virtually everything under the sun, from local politics and the way to work out the cost of living, to the history of the world and astronomy. Moreover – apart from those deplorable periods on the bottle, which unfortunately seemed to be getting more and more out of hand – he was well organised, a skilled craftsman, an inventive and handy person, and something of a draughtsman and artist; he had painted some extremely commendable signs and advertisements for the bigger shops, and a caricature of Bergthor Ørnberg which Skælling had chanced to find down in the print room was really both talented and delightfully malicious. What a terrible shame it was that Jens Ferdinand Hermansen, with all these virtues, should be socially contaminated; indeed, who knows, perhaps he was that very borer beetle that could bring the entire edifice tumbling down over their heads when they least expected it.

For the time being there was no immediate danger. The British occupying forces would scarcely tolerate revolutionary disturbances. But should one not view with unease the day when the war was over and the country was once more without firm government? For there was scarcely any help to be expected from Denmark proper, where communist resistance fighters and saboteurs held sway: they were probably arming themselves as fast as they could to take over the government as soon as the saga of the German occupation came to an end. It might be bad here, but it was far worse there.

Yes, there was unrest and ferment wherever you looked;

there were enemies at every turn, often where you would least expect them. For instance, where did a man like Doctor Tønnesen stand? His attitude towards his own class seems to be somewhat sarcastic. Among other things he was said on one occasion to have called the Club a harmless madhouse. What could that little word "harmless" imply? And this strange outsider was also supposed to have expressed himself rather deprecatingly about The Faroe News. In general, his political and social views were said to be *extremely* left wing.

Yes, there was plenty of reason for Mr. Skælling, the editor, to feel uneasy.

And then, one evening, a trapdoor opened in the floor revealing the workshop of the Evil One himself!

It was a Sunday evening. Mr. Skælling had spent most of the day working on a little reflective piece, part lyrical, part philosophical, for the editorial column, The Spectator. He had given the article the title of *The Cauldron Boils On*. He had at last put the finishing touches to it and taken it down to the print room; however, after supper he had decided that the title was scarcely suited to serious reflections of a moral and edifying nature. He must think up another title. This column was the apple of his eye, it was – as Mr. Licht the pharmacist had so aptly remarked – a little aperitif for the intelligent reader. There was a particular aroma to it, a fine, slightly bitter, aroma. Originally the idea had been that it should be good-natured and subtle, much in the style of similar exquisite little reflections in the conservative newspapers in the major countries. But times had gradually become anything but humorous, and the views expressed had followed suit. Therefore a change of title was an absolute necessity. *Beneath the Storm Cloud*, for instance. That didn't sound too bad. And it would be best to make the change straight away.

Mr. Skælling pulled on his galoches and went down to the print room and made the change. But just as he was about to go home again there was a strange, rather disturbing noise from one of the writing desks. It sounded rather

like an alarm clock going off, but it was ridiculous to imagine that anyone would hide an alarm clock here. Mr. Skælling went across and examined the desk. Yes, in one of the drawers he found the works of an alarm clock. It was going. There were a few old books in the drawer, too, full of black finger marks. Werner Sombart: *Krieg und Kapitalismus*. In German! H. G. Wells: *New Worlds for Old*. And there was also a little pamphlet on the personality of Lenin, written by the world-famous bolshevik Maxim Gorki!

Good God! The editor started trembling violently and had to go into his office and sit down. "Don't panic," he said to himself. "It's no more than you knew beforehand." Evil forces were at work here. It was well known that the works of a clock were a classic component of a time bomb. All that was missing was the explosive charge. All right. A good job that he had discovered this nest of scorpions in good time. He would now take the necessary measures. First of all, the typographer must be sacked and turned out. In general, the necessary measures had to be taken.

But how? The more he thought about it, the more difficult the task admittedly appeared. If these devils really managed to establish communism throughout the world after the war, he would be sure of his bullet in the neck. Indeed, that might be his immediate prospect if he didn't manage to put a good face on things. The bomb! It would doubtless be best to proceed carefully . . .

Mr. Skælling started trembling again. He carefully replaced the works and the books, switched out the light and remained standing behind the exit door for a moment before opening it. He was shuddering with annoyance and nervousness. Good Lord . . . Here he had gone around feeling personally secure and neutral. And suddenly he was finding himself drawn inexorably down into something that might turn out to be nothing less than a political witches' sabbath.

Below the stairs leading from the print room a man was standing, aiming a pistol at him. He glimpsed other figures behind him, silent, watchful. Mr. Skælling was just on the

point of shouting for help when, to his relief, he discovered that the revolver was a bottle which the man was holding to his mouth. So it was only a little group of thirsty men such as you can never avoid on a Sunday evening. Thank heavens for that.

Nevertheless, Mr. Skælling did not feel totally reassured. He hurried home, indeed, he almost ran. He was almost knocked down by a car on the corner near Masa Hansen's shop; the car stopped with a jolt, and a tall person dressed in a fur coat got out, followed by a silent dog. Mr. Skælling had some dim vision of wolves and Russian furs; with a hammering heart he stepped aside and positioned himself behind one of the pillars by the entrance, but the fur-clad stranger soon found him and shone a merciless beam from his torch on him. With a groan the editor raised both his hands: "For God's sake, man . . ."

"You're not hurt, are you?" enquired the stranger. Mr. Skælling immediately recognised the voice; it was Consul Tarnowius, of course. Thank God, thank God, thank God. He could have thrown his arms round the consul. "No," he said hoarsely, and burst into a teeth-chattering laugh. "I was simply so frightened, Consul."

"Yes, it's this confounded black-out," said the Consul in relief. "But I did hoot, you know, Mr. Skælling, I did hoot, quite loudly in fact, didn't I?"

"Yes, but I was in such a hurry, I didn't notice anything. I was lost in thought . . ."

The two men shook hands heartily.

"Actually, I'm on my way home bearing very sad tidings," said the consul. "My son-in-law has been killed. He went down on a troop transport last night."

"Oh God, oh God," said the editor, once more grasping the consul's hand. "Please accept my sincere sympathy."

"Thank you, yes, it is very sad. We were all so fond of Charles Gordon; he was an extremely gifted young man. Captain Gilgud thought very highly of him indeed. Aye, but this was always to be feared. These are difficult times, Skælling, difficult times . . ."

"Yes, difficult times indeed," agreed the editor, shaking his head.

He hurried home and flung himself in confusion on his settee.

"You look upset, Nikodemus," said his wife anxiously. "You're not ill, are you?"

"Not in the least. But make me a little toddy, Maja, there's a dear."

He drank four toddies before going to bed, but even so, he had a bad night. He lay listening. A storm was brewing, and strong gusts of wind were sweeping down the mountain sides. A loose window pane rattled gently, sounding like a telephone ringing endlessly. Another rattle came from the clothes line outside in the yard. And then there was the sound of the big clock downstairs in the sitting room. That was all right. And furthermore there was his own pocket watch on the bedside table. All these four sounds were noted and deemed completely legal. But then there came a fifth sound ... or was it perhaps only his imagination? No, there it was again ... a little regular ticking like an alarm clock. There *was* no alarm clock in the house, not even in the maid's room. The maid was an early riser and needed no alarm clock.

"Are you asleep, Maja?"

Mrs. Skælling awoke with a start. "What's the matter, Nikodemus? There isn't an air raid, is there?"

"No, no, don't worry," intoned her editor husband, and explained things to her in brief. They both listened.

"Can you hear?"

"Oh, that," laughed Mrs. Skælling in relief. "That's only a death watch beetle."

"Are you sure? I've never noticed before that we have death watch beetles in the house."

Mrs. Skælling yawned. "Oh yes, there are lots of them, Nikodemus, especially in the autumn. And what on earth could it be otherwise?"

"No, I suppose not," Mr. Skælling admitted. He put out the light and lay back in bed. No, now he, too, could hear

that it was not the ticking of a clock. The sounds were not entirely regular, and sometimes they split into two. It was some of these strange, fabled and invisible tiny insects signalling to each other. Amorous signals. So it was not a bomb, as he had originally feared in his excitement.

He was just about to fall asleep again when there was the sound of loud knocking on the front door. Who on earth could that be? He got up quickly, put on the light and again woke his wife. It was two o'clock. The knocking resumed.

"You could go down, of course, and ask what's going on . . . without opening the door," suggested Mrs. Skælling. "Or shall I?"

"No, of course not. I'll see to it. There might be a fire or something. Or a German invasion, who knows? Or . . . or a *revolution.*"

Mr. Skælling suddenly turned ghostly pale and felt his legs trembling violently. He tottered out into the vestibule and shouted: "Who's that knocking?"

"*Jesus!*" replied a deep, calm male voice.

"What nonsense is this?" shouted Mr. Skælling plaintively. "Be off with you."

"He is coming," came the reply. "Be prepared. He will be coming soon."

"Who was it he said he was?" asked Mrs. Skælling from the top of the stairs.

"He said he was Jesus. What do you make of that?"

"God!" exclaimed his wife, curling up in her nightdress. "Perhaps it was an omen, Nikodemus."

The house shuddered under a powerful gust of wind. It appeared a real gale was coming on. Skælling crept back into bed. He could not speak for cold and chattering teeth. His wife sat on the edge of the bed.

"You don't answer, Nikodemus," she said quickly and tugged at his arm. "Are you afraid? Perhaps you ought to have opened the door, don't you think?"

Mr. Skælling shook his head, irritated, but his wife went on doggedly: "Yes, for suppose . . . suppose it really was *He* . . . ?"

"What do you mean, woman?"

Mrs. Skælling turned away and pressed both her hands to her face. "Oh, I'm so afraid," she said. "Yes, for in a way we've both got so far from God. Yes, we have, Nikodemus. I've been thinking so much about it since reading that little book, you know: *Only for Sinners*."

A fresh gust of wind swept down from the mountain, howling around the gable, while huge hailstones began to thunder against the window.

She turned towards him suddenly, and their eyes met in a mutual stare: "You're frightened yourself, Nikodemus. Admit it. You always look as though you're cold. And you've lost weight recently."

"These are unpleasant times," admitted her husband, caressing her hand. He added, staring ahead with troubled eyes: "Incidentally, it's strange you should mention that book, Maja, for Heimdal's read it recently and been very taken by it. We were talking about it in the Club the other day, and Licht said, too, that he was surprised that the Oxford Movement had not reached us yet. But it will be coming, he thought. For it's still going strong."

"I wish to God it would come," sighed his wife.

The explanation of the mysterious nocturnal visit came the following morning. Skælling was not the only one to have had someone knocking at his door; pretty well every house in the village had been visited in the same way, some by Simon the baker, some by Markus the mad boatbuilder and Benedikt Isaksen from the hospital; the three half-wits had divided the village among them: the baker had taken on the western part, the other two crackpots the eastern. In various places people had been furious at having their peace disturbed in this way: up at the police inspector's the porter had had a chamber pot emptied on his head, and the boatbuilder had been caught and restrained by Tarnowius's big and intelligent alsatian.

It was the maid who brought this comforting news to Mr. and Mrs. Skælling when she gave them their morning coffee in bed.

"It's a very tangible kind of revivalism," laughed Mr. Skælling bitterly.

The three evangelists were not finished with their rounds. From Solomon Olsen's office window the baker could be seen approaching. He was bare-headed; the wind and the sleet were lashing his ears; his sharp face was wet and blotchy; people who met him stopped and looked thunderstruck; startled faces were appearing in every window and doorway.

Now the cuckoo was approaching Solomon Olsen's store. Some employees came out and made to hold him back, but nothing came of it, and they stepped aside gawping and allowed him to pass. However, just as he was going inside he was stopped by Bergthor Ørnberg, who had hurried down from the office.

"Just you restrain yourself," commanded Bergthor. "You've no right in here."

"Oh, generation of vipers," cried the baker so it resounded throughout the shop. "It will avail you nought to kick against the pricks."

"No, this really *is* going too far," Gjowstein the chief clerk came to Bergthor's assistance. "What nerve. You're out of your mind. I'll fetch a doctor, that I will."

Then Solomon Olsen's voice could be heard from the staircase: "All right, let him come inside. Just you come in, Simon."

Solomon Olsen looked quite calm; his well groomed face merely expressed worry and compassion. "What is it, Simon?" he asked gently. "Is it me you want to talk to?"

The baker swallowed a couple of times. He stared at Solomon, and his nostrils quivered. The office staff came down into the shop and congregated in a group at the foot of the broad, white staircase. People from outside came in droves, too, and soon the shop was full. Everyone was staring at the two men.

Simon opened his mouth and made to speak, but it was almost as though the big, self-assured figure of the merchant robbed him of words.

"You've deserted us," said Solomon. "In fact, you're working against us, Simon. But why? Were we not friends and brothers before? Why can't we go on being that? Have you really thought properly about what you're doing, Simon?"

"Yes, I have," said the baker in a thick voice, contracting his brows and nodding in bovine fashion. "And I've consulted the Scriptures. And there it says that no man can serve two masters, and that you've got to choose between God and Mammon. Do you remember that text, Solomon Olsen? And have you experienced the truth of those words?"

"You know really perfectly well that I don't place Mammon above God," Solomon replied calmly. "I don't worship Mammon in my heart; I worship God."

"Go and sell that thou hast, and give to the poor," replied the baker. "Or have you forgotten that text?"

Solomon sighed and smiled a little wearily, glancing paternally at those gathered around him: "Yes, you can soon get the better of me, Simon, for you've always had the gift of the gab and your memory is quite incredible, but you know how bad I am at interpreting the Bible. I've got one thing only: I have Grace, for everyone who believes has Grace. But . . . let's suppose that I sold all my possessions and gave the money to the poor. Then my firm would go to the dogs, and what then? It's not the actual money that's worth anything, Simon, it's the firm; that provides us all with food and clothing and light and warmth. Isn't that so? The talents God has entrusted to me . . . should I, like a wicked and slothful servant hide them in the earth instead of making them bear fruit in the Lord's vineyard. I waste no money on fine living, indeed I don't put a penny aside — that you know well. I put *everything* into the firm. And if we all did as you demand, what then? Then the whole country would soon be transformed into a desert."

The baker turned his head and looked warily at Solomon.

"It would be better if it were like a desert," he said hoarsely.

Then he looked up and cleared his throat loudly. He had regained the use of his voice, and he raised his arms threateningly at Solomon and cried: "For in any case it will not be long before everything is a wasteland. It is but a brief while before the Lord's day. And then what will be the use of running your firm? It gives neither you nor anyone else oil for your lamps. And that is the one thing needful. Jesus took up His own cross . . . if you want to be His disciple, then take up *your* cross and follow Him. But that is the problem: None of you takes the Word of Scripture seriously. You only pick out what you can use, what can sooth your consciences and lull them to sleep. But read. Read Matthew 24. Read the Book of Revelations. Read Daniel and the other prophets."

"I know you are a serious man," said Solomon warmly. "You're probably a far better man than I. But you are not one of the humble, that you are not. And perhaps you are even a little arrogant. Aren't you, Simon? When you are so severe on others, what about yourself? Judge not, you know."

"As for me," replied the baker, showing his teeth in a sort of smile. "I will also demonstrate my faith in deeds."

Solomon stretched out his hand to him: "All right, but let us part as friends and not as enemies, Simon. We have surely both got our faults, but through our faith we have both received the gift of Grace and the promise of redemption from our Lord and Saviour Jesus Christ. Let us try to reach an understanding again. Let us meet in Capernaum chapel, as we have done so often before, Simon. Let us talk things over there."

The baker turned away. His face contorted, and he shouted in a husky voice: "*No!* We shall not stretch out our hands to each other as though everything was back where it once was. For the day will come, and come soon, when the Kingdom of God has conquered the prince of this world."

The strange smile reappeared on the baker's face. And suddenly a wild light flashed in his eyes, and, foaming at the mouth, he shouted: "You are making a grievous mistake if you think your soul is saved, Solomon Olsen! You will soon learn that from the Lord's own mouth when He reveals himself in the clouds. For, as it is written: the merchants of the earth shall weep and mourn; for no man buyeth their merchandise any more."

Simon looked around in the big shop. Pointing at all the shelves and cupboards surrounding him, he went on: "Yes, that is just what is written: The merchandise of gold, and silver, and precious stones, and of pearls, and fine linen, and purple, and silk, and scarlet, and all thyine wood, and all manner of vessels of ivory, and all manner vessels of most precious wood, and of brass, and iron, and marble, and cinnamon, and odours, and ointments, and frankincense, and wine, and oil, and fine flour, and wheat, and beasts, and sheep, and horses, and chariots, and slaves, and souls of men."

The baker turned once more towards Solomon Olsen and shouted in a strong voice, while he raised both his hands in the air: "Woe unto you. The fruits that thy soul lusted after are departed from thee, and all things which were dainty and goodly are departed from thee, and thou shall find them no more at all."

He lowered his arms. He took a step towards Solomon Olsen and stared him straight in the eye. Then he quickly left the shop.

Solomon Olsen slowly walked to his office, shaking his head.

"He's mad," he said to Bergthor. "He's stark raving mad."

"You can see the madness shining in his eyes," confirmed Bergthor humbly.

Solomon Olsen sat down with a sigh. There were two unopened telegrams on his desk. He opened one and read it through excitedly.

"Just look at that," he said.

"Is it from the Joan of Arc?" enquired Bergthor.

"Yes. They've got £8000 for their catch. That's quite a tidy sum, isn't it? And there I was, getting worried."

He was humming to himself as he opened the second telegram. He suddenly went silent. He got up without a sound and went out into the corridor. Bergthor heard the click of the bolt being pushed on the toilet door. The telegram lay open on the desk. It was from Solomon Olsen's agent in Reykjavík. Bergthor read it and started trembling.

"Good God. 'Trawler Magnus Heinason mined off Iceland. Disaster observed by two other ships, but violent gale made rescue impossible. Probably no survivors.'"

Bergthor passed on the tragic message to Gjowstein. There was no reason to keep it secret, it would soon be out in any case. Soon the entire building was humming with sombre and subdued talk.

"It's so awful, you can't credit it," said Gjowstein. He had a heavy cold and his mouth was full of liquorice tablets. "Awful. Twenty drowned. And all from the fjord here. And then the ship . . . the best we had. Or at least the next best."

Bergthor gave him an intense look, raised his head high and said: "They fell at their posts, Gjowstein. They died for their country. Never, never shall they be forgotten."

He turned round, quickly put a sheet of paper into the typewriter and began to write. It was a poem. The words came of their own accord; they gushed forth from his sorrowing breast and brought a trickle of tears from the corners of his eyes.

# 5

"And of course, the entire front page edged in black. And a cross above the obituary. And italics for the list of names of those lost. Or perhaps bold, or at least semi-bold. It has a more sombre, more solemn effect. And the two more . . . more optimistic headlines will have to go out – God help us. Yes, I mean 'Keep smiling' and 'Beneath the Storm Cloud'. This is very definitely a mourning issue, a *black* issue. What are you smiling at, Hermansen?"

Mr. Skælling, the editor, gave his typographer a surprised and offended look.

"Well, it's this advertisement from Opperman. We can't possibly include it in this issue, can we? *Top quality life jackets!*"

"No, definitely not. It would border on the ridiculous, even the blasphemous."

"And then, there's this one: 'Drown your sorrows and worries in coffee and cakes at the *Bells of Victory*.'"

"Yes, that's just like Opperman," the editor said, shaking his head. "He's a bad lad, a really bad lad, by God."

"Well, he's not the only one," the typographer went on. "For instance, there's this one from Masa Hansen for mourning clothes for women and children, widow's veils, mourning decorations, huge selection."

"Does it really say mourning decorations?" asked Mr. Skælling in consternation. "Incredibly bad taste. Yes, it's vulgar, definitely vulgar."

"Yes, there's no denying that," the typographer agreed, studying Mr. Skælling through half-closed eyes. "And what do you think of this one: 'Make the orphans happy with books and toys from S. F. Heimdal.'"

"But surely, it can't be possible." Mr. Skælling put his hand involuntarily to his head; he was momentarily confused. Heimdal . . . that sober, civilised man. Could he have a screw loose . . . or was it perhaps his wife . . . or no,

of course . . . it was Hermansen making a fool of him. Were there no limits to this monster's disrespect?

He heard the typographer going on in the same sharp, cutting voice as he took a new sheet of paper: "Seamen. Nordic brothers. Help a brother nation drowning in over-production of fish. Iceland needs you. Still huge profits to be made for poor sailors who will risk their lives in the greatest rush for profit the world has ever known . . ."

"Stop it, for God's sake," shouted Mr. Skílling in a plaintive voice, raising his elbows. "Are you out of your mind, man? Is that supposed to be funny? Do you really think this is the right moment . . . ?"

The little typographer had a hectic flush in his cheeks; he gave the editor an acrimonious look and said: "Yes, I think the time has come for me to say goodbye to this disgusting, lickspittle newspaper of yours. I'm fed up with your damned sentimental, snobbish rubbish. Understand?"

Mr. Skælling had become very pale.

"You . . . you're leaving, Hermansen?" he asked quietly and almost imploringly. "Yes, but . . . what have I done to you, Hermansen? Why are you so dreadfully angry with me? I must say that it makes me profoundly upset. You know, I've always been well satisfied with you . . . we have worked together very well indeed . . . we've never exchanged as much as an angry word . . . and your wages . . . your wages . . ."

Shaking his head, the editor groped his way to a stool. He went on in a subdued voice: "Of course, Hermansen, I know your . . . your rather extreme views. Society, yes. It's admittedly something quite . . . paradoxical, yes, you're entirely right in that. But perhaps in the final analysis not quite as bad as you make out, no, thank God. And – well, in the name of heaven . . . what is it you really want? Do you demand that all economic life should cease? But where shall we drift off to then? I must admit, it's beyond *me*. But perhaps I'm one of the . . . hm . . . old school."

The typographer had taken his cap. He shrugged his shoulders briefly and went without saying goodbye.

The editor got up, shaking his head. What did the

desperate man intend now? The alarm clock! Mr. Skælling went quickly across to the type case and pulled out the drawer. Yes, of course, the alarm clock had gone.

Gone and gone. Perhaps it had not gone. Perhaps not gone at all, but simply set in motion.

He listened. Yes. There was the sound of a steady ticking from somewhere or other. There was no mistaking it. Tick-tock-tick-tock, it sounded, with a kind of wooden resonance. Was the devilish contraption hidden somewhere behind the panelling or under the floor? And suddenly the sound would stop, and . . .

Mr. Skælling rushed out, bareheaded and without his stick or galoches. He did not stop until he had the printing office at a safe distance. There was an ear-splitting roar. But admittedly, it came from the opposite direction. And then a fresh roar, and then another.

Oh, of course. It was the usual artillery practice. Yes, now he could see the smoke from the gunpowder rising from the battery over on the point.

Mr. Skælling had to smile a little, in spite of everything. What times we live in, what times. By God, it was not surprising if your nerves let you down occasionally.

He breathed a deep sigh of relief.

The fresh air brought in by the gale did him good. The printing office was still in its usual place. No damage had been done. The ticking sound was still there, but it was coming, he noticed, from outside. More precisely, it was coming from the little inlet called the Seaweed Pool, where Markus the mad boatbuilder had his yard.

Mr. Skælling took his hat and walking stick. He would go for a short stroll along the shore before dinner. That would take him past the Seaweed Pool, so he would be able to discover the source of the noise that had so thrown him off his balance. And then he would be able to think through the situation. It would presumably be possible to find another typographer. At a pinch he could use Hugo, the painter and decorator, who usually helped Hermansen when he was particularly busy. He was not too bad, really.

Mr. Skælling stopped in front of Markus's boathouse. The hollow knocking had ceased. He peeped in through the door, which was standing ajar. But the sight that met him here was once more on the point of taking his breath away – a *cross* . . . a huge wooden cross filling practically the whole of the long workshop. Good God. What on earth was this?

The cross was beautifully finished, planed smooth and varnished, and up on the crossbeam there was a plaque on which some lettering had been carved. I. N. R. I.!

What in the name of heaven was going on here?

He went inside. Markus came wading towards him through a billowing pile of fresh shavings. And there were shavings in his thick beard.

"What on earth is this cross?" asked Mr. Skælling breathlessly.

"It's the cross of Jesus Christ," replied the boatbuilder calmly and informatively, almost like a teacher helping a backward pupil.

"Where is it to be . . . put?" asked Mr. Skælling. He felt strangely crestfallen and weak at the knees.

"At Golgotha," came the reply. Markus turned around dolefully and began searching on a shelf.

Mr. Skælling had started trembling again. He was feeling more and more confused. A line from a hymn kept on going round in his head:

> Light is the cross as others' guerdon
> But heavy when one's own sad burden.

Sensation is always sensation, whether it is sad or joyful; there is always something pleasurable, voluptuous about the actual shock for the first few moments. The mighty experience lights a fuse . . . the spirit is projected aloft with the force of a rocket, and only when it loses speed will it be seen whether the fiery fruits it dispenses are the fruits of joy or sorrow. People love this brief extravaganza of sensations and seek it, blinded by their fixation, as moths

seek the light. Warmongers well know this law and exploit it in their devilish speculations. But wait, obnoxious creatures that you are . . . retribution is already upon you; the demons of retribution have brewed the magic potion of malediction for you who speculate in human life and feed your fruit trees on human suffering and misery. . .

Jens Ferdinand forces his clenched fists down into his jacket pocket and flaps his arms like a bird. For a moment he is suffused with hatred and fury. But then he feels the flush slowly subside and condense in mockery, powerless mockery, clownish behaviour . . . the fate of the village reformer. Aye, even a Lenin would have been no more than a wretched clown if he had been cursed with having to spend his life in a village . . .

You ought to have been a priest, he thinks with a cold little laugh. Or at least a lay preacher. Like Simon the baker.

He catches himself feeling some sympathy for Simon. What a great pity that this untiring fanatic didn't tread the path of reason, but that of religious mania. But there is a devilish drive and power even about his mania as he stands totally isolated and aims his shafts at wartime profiteers and bigwigs.

There he is now, standing on the little square in front of Solomon Olsen's shop, talking to a throng of widows and orphans, fiancées and relatives, people who have, as it were, still not quite realised that this time *it is they who are affected,* but are still expecting a miracle and stubbornly cling to the telegram's *"probably"*. There might, after all, just be a chance that a few of them were rescued . . . if no one else, then at least my Peter or Hans.

"For we must wrestle against principalities and powers," cries the baker. "Against the rulers of the darkness of this world. Against spiritual wickedness in high places."

Simon is quite hoarse by now and ought to stop before people begin to feel sorry for him. And yet, as he stands there, lonely and windswept and drenched, but full of the indestructible ardour of inspiration, he really does resemble a genuine prophet . . . John the Baptist, crying in the

wilderness. Yes, even the Messiah, when, He raised His whip in fury against the moneychangers.

"It's dreadful, dreadful," says old Verlandsen, the headmaster, shaking his bent, bespectacled ram's head. "Almost all those lost were my old pupils. One of them wasn't even sixteen yet; he'd just left school, and he was the best pupil I've had for many years, perhaps the most gifted boy I've ever known . . . after you, Jens Ferdinand. He wanted to go on and study and become something great. And now he'd got the chance of earning some money to finance his studies. He'd already managed to collect enough to start on."

The old teacher suddenly nudged Jens Ferdinand: "That's his mother coming along over there. She was once a pupil of mine, too . . ."

A wispy little woman with seasick eyes and apple-green cheeks approached the teacher. He held out his hands to her, and they were for a moment united as though they were father and daughter. Jens Ferdinand turned away. He was seething deep down in his breast.

Now Bergthor Ǿrnberg appears in the door holding a telegram. He opens his mouth and calls out a name, and suddenly a little whine can be heard from the crowd, and a young girl, well dressed but drenched and tousled, starts shouting jubilantly: "He's saved, he's saved." And like a gust of wind it spreads from mouth to mouth: The skipper's safe. Poul Strøm's been rescued. He'd drifted far out to sea on a plank . . . and was found by an American ship . . .

And the girl, the skipper's fiancée, runs off, flapping her arms like a bird that has extricated itself from a snare and suddenly feels the life-giving thrust under its wings.

Jens Ferdinand feels overwhelmed by emotion at this sight, and a lump grows in his throat. Life, good Lord . . . life! In the midst of all this misery and suffering, a bubble of happiness, a delicate, poor soap bubble . . . how long will it last? But what heavy, joyful, intoxicated colours swirl around on its clear, reflecting surface. He has to think of Liva's absolutely ridiculous, foolish delight when it emerged that Johan had survived his pneumonia. She

sobbed and laughed at the same time, bit her finger tips and waddled her bottom so that people who saw her were almost embarrassed on her behalf . . . and finally she had kissed him, Jens Ferdinand, kissed him on the cheek. This was the only time he had ever been kissed . . . but the kiss had, of course, not really been his. It was a kiss of joy, not aimed at anyone is particular. It was for life. Life . . . life had kissed him for the first and last time.

"There you are getting all sentimental, you humbug," he said to himself and tried to pull himself together. But it was no use. Tears ran unashamedly down his cheeks, and he had to hurry away. Liva – he heard the cry deep down within him, forcing its way into his very being and drowning everything else: "Liva. I love you. This is no banal infatuation, it's . . . it's a poor, lonely man's hopeless love of life."

"Nonsense, rubbish . . . shut up once and for all and stop that self-centred claptrap." He clenched his hands in his jacket pockets and flapped his wings hard. But it was no use; it was as though something had sprung a leak inside him; it was leaking like hell, he was bleeding unceremoniously, and it was doing good, not harm. It was bliss to be able to formulate those words: "I love someone. I love *you*."

"Humbug" - he tried once more to put a stop to all this crazy sentimental nonsense bubbling up and carrying on inside him like carbon dioxide in a bottle of soda water.

That reminded him: soda water. He had some whisky and soda at home. And now he was no longer tied to slaving over printer's ink, that was always something.

He hurried home.

There. Here he was alone, at least. He took out a glass and some bottles and held the clear soda water bottle up to the light for a moment. How still . . . wasn't it. Now for the shock. He took off the patent stopper and the calm water exploded in the well-known hysterical turbulence and formed an effervescent pool on the floor. The outbreak of war and the general will to sacrifice. And in the background all around lascivious hands were being rubbed

together, and weapons manufacturers and food merchants were clearing their throats expectantly . . .

With eyes half closed, he sipped at the salt drink and settled down in a canvas deckchair. The bubbles of carbon dioxide rose eagerly, propelled aloft like some bewitched snowstorm. He emptied the glass in a single gulp and murmured: "And that was the end of that one."

"And good morning to you, too, sir," he greeted the new effervescing drink. "Good morning, Mr. Cluny, how do you do?" He transformed his voice and spoke in a calm, drawling English tone, curling his tongue upwards to form the little twist found in all Anglo-Saxons mouths. And all foxes. With this indomitable twist on their tongues this proud people of missionaries and dealers had gone out into the whole world to convert the heathen to God, whisky and capitalism. There they come, these pioneers of civilisation, everlastingly travelling and trading . . . traversing boundless oceans, endless deserts, poisonous jungles, icy mountain passes . . . unflinching and young and cruel, enveloped in tobacco and gunpowder smoke and early mornings . . . !

Jens Ferdinand surrendered voluptuously to the sense of being on a dizzying journey. Aye, the measureless loneliness of the Canadian prairie, where you could go and pee in any direction you liked, if it amused you. The solitary desert afternoons, carefree like the life after death. Beneath the mighty vault of heaven, beneath the high, silent sun, across an endless plain, slowly and with eternity before it, creeps a tiny golden beetle. Where are you off to? Nowhere, really, only creeping, today and tonight and tomorrow. No one can object to that, that's clear. Your health, little beetle. . .

Oh, blast it, now someone's coming . . . the mirror of silence is shattered; the door opens, and there are hurrying footsteps. It's Sigrun. Dissolved in tears like an opened bottle of soda water. And with a voice as mercilessly insistent as an alarm clock: "*Johan is dead. A telegram. I got it at the exchange. Look: Johan died last night. Liva.*"

And then – in a low voice, but terribly reproachful – "*Don't you care?*"

And – turning away from him, with her face hidden in her hands, and sobbing: "He doesn't care, he just sits there as though nothing has happened."

And then, wild-eyed and minatory: "You'll have to go, Jens Ferdinand. Do you hear? It's up to you. Liva can't be left alone a stranger in that place. And Magdalena can't leave the children and the old man . . . 'cause Thomea's ill. And I . . . I won't do it. For I *daren't*."

Fresh weeping and lamentations. "I admit it . . . it's disgraceful of me . . . but I'm so afraid, so afraid . . . and besides, I get so terribly seasick that I can't move a hand . . . my nerves would give way before I ever got there . . . I wouldn't be a scrap of use . . . I'd only be a nuisance to her . . ."

Jens Ferdinand got up calmly and said with a sigh: "You don't need to get so worked up, Sigrun. Of course I'll go."

He emptied his glass and put the bottle back in the cupboard.

Sigrun gave way to lamentations again. He could not be bothered listening to her, lit a cigarette and took his cap.

"It's thoughtless of you to go off now," came the voice behind him. "You know what my nerves are like. Where on earth are you going?"

"To find out when the boat leaves."

"It goes tomorrow morning. I know that for a fact. There's nothing to enquire about. Jens Ferdinand!" She tugged hard at his sleeve: "Would you give me a drink. It's the first time in my life I've ever asked you for one."

He turned round in amazement: "All right, of course you can have one."

Sigrun downed the strong liquor without blinking, and then asked for another glass.

She sat down in the easy chair. Her brother began pacing back and forth.

"So it was God's will that Johan and Liva shouldn't have each other," wailed Sigrun. "So I suppose it was all for the

240

best. I don't think they'd ever have been happy. He wouldn't have been able to take her sectarianism. Do you know, Jens Ferdinand: I think he would have been hard on her. He could lose his temper so, when the mood took him. And she'd have deserved it, for just fancy, being in with *that* crowd. He'd never have put up with that, at any rate. Can you imagine a man like Johan sitting across there in that greasy bakery and . . . no, impossible. And in any case, *she* wasn't the one for him . . . even if she was quite pretty, of course . . . she wasn't the one for him at all . . . for Johan was quite a stylish chap . . . yes he was, Jens Ferdinand. There was something masterful about him. He was used to giving orders and being obeyed. *Our* splendid Johan. And then Liva from Angelica Cottage!"

Sigrun was battling with tears. But then she overcame them and went on: ". . . And then that Magdalena. She's nothing but a real tart. Just fancy, she was out at a dance the very evening she arrived, quite a lot of people saw her. And then Thomea, the one with the hairy face. Just think . . . that peculiar Icelander she's been running around with . . . aye, it's incredible, isn't it? Imagine them carrying on like that! . . . But he's dropped her in any case, and now Mrs. Lundegaard from the hotel's going to have a baby with him . . . . And then . . . Consul Tarnowius's daughter's lost hers. It happened the night they heard her husband had been killed in the war. And now they say that she's going to be hooked up with Captain Gilgud himself . . . just imagine . . . she's seventeen, and he's fifty-six. And then, you know fat Astrid – her old sergeant's been killed, and now she's going to have a kid with another NCO. And Rita, the fair-haired girl who used to sell tickets in the cinema – she's been raped by a sailor, and now they say he's really in for it . . . for now they suddenly say its *not allowed*. What do you say to that? Now it's not allowed . . . after going on for three years without anyone lifting a finger to stop it . . . virtually undisturbed, out in the open."

Jens Ferdinand half listened to his sister's nervous torrent

of words. He filled their glasses and secretly returned to his voluptuous dreams of loneliness.

The little golden beetle is still faithfully stumbling on its way under the gaze of a sun that is bright like clear water, but towards evening it becomes darker and darker and dusty like a Spanish pepper, until finally it disappears beneath a cloudless horizon.

Then the night comes, and with it the planet Jupiter, which is 1400 times as big as the earth and enveloped in a gigantic ocean of clouds. And while the shining, wandering tiny little beetle glistens gingerly in the starlight, a distant, dark sun plays on the heaving ocean of clouds covering Jupiter; not a cloud of water vapour or ice crystals, but of carbon dioxide and reeking ammonia . . . and yet it, too, has its day and night over the inconceivable expanse of its wilderness . . . aye, Orion and the Pleiades shine over its heaving ocean of poison just as we know them here on Earth; all the constellations shine and twinkle with their familiar features on this vast, alien Niflheim, which is more dead than death . . .

"And Pjølle Schibbye's having a divorce," he heard Sigrun's distant and irrelevant voice. "They've both been having it off with someone else, but she's been the worst by far, for she . . ."

"Do you know what the oceans on Jupiter consist of?" he interrupted her in fury. "Ammonia water. It has a penetrating smell like salt of hartshorn . . . stables . . . old, rotten urine."

"What do you mean? What are you getting at?"

He thrust his fists down into his jacket pockets and flapped his arms in deep inner tumult. "What do I mean? I'll tell you exactly what I mean: I mean that the whole of this vast, gigantic planet stinks like one vast piss-sodden eiderdown."

"Jens Ferdinand!"

"Goodbye," he said suddenly, and slammed the door as he left.

★

Jens Ferdinand wandered haphazardly out into the raw, stormy day. The gusts of wind were whipping up fans of darkness across the grey fjord, and along the edge of each fan there was an aura of white and grey, like clouds of dust being brushed up. Not even the harbour pool was calm, and the ships and boats were dragging at their anchor chains, while the water was splashing irascibly and tirelessly in over the quays. Enormous armies of grey storm clouds came pouring in from the sea. For a moment a crystal white ray of sunshine awoke in the grey mass and turned the sky into a landscape of mountains and bluish ravines. . . the curtain was drawn aside to reveal a tempestuous Jupiter landscape of demented, cruel beauty. But the next moment the tumultuous vision was extinguished. It was nothing for human eyes, a vision reserved for gods and giants. . .

But this sombre day had still not emptied the cups of its anger; there was still more dread hidden in its depths. In the early afternoon two destroyers arrived in the fjord together with three badly damaged freighters, the remains of a convoy that had been dispersed. One of the steamers had a catastrophic list and looked like a petrified cry for help. Military ambulances and lorries stood waiting on the cordoned-off quayside. Stretchers were quickly taken aboard and carried slowly back to shore with their sad freight. The wounded were taken first, and then it was the turn of the dead bodies – there was no hurry as far as they were concerned. There were something like thirty bodies. Men in the flower of their youth, congealed youthful blood that would never pound through the veins again. There was a silent, oppressive flurry of activity in the hospital; they had to find room for these unknown victims of the great imperialist madness; the operating theatre was prepared, and the doctor prepared for a long and difficult night.

"Make sure there are plenty of cigarettes," he said brusquely. "British sailors *insist* on dying with a cigarette between their lips."

★

Jens Ferdinand opened the door to his room, and Myklebust and Thygesen entered with a slight bow. The two foreigners, ultra polite and modest, stood rubbing their hands while they looked around the little room, the walls of which were decorated with coloured sketches for advertisements and lively caricatures. Jens Ferdinand had chanced to meet the curious pair out at the Seaweed Pool, and they had invited him aboard their funny old Viking ship that lay anchored down there. They needed to fetch some things they had left on board, including Thygesen's guitar. They had had a couple of drinks, and then Jens Ferdinand had invited them home so he could show them his *merry-go-round*. Thygesen was carrying his guitar under his arm.

"You're a real caricaturist," said Myklebust. "Let's see whether we know any of them. Oh yes, there are Solomon Olsen and his son as large as life. And Mr. Opperman. Hey, look here, Thyge, never in all my life have I seen anything as malicious as this. Consul Opperman in his négligé and wearing a pair of knickers. And ... good heavens, what is this distinguished chap up to?"

"It's Consul Tarnowius kissing Captain Gilgud's bum; I can see *that* all right," commented Thygesen without mincing his words.

"Aye, the man's not without talent," said Myklebust. "It reminds me a bit of Gulbransson and Blix and that crowd. He could have got somewhere, I'm sure he could. *Nihilism*, eh?"

He stopped in front of the drawing of a bar behind which the bar-tender, in the shape of Pjølle Schibbye, was mixing a cocktail for his mother. Mrs. Schibbye was the only guest in the pub, but on the other hand she filled the entire room with her octopus-like body. "Human blood", it said on the cocktail shaker. And here was Nikodemus Skælling, the editor ... stark naked in the middle of a duckpond, covering up his private parts with both hands, while out in the shallow water there was a notice saying *The Ocean of the Spirit*.

Jens Ferdinand had set his merry-go-round in motion. It

was an ingenious little machine, driven by clockwork. A kind of puppet theatre or circus. *The Black Cauldron* was written above the little cardboard proscenium, which was decorated with grinning satyr masks.

But the piece being performed was anything but funny.

The background represented a grey ocean, dotted with mines and periscopes, and the air above the horizon was plastered over with a formidable collection of aeroplanes. In the left foreground there was a quayside with a group of figures in party dress sitting around a table weighed down with bottles and glasses and small flags. And now a ship came sailing in, loaded with money bags and gold bullion, and as it passed the bridge the party-goers rose excitedly and waved hurrah with their arms. And the ship sailed on.

The scene was repeated and was in danger of becoming a little tedious, but then, suddenly, something else happened; the typographer pressed a button; an explosion was heard, and the ship disappeared without trace out at sea. At the same time the party-goers on the quayside had been replaced by a group of women and children, dressed in black, standing uneasily and raising their arms in despair.

But before long it all reverted to the first act with its party and welcoming scene . . .

"Aye, you've made a good job of that," commented Myklebust. "But the action's a little on the simple side, isn't it? It reminds me of those hard-boiled socialist satirical magazines from before the war. Are you a socialist, Hermansen? Yes, of course you are; ugh, so's Thyge, I think, he just doesn't say anything; he only sings. But *I*'m certainly not, by God. I'm a nationalist, a patriot."

He nudged Jens Ferdinand and whispered meaningfully: "I had to get out, you see. They were after me, to shoot me or send me to Germany . . . but then I managed to get myself disguised as a *priest* . . . oh, well, but that's a long story . . . you can hear it another time."

Thygesen extracted a bottle of Ainslie from his coat pocket and planted it on the table. Jens Ferdinand fetched glasses and water.

"Cheers," said Myklebust hoarsely. The two guests emptied their glasses at a single draught, and Thygesen hurried to fill them again.

"Another glass of the mahogany, please, Thyge," said Myklebust. He was sitting bent backwards, with his feet apart and his hands hanging limply down, staring at the merry-go-round. "Yes, but what do you really *mean* by it?" he asked. "Are you going to have it put on show?"

"It was originally going to be something with dancing fairies to put in Masa Hansen's shop window at Christmas," said Jens Ferdinand. "I usually draw or make something of that kind for people . . . it makes me a bit of extra money. But then I made this instead. For my own amusement, really."

Myklebust nodded. With a quick movement of his arm he took hold of the new glass of mahogany coloured liquid and had a drink without wishing their health. Thygesen did likewise. Their tempo was a bit too fast for Jens Ferdinand; he was already beginning to feel strangely mottled and sandy inside. Thygesen laid a paternal hand on his arm and said gently: "Don't try to march alongside us, my friend . . . we are the *shock troops*."

"When the war's over," began Myklebust. He sighed without completing the sentence, but he took it up again a little later. "When the war's over, you, you caricaturist, what's your name? . . . you'll have to come with me to Norway. I'll bloody well make an artist of you."

He returned to his contemplation of the merry-go-round. His baggy eyes were quite bloodshot. He gave a deep sigh and murmured: "The Black Cauldron, aye, indeed. I suppose it symbolises the Cauldron here, eh? Or the North Sea? Or . . . well, I suppose the whole world, the entire present age, doesn't it? Aye, the Lord protect our coming in and going out. Cheers. Now they're killing thousands of Polish and Jewish prisoners in the German gas chambers. Don't call it barbaric - that's not the word. Don't call it Hell, for that doesn't cover it, either. When all's said and done, Hell encompasses a moral dogma. No,

246

our age hasn't got a bloody term to cover the sins that are being committed today. It's brand new, the whole lot of it. It's never before been seen. Scientific cannibalism. Natural catastrophes set in motion by small-minded folk, shoemakers and tailors and greengrocers . . . decent folk, fundamentally, who would shed a tear if they saw their mangy dog get its tail jammed in a door."

Shaking his head, he got up and sought Jens Ferdinand's glance with his heavy eyes, adding: "Decent little people, then. Not ignorant. Not barbaric. Not stupid. But superstitious and afraid. Related to dogs that bite you out of fear. In some Wagnerian hall with Victorian furnishing there's a benighted, phobic painter's mate holding Jove's lightning, the unfailing lightning of modern technology, in his nervous and anything but chivalrous hand. While with his other hand he blesses the little children whom mothers bring to him in countless numbers. To Hell with him. Tread the vermin underfoot. Squash the earwig flat . . ."

Myklebust got up lurching and thumped the table so that the merry-go-round jumped and came to a standstill: "Kick the dog to death, it's got rabies. *Hitlerism must be crushed.*"

Myklebust had shouted until he was hoarse. He settled down heavily again and leant forward. "The future will fashion new words, terrible words for the nameless sins against humanity that are being perpetrated. Cheers. Sing something, Thyge, there's a good chap."

Thygesen had lit himself a cigarette; he took the guitar, rocked to and fro with his head and sang, this time in a high falsetto:

> Now the bridge is falling down,
> Now strikes the clock eleven,
> The emperor stands in his shining lofty hall,
> As white as chalk,
> As black as coal.
> Go forth, oh warrior bold,
> With death thou aye must reckon,

> He who comes the last of all,
> Ends in the deep black cauldron.

Thygesen produced a few plopping final notes and clicked his tongue loudly.

Myklebust had got up again; he threw his hands deprecatingly in the air: "Not that, Thyge. We'll have no defeatism as long as I'm here. We're going to win. We want nothing less than the total annihilation of these monsters. We want to see Norway and Denmark free. Sing a patriotic song, for God's sake, Thyge. Or one of your hymns. Sing a hymn, Thyge. Something to comfort us, something to comfort us."

Thygesen sighed, emptied his glass, cleared his voice a couple of times, sighed again, struck a deep, warm chord and finally broke into song:

> The cheerless night is waning fast
> And glorious day is dawning bright . . .

During the afternoon the black showers of sleet merged to produce driving snow; the wind grew in intensity, and in the evening the south easterly gale thundered through the pitch black streets and plastered doors and windows with cakes of wet, salt snow.

At about nine o'clock there was a loud knocking on the door of Angelica Cottage. Magdalena, who was the only one still up, had difficulty in getting the door open. A small, heavily cloaked figure was standing outside; it was difficult to see whether it was a man or a woman. Whoever it was, was out of breath and spoke in a choking voice, as though in distress. Magdalena managed to drag the strange visitor inside, and to her amazement she saw that it was Pontus the watchmaker.

Pontus unwound an enormous shaggy scarf from round his neck and with some difficulty loosened the ear flaps of his fur cap, which had been tied under his chin. His face was glowing red, and cakes of melting snow were dripping from his beard and eyebrows. He was gasping for breath, and it was some time before he could make himself under-

stood. Magdalena was full of anxious misgivings; her heart was beating violently; she sat down and hid her face in her hands, but suddenly Pontus exploded with laughter, and came across and shook her.

"Eleven thousand pounds," he said. "Look, girl. My God, but that's nothing to look miserable about. Frederik's telegraphed that the Admiral has sold fish for eleven thousand pounds. Don't you understand what that means? It's top price. Absolutely top price. It couldn't be better. It's a record, my dear. And then he says: 'Love to Magdalena'. Aye, congratulations, Magdalena, my heartiest congratulations."

He shook her hand convulsively and showed his black teeth in something half way between smiling and weeping. "I had to come up to tell you; I couldn't be on my own with the great news, and Frederik has no other relatives, and I've none myself. I had to have someone to share my joy with. And you need a bit of encouraging news up here, considering what you've had to go through recently. But now you'll see, Magdalena, things are going to be brighter."

"So we can expect the ship back . . . well, when?" asked Magdalena.

"Hey, steady on, my dear," said Pontus, rubbing his wet nose. "The Admiral's not coming back on this trip. For I've hired it for at least another two trips and I'm having it provisioned in Aberdeen and sailing direct to Iceland without landing here on the way. Understand? We must make the most of the time. Time is money."

He winked roguishly at Magdalena. "Well, I'd better be getting along, Magdalena, for the snow's melting on my clothes, and I'll soon be drenched to the skin."

The watchmaker wrapped himself up again and disappeared with a satisfied little grunt into the tempestuous night.

# 6

Thick snow falling over black waters. As white as chalk, as black as coal. The little motorboat the Kittiwake slipped quietly out through the long fjord; this was no place for open exhausts – the engine emitted no more than a quiet chuff-chuff. The skipper, Kristian the Beachman, smiled as he quietly announced that he'd had extra silencers fitted. This had been done so as not to attract more U-boats than absolutely necessary. And with this poor visibility they ought to be pretty safe. And in any case, not a sparrow falls to the ground except . . .

Jens Ferdinand was quietly surprised to hear these words. The man belonged to the bun sect and was longing for the end of the world with all his heart. But such is the human mind.

Kristian's white-haired son Napoleon was at the wheel, a lad strangely like an overgrown garden, with eyelashes so long and fair that they imparted to his eyes something of the quality of half-open marguerites. He seemed to be what is known as an albino; his face shone flour-white under the black sou'wester.

As white as chalk, as black as coal.

Jens Ferdinand was suffering from an intolerable thirst. But there was a remedy for that: Kristian the Beachman drew a generous draught of water from a newly-filled barrel. The fresh, ice-cold water was bliss itself to Jens Ferdinand's mouth and throat. But as soon as his thirst had been quenched he was overcome by a dislike of fresh water which was just as irksome. His stomach felt as though it was full of half-dead fish squelching around sleepily and weakly flapping their gills. He disappeared behind the poop for a moment to take a swig from his hip flask. It held no more than could be contained in a soda water bottle, alack and alas. So he would have to go easy on the life-giving golden drops.

Meanwhile, the little *snaps* had its effect, and gave a good, long-term perspective to everything. Here he was, on board a lousy little boat coughing and spluttering across the enormous floor of the Atlantic Ocean. Almost like a Sahara Desert ground beetle. And as the sole passenger on board, there he was as though fixed outside time, at least for a moment. He was a scarab, a creature insignificant but sacred, unheeded but racked by the divine world thirst, that sacred urge to belong in the totality of creation, to feel himself as part of the convoy making up the solar system, a participant in the breathtaking and probably crazy expedition to the constellation of Hercules. A curiously battered convoy, too, most of it doomed to destruction . . . from a completely carbonised Mercury to a Pluto entirely covered in ice. And as to whether there was any life left amidst the impenetrable cover of smoke on the SS Venus, that was a matter for conjecture. On Mars they were all dead from cold and scurvy, and those great ships Jupiter, Saturn and Uranus were without a crew, deserted and left to drift aimlessly with their cargoes of acid and poison gas. While on Earth a bloody mutiny was raging . . . but enough of that. What a charming collection.

A bit of a breeze was getting up, and it was turning cold. Jens Ferdinand found himself a place at the top of the stairs leading down to the cabin; there he could stand comfortably in the shelter of the poop. But at the same time he was appalled to feel the octopus tendrils of melancholy creeping vengefully around him and taking hold of him with their suckers. It started as an ordinary heartfelt sigh: If only I were sober and could think clearly. Then came another sigh from a greater distance, as though from one of the oldest and deepest cellars of his soul: If only I were normal and well built, with the authority of a grown man, the imperturbable authority of a man alive to his own responsibility. In short, if only I were like *Johan* used to be.

And then came a mighty wave of self-reproach: Why were you never fond of Johan, your only brother? Why

were you not numbed by the news of his death? And when sickness sank its scorpion claw into him – why did you not sorrow on his behalf?

Not that you were pleased about it, Heaven forbid. You are not exactly a monster, when all is said and done. But sorrow and pain . . . ? Be honest: never. But on the other hand, was there not perhaps after all a certain . . . *Schadenfreude*? Good heavens above, what are you getting at? No, I wasn't insinuating anything, but search your heart, sir – wasn't there *something* in that suggestion? Didn't you envy him his health, his stature, his superiority, and – yes, first and foremost his fiancée Liva? The natural ease with which he appropriated her without further ado, right in front of your eyes . . . didn't it both infuriate and mortally upset you?

Yes indeed! shouts a rasping voice from the edge of the audience.

The tiny demons of retribution were surely already at work. The bigger ones would follow. An oppressive smell was rising from the cabin, making him want to vomit – he didn't otherwise usually suffer from seasickness. He quickly grabbed his bottle and took a hefty swig. And then another.

No, he went on, more and more buoyed up by righteous indignation: Never ever have I felt envy or jealousy towards Johan. You're playing far too easy a hand, my fine friend. Surely it's obvious that the crippled brother would be bitter towards the one who was well shaped . . . a cheap film motif of course. And what about the brother's pretty fiancée? But this is no cheap film with an expected happy ending, my dear sir. For my own part I have never felt that I've had less than my share. What my brother had in looks, I compensated for in intellect. I had the ability to see perspectives, to comprehend, to understand. Not that understanding leads to happiness and certainty, on the contrary, it is more inclined to lead to endless worry.

Jens Ferdinand had a feeling that these last thoughts were straying from the point and ought really to have

been left unsaid. They revealed a weakness in his general argument. The shouts from the demons on the back rows of the auditorium became more offensive: You were born with the gift of philosophical composure, mock Archimedes that you are. That's why you went blubbering in the middle of the street yesterday even while you were perfectly sober. "Liva! I love you!" you howled like a mangy dog.

The sound of heavy coughing suddenly emerged from the cabin, followed by the champing of someone in troubled sleep. What the devil . . . were there other passengers on board, then? Jens Ferdinand clambered down the staircase. Yes. Stretched out on a bench, lying with one hand under his neck and the other hanging limply down, someone lay fast asleep. He looked remarkably like . . . indeed, it really was none other than Simon the baker!

Jens Ferdinand returned to the deck. He plunged his clenched hands deep in his pockets.

Well, why not? Why not?

Calm down. First of all admit your own faults. Acknowledge your own motives.

He emptied his bottle and perceived relief momentarily burgeoning in his tired mind, but the tender shoot froze and withered, and misery returned with all the inevitability of a chemical process. It was no longer snowing. The retreating shower hung wide and leaden grey like a mountain landscape in the west. Another shower was gathering in the east. A desolate island loomed into view in the midst of the ocean, everywhere dusted in white except by the water's edge, where the sea's warm breath had washed it black.

As white as chalk, as black as coal.

Jens Ferdinand found Kristian the Beachman. "You don't happen to have a medicine chest or something on board?" he asked.

"Seasick?" said the skipper with a smile, and Jens Ferdinand nodded with hope in his eyes.

"No, I'm afraid we haven't got any medicine on board.

But you could have a drop of coffee." Kristian raised his bushy eyebrows questioningly.

"No, thanks."

No, there was nothing for it but to endure to the bitter end. Jens Ferdinand flapped his wings and opened his mind to bitter thought: Come on then, you devils. Yes, I know, I'm a heartless, self-centred cripple. A cynical egoist. This trip, this mission to the dead, these obsequies . . . all right: I had thought of it all as a kind of – platonic – courtship. But in fact I'm a ridiculous figure lusting like a love-sick tomcat for my brother's grieving widow, and I'm livid because I've got a rival on the journey.

Fine. Is there anything else you want to know? For instance, what I'm going to do now that I've been un-masked? OK, I'm going to drink. Get it? I'm going to get hold of a bottle and quite simply drink myself silly and get to where the scarab lives. I'm no good among living beings in any case.

He leant out over the gunwhale and tried to vomit, but without success. He noticed that his hands were pale green and dirty like turnips.

"Napoleon says that Karl the engineer has got some tincture of cinchona," whispered a voice in his ear. He pulled himself together with a start to see Kristian the Beachman's bushy eyebrows and everlasting smile.

"Be an angel and let me have that bottle," he groaned. "I'm so ill, so ill."

"It's one some passenger once left on board," said Kristian as he returned with the bottle. "You're welcome to it if you think it'll do you any good. You don't look at all well, Jens Ferdinand."

The bitter drink thrust its mordant roots throughout his body, and a sweetly-perfumed herb of innocent peace grew up within him. His ears were filled with a high-pitched joyful ringing.

He emptied the little medicine bottle and threw it over-board.

★

The cinchona did not keep him intoxicated for very long; the prolonged chimes died away and dissolved into a confused jangling and jingling, and then the bill was immediately placed before him in the form of headache and seasickness . . . he leant out over the gunwhale and brought up a little green bile.

Alas, alas. It's easy enough to take a heroic stance before trials for which you are not yourself responsible, but not when the suffering comes simply as the result of foolishness and weakness. And just as the blessings of intoxication are mere delusion, so, too, the curses of intoxication are fundamentally something of a joke, a cruel joke . . . it is a kind of caricature suffering, painful and distressing enough at the moment, but in a week's time, when the thorn of immediate pain has been drawn, they will produce no more than an indulgent smile.

But unfortunately, you can't take this smile on account. You know this perfectly well, and that knowledge is itself part of the devilish torment of retribution. You are condemned to stand with the bitter taste of bile in your mouth and on the verge of insanity, and yet you know all the time that it's only a passing phase. Frivolously and foolishly you have forfeited your real self . . . and now it's wandering about lost and with a darkened mind, longing to be back where it belongs, and sooner or later it will find its way back, but before that . . .

Then suddenly something put all the dispersed elements back in their proper places: *a periscope!* A tiny vertical line sticking out of the dark water, a walking stick taking a stroll all on its own out in the ocean, and leaving a tiny wake of wavelets behind it.

Kristian and his son had also seen it and immediately reversed the engines.

What else could they do? There was in any case no point in the little Kittiwake trying to make its escape from a U-boat. There was no mousehole here where the poor little creature could seek refuge. There was nothing for it but in all humility to hope that this big fierce cat was a kind cat,

an understanding beast with a warm heart, which would only reluctantly stoop to murder. Kristian the Beachman had made the decision to stand and smile; his smile was that of someone at the photographer's, slightly embarrassed at the hidden eye taking aim at him.

The engineer had come up from the engine room. He carefully took a pair of clean horn-rimmed spectacles from a case and put them on over his oily face.

Jens Ferdinand felt icy cold all over; he was aware of tension and tightness in every pore, as though he had been dipped in a solution of alum, but never in his life had he felt himself so collected, so much a single entity; his thoughts were clear and cool, like those of a general: it was unlikely that the U-boat would waste a valuable torpedo on an old tub like the Kittiwake. So in all probability it would soon show its conning tower on the surface and give the boat a single coup de grâce. And that would be that.

Unless they made a counter-move. What do you do in a situation like this? How do you surrender? Suddenly he raised both his arms in the air and signalled to Kristian and the other two to do the same. The few German phrases he could remember suddenly obliged by making themselves available to him: "Freunde. Freunde. Nicht schiessen!" Presumably they have their monitors to hear them. Amazing how much German you can remember when you really need it. "Wir sind okkupiert! Sie willen uns befreien, Freunde! Heil Hitler!"

These hypocritical intimations of submission, uttered in the brisk tone of a command, would surely have their effect. But of course, they would be rejected. Of course. No cowardly surrender here.

A reckless flame had been lit within him. He cupped his hands and shouted at the very top of his voice: "Nur schiessen, Schweinhunde! Morder! Gaskammerschweine!"

"And get a move on," he added in his own language. "Get a bloody move on. Schnell. Schnell."

The periscope was no longer moving. Kristian and his

son and the engineer stood staring at it. All three of them were completely petrified; even Kristian's smile was almost extinguished, and Jens Ferdinand felt the paralysis spreading to him, too. He was no longer icily cold, but burning throughout his body; his blood was pounding in his temples and baying in his ears. So this is how it's going to end, a voice said within him, but no thought arose as a result. There was only this pounding in his heart and his head. And then a vague regret at having exposed the bespectacled engineer and Kristian's young albino to this. Never mind the rest of us. Especially never mind the baker!

And then, gradually, the feeling of having a bullet in the midriff, the dull sense of having been shot . . . he recognised it from certain kindly dreams of revenge . . . there was no sense of pain . . . it was too *extensive* for that. It was too broad, the words began to grind around in his mind, too extensive, too extensive . . . like a fly being hit with a leather belt . . . extensive, extensive, extensive . . . !

The four men on the ship stared hypnotically at the periscope. It moved. It rose a little from the water. But then it was lowered. It disappeared. Slowly. Deliberately. There was a low sucking sound under the water, and a hollow snap. The torpedo being fired?

"Simon!" Kristian suddenly burst out, and like lightning he rushed forward and disappeared below deck. The albino pulled a face as though fighting an attack of sneezing; his mouth fell open, and for a moment he looked just like a baby about to start crying.

But nothing happened. Nothing except that the periscope was no longer to be seen. Kristian returned with Simon, who was perfectly calm, indeed even yawning a little, heavy with sleep, screwing up his eyes good-naturedly in the light. Kristian shook his head gently, and his smile returned. His son's face, too, adopted its customary form, expressionless and overgrown with light down and eyelashes. And the engineer took out his spectacle case again and carefully replaced his fine spectacles in it.

And the engines started again. And light snow began to

fall over the everyday grey water. So life had returned. Jens Ferdinand was still scarlet and sweating all over as though he had a temperature. But this warmth disappeared, too. And then came something reminiscent of disappointment.

"You're ridiculous; you always have been and always will be," he confided to himself on the point of tears. "Whatever situation you're in, you act the fool. Now, for the rest of your life, you'll be pestered by the memory of this episode at sea when – presumably (and luckily for you) speaking to deaf ears – you renounced Hitler and put four innocent human lives at risk purely and simply to strike an attitude. Or no . . . Not even that. In actual fact, you had murder in your heart. You wanted to get rid of Simon the baker. . . ! There, now you've said it."

Simon rubbed his eyes and gently brushed his clothes down. Dressed in a brown smock and wearing a dark blue Faroese cap, he looked every bit the honest and sensible farmer. He glanced around in an almost matter-of-fact manner, nodded to Jens Ferdinand in recognition and understanding, and went over and shook his hand. There was nothing unbalanced about him as he was now; he was a respectable and thoughtful man undertaking a journey. Moreover, he must be very tired after the excesses of yesterday and the preceding night when he was going around knocking on doors and proclaiming the Day of Judgement.

"No, I felt in myself that the hour had not yet come," said Kristian. "God's numbers were not yet complete."

Simon made no reply, but was briefly lost in thought. A moment later he was up in the wheelhouse refreshing himself on a mug of coffee. As though he were a quite ordinary, nondescript person . . . a smallholder or fisherman summoned as a witness in a boundary dispute.

Ahead of them a great violet bay opened out in the grey-red showery sky, and a strip of sunlit mountainside came into view. Simon thanked Kristian for the coffee, wiped his mouth and descended from the wheelhouse. He went across to Jens Ferdinand with an expression of kindly concern on his face.

"Seasick? You should have a cup of black coffee, it would buck you up. Don't you want one? All right. Seasickness is a nasty thing. But when all is said and done, it doesn't last. Hm. Aye, we're both travelling on the same errand, Jens Ferdinand. I wanted to be a bit of help. For Liva's sake. She is such a splendid woman, you know. And she must be having a difficult time of it, all alone with what has happened. She was so very fond of him. But it's a good thing there are two of us to comfort her. Or rather: five, for the other three here on board are coming with us, of course. How old was your brother? Only twenty-nine! And how old are you yourself, Jens Ferdinand? Twenty-five. Oh. I'm thirty-eight myself. I knew your father quite well, Martin from the River Cottage; he was a carpenter, such a good, quiet man. A sensible, honest man. He helped me to build my house. That was a long time ago, though. And a lot of things have changed since then."

Simon the baker uttered a prolonged sigh ending in a rather old-mannish ho-ho-ho-ho. Then he withdrew, brooding, and slowly settled himself on the cargo hatch beside Kristian the Beachman, who was smiling in wonderment, still moved to the bottom of his soul by the great event of the day.

Jens Ferdinand was shivering with cold and irritability; there was the bitter taste of cinchona drops and bile in his mouth, and the clammy fish within him were once more squelching around half dead and pressing on his heart. Exhausted as he was, he clung to a memory . . . an old memory, a little worn from the many times he had taken it out for consolation, but nevertheless still very much alive:

It is not long after his confirmation . . . all the children have been for a cup of chocolate at the pastor's house and are now on their way home. Liva and he are walking together. They are of about the same height. Liva was little and slightly built at that age. She is wearing a white dress, and her dark plaits fall heavily against the thin, soft material. As white as chalk, as black as coal. Then there is a

cheerful shout behind them: Liva! It is Pjølle Schibbye running up; he is big, with down on his face, and he already has a deep voice. Pjølle was such a kind lad, helpful and fat and amusing.

"What about coming home with me, then we'll have a bottle of pop and smoke a cigarette up in the warehouse loft?" he says.

"Yes, Pjølle," says Liva gaily.

But now he bends down towards her and whispers something in her ear, and she suddenly blushes deeply and in her confusion takes Jens Ferdinand by the arm.

"No, Pjølle," she says and shakes her head energetically, at the same time clasping Jens Ferdinand's arm. She will most certainly not go with Pjølle.

"All right, then, don't, you silly little schoolgirl," he says irritably. He grabs one of her plaits and flicks her neck with it: "What are these things – cows' tails?"

Pjølle stops and is swallowed up in a new group of girls and boys, and his carefree laughter can be heard further away.

"What was that he whispered to you, Liva?" asks Jens Ferdinand innocently.

"He said we could . . . you know," replies Liva, adding: "That's what he's like. I know. There are quite a lot of them like that."

. . . Jens Ferdinand leant against the gunwhale and looked at his turnip-green hands. For a brief moment that little memory filled his turbid being with innocent green leaves, cool damp sorrel leaves. It had been spring; the weather was showery and the light intense; his expectations great but undefined; alas, alas, he could weep over it. So now he was at it again, dripping with sentimentality. Liva . . . she had clasped his arm, she had stayed close to him for protection. He had lived on that little experience for years, modest as he was, self-effacing, hopelessly handicapped, despite his youth resigned like an old maid.

And he continued with his memories.

A few years elapsed; he saw Liva now and then; she

became a grown woman while he himself was still the same stripling as when he was confirmed. Children and young people all towered above him – that's how it was, and there was nothing he could do about it.

Another blustery spring day he sees himself going past the Tarnowius quay and finding Liva standing together with some other girls and women, washing fish in huge coffin-like wooden troughs. It's cold and frosty and most of the women are bluish-red in their faces. So is Liva; she looks tousled and harrassed, but her hands are working willingly. She is busy, but she nods to him, and they exchange a brief glance, and for all the rest of the day, indeed all the following days he wishes he could do something for her . . . for instance go over to her and say: "You mustn't stand and get cold here, Liva. Come with me: I already earn fifty kroner a month in the printing works, and you can have them." And then he would take her hands and rub them and warm them . . .

But shortly after this he meets her one Sunday evening together with her sister Magdalena and two young, well-built lads, and then he is once more made to feel how small he is and indescribably superfluous. One of the two young men is Pjølle. Liva looks very taken by him, but nevertheless she has time for a brief, kindly nod to Jens Ferdinand. He, too, is in his best clothes, elated by the Sunday evening dancing . . . but as usual, he is walking home alone, diminutive and overlooked, a mere spectator, a voracious reader of the book of life. And Pjølle is both tall and well-built, and then he is wealthy, too.

But he *shall* not be the one!

Good God, frail as he was, he was strong and determined in this one desperate wish: it must not be that libertine Poul Schibbye, that seducer and fop. Liva must not be wasted. Liva must be happy!

And he goes home and lies working out what words of warning he will say to her when they next meet: "You mustn't throw yourself away on someone who isn't worthy of you. You must guard that treasure they call life. There is only one life, and your youth will never return."

261

Then, finally, the evening arrived when Liva became Johan's.

And it was I, the helpless onlooker, who brought them together, thought Jens Ferdinand, grimacing tearfully at the ocean. It was I who suggested that Liva should come home with me, and I did it quite deliberately. I was so eager to bring those two together. Not really for his sake or for hers . . . but for my own, of course. I can see that now. But then I really felt I was a kind of superior being, a lifesaver, ugh. I enjoyed seeing her every day and having her around me. And while Johan was away at sea I was a sort of stand-in. I had her alone, for myself. I enjoyed it. Enjoyed pretending I had no erotic interest in her. I suppose I didn't, either. It was her *soul* I loved. Perhaps that sounds affected, but it's true even so.

Aye . . . and then disaster struck Johan.

And then, naturally, you're no jackal, and you withdraw doggedly, taking care not to take advantage of his handicap; you make yourself hard and bitter, you avoid her, happily you have other interests, and for a time you become almost a sort of woman-hater. You lie to yourself . . . out of decency. For the fire deep down inside you is still burning, even if it is in a locked and blacked-out room.

You know all that perfectly well. But you become practised in lying.

Until one fine day you burst down the door, like a thief breaking in.

Jens Ferdinand thrust his hands down in his coat pockets and bent forward, lowering his head as though to meet a heavy hailstorm, the hammering hailstones of self-scorn and dull disgust.

I ought to jump overboard, he thought bitterly . . . so that this impossible drama could end with the annihilation of the onlooker. . . !

But the drama continues with all the implacability of fate, while the spectator looks on.

A tall, serious man, with sharp features, but with a

vigorous growth of fair hair still bearing the traces of youth, and a little hunchback with intelligent sharp eyes and a sarcastic tongue arrived at Hansen's Hotel and asked for Liva Berghammer. Martha the maid looked at them curiously; she estimated the tall man to be a schoolteacher, but gave up in disgust at the little man – she had never been able to stand ugly or deformed people.

"Have a seat, and I'll fetch Miss Berghammer," she said in a formal tone.

Liva came straight away. Her face was waxen and she looked as though she had just lacquered her eyebrows and lashes. As white as chalk as black as coal. Her part-open lips were devoid of colour and slightly cracked. She looked around the overcrowded room with eyes that clearly showed her to be in need of sleep. It was some time before she discovered Simon ... then, suddenly a bright light came to her eyes, and two clearly defined patches of red appeared on her cheek. Two red flowers. Yes, by God that's what she did, she burst into flower ... like a rosebush. And as she approached Simon she tossed her head as though she was shivering with cold and closed her eyes.

He rose and took her hand; she inclined her head and he touched her hair with his lips.

Jens Ferdinand had also got up and was standing watching, part in protest, part in awe. The little scene was undoubtedly beautiful, a rare union of grandeur and grace ... an unhappy girl and her spiritual mentor! He vaguely remembered something about Jesus healing the woman with an issue of blood. Aye, she was healed, all right; the bloom spread all over her cheeks. He felt hot and wicked bubbles rising within his breast, as though some destructive and agonising decoction was seething there; he could scarce hold back his tears, ridiculous and humiliating as it was; never had he felt so expendable as at this moment, so degraded by his irrelevance. It was incredible, completely absurd, that she has not even noticed him. Red-eyed, he held out his slender, dirty and icy hand to her.

"Jens Ferdinand. Are you here, too?" And then came

the exchange of a few everyday words. "Thank you for coming . . . it was kind of you . . .!"

And then Simon again. Again this deep inclination of the head, this humble devotion, the trustful light in her eyes . . . yes, indeed, this is love – sublimated . . . although . . . it'll never be forgotten.

Now Simon took her hands; she sat down at his side; they held their folded hands together and prayed with eyes closed.

Jens Ferdinand moved away, as far as possible, sat down at another table, beckoned to the waitress and asked for a beer. He drank it down without glancing at the praying couple. Religion was only masked eroticism in any case. At least young women's religion. All these girls and sinners with their hope and faith, their compassion and despair . . . the female disciples . . . the woman at the well, the woman who salved His feet, the women at the foot of the Cross, the woman who met the risen Saviour in the Garden . . . !

But good heavens, thought Jens Ferdinand as he drained his second glass and considered ordering a third: "All goodness, all beauty . . . at bottom, most of it is sublimated eroticism . . . Like birdsong. And it's far more natural to us mammals."

"Another beer, yes please."

Jens Ferdinand ducked down and felt like doing something desperate. He felt a sudden urge to get up from his seat, point to Simon and shout: "You're under arrest! I arrest this man. He is a notorious violent criminal, a sexual miscreant. And the young woman is my beloved fiancée, the only woman I love, the woman who is everything to me in this life. My sun, my sun! My star in the night. *Halleluja!*"

"Who's that man sitting over there with Liva?" whispered Martha, bending over to him as she filled his glass. "Is he her father? Or her brother?"

"No, he's her fiancé," replied Ferdinand. It amused him to confuse the girl: "Her new fiancé, that is to say, because the old one's dead."

264

Martha stared at him and shook her head. Then, with a toss of her head she replied: "Oh, you are horrible!" And her mouth twisted in disgust as at the sight of a spider as she retired with the empty bottle.

Jens Ferdinand drifted around alone in the wet, misty streets. There was an odd sense of consolation in knowing himself to be alone in this alien place, where no one knew him. Twilight fell, a dense twilight in which glowing cigarettes and pocket torches flashed eerily here and there. Sleepy trucks equipped with medieval horn lamps were forcing their way through the narrow alleys. It was an old town, this, strewn with tumbledown hovels and ramshackle houses.

The sound of subdued bagpipes could be heard in the distance . . . it came closer; he arrived at a conglomeration of temporary huts lining dead straight concrete roads. The black-painted doors were closed, and there were signs in white on them saying NAAFI, Post Office, Sergeants' Mess. The sounds of singing, raucous voices and wild bagpipe playing issued from one of the huts. Two men in civilian clothes opened the door a little and slipped inside. Jens Ferdinand followed them, unnoticed, and found himself in a smoke-filled hall rather reminiscent of an old-fashioned madhouse such as he had seen in pictures, with demented patients mixing freely with each other and allowed to do as they like. "No civilians allowed," - he heard the words, spoken a little wearily and unconvincingly by a pale, fat man with rolled-up sleeves; he led the men in civilian dress across to a corner where he revealed his false teeth in an enquiring smile while at the same time scratching the back of his neck: "No, we've no gin. Whisky?" he looked around, whistling, and stuffed a bottle down into Jens Ferdinand's pocket; then he whispered a price and took the notes with a yawn. Finally, in a loud, stern voice, he shouted: "Not in here; no civilian visitors allowed."

Jens Ferdinand slipped out into the darkness again. It was pouring with rain. Where should he go?

Quite unexpectedly he found an instant solution to the problem: immediately in front of him there was a black

cave gaping in the cliff; all he needed to do was to go inside – it was an air raid shelter hollowed out in the rock. There was an acrid smell of mould and tomcat, but at least he had a roof over his head, and he was left to himself. There was even a sort of bench to sit on.

He unscrewed the top of his bottle.

"Your health, sir," he murmured, with a slight, deferential bow in the dark. "And welcome to the island of Jan Mayen one rainy October evening in the year of Our Lord 894. It's nice and clean and uninhabited, swept out and washed, and everything freshly polished. May I introduce you to the absolute polar night. Your health."

Simon and Liva walked out along the quayside. They had a great deal to talk about, and there was no peace in the overcrowded hotel. So Simon had suggested that they should go on board the Kittiwake.

"I didn't have a good night last night," said Liva, breathing deeply. "I was so afraid. I lay wondering whether Johan had . . . had grace . . . was redeemed . . . yes, they were the same thoughts as I had after Ivar's funeral, you remember. One is sometimes so weak and frightened, Simon. You said that yourself then, do you remember? You were afraid yourself, you said, and then you said that it was God's will that we should live in uncertainty, it was part of our suffering . . . didn't you? I lay thinking about all that. But that uncertainty, Simon . . ."

"Yes, I remember it all right," Simon interrupted her. "I was weak and pitiful myself then. But that was because I hadn't completely committed myself. I daren't drain the cup that had been filled for me. I was afraid."

He sighed and went on: "I was afraid of the *cross*, Liva. But I'm not any longer. Now I've discovered the meaning of the command that we should take up His cross and follow Him. It is so simple, really. He overcame death on the cross and thereby atoned for the sins of others. That's what we ourselves must do. Those of us who seriously want to follow in His footsteps."

Simon was speaking quite calmly, like a man who has learned his lesson and knows unfailingly which way we he must go. He repeated: "We must atone not only for our own sins, but for those of others. The living and the dead. We must atone for them with our love. We mustn't flinch from any sacrifice."

He stopped and touched her arm. "Liva," he said, with urgent tenderness in his voice: "As the Scriptures say: In this we have known love, that He has sacrified His life for us. *And we, too, have a duty to sacrifice our lives for our brethren.* That is the commandment, Liva. Once we have understood that, then the hour of trial has come in earnest."

They walked on slowly. Simon continued: "You know, they all try to avoid that commandment . . . the Church, the free churches, all these *false prophets* who, as the Scripture says, will be heard in the last days. They try to explain away the difficult truth and make arduous things easy, turn them into something that requires no *sacrifice*. They think that if we only believe, our skins are safe both in this world and the next. As though Jesus did not say quite clearly: He that findeth his life shall lose it; and he who loseth his life for my sake shall find it."

He stopped again, grasped Liva's hand and pressed it hard. "You will come to understand me, Liva, even if you perhaps don't this evening. I know. God has told me that He has chosen you, too, as His mighty servant. He will open your mouth, woman. Before long, you will *speak*. And your testimony shall be heard by many and bring with it disquiet and anxiety and awaken many souls. We must fight the last great battle at each other's side, as God wishes. *Selah!*"

"Selah," replied Liva. She felt dizzy. For a moment things went black before her eyes, and she had to cling on to him. "Thank you, Simon," she said, overcome with emotion. "Thank you for saying that to me."

They went aboard the boat. The sounds of feeble singing emerged from the cabin; it was the three crew members at evening prayer. Simon joined in with a loud voice. Liva,

too, sang along with them. She still felt dizzy. All those devastating, dreadful experiences of the past few days and nights vanished as though time and forgetfulness lay between then and now. She felt *at home*. Indeed, here, with Simon, there was comfort and spiritual elevation; this was her true home, her only home.

# 7

"So eternity is supposed to consist of sawdust?"

"Yes, according to the latest estimates this quite ordinary and everyday substance constitutes the major component in life after death."

The stranger's voice was as dry as a creaking door, and with a little smile that revealed the avenger in his otherwise correct and honest face, he repeated: "Sawdust. Billions of tons, an inconceivable heap of it, so huge that even the Himalayas, massive as they are, seem no more than a speck of dust beside it."

And as, half suffocated, he surrendered himself once more to the rustling, crackling dry matter enveloping him, Jens Ferdinand caught a final glimpse of the famous physicist's cadaverous and phosphorescent grin. With a supreme effort he managed to clear a little space around his face so that he could breathe a little while yet. He opened his eyes and glimpsed a low, sloping wall . . . this was reality, not a dream . . . he was in a small attic room. The cold light of morning was streaming in through a low window. A slender woman's figure was standing by his bed. He had a vague notion of hospitals and nurses.

"You must get up now," came the implacable command.

He suddenly recognised her. Of course, it was the waitress from Hansen's Hotel.

"Do you think I could have a drop of water?" he asked.

She handed him some green liquid in a cup without a handle. He emptied it avidly. It was not water. It was liqueur.

"Thank you, thank you so much," he said warmly.

She gave him a severe look. "You oughtn't to have had it at all, really. The way you've been carrying on. Is there no shame in you? To come home dead drunk and start bawling like a hooligan. Luckily I was at home and got

you out of the way. Yes, you've got me to thank for not ending in the police station. Now you'd better pull yourself together. Gutless creature that you are."

Martha was very angry. Her hand was trembling as she replenished the cup from a conical bottle.

"You'd better have a drop more so you don't go completely to pot when you leave, you little bastard. But then not a drop more. Here you are. And here are your socks and your shoes and your trousers. God knows what gutter you've been lying in, you filthy beast. You ought to have been in clink by now, my fine friend, that you should, but instead I've gone and cosseted you and dried your clothes. But it was purely and simply for Liva's sake. Liva's my friend. She's a lovely person, noble and kind and beautiful. She didn't even get mad when I told her what you'd said . . . about her new fiancé. She told me everything about you, so I was that bit wiser. She said ever so many nice things about you, far better than you deserve, I suspect."

Jens Ferdinand suddenly threw himself down on the mattress and curled up sobbing.

"Now, pull yourself together, you cry-baby," said Martha imperiously. "For you don't expect me to dress you as well, do you? Stop that snivelling. Ugh, you're *really* horrible. . . Good heavens, here he comes to take his own dead brother back home, and then he behaves in this way. First he says the most dreadful things about his poor sister-in-law . . . nothing but lies and nonsense. And then he buzzes off from the others and comes home dead drunk at three o'clock in the morning. If you were *my* brother-in-law, I'd . . . Right, get a move on. You've no time to waste."

Martha banged the trapdoor shut and, still grumbling and fuming, hurried down the stairs.

Jens Ferdinand felt awake and cold; he could clearly remember the events of the previous day – to a certain point. The journey. The U-boat. Simon. His arrival. Hansen's Hotel. Simon's meeting with Liva. The despair that came over him. The visit to the canteen. The bottle.

The air raid shelter. And then? A desperate walk in pouring rain out to the sanatorium. But he couldn't remember how it ended. And then a crowd of singing drunks had dragged him down into a cellar with floors covered with sawdust and wood shavings, and there they had danced to some of the ancient ballads. And then somehow or other he had got back to the hotel and caused a stir and been hidden away up here in the little attic.

And now you've got to get off again ... back to the Cauldron. Back to that cesspit. And they'll be slobbering and blethering over Johan's grave ... Pastor Fleisch ... and, of course, Simon the baker. He could be forgiven if he signed off and left the others to get on with the whole thing themselves. Just at this moment the thought of going back seemed almost more than he could bear. It was simply impossible.

Suddenly a scene from the previous night appeared in his memory and filled him with deep shame ... : A nursing sister in a black dress and white collar ... and then his own voice bawling out: "You've no right to keep the body hidden from me, you executioners. . . !"

There was the sound of footsteps on the stairs, and a gentle knock on the door. The thought flashed through his mind: It's Liva!

Yes, it was Liva. She was dressed ready to leave. Drops of rain were shining like pearls in her clothes and hair.

"Jens Ferdinand, my dear, we've got to leave in half an hour. Do you hear?"

She stepped over to his bed and touched his hair, patted it gently. As though in fever, he grasped her hand and in a choking voice said: "Liva! I . . . I . . . thought you were very angry with me."

"God bless you," she said soothingly. "I'll willingly forgive you what you have said about Simon and me. I'm not at all angry with you. Let's forget all that. Everything except the one thing necessary ... *hope*, Jens Ferdinand ... hope in Jesus Christ."

She withdrew her hand and in an exalted voice ... a

271

voice suddenly alien, the voice of a preacher, like that of Simon, she said: "He is the light of the world: he that followeth Him shall not walk in darkness, but shall have the light of life."

Jens Ferdinand got up quickly, stared at her and said hoarsely: "I don't believe in you, Liva. I'm sorry, but I can't stand your . . . double dealing. You're a whore. Yes, I said a *whore*. That made you open your eyes. *That's* something you didn't expect to hear."

She stared at him, speechless. He couldn't stand that look. He was already bitterly regretting what he had said, but now it was as though impossible to stop; he couldn't control his fury, his sorrow, his hatred, his contempt. He heard himself hissing furiously: "You forgive me, you say. But *I* don't forgive *you*. I'll never forgive you your spiritual whoring, your spiritual incest. You're no better to me than a tart. Understand?"

"Jens Ferdinand," he heard her plaintive voice. "Do pull yourself together. You're drunk. You don't know what you're saying. May Jesus Christ forgive you your words."

She suddenly burst into tears and turned away.

Jens Ferdinand's heart was bursting with compassion. "I love you, I love you," - the words were bubbling inside him. But at the same time his voice sneered: "Jesus Christ! Yes, He can be used for many things. Even as a chaperon, obviously."

And as though summoning up his last strength, he screamed: "For God's sake stop standing there blubbering. Go down to *him*, that sanctimonious whoring devil. Let him console you. Let him *kiss* you!"

Suddenly she turned towards him, grasped his hand, crushed it between both hers and said, in a low, earnest voice: "Jens Ferdinand. You know you don't mean what you say. You know perfectly well that for me there is no earthly love any more. There is only the love of God and Jesus Christ Our Lord."

He felt her breath against his forehead. And the lissom, touching scent of her face and hair. And suddenly he felt

272

how ridiculous he was lying there in his damp underclothes under the waitress's old blanket . . . like a naughty child that has got itself dirty and is exposed to the mercy of women . . . of motherly forgiveness and care. And full of contempt and disgust for himself he wriggled his hand free and turned to the wall with a scornful laugh: "Don't touch me, Liva. Don't filthy yourself on a malformed cur like me. Send me to Hell . . . that's where you think I belong in any case."

And in dull horror he heard her whispering in a voice which was yet composed and warm: "You mustn't be like that, do you hear? You mustn't become callous. And you mustn't think you can push me away. I'm not going to give you up like that. For I'm fond of you . . . I'm almost as fond of you as I was of your brother. I would so much like us to be able to walk together the last part of the road . . . to God. Do you hear? It's only a short road, my dear, for the hour is nigh. So pull yourself together, man, and be yourself. Let me pray for you . . ."

With a mixture of horror and something approaching sensual pleasure Jens Ferdinand felt that she had won over him. He could only give up before this voice which from the simplicity of its heart was praying for him, praying for grace and kindness and forgiveness for him. There was only *her*. There was only her in the whole world. Everything else was insignificant and unreal. Here was the *meaning*. Here throbbed the warm pulse of life, the maternal heart, the first thing and the last. He felt that something had been brought to perfection within him, that a longing had been satisfied, an urge had finally been effaced . . . as when a great river is swallowed by the ocean.

Then began the journey home.

It was cold, with blustery showers. Jens Ferdinand had found himself a place in the stern, behind the wheelhouse; he sat staring apathetically out across the sea where momentary ridges of white were rising here and there among the blue-grey waves.

"Aren't you cold?" – It was Kristian the Beachman's voice. "You look pale. Wouldn't you rather come into the cabin? We've got the heater on."

"I'd rather stay here."

Kristian returned with an overcoat, an old, stiff oilskin coat smelling of whale oil. Jens Ferdinand pushed the coat and the helping hand away: "No, I don't need it. I'm not cold." But smiling stubbornly, Kristian spread the coat over his knees and stuffed its sleeves down behind his thighs so that it could not blow away.

Liva was sitting leaning against the lee side of the poop, wrapped in her travelling rug. Four soldiers sat silently below the wheelhouse. One of them was wearing an officer's insignia – a very thin man, almost shadowy thin. He took out a large pair of binoculars and scanned the sea. Liva was battling with sleep, sometimes losing herself entirely ... it was a blissful feeling. But then she was awakened again by the movement of the boat and shivered with cold. Before them lay a dazzling rampart of sea and sunshine, gradually coming nearer ... and just as she was again on the point of dozing off the boat glided into the torrent of sunshine; the light was reflected off the wet coffin on the cargo hatch with a brilliance that hurt her eyes; half asleep she heard a whispering voice singing: Death, where is thy sting? And for a moment she sensed a glow of ecstasy that was almost more than she could stand: Death ... death is no more, it has been vanquished, trodden underfoot by the victorious Lord of Life. It went dark before her eyes; she felt that as a human being she was too frail to bear this mighty grace, this happiness transcending all understanding. Her lips moved in a sleepy smile.

"She's asleep now," whispered Simon to Kristian. "She must be worn out, you know. She's had a difficult time, poor thing."

"I think it would be better if she went down into the cabin," said Kristian. "There's a shower on the way, and there's going to be a good deal of spray once we're south of the point."

"Isn't it terribly stuffy and overcrowded down there?"

"No, there's no one but Pastor Fleisch. So one bench's free." Kristian gave a broad smile. "Yes, the pastor's been there since early this morning . . . he came to make sure of a bench to lie down on, he said. He'd taken some travel tablets and needed to lie down . . ."

The two men carefully led the girl down into the cabin and wrapped the rug around her. It was pretty hot down there, and the two inner rings on the stove were glowing red.

"Good morning," Pastor Fleisch greeted them amiably from his bench. "Oh, it looks as though some poor creature's seasick. Aye, seasickness is a miserable thing. I myself have . . . oh, but it's Liva Berghammer. Yes, good Lord, yes, . . . I *have* heard . . . yes, it was a terrible blow . . . and so soon after her brother. . .! Unfortunately, it was some time before I was told . . . for otherwise I would have been along to see her. . ."

"Sshh," said Simon. "She's asleep."

"Oh, it's you, Simonsen," breathed the pastor. "Have you been to the capital as well?"

Simon made no reply. He had taken out his New Testament and settled down to read by the sparse light seeping in through the opening in the poop.

"Oh well, oh well," sighed Pastor Fleisch. "It'll be a good job when the journey's over."

A heavy, icy cold shower struck the boat. Jens Ferdinand ducked his head down and plunged his hands into the sleeves of the coat. He heard Kristian's voice: "You can't stay here, you'll be soaked, the sea's getting up. Wouldn't you rather come up to Napoleon in the wheelhouse?"

"No, I'm all right here."

"Then get properly into that coat," advised Kristian, and Jens Ferdinand complied.

The shower passed. An enormous rush of wind and sun streaked across the empty ocean. Then it went dark again. White crests appeared here and there. The boat began to pitch. Jens Ferdinand got up with difficulty; he was trem-

bling all over. Everything went black before his eyes, and in the blackness he saw great stars and sparks. He caught a glimpse of the back of Napoleon's unsuspecting neck up in the wheelhouse . . .

A shower of hailstones whipped across the deck. The boat pitched violently. Pastor Fleisch noted with amazement that his travel tablets actually worked. He allowed himself to be rocked up and down. It was almost pleasurable, and he had a tickling sensation all down his spine, just as he did when he was sitting in his little swing as a child.

Simon the baker was reading his Bible.

"If," thought Pastor Fleisch. "If I were numbered among the arrogant clerics, for instance like Pastor Simmelhag, I would simply have shrugged my shoulders at these sectarians and lay preachers. Or perhaps let myself be provoked by them. But I've never been like that. Not that I deserve any praise for that. For it's not something I've actually achieved by my own efforts. I'm a countryman. I'm not from of a well-established degenerate clerical family. I don't suffer from gastric catarrh or obsessions. I'm engaged in real life. I understand these islanders as well as I understand my own folk from Jutland. I can talk to them in their own terms, and I can take part in their everyday lives, and now and then I give them a helping hand insofar as I'm able. Instead of sitting in my closet cracking theological nuts. And, to be honest, I'm probably not bright enough for that in any case. But at least I have enough brains to know that Jesus was no friend of the scribes and Pharisees. Oh well, let's not be bitter. But if it were Pastor Simmelhag lying here instead of me, and he saw the mad baker with his Bible . . . well."

Pastor Fleisch's thoughts drifted back to the day when Ivar Berghammer was buried. That curious harangue from the baker. Yes, they were the words of an untrained, ignorant man. But what a memory he had. But then that was what Simmelhag would have called glossolalia. Or: the razor of the word in the hand of a drunken man. And

276

yet some of the things he had said were true and weighty. It was a good thing sometimes to see things from the desperate angle, indeed it was. The Apocalypse was the word of God, too. And fundamentally the whole ceremony ended in peace and harmony, when they sang that hymn . . . "Now take we all our leave."

Pastor Fleisch folded his hands and quite quietly hummed the lovely hymn tune to himself. Simon's glum, stern profile was outlined against the half light under the poop. Pastor Fleisch really felt a certain liking for this lay preacher, this baker, this raw human material who had been fired by the Word and felt himself to be a preacher, an apostle, a prophet. None of the Apostles was a baker, of course, but otherwise they were certainly ordinary men, fishers and artisans. Indeed, the Saviour Himself was the son of a carpenter.

"Fundamentally," said the pastor suddenly, having cleared his throat: "Yes, forgive me for disturbing you, Simonsen, but what was it I wanted to say: Fundamentally . . .. oh, this boat is rocking."

He felt himself being lifted up, and for a moment he hovered almost freely in the air, as though the law of gravity had been overcome. But seasick? No.

The sound of a sigh and heavy breathing came from the other bench, where the young woman was lying. The baker quickly got up and went across to her. Seasick? No. She shook her head: "But it's so hot in here."

"Yes, it really is hot," the pastor confirmed, noting that he was sweating profusely. Not all that surprising, really, considering he was lying there in his coat and leather waistcoat and long rubber boots. Once more he was lifted up . . . hey-ho – almost right up to the ceiling. And then he was drawn down again . . . oh! But seasick? Not in the least. Miraculously.

"Where's Jens Ferdinand?" asked Liva.

"In the stern. He's not very well," the baker told her.

Pastor Fleisch started humming to himself again. He suddenly realised what he was doing, and stopped. Perhaps

it was not quite the thing to be doing here on a boat filled with sadness and death. He uttered a long, demonstrative sigh. Aye, aye. He thought: Unfortunately that's what we elder pastors are like, a bit hardened to sad events. When you've been engaged in it for a generation ... indeed, indeed, you can hardly avoid being like that. When you hear of a death, you are first and foremost affected by it in a professional sense. You concentrate your thoughts on what you are going to say at the graveside, and you put personal feelings aside at first ... you save up your reaction for the actual funeral, for the moment when you are in the midst of it all. Perhaps it's not right, God help us, but that's what it's like, and there's no point in trying to make it look better than it is.

But now it would be quite fitting, as I'm lying here with nothing to do and without being seasick, to prepare the graveside sermon which in any case I'm going to have to preach for the poor chap lying dead up there on deck. A sorry fate. A strapping young man, a gifted sailor who defied danger and unlike certain other people I could name didn't stay behind on dry land when sailing became really dangerous. And then he was shipwrecked. But he was saved as though by a miracle. Then only to be struck by another and perhaps worse fate. For our paths are fraught with danger.

But then, what of the danger: Pastor Simmelhag had yesterday specifically declared that he could not understand how he - Fleisch − *dared* undertake this journey to the capital and back over a stretch of sea that was notoriously treacherous in more senses than one. Even if it was not really a long journey, it still took them through the danger zone, indeed right across the theatre of war. And to this his only reply had been: "Oh well" - he didn't want to make a great fuss about it. This was the only reasonable reaction ... he wasn't one for attitudinising. It wasn't in his nature really to be afraid. It was not for nothing that throughout a whole life he had built up a trust in Providence, a trust which had never ever been disappointed.

Strictly speaking, this journey had not been necessary. He could have let his merchant friend Lillevig go himself and negotiate on the ship that was for sale. But despite his many other good qualities, Lillevig was a little unpredictable, easy to fill with enthusiasm and easy to persuade; that had always been his weak point, and that was why things had gone badly for him in the past. He would probably have let himself be persuaded to buy the Lord Nelson for 75,000 kroner, whereas Fleisch had made a few discreet enquiries and discovered the true situation. And said no thank you. And at the same time he had found some better cards to play. And he asked for a little while to think it over.

And then, almost unawares, he had concluded another deal and earned 5000 kroner net on it. And he had put all this money into *tracts*.

This idea of tracts had become a major preoccupation with Pastor Fleisch. Tracts had their own silent but effective manner of working. And especially now, during the war, when no newspapers or periodicals came to the islands and the lack of reading material was very noticeable indeed, now was the right time to launch his tracts. While the businessman rests, his advertisements work, says an old proverb, and in the same way it could be said that while the priest rests, his tracts work. Yes, even when he is dead the tiny sheets with their small print will live on, live their own life, these tiny Noah's doves. This was not a bad idea for a collective name for them: Noah's Doves. He was filled with gratitude for that idea. No publisher's name, nothing like "edited by Pastor Johannes Fleisch". No, nothing but Noah's Dove. And then a vignette of a flying dove carrying an olive leaf in its beak. At the same time it would symbolise the living Word which would remain unchanged even if the entire world should be destroyed in these terrible times . . . !

Five thousand kroner would provide at least 200,000 tracts. Pastor Fleisch was looking forward to getting home and quietly making a start on the task of choosing suitable

passages from the Bible and composing his texts on them. He imagined a swarm of white sheets drifting down from heaven, all this free and anonymous reading matter filled with blessings, this noiseless snowfall in the hearts of men ... no, not snowflakes, but seed corn ... millions of golden seeds ... riches ... riches.

"How far have we got?" – half asleep he heard Liva asking and Simon replying: "I think we'll soon be close inshore." "Oh, already," thought the pastor. "That means I must have been asleep ... for hours, at that." He felt thoroughly refreshed after his sleep. The boat was not pitching so much now, the swell was broader out there in the open sea where the current was not so strong.

For a moment it went pitch dark. Kristian appeared on the stairs and asked breathlessly: "Is Jens Ferdinand here? No, I thought not. But then he's disappeared. Aye, he must have fallen overboard, Simon."

Liva got up quickly and pressed her hands to her lips: "Jesus Christ."

In a trice both Kristian and Simon were up on deck. Liva went after them. The sea was an intense blue, and the sun was shining on the wet deck.

"Well, of course, I oughtn't to stay down here," thought Pastor Fleisch. "But on the other hand, there's nothing useful I can do, and if I'm seasick I shall only be a burden on the others, so ..."

For about an hour the boat circled the area where the misfortune had occurred, sailing back in the direction from which it had come, further than was really reasonable; but then at least they had done what they could. The thin officer led the search and made eager use of his binoculars. But it was all to no avail ... Jens Ferdinand had disappeared, and there was no trace of him.

Then they continued the journey southwards.

"I can't reproach myself for having been careless," said Kristian the Beachman, forcing his mouth into a wan smile. I asked and implored him to come down below

deck or go up into the wheelhouse. And yet for all that: the weather is not so bad that a man could be washed off the stern without further ado. Far from it. Either he's been leaning out over the gunwhale and lost his balance . . . or he's put an end to himself."

The baker nodded in sombre agreement. "What's happened to Liva?" he asked uneasily and went down into the cabin. Liva was lying with her face buried in her travelling rug. The heaving of her back and shoulders betrayed her sobbing.

"Yes, she's taken it terribly to heart," said Pastor Fleisch. "And good Lord, first her brother, then her fiancé, and now her brother-in-law. I've never known tribulations like this. Poor child, poor child."

He sighed and shook his head. His joy in not being seasick was now completely wasted. Rather seasick, he thought, than this.

"He was an unhappy man," whispered Liva when she finally managed to stammer a few words after her sobbing. "I know. And . . . and what now, Simon?"

With trembling fingers she started fiddling with her travelling rug, gasping for breath a couple of times. "I'm so afraid . . . that it's some kind of punishment . . . for mocking the word of God this morning."

"What do you mean: mocking?" asked Simon. "Did he mock the Holy Ghost, perhaps?"

"No, not exactly the Holy Ghost," said Liva. "But . . . but the name of Jesus Christ . . ."

"Jesus will forgive him that," interrupted Pastor Fleisch unexpectedly. "He Himself says . . ."

Simon beat him to it: "And, whosoever shall speak a word against the Son of Man, it shall be forgiven him; but unto him that blasphemeth against the Holy Ghost it shall not be forgiven."

"Exactly," agreed Pastor Fleisch. "These are the words that are supposed to have brought so many people to the verge of despair. But it is as though Jesus takes a broader view when He Himself is concerned, isn't it?"

The priest sought to catch Simon's eye, but Simon was concerned only with the girl. He heard him say in a whisper ... that is to say not intended for the ears of others: "If he has sinned, Liva, we will atone for his sin. You will understand that later, when the time is come."

"*Atone* ..." thought the priest. "We poor, miserable sinners, we can repent, certainly, but atone for the sins of *others*?" He considered interrupting: "Excuse my saying so, but there is surely only one person who can *atone*." But he refrained and contented himself with thinking: "A splendid example of what Simmelhag means by theological dilettant-ism. And yet ... before God we are all dilettantes, even you, Simmelhag, when it comes to the point ... don't you think?"

"Dilettantes, dilettantes," sighed Pastor Fleisch to him-self, with his hands folded across his stomach.

At that moment there was an ear-splitting explosion; the boat heeled over violently; there was the sound of wood-work being smashed and the immense noise of water rushing in. And Kristian's voice from the poop: "Up on deck, up on deck, we're sinking."

Liva clung to Simon with a shriek; she heard his voice close to her ear: "Fear not, nothing will happen to us. I know."

But at that moment everything went pitch dark, and it seemed to her that both of them were whirled with irresistible force down through a rushing, seething gorge ... down, down ... until at last they could feel their feet against the bottom. Then, slowly, they rose up again, the light dazzled her eyes ... she was in the stern of a little, four-oared dinghy being rowed by two soldiers, Napoleon the Beachman and the NCO. Two arms that had been seeking to shelter her against something damp, let go their hold ... they belonged to Kristian the Beachman. Just behind Kristian sat Pastor Fleisch with a black leather fur cap pulled down over his ears. Simon ... Simon ... where was *he*? Yes, thank God, he was there, too. But how strangely pale and distant he looked. He was sitting leaning forward with his eyes closed. He was in shirt sleeves.

"Are you cold, Liva?" asked Kristian, holding her closer. "We didn't manage to get your travelling rug with us, but the coat's more or less dry, isn't it?"

Liva now discovered that she was dressed in a man's brown coat . . . it belonged to Simon. The engineer was sitting just opposite her, shivering hard, his working clothes soaked through. The dinghy was pitching its way slowly forward over the great rollers. Slowly, slowly . . . and sometimes it was as though they were enclosed in a court-yard of looming waves, but then they were lifted up as though on the ridge of a mighty roof and caught a glimpse of nearby towering rocks rising up towards the sky.

Suddenly Liva felt as it were an electric shock, terrible and painful, shooting through her breast: the thought came to her that Johan's coffin, too, had gone down with the ship.

All at once she noticed that she was inordinately cold. And so, presumably, were the men all round her. They looked withdrawn and desperate, presumably unable to talk for cold.

Now it was time for others to take a turn at the oars; the reliefs took over, one at a time so as not to bring the boat out of balance. She noted an ice-cold hand on hers; it was Simon; he was terribly pale and serious; his eyes searched deeply in hers, but his glance was strangely lacking in warmth, as though he had something to reproach her for.

Kristian, too, had to row. "What about you, now, Liva?" he asked. A fair-haired young soldier, who had just settled in the engineer's place, stretched out his arms, eager to help: "Let me. I'll look after her." Liva and Kristian both shook their heads energetically. "I'll be all right," said Liva and in spite of the cold and the hurt she felt a brief hint of a laugh in her breast. She heard Pastor Fleisch say: "Here, my child, here . . . see, like this." And resist and shake her head as she might, she slipped backwards into the priest's comforting embrace.

"You'll see, it's going to be all right," were Pastor Fleisch's comforting words. "We are not far from land,

and we've got some strong chaps on board. Thank God those soldiers were travelling with us."

The priest's voice sounded so nice, comforting like the voice of a father.

"You didn't see much of it at all, did you?" he prattled on. "No, for you fainted, and perhaps that was a good job for you. For it wasn't nice, no it wasn't nice at all. They couldn't launch the lifeboat, and we were expecting the worst, up to our waists in water . . . no, not you, for that friend of yours, Simon, he carried you in his arms, he held you above the waters."

"Was the ship torpedoed?" asked Liva.

"The lieutenant doesn't think so, because a torpedo would have blown the boat to smithereens, and so would a mine, but that's not what happened . . . it only sprang a leak . . . otherwise we wouldn't be sitting here now. No, he says that we strayed into a minefield, and there was an explosion somewhere near us."

Pastor Fleisch took the young woman's hands and pushed them down into his shaggy coat pocket. "There, that's better."

He was thinking to himself: "Good Good, she's young enough to be my granddaughter." He felt he would like to do something for the poor child. Give her something. A thousand kroner, for instance. Or, if nothing else, the old illustrated Bible with Albrecht Dürer's woodcuts and those beautiful pictures by Raphael and Leonardo da Vinci. It would be a beautiful present for someone interested in religion. The book had cost 175 kroner. But that was in 1929. At present-day prices it must have been worth between 500 and 800 kroner.

And he continued thinking to himself: "We're making reasonable, but rather slow progress. We're almost certain to make land before it gets dark, or perhaps we might be picked up by some ship or other before that. And just think that I've not been seasick. Not even when I'm not lying down. And not in this nutshell of a dinghy, either. It's an ill wind, as you might say, a bit of good luck in the

midst of all the ill fortune. Aye, aye, you've got to be grateful for small mercies in a situation like this. And then you were bright enough to put two sets of woollen underclothes on this morning, besides your leather waistcoat. And then, thanks to the long rubber boots you've not got your feet wet at all."

The twilight was far advanced by the time the castaways finally reached the tiny village of Nordvík, which was their immediate goal.

Down on the jetty a crowd of astonished villagers had gathered. A huge red moon had just appeared in the mountain pass above the village. It was like a wondrous dream to see the reassuring grass roofs of the houses and the careless rings of peat smoke rising from the chimneys in the copper-gold moonlight. Two women, one oldish, the other young, took Liva by the arm and led her quickly up through the stubble fields.

"Wasn't it dreadful?" asked the younger woman, but the other hushed her. "Wait to ask later. You can see how worn out she is. Now we'll see about some good hot food for you, you poor thing, and some dry clothes."

Up in the farm everyone was soon busy; a fire was lit in the best room, woollen clothes were warmed by the stove, scalding milk was poured into mugs and cups. The girl had helped Liva out of her wet clothes, changed every garment on her and wrapped her up in a big woollen shawl that smelled warm and smoky.

"Ha, ha," said the pastor, giving her a friendly pat on the back. "You're a real farm girl all of a sudden now, eh? Aye, that's better than drifting around in the dinghy, isn't it?"

In broken English he addressed the officer, nudging him vigorously: "The mermaid's a farm girl now, how do you do."

The pastor was in high spirits, almost frolicsome. But in the midst of it all he suddenly folded his hands and began to pray in a controlled and serious voice. Liva's eyes sought

Simon ... yes, there he was, over by the door, still pale and distant and with a frozen expression in his face. Why is he avoiding me? she thought in torment. She heard the pastor's voice: "And then, heavenly Father, we pray for those who are not among the saved ... for the two brothers who stayed behind ... and for the young woman who was so close to them, and for whom the events of this day have been such a heavy blow ..."

A cold shiver ran down Liva's head and back, and she shamefully had to admit to herself that neither Johan nor Jens Ferdinand had been in her thoughts now, only Simon. The rest was so strangely distant, a thing of the past. A terrifying thought arose within her: "Were you really bothered about Johan, since you have already been able to forget him?" She was filled with an indefinable fear. The thought continued to pursue her. Tears came into her eyes. Why is Simon avoiding me? What has he to reproach me with ?

"You look awfully pale." The girl gave her an encouraging nudge. "Haven't you got warm yet? You're not going to be ill are you? Perhaps you'd better get to bed."

Liva shook her head. "I'm feeling perfectly all right now," she said, with an attempt at a smile.

"You can't be all that surprised if she's pale, Helga," said the elder woman, the farmer's wife, reprovingly. "Just think what she's had to go through today."

Liva felt a caressing hand against her cheek and suddenly began weeping uncontrollably. Why does he look at me like a stranger? Why is he angry with me? These were the questions which went through and through her.

Helga took Liva to her bedroom in the attic. There were several big bottles in the bed, each filled with warm water and stuffed into woollen socks.

"Where are the others going to sleep?" asked Liva.

"The pastor and the officer are sleeping here in our house," said Helga. "The four sailors from Kingsport are going to sleep at my uncle the teacher's, and Martin the skipper's going to put the soldiers up. Are you feeling

better now, Liva? Wouldn't it be best if I sat with you for a while?"

"No, there's no need at all ... I'm quite all right now, and it's so lovely and warm here."

"Well, in any case, I'll be sleeping in the next room," said the girl. "So if you need anything, just knock on the wall."

"Thank you so much, Helga."

Liva felt uneasy and watchful; all weariness seemed to have been blown away. She had no control over her thoughts. Detached sentences came unexpectedly to her and made her start: "You're a whore, I said. Yes, that made you open your eyes. – As far as I'm concerned, you're no better than a tart. Understand?" – and Simon's strangely distressed words: "I was afraid of the cross, Liva. We, too, have a duty to sacrifice our lives. – If he has sinned, Liva, we will atone for his sin. You will understand that later, when the time is come."

She bored her face down into her pillow and whispered: "Yes ... you and I, we two, were to keep each other company. You said it yourself. We shall fight the last fight at each other's side, you said. So why are you avoiding me? Why do you hate me? What have I done to you?"

"Perhaps it's only something I'm imagining," she sought to console herself. But the worry and confusion did not diminish. She sat up in bed. The floor and walls in the little attic room were tiled in moonlight. She cautiously got up from the bed and tiptoed over to the window. Moonlight across shaggy grass roofs. Black, defoliated trees, strange, in this north-facing windswept place. The old twisted trees cast angry shadows in the moonlight. And there was the neighbour's house, the teacher's house, where Simon was staying. In front of this house, too, there was a big garden. Suddenly she caught sight of a solitary figure down there among the trees ... and it was Simon, there was no mistaking him.

Quickly and silently, she got dressed. Helga was out on the landing.

"Liva," she said. "Is there anything I can do to help you?"

"No, thank you very much," replied Liva and ran down the stairs.

There was a gate in the fence between the two gardens. Liva tore at it, but failed to open it. The figure on the other side turned round. Yes, it was Simon. She whispered his name; he hurried across to the gate.

"Simon," she said. "Why are you angry with me?"

"I'm not angry with you. Why should you think that?"

"You're avoiding me."

She sought his glance, but he looked away and said slowly and warmly: "Yes, Liva. I am avoiding you. For there is something between us that should not be. That's why I am avoiding you. It's because of what there is between us. Do you understand me now?"

"No, I don't understand," said Liva accusingly. "There's nothing between us. Do you hear, Simon?"

"There was even before I left," Simon went on. "I knew it, but I deceived myself. I said to myself: You're going because God wants you to go. Because you need her. Because *He* had chosen her to stand by your side. But then, after all, it was Satan. . ."

Liva suppressed a cry; it turned into a strange hissing sound, like that from an angry goose: "Simon."

"It was Satan," repeated Simon, closing his eyes. He stepped right over to the gate and said in a whisper and still with his eyes tightly closed: "You must understand, woman. I have nothing but you in my thoughts. And when the boat sank and you clung to me . . . then it was suddenly clear to me that it was no longer love from God, Liva . . . but that it was evil lust, woman. And then what was it you said to me . . . what did you whisper to me when you no longer knew what you were doing? No, I won't repeat it."

"Yes, tell me, please."

Liva had regained her voice; she no longer sought to restrain it in any way and shouted: "You can't let me down. If you do, there's nothing else left for me, Simon."

"Yes, there is the Lord Jesus," said Simon earnestly. He, too, spoke in a loud voice. "*He* won't let you down. He doesn't let us down, Liva. We must obey His command, woman. We must drive out the Devil from our hearts. We must take up our cross."

Simon turned away; he stooped forward, clenched his fists in the air in front of him and shouted: "This is the greatest temptation, Lord. Help me, you living Christ. Give me strength, you who are crowned with thorns. You who came to scatter fire on the Earth – how I wish that the Earth were burning already."

"What in the name of Heaven?" said a surprised and reproving voice behind Liva, and a firm hand grasped hers. It was Helga. "What on earth is going on here? Are you out of your mind? Standing out here only half dressed in the cold night air. You ought to have been in bed getting warm. Yes, just look how you're shivering. Good God, if only I'd had the slightest idea . . ."

She pulled and pushed Liva along to the house and up the stairs to the attic. The farmer's wife was standing half dressed on the landing. In a pitiful voice she said: "Good God, my dear girl . . . what on earth do you want with that madman? Heaven preserve us. She's completely out of her mind. You must stay here with her, Helga . . . you never know . . . Shall I waken the pastor?"

"That won't be necessary, my dear." It was the voice of Pastor Fleisch. "I woke of my own accord when I heard him bellowing down there, our poor baker friend."

The pastor sat down on the edge of the bed and, pursing his lips, said in a gentle voice, "Look, Liva, my dear. Now we're going to forget all this. All those upsetting things, all those dreadful things. Now little Liva's going to sleep. I'm sure you need it. Your little eyes are going to close. God's angels are keeping watch at your bedside. Hush, hush. Don't cry. Tomorrow, when you've had a good sleep, you'll no longer be so overwrought. There, there, that's better. Just you weep a little, it helps. I've got such a lovely illustrated Bible that you shall have, you little woman of

faith. You shall come and see me, and I'll be like a father to you, little Liva. . ."

The pastor's voice sounded so infinitely kind and all-forgiving. It was beautiful and comforting to listen to. Helga and her mother were both deeply moved.

# IV

## 1

Frøja Tørnkrona had a big, almost splendid room over the Bells of Victory restaurant. Bright flowered curtains, light cane furniture and an enormous, broad ottoman littered with an abundance of coloured cretonne cushions and cute little dolls with flapping arms and legs and roguish eyes. Frøja collected these dolls and had a multitude of them; she had sewn their clothes herself; most of them were dressed in striped or flowered pyjamas, but there was an odd one in a dinner jacket and real stiff collar.

"Can you see who that is?" she asked.

"Yes, Opperman," laughed Magdalena.

"Yes, isn't he sweet?" Frøja held the doll to her cheek.

"Are you having it off with him?" asked Magdalena.

"Nice little girls don't ask things like that." Frøja screwed up her eyes and flicked her with the doll.

Magdalena laughed and felt unconstrained and carefree sitting here in Frøja's perfumed room. She had often thought of going to see Frøja, with whom she had been friendly as a girl, but something had always prevented her . . . grief and suffering of one kind or another. Aye, good heavens: what kind of a life was it they lived up there at home in Angelica Cottage? Her sick father and his heartrending convulsions, her daft sister Alfhild and the almost equally crazy Thomea. And now Liva was going the same way. Constant hard work and constant looking after children, yes, and constant *grief*. Scarcely had they got over Oluf's death when Ivar was killed, and of course Liva's Johan died just after that. You can get sick to the teeth of mourning too, she thought, tossing her head in irritation and dismissing an incipient bad conscience. Why

must one be condemned to grief? To sitting twiddling your fingers while *life* simply ran away from you? While Frøja . . .

"Thank you, Frøja, thank you . . . What's that?"

"It's a cocktail. Cheers."

"It's ever so nice and comfortable here, Frøja. Fancy being your own boss and doing as you like."

"I don't know, damn it," said Frøja, offering Magdalena a cigarette from a transparent packet. "What makes you think that, really? I've got plenty to do; it's hard work here, let me tell you, so don't think it's a bed of roses. You can get pretty fed up with it all. Opperman. Daddy. Putting it bluntly . . ."

She inhaled deeply, flopped down on the ottoman and started to blow smoke rings. "Opperman's basically rotten to the core. He's rolling in money, and he could afford to *keep* me if he wanted instead of putting all the restaurant on my shoulders. But he's too mean for that. Business before pleasure. Good heavens, I get a good wage. But even so, he's horribly mean and petty. The whole lot of them are rotten. Opperman's not the only one. Inspector Hansen, for instance. You should see how he was going on making up to my little sister Frigga when she wasn't even fifteen years old. Ugh!"

Frøja got hold of the Opperman doll and flung it the length of the floor. "No, Magdalena, life's not as easy for me as you think. And then I've got Daddy pestering me with his sins and conversions and all that. And what joy do I get out of that?"

Frøja turned over on her side and flicked the ash off the cigarette. She went on spitting flakes of tobacco out: tp, tp. "I *make love*, you know? And drink cocktails with Lieutenant Carrigan or Major Lewis. And that fool Pjølle Schibbye! And then they trot out all their usual rubbish: Oh, you're so nice, Frøja. You're a real little lady. And then, when things get really hot: I love you. Yes, I really am enchanted, really, really . . . enchanted, enchanted, dear love! Yes, thank you very much. At first I almost believed them."

She lowered her voice and stubbed the cigarette out on the bottom of the ash tray. "No, Magdalena . . . there's something far better, and that's to go out and play the young innocent. There's nothing like it, by God there isn't. Some shy young chap's bound to come along and have a go . . . you know, a nice, nervous lad who wants to experience the great rush to the head."

Frøja smacked her lips and shut her eyes dreamily. To her amazement she heard Magdalena expressing hearty agreement and gave her a surprised, quizzical look.

Magdalena blushed and relaxed, and they both set about confiding in each other.

"Yes, that's what life's about," said Frøja. "Then you feel young again. And nobody knows you. It's like starting all over again, you know . . . But I actually thought you'd turned over a new leaf, Magdalena. Now you're a widow with children. And besides, someone told me you were engaged to Frederik. Or was it somebody else?"

"Not really engaged," said Magdalena, blushing again. "I . . . I've just sort of been *playing* a bit with him."

Frøja got right up. With a laugh she took hold of Magdalena's hand. "Are you *really* still like that? Good Lord, I thought that once you were a widow and all that . . . ! But really it's wonderful to see how good you still look. You certainly don't look as though you wash your face in soft soap. Or have you got naturally beautiful skin? Yes, you sisters are really rather good-looking, *Liva*, certainly, but not Thomea, I must admit, but then Alfhild, she's going to be a lovely girl. It's such a dreadful shame that . . . ! Well, cheers. Let's have this glass and then another, and then we'll be suitably tipsy. And then we'll doll ourselves up like innocent lambs . . . you'll see, I know the tricks. And then we'll go for an evening stroll."

Frøja yawned and stretched, she danced a couple of steps across the carpeted floor and hummed elatedly:

> It's terrible sad when a cone
> Is frustrated and stands all alone. . .

It was a clear, frosty night, and the sky was full of stars. Frøja shivered with cold and held on to Magdalena's arm: "Ugh, winter's come. Shall we get hold of Pjølle or Opperman or some real grown-up instead?' She suddenly stopped: "I say, shall we go over to the Officers' Mess and ask for Carrigan and Lewis? They're a couple of smart lads, let me tell you. Lewis is rolling in it, he owns a whole railway company. It's him who's been going with Pjølle's wife for a time, but now he can't be bothered any more, because she's gone and got all sentimental with him and wants to get divorced and married and all that."

Frøja chuckled. "He'd much rather have me, you know. I'm so nice and easy, he says. He's fun. He calls me his chocolate liqueur. Funny way of putting it, isn't it?"

"Yes, but can't that wait until another evening when we've dolled ourselves up a bit better?" suggested Magdalena.

She could not help thinking of Frederik. She didn't want to be seriously unfaithful to him. She just wanted to have a look at life and secretly let herself go one single evening, now there at long last was a little opportunity. Thomea had begun to be more like herself again and had promised to look after the children and her old dad. No, Magdalena was not going to let Frederik down completely.

They drifted down towards the jetty. On the square in front of Schibbye's shop a group of sailors had gathered. "Hallo!" they shouted. And suddenly they were standing in the midst of the group. A pale young man with horn-rimmed spectacles revealed a row of front teeth beneath a little black moustache and turned imploringly to Magdalena. The whole bunch burst out laughing, and Frøja explained to her with a laugh that the man had been asking whether she had a tea cosy.

"Yes, a little tea cosy," repeated the sailor. "I've got a lovely pot of tea here, and it'll get cold in this bloody frost."

Frøja said something in English that caused great amusement.

"I asked him if he was missing his old grandmother," she explained. She tugged at Magdalena's arm and made to go on. "You can't get anywhere with those lads in this cold," she said. "No, we must go somewhere where you don't need to stand with your teeth chattering."

A ship was tying up on the quayside. It was a schooner.

"Come on, let's go and have a look at these chaps," said Frøja.

They could hear shouts from the blacked-out ship and replies from the quay. A firm, deep voice on board was issuing orders. Magdalena suddenly came to a standstill and listened with her lips slightly open. Was that Frederik's voice? She let go Frøja's arm and quickly stepped over to the edge of the quayside. Her heart was thumping in her breast.

"What's come over you?" asked Frøja in amazement.

Yes, indeed, it was the Admiral. And as in a fever she heard someone shouting something about a sick man and hospital. Good God . . . Could it be Frederik who was ill?

No, now she caught sight of him. He was dressed in a light grey coat, fur hat and big gloves.

"It's him," said Magdalena breathlessly.

"Who? Your fiancé .. or what? Oh! Now you're spoiling it all for us," Frøja grumbled. "Good Lord, her lover boy's suddenly come back."

There was nevertheless a trace of feeling in Frøja's voice. "What now?" she asked.

Frederik had discovered Magdalena; he jumped ashore and came over to her. He could scarcely speak for emotion, she felt how his big hand trembled in hers. Still without uttering a word, he pulled her across to the ship, helped her up over the gunwhale and took her down to his cabin. It was light and warm down there. Frederik locked the door. In a tremulous voice he asked: "Magdalena . . . you . . . kept your word?"

They sat down on the edge of his bunk. But now there was a violent hammering on the locked door . . . it was Pontus the watchmaker, shouting plaintively: "Have you ever seen the like? Locking the door on his own boss!"

With an oath Frederik got up and let Pontus in. The watchmaker was very excited, his whiskers were vibrating beneath his distended nostrils, he looked like Hitler. "I demand an explanation," he shouted. "Aren't you supposed to be on your way straight from Aberdeen to the Westman Islands? So what are you doing here? Are you going to delay going and ruin our chances just so that you . . . so that you can sit and cuddle her, or what?"

Frederik was very calm. "Sit down, Pontus, and stop standing there crowing like a bantam cock with its tail trapped. I had to put in here on the way because one of the men's got appendicitis. This was the nearest port."

"All right, but then get off again," said Pontus stamping angrily on the floor. "We've no time to waste. Every day costs me a minor fortune."

Frederik took out a bottle of rum from a drawer and filled three small glasses. "We leave at dawn," he said. "I've already got a replacement for the sick man. Cheers."

Magdalena sat staring fixedly at Frederik. She had tears in her eyes. How changed he was, it was as though he had become broader and firmer, all the indecisiveness was as though blown away, all those things that had reminded her of Oluf. She was proud of Frederik. Indeed, he had really become his own man, he was no longer Ivar's willing and obedient subordinate.

Pontus pulled himself together after suppressing an attack of sneezing and wiped his eyes. "I've had a dreadful time," he said.

"Yes . . . the tension," said Frederik, raising his head a little impatiently.

"Yes, no, yes, that, too," said Pontus sadly. "No, it was actually something else I meant. Aye, I might just as well tell you both, for who the Devil shall I tell it to otherwise? There's no one who takes the least damned bit of interest in my affairs except out of envy and professional jealousy."

He slumped down and suddenly appeared to be on the point of tears. "I've been let down. Let down by an awful harpy that I'd been so unforgiveably stupid as to get

engaged to. Yes, it was Rebecca, the woman working for me in the shop. Perhaps you don't know her, the devil. Aye, she was a *smart* lass, I'll give her that, and at least I've *had* her, ha, ha . . .! But . . . the intention was that we should get married, and . . . well, you know, there was no lack of money for setting up and all that. I heaped jewellery and things on her so she nearly sank under the burden. But then one day she comes along and tells me she's got engaged to an adjutant."

Pontus exploded with laughter and scratched various parts of his body. "Engaged," he repeated. "To an adjutant! Impressive, eh? Oh, what the hell . . . the woman wasn't worth an alarm clock. And then she was a thieving so-and-so as well. . . Not big things, but even so . . . !"

"Well, it was a bit of luck for you that you got rid of her, then," said Frederik, surreptitiously nudging Magdalena.

"Luck," said Pontus emotionally, holding out his glass for more rum. "Luck? That's not the word for it, Frederik. I feel like a man who's been put up against a wall to be shot and reprieved at the last moment. Aye, by God I do."

Revealing his long teeth he added: "And all those things I'd given her, you two. She had to bring them back on bended knee. There was no way she was going to keep them."

Pontus stayed on in the cabin. He drank heavily and soon fell asleep. Frederik laid him down on his bunk and drew the curtain.

"And now there are just the two of us, Magdalena," he said and made to lift her on his knee. But she gently pushed his hands aside, caught his eye and said: "No, Frederik. We've got to talk things over first."

An angry look came into Frederik's eye. She gave an involuntary start on seeing it.

"Aren't you . . . ? Aren't you *mine*?" he asked threateningly. The corner of his mouth was twitching slightly.

"I'm not what you think," said Magdalena, steeling herself.

"Have you let me down?" asked Frederik in a low voice.

"No, I *haven't*," replied Magdalena anxiously.

Frederik suddenly got up and clutched both her hands violently, forced her against the wall, stared straight in her eyes and said between clenched teeth: "It's a good job you didn't even try."

"Get off me," said Magdalena horrified.

"You haven't," snarled Frederik. "But perhaps you're intending to."

He suddenly let go her hands and flung them down. His face was pale, and there was a minatory look in his eyes.

"Frederik," she shouted. "Frederik. I hardly know you any more. You're so changed. Do you hear? I . . . I simply didn't want to be dishonest with you. I would have let you down if you hadn't come now. And now you can call me what you want. I . . . I imagined you to be quite different. . . ! Frederik!"

"You seem to me to be talking a lot of nonsense," said Frederik and sat down on the bench. He wiped his sweating brow. But suddenly he planted a great horny hand on the table. "Shall I tell you what I think of you? Well, I don't think you know what you want. Sometimes I'm not good enough for you, sometimes it's you who are not good enough for me. But all that's got to end. Understand? Here sits a man for whom you are everything. He thinks of nothing but you and wants no one but you, he's gathering money together to have something to offer you and your little children, he wants to marry you and have you for the rest of his life. And if you can't say anything but *perhaps* to him, then he'll . . . ! He'll not forget you, no he'll *swill* you out of his mind!"

Magdalena was kneeling before him, she took his hands and pressed her lips to them, kissed them passionately, bit into his great knuckles while summoning up all her strength to hold back her tears. Then she got up and in a choking voice said: "I'll never let you down, Frederik! You are the very one I've been longing for. We'll get married, Frederik . . . when? Oh, if only it could be this evening."

298

He lifted her up on his knee, their eyes met in a look of total abandonment, and she whispered in his ear: "At least I'm going to have a child with you this evening. We'll stay here, all night, my dearest. And we'll get rid of this corpse ashore."

Frederik burst into a great trembling laugh: "Yes, my dear, let's be quick and get the corpse out, there's no time to lose."

Magdalena did not go home that night. Thomea woke up about seven in the morning and saw that her bed was empty. The children were sleeping peacefully. But where was Alfhild? Alfhild had recently developed the habit of getting up early and wandering about outside. One morning she had been right down in the village and came home with a bag of sweets she had been given on credit at Masa Hansen's.

Thomea went out into the yard and round the house. The wind had backed to the west, the frost had gone, the air was mild and hazy. There was nothing to be seen or heard of Alfhild. Yes . . . suddenly she heard her voice quite plainly, but it was a long way away . . . it sounded as though she was talking to someone and laughing aloud. The sound came from the side nearest the Angelica Bog. And suddenly a suspicion struck Thomea like a flash of lightning: Engilbert! Engilbert, of course!

For a moment she stood still with her mouth open and her fists clenched. Then quickly but watchfully, she moved off towards the sound.

It was as she had expected. The backs of two people walking side by side emerged from the mist, none other than Alfhild and Engilbert. He was not carrying a creel. Thomea had heard he was no longer working for Opperman. Nor, apparently, was he any longer living at Mrs. Lundegaard's. He was simply living rough. Perhaps he was living somewhere up here. Perhaps he was living in the Troll Child's Cave.

The two figures merged into the mist. Thomea increased

her speed until she caught a glimpse of them again. They were walking quickly. She was about to shout to Alfhild, but something inside her told her not to, not to frighten them, for they might get away from her.

She heard the foxes crying. And now the first of the three long cages appeared. Alfhild and Engilbert were still there, walking quickly. Thomea was again on the point of shouting. There – now they disappeared behind the cage. She broke into a run, but took great care not to make a sound. At the corner of the cage she stopped. She had difficulty in breathing quietly so as not to be heard. Engilbert and Alfhild had stopped, they were talking in low voices. Then Alfhild said aloud: "But you promised!" And he told her to hush, adding breathlessly: "If you shout like that you'll not get anything in any case."

And then came a slight sound, exactly what Thomea had been expecting: a whimper from a mouth being held closed by a hand. Now!

Thomea suddenly stepped forward. Engilbert let go of Alfhild and stood staring at Thomea. They looked each other in the eye, unflinching. Alfhild tidied her clothing and wiped some strands of hair from her brow. She went closer to Engilbert and said in an accusing voice: "Now give me what you promised me. Do you hear?"

"Thomea," whispered Engilbert. "I knew you were here. I could feel it. I've sensed your eyes on my back all the time like a signal."

She saw that his eyes were full of lust, as so often before, and he was smiling a little, a smile that said he was sure of her.

"Go home, Alfhild," said Thomea quickly. "Go on, girl, straight away."

"Yes, but he promised. . . !"

"You shall have some chocolate at home if you go straight away," said Thomea. A fire was raging within her, and her voice was trembling.

For a moment Alfhild glanced from one to the other, and then she gave a little jump and started to run homewards.

"Thomea," whispered Engilbert.

Thomea bowed her head. He approached her quickly, but she backed away from him, and suddenly she turned round and dodged away.

"No, Thomea," he shouted, both plaintively and threateningly. She heard his footsteps just behind her and increased her pace; the ground was squelching and splashing around her ankles . . . she fell, but came to her feet again before he managed to catch hold of her.

And now it was his turn to stumble; he had one leg down in a pool of mud . . . and then the other sank in right up to the knee. Thomea got a start on him again and had time to take her bearings: right in the middle of the bog! It was a long time since she had set foot there, but otherwise she knew every inch of the area from her childhood and clearly remembered how to get out to the little firm grassy islet in the middle of the bog without sinking. Snipe Island, it was called.

She slowed down a little. Engilbert had got on his feet again and was continuing in pursuit. She leapt from tuft to tuft. In one place there was a long flat stretch of firm greensward, where the sheep usually grazed in the summer, but now it was flooded and looked like a lake. She ran straight through it, the water only reaching her knees. Then she danced and jumped on until finally she reached Snipe Island. There she stopped and glanced back.

It was not long before she caught sight of Engilbert. He had again slipped into a mud hole and was on all fours, struggling to free his legs from the unyielding mud. It was a slow process; he worked his way forward like a swimmer, throwing himself forward and twisting over on his back. But finally . . . she saw in dismay how he freed himself and got up. She felt a rush of horror and tension throughout her body. She stood there, upright. Couldn't he see her? She laughed aloud while she thought: "You'll never get out of here alive. Just you try."

Engilbert made straight for her, but he was making slow progress, for there were pitfalls everywhere; he was more

careful now, looking where he went and feeling his way with his foot before taking a step. But now he took a run and leapt – a bold leap, but it was all right, he had firm ground under his feet. Another leap. And that was all right, too.

"Just you wait," she thought doggedly.

The mist was becoming lighter, in the east a round rainbow patch was forming. It was the sunrise. Engilbert and Thomea were so close to each other that they could exchange glances. Engilbert smiled, out of breath, and waved arrogantly at her, warm with effort and lust; there were no more than ten paces separating them now. But what divided them was a single big expanse of light green quagmire, and she knew it would not stand a man's weight, indeed, not even the weight of a sheep. She had once with her own eyes watched a sheep sink here without hope of rescue. She saw Engilbert gathering strength for a fresh jump, he was aiming at a tuft sticking up in the middle of the expanse. He pressed his lips together, bent his knees and jumped. And suddenly he was up to his shoulders in the soft, yielding mud.

Thomea gave a hoarse grunt, she couldn't force a sound from her throat. Involuntarily, she threw herself on to her stomach and edged her way out on to the quagmire, but the sinking man's head had already disappeared, the surface rejoined with a squelch, there was only a black trace left, and that, too, was soon obliterated. Thomea wriggled backwards again, slowly, for she had no strength left, her ears were filled with a wild, mighty rushing sound. Exhausted, she threw herself down on the wet grass and felt herself gradually come back to life. The rushing sound slowly diminished, and there was a ferocious silence. Something was shining bright in the mist before her . . . a resplendent hole ringed with rainbow light.

Thomea lay out on Snipe Island until she was thoroughly rested. Then slowly and despondently she made her way home. The shape of the Angelica Outcrop was outlined through the dispersing morning mist. And there the shaggy

roofs appeared, silhouetted through a veil of haze and hanging peat smoke. Ever since her early childhood, Thomea had slept up there under the roof, in the eastern gable room, in a deep alcove right down on the floor, but recently, for the sake of Magdalena and the children, she had moved down into the kitchen. Now she had but one thought, one wish above all others: to get her old place back, to rest there, creep down and hide herself there and be completely alone in the dark alcove beneath the turf of the sloping roof.

# 2

There was a crowd gathered on the harbour bridge when the little motorboat from Nordvík brought the survivors from the Kittiwake back to the Cauldron. It was an overcast, windy Sunday afternoon. Flags were everywhere flying at half mast. Mr. Nikodemus Skælling and his wife had got themselves an excellent vantage point in one of the newly-repaired windows in Mrs. Schibbye's office. Mrs. Schibbye herself was sitting at the other window, chewing excitedly at a cigar stump while watching events through a pair of opera glasses.

"Pastor Fleisch," she chuckled. "Dressed like a polar explorer, with a fur hat and motoring gauntlets. *He* doesn't look as though he's suffered much hardship. But what the hell's that Japanese flag they're bringing down there? Can you see it, Skælling?"

Yes, Mr. Skælling could most certainly see the curious flag. It was white with a red circle in the middle, and in the circle there was a cross. Presumably the bun sect's banner, for it was being carried by Benedikt Isaksen from the hospital. So the bun sect was having some sort of parade. Or the *crusaders*, as the daft lot called themselves. Mr. Skælling could not help thinking of the enormous wooden cross he had recently seen in Markus's workshop . . . a good job they hadn't brought *that* with them out here today, not that it would have surprised him.

"I think there's going to be some sort of demonstration," said Mrs. Schibbye, and spat the cigar butt on to the floor. "That poor little Lydersen of mine's there as well, good heavens, the silly little man. Listen, now they're singing."

She opened the window and the sound of singing poured in.

> For now the night is near,
> For now the night is near,

Take hold your lamp, oh timid heart,
For now the night is near.

"Maja, what's wrong? You're not ill, are you, dear?"

"Oh, it's all so strange."

Mrs. Skælling closed her eyes and raised a handkerchief to her lips.

"No, it's not exactly pleasant," admitted the editor. "Ugh. But all these sectarians think of is proselytising, isn't it. And this is a unique opportunity for them. Their prophet is returning from a shipwreck!"

"Like Jonah from the belly of the whale," shouted Mrs. Schibbye with a loud laugh.

Someone knocked heavily on the door, and Dr. Tønnesen entered in high spirits. Mrs. Schibbye reached out her left hand to him without putting down her opera glasses: "Here, Doctor, bring a chair over to the window! So you can't resist it either!"

"No, it disturbs me somewhat," admitted the doctor. "For this madness is assuming epidemic proportions. I foresee that it can't be long before the authorities have to take it in hand. Why don't you write something about it in the paper, Skælling? There's something to get your teeth into here, I would have thought. Apply the brakes, apply the brakes, for God's sake. What do you think they'll get up to next? *Walking on the waters*, or something of the kind, I'll bet. Mass drowning. Or incendiarism. Or human sacrifice. No, quite seriously, have you ever heard anything like it? And all the preconditions you need are present here: unhappy, desperate people thirsting for a miracle, and then a couple of imaginative fanatics like Simon Simonsen and our well-known death's head of a porter. Fundamentally a nice man, not afraid of anything in the world. But as time goes on he's going a bit far. Do you know what he got up to yesterday evening? Well, he cured a girl with paralysis. She's a nerve patient, a seventeen-year-old we were just about getting on the right road again, for the paralysis was clearly hysterical in origin. Arise, take up thy

305

bed, and walk, roars Benedikt. And of course, the girl got up and started shaking the sides of her cot for all she was worth. And now a girl like that's totally convinced that there's been a miracle and that the Day of Judgement is at hand and together with her mother and her siblings and the entire family and neighbours she becomes an unswerving member of the bun sect . . ."

"Good God!" exclaimed Mrs. Skælling.

"See. Now the hippopotamus is going to pee!" shouted old Mrs. Schibbye, eagerly adjusting her opera glasses. "Yes, that's right, Pastor Fleisch, hurry ashore, for otherwise, God help me, we'll be thinking you've been bunned as well!"

Simon the baker had taken up position near the prow of the boat.

"Selah!" came the shout. "Selah! Selah!"

The doctor and the editor exchanged glances and shook their heads.

"Jesus Christ preserve us," said Mrs. Skælling timidly.

The square outside had fallen silent. Simon's voice could be heard loud and compelling . . . Remember therefore how thou hast received and heard, and hold fast, and repent, saith the Lord. If therefore thou shalt not watch, I will come on thee as a thief, and thou shalt not know what hour I will come upon thee. Yet some of you have not defiled their garments; and they shall walk with me in white: for they are worthy. He that overcometh, the same shall be clothed in white raiment; and I will not blot out his name out of the book of life . . .

"Selah!" shouted a loud woman's voice.

"That's Liva Berghammer," said Mrs. Skælling. "The girl whose fiancé . . ."

Mr. Skælling secretly nudged his wife. That was all that was needed. Maja started sobbing nervously.

"There, there," said the doctor, a little fretful at having been disturbed in his observations.

"Good Lord, Maja," said Mr. Skælling irritably.

"Yes, I know," she replied meekly. "I couldn't help it . . . I'll soon . . ."

Renewed sobbing. The doctor shook his head: "There you are, nothing could be more obvious, it's simply infectious."

He went and stood in front of Mrs. Skælling and said: "My word, you are susceptible to atmosphere, aren't you, my dear? Just you listen to my advice and keep *right* away from scenes like this. Read good books and listen to good, healthy music."

"Yes, Doctor," replied Mrs. Skælling with a slight curtsey as she obediently dried her eyes.

Her husband was very flushed. Maja was getting a good telling off there, all right.

"Selah!" came the shout down there again, and the Japanese flag was raised and lowered. Simon stepped ashore, followed by Liva and the three sailors.

And now the crowd, all dressed in black, moved off singing.

"There are quite a few of them, by Jove," commented Mr. Skælling.

"I suppose we must assume there were a few inquisitive onlookers among them," said the doctor. "But even so, there's no doubt the epidemic's spreading at an enormous rate."

He relit his shag pipe. "You know, it's very interesting from a purely psychological point of view," he said. "In its own little way it's something of the same sort of thing that's happening in Italy and Germany, mass suggestion and demagogy; it's typical of these times in general. But in practical terms it's all up the pole ... What shall we do about it, Skælling?"

"You write an article for the paper, Doctor," suggested the editor.

"Hm, yes." The doctor reflected for a moment. "Something on the lines of a warning, you mean. You know, from a medical point of view. 'Mental hygiene'. But I quite seriously fear that it won't do any more good than a ... I almost said a baker in Hell. We need a more drastic vaccine. Something like a religious counter-movement. Or

a rationalist counter-epidemic, like they've got in Russia. But no *Oxford Movement*, for heaven's sake."

He shot a peppery glance at Mr. Skælling.

"Yes, your Oxford Movement ended on the rubbish heap, didn't it," chuckled Mrs. Schibbye and put down her opera glasses with an amused look in her eye.

The editor could not suppress a slight blush.

"Well, Maja," he said and passed it off. "Now you've heard the doctor confirm what I have so often impressed upon you: good books, good music. Dostoyevsky. Mozart."

"Mozart's all right. But for heaven's sake not Dostoyevsky," the doctor corrected him, showing a couple of unpleasant corner teeth that otherwise seldom came into view.

Mr. Skælling blushed again.

"Have a drink?" suggested Mrs. Schibbye with a loud yawn.

"No, thank you." The doctor was busy, and so was the editor.

"You really mustn't expose me to your hysterical excesses," he said irascibly to his wife as they hurried home. "A person of culture must always be in command of his feelings."

"Oh, you and your self-control," she snapped, letting go his arm.

"Go on, start all over again . . . it's so delightful."

She sighed heavily. "You don't seem to understand how *serious* it is," she said.

"What do you mean? Serious?"

"Just that. It's a bit different from that silly Oxford Movement of yours."

"Oh, *that*," said her husband scornfully.

"Yes," Maja went on. "For this is a case of men and women in distress."

Mr. Skælling slipped his arm back under hers. "I suppose you're right, Maja," he said. "They *are* people in distress."

"Yes, don't you agree?" she said animatedly. Suddenly,

she clutched at his arm. "Nikodemus. Just look. No, up there . . . near the memorial mound."

"The memorial mound. Good God . . . !"

Mr. Skílling came to a sudden halt. Up near the memorial mound for shipwrecked mariners a huge crowd had gathered, and in the midst of it all towered the *cross* . . . the boatbuilder's enormous cross.

"But this is too bad," he groaned. "How tasteless. Maja, you stay where you are. Do you hear, Maja . . . ?"

But Maja was already on her way up there, there was no stopping her, and in any case . . . he himself felt it totally impossible to stay away and not be moved to hurry up the hill. Mass suggestion, indeed. The suggestion of a crowd. You *couldn't* avoid it. A basic instinct had been awakened. It was ridiculous. It was dreadful.

The whole area up by the golden cross was black with people. Heimdal the bookseller was there as well, by Jove. He touched Mr. Skælling's sleeve and said: "Do you know what it reminds me of? Yes, Signorelli's fresco The Resurrection of the Dead. Only they ought all to be naked . . . physically, you know, as well as spiritually!"

Mr. Skælling had found his wife again, she was hanging on to old Verlandsen's arm. The school teacher's thick spectacles exuded horror. "Look," he said. "Look what it says at the top of the cross. What are we to make of tha.?"

"Religious mascarade," said Mr. Skælling. It annoyed him that he could not keep his voice calm. He took his wife's arm and gave her a stern look of reprimand.

"*Death, where is thy sting?*" intoned a deep, ecstatic female voice.

It was the much-discussed Liva Berghammer, the girl from Angelica Cottage. A beautiful girl. She had stationed herself at the foot of the cross and was addressing the gathering, in wild ecstasy . . . it was really moving to listen to her, and her words went right through you: . . . "For if anyone can bear witness to Him who conquered death, it is I, who in the space of no more than a month have lost a brother, a fiancé and a brother-in-law . . . and have myself

309

narrowly escaped being drowned at sea. But for those who are saved there is no death. And this I bear witness of to you, that in a short while no one will speak any longer of life and death, but only of eternity. Of eternal damnation or eternal salvation."

"Selah!" shouted a chorus around her. It was like the rush of the wind in the air.

"Selah!" came the whispered word in Mr. Skælling's ear. He turned and saw his wife's contorted face. "Sela!" she whispered again and stared at him, her eyes round and her upper lip drawn back.

"Maja! No, no . . . you mustn't, do you hear? You must come home. I can't take this. Do you hear, woman!"

He grasped her hand and dragged her forcibly down the hill, down to the road, and into a waiting car. "For God's sake," he said to the astonished driver. "For God's sake, take us home. My wife's had a nervous shock."

"Not to the doctor's," implored Mrs. Skælling. "I won't go to the doctor's. He doesn't understand a thing of what it's all about."

"No, no," her husband sought to soothe her. "Not to the doctor's, just straight home." "And now straight to bed," ordered Mr. Skælling as soon as he had got his wife safely under their own roof. "No, I shan't ring for the doctor, you needn't worry. I'll be your doctor. Now we'll have a little pick-me-up. Both of us. And then you'll go to bed. All right? You're feeling a bit better already, aren't you, Maja?"

"Yes, of course, Nikodemus."

Maja managed a smile. "Good Lord, Nikodemus . . . we almost created a scandal, didn't we?"

"Rubbish, no one had time to notice. But Maja, can we agree that in future we keep right away from all scenes of that kind. You'll see, you'll be all right then. You just read some relaxing book. Cheers, my dear. The Thousand and One Nights, for instance. I say, I've got an idea . . . You go to bed now, and I'll come and read the story of Sinbad the Sailor to you."

310

She took his head between her hands and said gratefully: "You are so sweet, Nikodemus. But if you really want to read something for me, won't you take one of Olfert Ricard's sermons . . . since it's Sunday."

"Brilliant idea! Of course! By God, that's something to calm you down if anything will."

His wife had fallen into a gentle sleep well before Mr. Skælling had reached the end of the sermon.

He put the book down with a little yawn and went into the sitting room. It was quiet and warm in there. He felt deeply grateful. Good Lord, he had really been in danger of being drawn out into the maelstrom there. So that was how easily it could happen.

He mixed himself a toddy.

Yes, it had to be admitted. He had himself been very close to feeling moved, bewitched by that strange madness. Like a spinning top, yes . . . one of those that sing when they are set going. The sound of the girl's voice still rang in his ears. Of course, a certain sex appeal played its part, too. Oh well, never mind. It was happily in the past now.

Now it was only a question of keeping away and not looking in that direction, letting the epidemic rage and then spend itself. One day it would die down, like all epidemics. And all wars. And, in short, all evil times. And then things would brighten up again.

"In many ways you can already see light ahead of you," he said to himself while sipping from his glass. "Certain signs in the sun and moon. The Russians are now approaching the German borders at speed. The lack of an invasion on the part of the West has been suitably explained . . . The tactic is infinitely clever and far-sighted: leave Russia and Germany to bleed to death in each other's arms. Only then will the time have come to commit vast, superior forces in peak condition, the most crushing war potential the world has yet seen. Disloyal to the Russian ally? Yes, but there's no point in being too soft with those Asiatic hordes. *They* spare no one, by Jove."

Yes, Mr. Skælling felt clearly that a long-needed sense of

optimism had been gathering inside him for a few days already.

Nor were things *at home* as bad as he had believed at one time. The domestic political rebels were losing out to the Danish Governor, that strong, ingenious man who of course could also be said to have the occupation forces on his side.

And as for *communism*, what he had feared most of all, he had to admit to himself that there had probably been some kind of panic on his part – though by no means an unreasonable panic. The social democrats were behaving themselves well, even the young ones. And there were practically speaking no serious signs of an underground revolutionary movement. *The alarm clock works* were to have been used to drive a roundabout for a Christmas decoration. He had noted that significant fact the previous evening when down at Masa Hansen's, where he was going to buy a little tobacco, he had heard of the tragic death of that poor typographer Jens Ferdinand Hermansen. Masa Hansen had mentioned the roundabout as an example of how she, too, had suffered a personal loss with the death of the gifted young man, and she had even hinted en passant that she had given him 100 kroner in advance for the aforementioned work.

Mr. Skælling had to smile at himself when he thought back on the emotions he had gone through on account of those alarm clock works. Luckily, he had kept it all to himself. Not even Maja knew anything about it. Alongside his intelligence, he was obviously possessed of a certain valuable *instinct*.

Otherwise, the news of the typographer's death had not only been an enormous relief to him, but – there was no denying it – it had caused him pain, too. The quick-tempered and stubborn, but at the same time gifted and clever little man was no more. An unfortunate little life had been rounded off by a tragedy. And it would be a long time before he found anything like such a gifted compositor and proof-reader again. The new man down

there was almost illiterate. And the personal insults he had been subjected to by Hermansen . . . Good Lord, let him be forgiven them for all time. He was a bitter and lonely man, so to speak predestined to a secret hatred of the society in which his disability prevented him from playing a normal role.

And one thing with another . . . yes, things were looking up bit by bit. Even if the blissful days from before the great wars – the age of the Count of Luxembourg – would naturally never return in their glorious innocence. And even though there was still plenty to complain of. When all was said and done, disappointments were a part of life, and you usually got over them. The *Oxford Movement* had been one of these disappointments, God help it. And in any case that story was not exactly without its amusing aspects, either.

It had all begun so well. They had had a meeting one evening, dressed in dinner jackets as was prescribed, and the whole thing had more or less got off to a good start. Especially thanks to Mrs. Heimdal's energy. Which, however, soon turned out to be of an unfortunate kind. Hm. For in her almost endless flow of words the little lady got nearly all her foreign words wrong. And it was heartrending to witness the suffering she thereby caused her wise and cultured husband. Indeed, the bookseller literally broke down over it on that very first evening. He didn't go to the next meeting, which was held at De Fine Licht, the pharmacist's.

Alas . . . for that matter, Maja hadn't been entirely intellectually house-trained at first, the dear creature, but at his kindly but determined request she had kept in the background and allowed her husband to speak for them both.

And then there was Mrs. Licht. Far too willing to testify, she was a chapter all on her own. A deeply humorous chapter, as well. Good Lord, how she had let herself down, this forceful, big-built and effervescent woman. She was said to be French by birth, and she had what Heimdal

called Richelieu eyes, but on this occasion she was unmasked as an unparalleled goose, to put it bluntly.

Yes, quite honestly, this entire attempt, originally so well intentioned, to create a vibrant intellectual life on religious principles, *had* already been let down when Opperman came along and finally lit the fuse under the entire structure. *That* was more than men like the incorruptible Tarnowius, the philosophical Licht, the musically gifted Villefrance, the quick-witted Ingerslev, the quiet and well-read Lindenskov and he himself could take! Opperman . . . infinitely well-groomed and smiling, wearing a gold bracelet and with a silk-lined New Testament in his breast pocket . . . and with a *mandolin*! Though in fact the man had shown himself not to be without some talent as a mandolin player.

But good God. . . ! Mr. Skælling shook his head with a chuckle at the memory of the apalling clichés and platitudes coming from the lips of this incredible person. Of course, of course, it had been necessary to put a stop to the experiment. That was done at a secret and *extremely* pleasant meeting in the Club.

And the whole thing had only lasted the two days.

God help them. For fundamentally it was a terrible shame that the whole thing collapsed. Not least when this fiasco was viewed against the background of the phenomenal progress being made at the same time by those intolerable sectarians.

Mr. Skælling peeped into the bedroom. Yes, she was still sound asleep in there. He emptied his glass and took out his sleeping rug. By Jove, he needed a little snooze himself.

"Liva!"

Liva was moving like a sleepwalker, staring ahead with smiling eyes and apparently not hearing that someone was speaking to her. Magdalena and Sigrun exchanged worried looks. Sigrun showed signs of having wept and was dressed entirely in black.

"Liva," said Magdalena again and shook her sister by the arm. "Can't you see us, girl?"

"See you? Yes, of course, my dear . . ."

Liva took her sister's arm and a moment later Sigrun's as well. They walked quickly up the hillside. But suddenly Liva stopped and stared at Magdalena as though afraid: "Where are we going? Home? But I . . . I must go back; there's something I must talk to him about."

"Nonsense," said Magdalena persuasively. "We're going home now to have a bite to eat, and then you're going to have a *rest*, my dear. Pastor Fleisch said you were in desperate need of sleep, you've not had a wink of sleep since you all landed in Nordvík. Do you hear?"

Liva had again adopted her stare. She went along with them quite willingly. But suddenly she winked gaily to her sister: "Magdalena! Here we are, all of us, you and I and Sigrun, eh? Here we all are, waiting. But I say, the lamps, the lamps – where are they?"

Sigrun and Magdalena exchanged a glance. "Oh, God help us," wailed Sigrun. "Sshh," Magdalena passed it off. "She'll be all right when she's had a sleep, you'll see."

Liva seemed to relapse into deep thought. "He still won't look at me. He won't look me in the eye. But he pressed my hand. We're still together after all. He said: 'The hour approaches. We have conquered ourselves. And I'm not afraid any more. Let it come, Lord. This evening as well as any other time. I enter into it with joy,' he said. 'So must you.'"

"Yes, I will also enter into it with joy," exclaimed Liva in a loud voice, clutching her sister's arm.

"You really must pull yourself together," said Sigrun.

"Now!" Magdalena winked at her to keep her silent. "Let's not get excited."

"I'll run and fetch the doctor," said Sigrun.

"No, you won't. I think you'd better go home, Sigrun."

"Oh, so you're actually turning me away?" said Sigrun indignantly. "Yes, you are. That's nice of you, I must say.

But I'll go, you needn't be afraid. Home . . . to an empty house."

"No, dearest Sigrun, don't take it like that."

Sigrun tossed her head and was clearly offended: "*I'm* not one to make a nuisance of myself, Magdalena, you can be sure of that. In future I'll look after myself, I promise you. I've had enough of you and your daft family. *Thank God* I can be rid of you all now."

She twisted her mouth in disgust and quickly turned round.

"There's father," said Liva. She embraced the old man warmly.

"Dearest child," he said emotionally. "God be forever praised that we have you here again. I was so worried because it dragged on for such a long time, I was almost afraid you were ill and . . ."

Magdalena motioned to him, and he fell silent, with a questioning look.

"She's very tired," whispered Magdalena. "We must get her to bed straight away."

"Alfhild," exclaimed Liva in delight. "You, too, Alfhild!"

"What have you brought for me?" begged Alfhild, dancing around in expectation. "What have you got, Liva?"

Magdalena managed to move her aside. Thomea was standing in the kitchen. She looked up dully and stretched a lifeless hand out to Liva.

"Come along, now," said Magdalena gently and persuasively, pushing Liva gently in the back. "All we need now is some sleep. Then everything will be all right, you'll see."

Before long Liva had been put to bed in her alcove in the loft. But she did not sleep. She lay murmuring to herself, sometimes smiling, sometimes gently sobbing and with a scared look about her. Magdalena fetched a bottle of *snaps* and offered her a glass: "See, my dear, drink this, it'll do you good."

Liva emptied the glass at a gulp and gave her sister a grateful look. "It's *angelica*," she said with a smile. "Do

you remember when we used to make wine of angelica? When was that, Magdalena? It's not so long ago. And then we dressed up and went down into the village, do you remember?"

"Yes, we used to go dancing," said Magdalena. "Those times are past, dear."

She poured herself a small glass.

"Now you'll see, you'll soon be asleep," she said. "Shall I sing a while for you?"

She laid her hand on Liva's and gently began to sing:

High in the oaken grove
There hangs a golden bowl,
There dance the maids at Christmas,
The maidens all. . .

Tired out, Liva wriggled a little under the duvet and finally fell asleep.

When Liva woke up, it was in deep twilight. She sat up in bed for a moment and rocked backwards and forwards in great confusion and fear. She had had a bad dream . . . she had dreamt that she was walking along among some blacked-out houses with a lighted pocket torch in her hand . . . it was Judgement Day, and the darkness far and near resounded with calling voices. In the distance she caught brief glimpses of small flickering lights . . . they were the wise virgins' lamps, they were moving slowly away and grew distant like a group of stars in the sky. She held her torch up to show that it had not gone out, but now it was losing strength, its light was becoming more and more reddish and weak, and suddenly it went out, and she was left alone in the dark . . .

Trembling she leapt from the bed; foaming waves of anxiety and terror tore through her breast. But now she heard Magdalena's calm voice: "Well, Liva. Have you had a good sleep? You must feel better for that, don't you?"

"Could I have a glass of water?" said Liva. Her sister fetched her a glass, and she drank greedily.

"More?"

Liva was trembling violently. Wasn't there a little more of the angelica wine in the bottle? She heard Magdalena laugh: "Yes, but be careful you don't get completely addicted to it."

As though in a fever, Liva downed two large glasses of *snaps*. There. Now she was calm again. Good heavens, but she felt better for it.

"Now we'll have something to eat," said Magdalena. But Liva would not hear of eating, she was in a hurry . . . she must go down and have a talk to Simon.

"Nonsense," said Magdalena persuasively. "You just take it easy this evening. Now, we'll go for a walk, just the two of us, shall we?"

Liva obviously had no objection to the idea. Magdalena lit the lamp. Liva took down the little looking glass from the wall and put it on the table.

"Oh no, do you know what?" she exclaimed with a laugh. "I can't be seen like that. I must have my black Sunday dress on. And . . . Magdalena, be a lamb and lend me your silver necklace, the one with the cross on."

Magdalena could not refrain from laughing aloud. "Well, that's the limit. You're actually going and getting all vain, aren't you?"

Liva did her hair carefully in front of the mirror.

"Wouldn't you like to borrow my hair slide?" asked Magdalena. "And my earrings?"

"Yes, dear," said Liva eagerly.

Magdalena could scarcely believe her own eyes. Liva was actually sitting dolling herself up as though she was going to a dance. She had to give her a powder puff and lipstick and eau-de-cologne.

"And then some shoes," implored Liva. "Won't you lend me your lovely new shoes, those with the silver brocade on? I'll be careful with them."

"Of course," said Magdalena cheerfully. It suited Liva to have a bit of make-up on. Her cheeks were glowing now. It was like former times. Good Lord, that's what she was

like only a couple of years ago, a happy, fun-loving girl, full of life. Magdalena almost had tears in her eyes on seeing that the old Liva was not dead and gone. No, of course she wasn't! And she wasn't more than twenty-three in any case. And . . . time is the great healer.

"But it's Sunday evening, isn't it?" said Liva. "So there'll be a dance down at Marselius's."

"Good Lord!" Magdalena leant back and laughed. "Yes, but we can't possibly go *there*. Not yet, at any rate. But later," she added. "Later, Liva. At my wedding."

"Yes, at your wedding," said Liva, rubbing her hands. "When's that going to be, Magdalena?"

"At Christmas."

"All right, then we'll wait until Christmas. But at least we'll go for a little walk, I'd love to do that. Listen, let's have another drink, just a little one, there's a dear."

"No, dear, we'd better be careful." Magdalena was thinking what a good job it was that Liva was not going to be able to go off on her own that evening.

Thomea opened her eyes wide when Liva went down into the kitchen all made up and smiling.

"Are you coming, Thomea?" she asked persuasively. "A walk down to the village. Oh go on, you come, too."

Magdalena nudged Thomea to encourage her: "Yes, you come for a little stroll with us, you need a change, too."

Thomea looked from one to the other, her mouth twisted in an irresolute smile, she slowly shook her head. "No," she said suddenly. She sat down and crouched over the fire and shivered. But Alfhild very definitely wanted to go with them, and was allowed to, too. She clapped her hands in delight and rushed to get her red beads out, she was going to wear them in her hair.

"Hey, where on earth are you all going this evening," came the sound of their father's gently surprised voice from the hall.

"We're off for a sail," said Magdalena in high spirits. "Old Myklebust, you know, has invited us out for a sail in his Viking ship."

"Good-bye, father," said Liva, giving him a little pat on the cheek.

The three sisters were laughing at the top of their voices as they danced hand in hand down the path.

The weather was calm. The earth was sparkling with frost beneath the waxing moon. Once more Magdalena had to think of the days of freedom in her youth . . . the soaring feeling she had in her body as she ran down into the village in the evenings to go to a dance.

"Hey," shouted Liva so that it echoed from under the outcrop. She crushed her sister's hands, danced a couple of steps and started singing, in a warm, exuberant voice:

Blow wind, blow wind, blow wind in the yard,
Fill the sails, fill the sails, fill the sails so hard.
Off we glide, off we glide, off we glide anew,
O'er the waves, o'er the waves, o'er the waves so blue.

"Hush, don't let's make so much noise," said Magdalena. "There's someone coming down there on the road."

"We'll do what we like," hooted Liva, still loudly.

Old Neptune never rests,
See how he wilder grows
And ever harder tests
So many brave heroes.

The figure down on the road stopped and listened. Magdalena shook Liva's arm and tried to quieten her down, but without success. She went on, in a deep, boyish voice:

A fiery dram, a glass of ale
Our loyal friends shall be,
Where'er we go, where'er we sail
All o'er the rolling sea.

And now a rather cracked voice joined in from down on the road:

All flesh, it is but grass,
The prophets all did say,
This earthly life will pass,
Whenever comes the day.

It was Pontus the watchmaker. "Good evening," he shouted gaily. "I was actually on my way up to your house with a bit of good news, Magdalena. No, it's not about Frederik this time, it's about myself. But where are you off to? What about coming home with me and having a glass of port? A glass to drink to the good health of all of us?"

Pontus smelt strongly of spirits. "I'd hardly expected to find myself in the company of ladies this evening," he laughed, and his voice became quite amorous. "And beautiful ladies at that. Aye, for it must be admitted that you girls from Angelica Cottage aren't outshone by many. And you've got it from your mother . . . she was a devilish beautiful woman, I remember her well, she was always in demand at dances. I was mad about her myself. And so was old Schibbye, aye, good Lord what a fuss he made of her; your mother could easily have been a shipowner's widow and you shipowner's daughters if she'd wanted. But then she married Elias, and no one could understand that. But that's a thing of the past now. And Schibbye got old Mrs. Schibbye, the stewardess from the steamer . . . and he was welcome to her. He's in his grave now, God rest his soul."

Pontus went on with his carefree chatter as they walked together through the village. "Aye, we both got tartars, both Schibbye and I," he laughed. "But his was the worst, though. Aye, he died of it, by God he did. He simply couldn't take her. He was a weak man, round and fat like his foppish son. And my Kathrine . . . yes, if the truth be told, girls, it's because of her and her alone that I only started to *live* far too late in life. Aye, for now I suppose it's really too late . . . I'm getting on. And yet, by God. Yes, now I'm getting cracking. But let's go inside first. After you, ladies."

They went in through the dark and stuffy shop. Pontus lit the lamp and took out glasses and a bottle.

"It gives me great pleasure," he said with a little bow. "It gives me extraordinary pleasure to see you gathered here, dear ladies. Not least, I must say that it gives me pleasure to see *you* here, Liva. To hear you speak and laugh like an ordinary human being. Aye. For I honestly believed . . . but enough of that; one hears so much gossip and nonsense."

Pontus did battle with and conquered an attack of sneezing. He raised his glass and said, with a delighted but restrained little laugh: "And then, you can congratulate me, ladies. For . . . well, we don't need to be prudish, do we?"

He lowered his voice and suddenly his look became serious, almost threatening: "I'm going to be a *father*! With Rebecca, my shop assistant. She's only nineteen . . . !"

Pontus pushed the bottle aside, spread his elbows out on the table and went on: "She got the worst of the bargain after all, Magdalena. She was forced to come back to me and give up her adjutant. That's quite a triumph for me . . . but let me not boast, let me rather thank God, who has wanted to make a human being again of an old man like me . . . being fruitful and multiplying and replenishing the Earth. Cheers."

Liva left her glass on the table. She was very pale and looked around in amazement.

"For God's sake," said Pontus impatiently. "Won't you drink my health? Damn it all, there's no reason to make a fuss about it. I'm not leaving the girl in the lurch. We're getting married in January. Now, Liva. Raise your glass, damn it."

Liva suddenly gave Magdalena a look expressive of the deepest despair, and she quickly got up.

"I must go," she whispered.

"No, Liva," implored Magdalena. "Where are you going?"

"I need to talk to *him*."

Liva was already outside the shop. Magdalena got hold of her arm and tried to hold her back. "You can wait for us, at least, Liva?"

"It can't wait," said Liva. "Let me go. I've *got* to go."

"Then we're coming with you," said Magdalena.

"What's all this nonsense?" asked Pontus petulantly. "Why do you suddenly all have to go? And just when I was going to fetch Rebecca. I've never known anything like it."

It was pitch dark and cold in Simon's bakery. Liva felt she was on the point of fainting. She sat down on the nearest bench and pressed her clenched fists to her eyes.

"Liva," she heard Magdalena call from the entrance. "Liva. What on earth do you want here? There's not a soul down here. Do come home with us, do you hear?"

Liva sat still, holding her breath. She heard her sister coming closer, groping her way forward. But then she stopped and murmured to herself: "That's odd. I'm sure she came down here."

"Liva," she shouted again. And yet again, despondently: "Liva. No."

"Ugh," she said suddenly, and quickly disappeared.

Liva sat there for a long time. But all of a sudden she felt beside herself with fear. She got up with a stifled groan; the thick darkness came to life and started moving; huge sail-like curtains went flapping past, columns of mist came drifting by, faintly illuminated from below ... oblique, hovering shapes, pale faces with extinguished smiles, stern faces with keen birds' eyes, crazily distorted faces, dead faces, wooden and stiff and open-mouthed ... young faces helplessly rigid and set ... Ivar's ... Johan's ... Jens Ferdinand's ... !

She let out a piercing shriek: "Simon," she shouted. "Simon! Where are you?"

"Yes," it seemed to her he answered. Yes! Then came the sound of a trapdoor being opened and shut. And footsteps on the stairs leading down. And suddenly Simon's

figure came into view in the flickering light from a candle he was holding out in front of him.

"Is it you, Liva?" he asked as he came closer. "Your sisters are looking for you; they were here a moment ago asking if you were with me. But why are you sitting here all on your own, girl? Jesus Christ, child. Are you in despair?"

He stepped quickly across to her. Liva was trembling and her teeth were chattering, and she could not utter a word.

"What is it, Liva?"

Simon had taken her hand. He led her across to the narrow staircase. "I, too, have been afraid this evening," he said. "I still am. I have been alone with myself. Fighting. Fighting against fear, against Satan. I have again been afraid of *the cross*! Fear is the seed that Satan tries to sow in our hearts, Liva. And he does his utmost. But he shall not succeed. For he is but miserable vermin, doomed to destruction and retribution, doomed by the Prince of Light, who will soon be approaching in the clouds. He who crushes the serpent's head beneath his heel."

Simon lowered his voice and whispered, opening his eyes wide:

"I shall come with Him when He comes in the clouds."

He put the candle down. He stared at her, alert, watchful, without warmth.

Liva stepped across to him and her eyes penetrated his.

He retreated a step. His mouth twisted. "We must be on our guard, Liva," he admonished her quietly. "We must arm ourselves. We must tear out our eyes if they offend us . . .!"

"If they offend us . . .!" she repeated without releasing him from her gaze. Suddenly a tiny smile appeared in her eyes. She threw herself at him, hugged him, bored her head in to his chest.

"No!" he shouted. "*No!*" His voice was thick with excitement. He tore himself brutally from her embrace, pushed her mercilessly away, raised both his arms and groaned in invocation: "*Get Thee behind me, Satan!*"

She fell to the floor and remained there, kneeling, gasp-

ing as though she had run a race. There was a rushing sound in her ears as of many voices whispering all at once, and through the confused din she could hear Simon praying: ". . . And lead us not into temptation, but deliver us from evil."

She rose with a hoarse cry, stepped quickly over to the praying figure and tore his folded hands from each other.

"Satan," she bellowed. "Satan."

He got up, she gripped him by the shoulders with both hands, while she frantically sought his gaze: "I've got Satan! Satan! Satan!"

And now she again threw herself at him, pressed her breast and her lap against his body and with a gentle laugh repeated: "I've got Satan."

He freed himself from her grasp and held her at arm's length, calmly and with a composed mouth.

"I've got Satan," she whispered again, baring her teeth at him. "Let go of me, Jesus."

He let go of her hands and she once more collapsed to the floor, slowly and without a sound.

"We must pray together," she heard him say. His voice came from far away, as though from another world. "The Blood of Jesus Christ . . . The Blood of Jesus Christ cleanses us from all sin. . . !"

"No!" came the sound of an alien voice, hoarse and uncouth, and to her horror she heard that it was coming from herself. "No."

She got up and approached him for the third time, noiseless, watchful, with the stealth of a cat. He prepared himself to repulse this attack, too. "Liva," came the sound of his voice, cold and imperative. She took a couple of hasty steps towards him, her raised hands outstretched and threatening, her fingers extended like the claws of a beast of prey, but then like a flash she turned round and was out of the door. He heard her laugh in the entrance . . . a dark, alien laughter.

"Liva!" he shouted and rushed to open the door. "Liva!"

But she was already gone.

"Liva!" A shout was also heard outside in the moonlight. It was Magdalena; in the course of her own search for her sister she had returned to Simon's house and heard the voices and commotion inside.

"Liva! For heaven's sake stop, girl. Where are you going?"

But Liva did not stop. With the agility of a cat, she hurried off and disappeared round the corner of a house. Magdalena could hardly believe her eyes. "Be quick, Alfhild," she shouted. "We *must* get hold of her."

Liva stopped at the corner. She saw her sisters running up and waited until they were quite close, then she dodged away with something between a stifled laugh and a whine. It was like playing tag as children; she had a tickling in her back, kept watch at every corner and almost let herself be captured, but then escaped at the last minute.

"Liva!" Magdalena called out. Her voice had become more and more imploring and she was by now on the verge of tears.

But suddenly there was no longer any sign of Liva. She had dodged in through an open cellar door, closing it after her and bolting it. Through a dust-blurred window she could see her sister hurrying off. She laughed in delight as she regained her breath. The moonlight was falling obliquely in through a little, greenish window and over on to a pile of peat. There was a cosy smell of peat and mould in the low cellar, and above her head she could hear the sound of a cradle rocking to the strains of a gentle, sleepy voice. Liva leant against the wall and listened. The moonlight flashed on the cross on Magdalena's lovely necklace. Liva gently started to join in the lullaby, she felt sleepy and looked around for a place where she could lie down.

But suddenly there was life and movement in the gloom, the ceiling was as though raised up, the lullaby became distant, as if it was coming from some desolate region far away, and quite close to her a voice whispered: "I've got Satan."

Filled with terror, she tore open the cellar door and with her heart hammering in her breast she stepped out into the moonlight.

Coming out into the fresh air helped her. "I've got Satan," she said tentatively to herself, clearly seeking to impress it upon herself. When she admitted it to herself in this way, it didn't hurt so much. It wasn't even particularly bad. Perhaps he wasn't worse than the general run of people ... Opperman, Inspector Hansen, or Pjølle Schibbye.

When it came to the point, having Satan wasn't as bad as all that. She suddenly felt calm and looked around in wonderment. Yes, here she was, herself once more, the moonlight was glinting in Masa Hansen's big shop windows over on the corner. It looked as though the windows were lit up for some festive occasion. And over there was The Bells café. And there was Opperman's new house. And the school was over there. People were walking quietly past in the street, soldiers, girls, people in conversation with each other, and nobody noticed her. Provided she didn't run and play the fool she could walk about unhindered, even if she had Satan.

"I've got Satan," Liva repeated the words to herself, as though not quite able to forget it after all, while she slowly strolled on in the shadow of the houses, where no one took any notice of her.

Where was she going?

Well, she'd better go down to the dance hall, for now she'd got Satan, she could naturally do what she wanted. In a way it was so easy and straightforward, she'd got the evening off, she was herself. But to turn up at the dance hall in a black dress and play the lonely widow in the midst of all that happy throng, no, that would be far too distressing. But she could go back to Opperman's place and choose a suitable dress for herself, there were plenty to choose from, and now she could do as she liked.

She stopped at the entrance to Opperman's office and tried the door. It was locked. Just then she caught a

327

glimpse of Magdalena over on the other side of the street. She had Magnus, the policeman, with her. Oh, had those two started going out together? That was up to them. She ducked down behind the railings lining Opperman's steps until they had passed. My, they were in a hurry. Then she got up again and rang the bell. Opperman came out and opened the door.

"Oh, *Liva*," he said. "Why, you come here this evening? But what you have on your mind, my dear? Do come in."

Opperman's voice was strangely without strength, as though he had a mouth full of dry flour.

"I've got Satan," said Liva in a friendly tone, shaking hands with him.

Opperman opened his eyes wide. Then he rounded his lips as though about to whistle. Aye, aye . . . so Liva had got to that stage. He turned the key in the outer door.

"Come in and get warm," he said tenderly and cautiously stroked her thigh.

There was a comfortable, spicy scent in Opperman's office; strings of blue cigar smoke were rising in the air, and the smoker's table was covered with glasses and bottles. A hefty figure rose from the sofa. It was Pjølle Schibbye.

"Good heavens, surely it can't be Liva?" he exclaimed, opening his arms wide to her. "The only rose in the world? Hey, listen . . . take your coat off, lass. Sit yourself down and have a drink."

"Liva is here on very important business," said Opperman sharply. "She help me with very important matter. I sent message and asked her come here, so it best you leave us alone."

He placed a hand on Pjølle's shoulder and whispered: "You better go, you need cool air, you drink too much, you only disturb."

"The rose of life is found," cooed Pjølle and chucked Liva under the chin.

"Now," Opperman was irritated. "Will you please do us the favour I ask, Schibbye."

Pjølle ignored him totally and pressed Liva down into

the sofa. "A glass," he said, with a sweep of his hands. "A glass for the rose. Well, Opperman. You'll give her a drink, won't you, you . . . ?"

Opperman tossed his head resentfully and took out a liqueur glass. Pjølle unscrewed a bottle of Cluny, but Opperman rapped his fingers: "She doesn't want the strong stuff, you idiot, she wants a little liqueur."

He bent over Liva and said mawkishly: "You have little liqueur, Liva, won't you?"

Liva nodded and gave Pjølle a warm smile.

Opperman filled her glass. His hands were trembling. "Cheers, Liva," he said. "But now . . . we talk together as you promise me . . . about the invoices that were lost when you work here . . . so prices so wrong that Price Control Commission make fuss. Ach. No one make himself heard when he bellow like that."

"I'm not bellowing," said Pjølle. "I'm just so pleased, for I've always wanted to have a proper talk to Liva . . . we've not had the chance since she grew up. She's always been shy. Haven't you, Liva? We were old friends, Opperman, you realise that? We went to confirmation classes together, and since then she's always been in my thoughts. Haven't you, Liva?"

She nodded and leant back comfortably in the sofa. Her eyes were warm and calm, and she didn't take them off Pjølle.

"I've got Satan from Hell," she said quietly.

"*What* do you say?" asked Pjølle, frowning and smiling. "I'll be damned if I didn't think she said: Like Hell!"

"She told you to go to Hell." Opperman darted an embittered glance at him.

"Rubbish, that wasn't what you said, was it?" asked Pjølle, pouching his lips like a peevish child. "You're very fond of me, aren't you, Liva?"

"Yes," she replied.

"Now you *mustn't* disturb us any longer, Schibbye," said Opperman, now seriously angry. "Understand. This is my house and my assistant who come to me on urgent

business, and you sit here and are blind drunk and just interrupt everything. You've been here long enough . . . and your mother ring and I said you not here . . . but now I ring to your mother and say you here . . . for she had important telegram."

"My dear chap," said Pjølle, raising a hand. "Be reasonable, Opperman. Now we'll drink Liva's health, won't we. You *must* let me do that."

"All right, *one* more, and then absolutely no more."

Opperman turned away livid with anger. Pjølle calmly seated himself on the arm of the sofa. He filled Liva's glass with a dry whisky. She emptied it at a single gulp, and he gave a little falsetto hoot: "Good Lord! Our little revivalist lass! What *is* the world coming to?"

Liva exchanged glances with him. Her look was happy and confident. He took her hand and raised it to his lips in adoration.

"Oh, you get her drunk," said Opperman. He was standing on tenterhooks, wringing his hands. "And she must help me with big calculation. You do us much harm, that is certain. You behave like bad person, Schibbye. Shame on you. You are bad gentleman. You a humbug."

He was interrupted by the loud ringing of a telephone; he took it with an expectant look in his eyes. Pjølle ducked down, listening and making roguish eyes at Liva.

"Oh," said Opperman. "No, not now. Absolutely. What you say? *Dead*? Oh, not dead? Nearly? That cannot be. Ugh. That only usual hysteria, nothing else at all. What? The doctor? Well . . .? Yes, I come. *I come*, I say."

He banged the telephone down, turned to Pjølle and shouted, completely beside himself: "Get out! Get out! My wife dying. Liva wait here. Get out immediately, Schibbye! There no time for nonsense."

Pjølle got up. "Is your wife dying, you say?" he asked in amazement, raising his hands to his head.

"Yes," groaned Opperman. "And here you are . . . and . . .!"

"Yes, but who could have any idea?"

Pjølle's eyes had suddenly lost all sign of life. His lower lip hung limply down.

"I say it all the time," Opperman stamped his foot.

"Well then, you must forgive me." Pjølle turned towards Liva. "But what about her? What about her? Shall I take her home?"

"No, Liva come with me," said Opperman, pushing him impatiently in the back. "She help me. She help the maid. She a good nurse. She also good seamstress, she perhaps sew shroud."

Pjølle stared at Opperman in horror. "Good God," he said and looked down.

"Yes, it terrible misfortune," said Opperman while he helped Pjølle on with his overcoat. He wiped his nose, whimpering: "Dreadful. Now I become completely alone."

Pjølle shook hands with him in commiseration and gave Liva a melancholy bow.

Opperman hurried up to the house. In the doorway he met Doctor Tønnesen.

"Oh, Doctor," he asked breathlessly. "Bad?"

"Yes, it's very bad, Opperman. She's unconscious. It's her heart. I'll get a nurse to come and keep watch with her tonight."

"Oh, poor, poor," said Opperman. His eyes were filled with tears. "Oh, goodbye, Doctor, and many thanks."

The doctor gave Opperman a searching look. Yes, they were real tears. He made as though to say something, but changed his mind and disappeared without saying goodbye.

Opperman fetched Amanda. He allowed the tears to remain in his eyes. "Ah, I not bear see her die," he said. "I rather go back and lock myself away with my sorrow. Ah."

Amanda snarled scornfully, but made no reply.

When Opperman returned to his office a little later, Liva had fallen asleep. She was snoring lightly and breathing

through her mouth, her hair was dishevelled, just above the neckband of her dress a tiny brown birthmark was visible. Trembling, he bent down and kissed her breast; he sucked hard and saw the tiny red-dotted mark that appeared, made another mark beside it, pulled off her shoes and stockings, kissed her wildly and madly on the face and body, even the rough skin on her knees and the hairy legs received their kisses. She complained slightly in her sleep, a long and trusting sigh, and there was a little smile on her lips.

Then he quickly went over and put out the light.

At that moment the telephone rang. Blast! He left the receiver on. You couldn't even be left in peace at home. Though . . . if it were Amanda or the doctor! He took the receiver and put on a plaintive tone.

"Yes?"

It was Inspector Hansen. Was Liva Berghammer there by any chance?

"Oh, her," said Opperman. "No, she's not here."

Had she been there?

Opperman hesitated slightly, it would probably not be a good thing to tell a lie. "Yes, she was here, a few minutes ago, together with Schibbye, but then they went, for . . . for my wife is dying."

"Oh, I see," said the inspector. "I'm sorry to hear that. But . . . but Liva Berghammer's in a bad way, we're looking for her, she seems to have gone round the bend. What was it I was going to say: You didn't notice anything peculiar about her? What did she want at your place?"

"Ask for her old job back," replied Opperman. "And she got it, too, for Liva is a good worker and very sensible. No, there was nothing unusual about her. Yes, she left with Schibbye. Oh, don't mention it. Hope she . . . you . . . Goodbye."

Opperman left the receiver on the table. Damned unfortunate his voice had trembled so much. But perhaps there was nothing particularly strange about that when his wife . . . !

He quickly drank a mouthful of liqueur from the bottle.

Then he stretched out comfortably on the sofa. There was no time to lose now. Liva whimpered and complained in her sleep. "Dear, dear," he said to calm her. "You are here with me . . . I love you . . . I love you . . . !" With a sigh she laid herself in his arms and whispered: "Yes, that's right, that's right."

Opperman was in a bit of a whirl. It was as though there were fireflies dancing in the air round him.

"Now," he whispered. "You must go now, Liva. Do you hear? No, you must get up now, girl."

He bounced up from the sofa and held his head, whistled a brief melody while he considered what to do. Quick. Quick. She must be dressed properly and then get out. Out through the back door in the cellar. "Good Heavens, girl, do be reasonable. Look, here's a glass of liqueur. Ugh, for heaven's sake hold it still, woman."

Liva laughed, a deep and carefree laugh. Thank God, she was still mad. "Do you know," she said. "I've got Satan. Yes, really, I really almost believe it." And then there was again that chuckling laugh. "So have you, Pjølle, haven't you? And you, Simon . . . Oh, stop putting it on, I know what you're all like, 'cause you're all married to me now, you can't get away from that. What will folk say when they hear about it? All those wise virgins! No, stop it . . . surely I can be left to lie in my own bed, Magdalena. Or shall we go down to the village again?"

"Yes," said Opperman. "We're off to the village. Come on."

Opperman was sweating. He was on the point of weeping with irritation at Liva's shoes, a pair of cheap, hard shoes which seemed far too small for her feet. They were new. Cheap gilt things from Masa Hansen, bought through Spurgeon Olsen, who had now set himself up as a shoe wholesaler.

"For heaven's sake help me a bit," he grumbled, slapping her with a free hand just above the ankle.

"Have you got any more of that angelica wine, Magdalena?" asked Liva.

"Shut up!" Suddenly, Opperman could no longer find the bottle in the dark, a glass fell to the floor and broke. There was a humming sound from the telephone receiver over on the desk. Liva yawned and stretched: "Ah . . ." But suddenly she pulled herself together and seemed determined to leave. Opperman started in relief. He fetched her coat. Now just down into the cellar, down in the air-raid shelter, and then out. . .!

Suddenly Liva started singing:

> All flesh, it is but grass,
> The prophets all did say. . .

Opperman nudged her arm hard. "Will you be quiet, woman!"

"Oh, all those stairs . . . all those stairs," laughed Liva, making a couple of superfluous dancing movements on the floor of the air raid shelter, as though she thought they had to go down even further.

Now they were at the outside door.

"Be absolutely quiet now," urged Opperman.

"Be absolutely quiet now," repeated Liva in a whisper, tugging at his sleeve and laughing.

Opperman opened the door gently and looked out. A couple of soldiers walked past. They were singing gently in competition with each other and appeared to be in high spirits. But it would be best to wait until they had gone. Now.

"Is it now?" asked Liva excitedly.

"Yes, it's now. Come on, Liva, *now!*" He gave her a shove in the back, she bent forward slightly, bit her lip and shivered, tiptoed away, and disappeared.

What now? She suddenly felt so lonely. "Simon," she called. "Simon." No reply. She started to run. Someone came running after her. She screamed aloud with excitement, but at that moment she felt an arm round her shoulder. It was he. "Thank goodness," she said breathlessly, so filled with a sense of happiness that she became

weak and almost on the verge of laughter. "Thank goodness, Simon. I knew you would come. Have you got my lamp?"

With a long sigh of relief she clung to Magnus's arm. He uttered a few sounds betokening sympathy, but soon gave up trying to reason with her. He then took her by the arm and quickly led her off towards Inspector Hansen's house.

"I haven't got a lamp," said Liva.

"That doesn't matter," Magnus sought to comfort her. "Doesn't matter in the least, Liva, not in the least. It's a lovely moonlit night, you know."

The door in to the inspector's lobby was standing open. Shouts and excited voices could be heard coming from inside.

"Terrible. Terrible. I think they're crucifying him!"

"*What* are they doing? Yes, but . . . surely that's not possible?"

Tørnkrona, the tailor, repeated in a choking voice: "Crucifying, I say, crucifying."

The man was obviously beside himself, standing there loosening his collar: "Terrible."

"Magnussen," shouted the inspector. "Oh, you've found her? Quick, bring her into the sitting room. We've got to go straight away . . . up to the memorial mound. They seem to be committing some sort of a crime up there. Masa can look after her meanwhile. Masa – ring the doctor and ask him to come up to the memorial mound. Yes, the memorial mound, damn it! They're crucifying someone up there."

Magnus ran as fast as he could, while the inspector and the tailor followed some way behind. The sound of hammer blows were coming from up on the memorial mound, together with subdued shouts and a hollow groan like a death rattle. The baker was lying bent forward on the ground beside the wooden cross, and Benedikt and the mad boatbuilder were standing shaking him and trying to force him over on his back. Magnus drove them off him

with an embittered oath and bent down over Simon, who lay gasping for breath. Blood was trickling from his right hand, which was firmly fixed to the bar of the cross by a solid nail.

# 3

Mrs. Opperman was given a quiet funeral. This was out of respect for her own wishes. It poured with rain, and black umbrellas and mackintoshes put their monotonous stamp on the little cortège and made it strangely faceless and impersonal, almost like a procession of insects.

"There's as it were something *symbolical* about it," whispered Mr. Skælling to his wife. "No one knew much about Mrs. Opperman or of the relationship between the two of them. Strange, mysterious, isn't it?"

The editor and his wife walked close to each other under their common umbrella.

Yes, indeed, he thought to himself, it was mysterious, this thing. And this mystery would never be solved. But people would guess and speculate, and new incredible anecdotes would circulate and add to the strange web of popular myths in which the tale of Mrs. Opperman and her illness was already enmeshed.

Had Mrs. Opperman been mad, "possessed", as some said? A girl who at one time had helped Amanda in the house was said one evening to have heard her summoning the Devil and talking to him for a long time in Opperman's presence. Opperman himself had not uttered a word. There was much to suggest that his wife had had periods of mental instability, with attacks of fury and hunger strikes. But as for Opperman, it appeared that he had taken her unpredictability with equanimity. It had never been heard or suggested that he had spoken to her reproachfully, let alone in harsh tones. And never had he spoken of her in anything but warm, sympathetic words.

One drastic assertion – still coming from this maid, for nothing at all ever came from Amanda – was that Opperman had deliberately ruined his wife's nerves and made her ill. Among other things he was supposed, before she took

to her bed, to have engineered some absolutely dreadful shocks for her.

Old wives' tales, presumably, to judge from their curious, clammy and undeniably poignant style. In particular there was one diabolical story which said that one evening when Mrs. Opperman thought she was alone at home he had hidden in the loft, switched off the electricity and, from a half landing, teased a funeral wreath down over his wife's head. On another occasion, it was said, he had placed a notice of his own death in an English newspaper to which the couple subscribed. Solomon Olsen's head clerk, Gjowstein, took the same newspaper and was said to possess the issue in question. On certain occasions Opperman was also said to have tried to scare Amanda out of her wits, for example posting a parcel to her containing a bag of wet soil, a hymn book and a shroud.

Typical of the popular imagination. On the other hand it was quite authentically told that Opperman often gave his wife flowers, fruit, exquisite chocolates and countless expensive books and magazines – Heimdal the bookseller would confirm that.

Now the cortège stopped by the water-logged grave. The rain could be heard beating down on the opened umbrellas and then splashing down on to the white coffin lid. Pastor Fleisch officiated, but there were no speeches, merely a prayer and a hymn: "Fair is the earth". It sounded terribly dispirited and umbrella-muffled. And that was all. Nothing but the seething rain. Mrs. Skælling wept quietly into her handkerchief.

"You know, we must go over and offer him our condolences," whispered her husband. He was thinking of the big advertisements and the generous gifts to the orphans.

But in an odd way Opperman had made himself inaccessible. He was kneeling by the grave and had hidden his face in his hands. His hat and umbrella lay in the withered grass at his side.

Small groups of people stayed under the umbrellas waiting for him to get up, so they could express their sympathy.

But he made no attempt to change his position, simply knelt there, deaf to the world like a tortoise in its shell. So there was nothing to be done.

Mrs. Opperman's old maid, Amanda, was standing on the other side of the grave, hidden beneath an umbrella of a rather out-of-date design. She, too, stood motionless. Mr. Skælling could not escape the impression that she was keeping an eye on Opperman and that it was she who in some way or other was the cause of his not getting up.

"He'll be drenched," he whispered to his wife. "Heavens above, who would have thought *that* of Opperman?"

The gathering dispersed, and people went home in wonderment. Down by the entrance Mr. Skælling and his wife turned round and took one last look at the cemetery. Opperman had still not got up, and the old maid was still at her post.

"I do feel ever so sorry for him," exclaimed Mrs. Skælling. "And then there's something strangely eerie about it, don't you think so, Nikodemus?"

"Opperman's a mystery." Her husband shook his head. "He's both ridiculous and sublime. A strangely moving combination of good and evil, Maja."

The couple found themselves in the company of Doctor Tønnesen and his son Lars, a medical student. They naturally discussed Opperman, and Mr. Skælling said: "Yes, but is it possible to understand him, Tønnesen? I'd give a lot to borrow the key to the innermost corner of his heart."

"I'll give it you," said the doctor, in fine spirits and taking a deep breath. "Eh ... Opperman suffers from *moral insanity*. He's morally incoherent, disintegrated. So he won't go to pieces. He's like an earthworm that can be cut into several bits and yet go on living in the best of health ... through all the changing scenes of life, ha, ha. Aye, it all looks very strange indeed to the rest of us, but in reality it's perfectly straightforward. Therefore he's both a softy and a dangerous man. Do you see?"

Mr. Skælling blushed slightly. That man Tønnesen was really sometimes a little supercilious, just a little bit too

keen to teach others. A clever surgeon, admittedly, an excellent butcher. But otherwise he was a hard-boiled materialistic cynic. And pretty boorish, too.

"And of course it's this conscience-free *amoeba-like character* that makes such a successful business man of him," the doctor continued his philosophising. "And that's fundamentally something we can say about the whole bloody lot of them, Mr. Skælling. These so-called hale and hearty businessmen who *carry society on their backs*, as is usually said of them, and as they think themselves ... there's nearly always something defective or warped inside them. Their thoughts are arid, centred on one single problem: Is there any money in it? Their emotional life has congealed in some religious cliché or other ... once and for all they take out a spiritual life insurance, and then that's that, and they've got their hands free to go about all kinds of unsavoury business with no holds barred."

Mr. Skælling sought to break in with a comment, but the doctor had still not finished with his analysis and he mercilessly cut him short ... "Fundamentally it's the same warped spiritual life – this atrophy of the organ that produces common humanity – that's responsible for all these wretched wars being fought all over the world these days – they're all about money ... Oh, I'm sorry, were you wanting to say something?"

Mr. Skælling smiled bitterly. "As far as I know, Opperman isn't particularly religious," he pointed out.

"Oh, isn't he," said the doctor happily. "So his mandolin playing didn't soften you up?"

"Oh, *that* ...!" Mr. Skælling blushed scarlet.

"No, it boils down to this," continued Tønnesen. "When all's said and done, there is more integrity in our two poor loonies, Liva Berghammer and her baker. They have honestly and truly taken their Christianity to its logical conclusion, and they've ended up in total absurdity."

"You don't seem to have much liking for that same Christianity, Dr. Tønnesen," Mrs. Skælling interrupted in a patently restrained voice.

"Sshh," her husband nudged her gently: "The caliph's words are those of wisdom. Well, goodbye, Doctor, this is the parting of our ways . . ."

"Goodbye, goodbye, old chap," said the doctor. He obviously had no sense of having upset anyone, thick-skinned as he was.

"The man's totally devoid of any understanding of the mystical element in life," Mr. Skælling said in a peppery tone. "Of the paradoxical nature of all things. And so he becomes superficial and banal in his judgement of the tenebrous powers of the spirit. That's what it is, Maja."

"Yes, of course a man like Opperman grabs the Oxford Movement mandolin when it suits him, Lars," continued the doctor. "And it's wrong to say he doesn't mean anything by it. On the contrary the mandolin-playing fragment of the earthworm is religious all right. And when he sits there and collapses over his wife's grave, it's not really affectation, for you can bet your bottom dollar that *that* bit of the worm is pretty devastated, at any rate by self pity. For he probably hasn't the slightest idea that it was really he who *killed* her."

"Was it . . . myelitis?" The son put the professional question. His voice trembled a little.

"No, it was hysteria," said the doctor, hitting out with his walking stick at a withered dock-weed by the roadside, making the raindrops splash up in all directions. "Hysteria and a weak heart. And how could it have been otherwise. Take an ordinary nice and decent girl and lock her up in a cage with a spider . . . a lobster . . . a centipede . . . a tapeworm . . . for eight years! She'll die of it even if she's as strong as an ostrich."

Opperman was still kneeling by the graveside. There was no longer a dry stitch on his body. Amanda, his old maid, finally took pity on him and went over and touched him. Opperman started and turned a distorted and grimy face towards her. His eyes were numbed with tears, and he was drawing his breath in gasps.

"Yes, this is *the punishment*," said Amanda. "But it's only the beginning."

"I didn't know it was so hard," sniffed Opperman. "Amanda, do you think . . . do you believe that . . ."

"Believe what?" She looked at him in disgust.

"That the forgiveness of sins. . ."

"No," she said. "I don't believe that."

"Then I shall always be unhappy, Amanda?"

"No, not always," said the old woman, raising her rasping voice. "*But at the end, Opperman.*"

He trembled miserably, and without looking at her said: "Amanda think . . . Amanda think . . .?"

"That Hell awaits you? Yes." She shouted, so loud that it made her hoarse, and she began to cough. "And now I'm going. And we shall never meet again."

Opperman threw himself to the ground and writhed silently in the mud from the open grave. Amanda turned away and spat.

The old gravedigger and his son had witnessed this scene from a place where they were waiting out of sight. "We can't leave him lying there like that," said the old man. They went over to the grave and got the desperate man on his feet again and took him home.

About five o'clock that afternoon Inspector Joab Hansen came and knocked on Opperman's door. He had heard of the events in the cemetery and was somewhat surprised to find Opperman sitting comfortably in a dressing gown and slippers, reading the Illustrated London News. It was very warm in his sitting room, and a steaming, fragrant toddy with slices of lemon was standing on the smoker's table by Opperman's easy chair.

"Please take seat," said Opperman. "Have a toddy perhaps . . . ? Cigar . . . ?"

Opperman's eyelids and cheeks were pale pink.

No, thanks, the inspector wouldn't have anything. He sat down and glanced sideways at Opperman through his slanting Japanese eyes, sighed deeply and slowly and in an

official voice he came out with his errand. To get straight down to brass tacks, it was something concerning Liva Berghammer. They had discovered out at the hospital that while she was wandering about she had been the object of a sexual assault, indeed, to put it bluntly, rape. And the doctor had now furnished the inspector with these facts and said that it was up to the authorities to get to the bottom of the matter.

"And the doctor's a dangerous chap," added Inspector Hansen. "A very zealous man in all matters of that kind."

"Yes, but where had she been, then?" said Opperman, putting down his magazine.

"Well, that's exactly what I wanted to ask you about. For she was here, among other places."

"Oh, I am not very clear about it," said Opperman, moving in his chair as though trying to remember. "It was that night my wife die. Oh, I was very upset, Inspector. But I well remember Liva was here and Schibbye as well. We sat in my office. We had a little drink, it was so cold. Then telephone rang . . . oh misfortune, misfortune. My wife. . ."

"Did Liva Berghammer drink alcohol, too?" interrupted the inspector.

Opperman raised his index finger, like a reprimanding school teacher: "I say to Schibbye: not pour. But he give her strong whisky. But I say: in any case only liqueur. In any case."

"Were you yourself drunk?"

"I? Oh no. Well, perhaps a little. But Schibbye . . . oh!" Opperman closed his eyes and shook his head.

"Was Schibbye alone with Liva at any time?" continued the inspector. He had taken out a cheap little notebook.

"Yes. While I telephone. I turn back completely."

"In other words, you were present all the time while Schibbye was here?"

"All time, yes," admitted Opperman, sounding almost melancholy, but all the time thinking hard.

"And then Schibbye left after you got the telephone message?"

343

Opperman clasped his hands and pondered very deeply. "Yes. Yes, indeed."

"And Liva left together with him?"

"Together with him, yes." This time there seemed to be nothing for Opperman to hesitate about. "Together with him."

The inspector made a note. "Then he's not telling the truth," he said pointedly. "I mean Schibbye. He says that she stayed behind with you."

"But I go up to my wife, you know?" said Opperman as though in great surprise. "Up to deathbed. . .?"

"But you very quickly came back, didn't you, back to Liva?"

There was a sudden ugly flash in the inspector's eye, but he quickly extinguished it again and his tone became confidential: "Is it really worth sitting here playing poker any longer, Opperman?"

"No, you are right," replied Opperman, seeking to catch his eye. "I not good at white lies. Oh, I was drunk, Joab Hansen. I was upset with sorrow and fear. I nearly not know what I did that evening. You understand?"

"No, I suppose not," said the inspector. "But what you've done, Opperman, is a very serious crime indeed. You can get eight years' hard labour for that. Understand?"

"For a grown woman?" whispered Opperman rising in his seat in amazement.

"She was not in control of herself," explained the inspector. "And you knew that perfectly well."

"Then I too not in control of myself," maintained Opperman sternly. "And Schibbye also not in control. For he had got us all drunk, all three of us."

The inspector blew his nose. He said persuasively: "You knew perfectly well that she was out of her mind, Opperman. Now don't let's have any more nonsense."

"No, how could I know it?" Opperman raised his eyebrows triumphantly like the top boy in the class catching his teacher out in some childish inconsistency. "She come here where we sitting drunk . . . She not tell that she

344

out of her mind, does she? She not bring documentation. Do be reasonable, my dear fellow."

"That makes no difference," growled the inspector petulantly and looked down. "Whether the girl was mad or drunk, you exploited her condition."

"No, I did not for I not know her condition. Be fair. She come to me, she stay here with me . . . what must I think? And Liva and I know each other so well from old times, oh, we have had so much together before . . . Have you not heard *that*, Inspector? No? No gossip, eh? You who know everything."

The inspector dropped his pencil on the floor. He bent down to pick it up, while he was thinking: "So the beast's trying to turn it all into a trivial matter . . . something that happened while they were all drunk . . . that's to say there were mitigating circumstances, very mitigating."

He sat for a moment considering. Then, slowly, he turned his gaze on Opperman and said, casually: "It doesn't matter, for if this comes to court you're finished in any case. You will be forced to admit that you were carrying on with a mentally deranged, drunk girl at the very moment your own wife was on the point of death."

The inspector got up and said in a shocked voice: "Opperman, Opperman. Quite honestly, this is the worst case I've ever met in my life. It's so appalling that as a private individual I dread bringing it to court. But as an official . . ."

Opperman lit a cigarette, shook his head, and said: "I understand. But, Joab Hansen . . . for me it is not such big scandal. It is mostly just like some kind of moral laxity. And moral laxity is great in our time. People also know I had Liva before. I know they say it. Yes, some say it therefore she became mad. And what can the punishment be? Perhaps I be acquitted, yes? Perhaps I just pay fine or alimony."

The inspector sat down and made a long note with many crossings out. "You admit that it is true, then. Well, that's the most important thing. You maintain that you did

345

not realise she was mentally disturbed, but you admit that she was drunk."

"The aforementioned woman has been my mistress for some time," Opperman dictated.

The inspector growled. Opperman was right: the whole affair looked less serious when put down on paper. Fundamentally it was not much more than a rather riotous merry evening.

In his impotence the inspector made some clicking sounds and passed wind. Here he'd come believing . . .

"Write also," added Opperman, "that she was in strange condition when she came, hair untidy, dress undone . . . write that I cannot guarantee that she not drunk when she came . . . and perhaps already raped. Write that, Inspector."

"I'll write as I please," said the inspector savagely and passed wind again. "I'm not actually acting in your defence."

"Perhaps you not write anything at all?" enquired Opperman suddenly, hastily and with a thin, expectant voice.

The inspector looked up suspiciously: "What do you mean?"

"One knows so much," smiled Opperman, looking away. "One knows so much, ,nspector. Shall we speak, shall we be silent? You know Frigga Tørnkrona, Frøja's little sister, don't you?"

The inspector got up with a threatening look, but turned away. "Yes, but that story's a wicked lie," he laughed dully. "I'd happily take my oath on that." He suddenly turned towards Opperman with a murderous look in his eyes. "Oh, you bloody rotter. You loathsome rotter."

Opperman placed a comforting hand on his shoulder. "Be sensible, now, Inspector, and listen to me. I don't think that story is a lie. If matter comes out, you also be disgraced. Then we both be disgraced, both rotters. Who will that do any good? And there are other things, Inspector, strange things. I know much . . . What about letting things drop, Joab Hansen. No, I just suggest."

The inspector was breathing heavily. He scratched his chest and appeared not entirely unwilling to negotiate. "But the girl *has* been raped," he said. "They're going to demand an explanation."

"The baker?" said Opperman quickly. "No one talk about *him*?"

He went over and took hold of the inspector's lapel. "Perhaps we two make agreement? Perhaps? You do me favour and I do you favour . . . as we have done before? Perhaps I say I give you Christmas present as good customer, I give you 5000 kroner . . . 10,000 kroner or 20,000 kroner or something. In cash, of course, not cheque."

He could not suppress a little laugh.

The inspector sullenly pursed his rather skew lips. He said slowly: "I don't know, Opperman, my duty as an official . . . you know what that is. But on the other hand, as you are well aware, I can't stand . . . And what would the girl get out of it? On the whole it'll be by far the best thing if we avoid a court case. It would be a pity for her reputation, a pity for her family. In short. In short, Opperman . . . I must think it over before I do anything."

He lowered his voice: "And between us, Opperman, *the doctor* . . . the doctor is after you. He'd love to get you . . . But shall we say we'll have another talk tomorrow? Good, then I'll give you a ring."

The two men shook hands, smiling, but without looking at each other.

The following day, towards evening, Mr. Skælling received a visit from Opperman.

"Forgive me for bothering you, Editor," he said with a slight, deferential bow. "And many thanks for the splendid wreath and all beautiful sympathy."

He gave Mr. Skælling an envelope: "It is advertisement, if I could have all back page. I have had delivery of many fine goods. But it was otherwise something else I come for. Thank you, I sit comfortably here, by the door, thank you."

"Oh," he said plaintively. "It is so much suffering . . . so many many people out of their minds, so many struck by tragedy, and unhappy people, Mr. Skælling. In whole world. And here, too, though we are not in war. And now my dear Liva Berghammer become mad. Oh, it make me so sad, she was good worker for me, respectable and decent girl. But what I want to say: There is nearly no room in hospital for all mentally ill desperate people, Editor, and so they must be sent home again before they are cured. Therefore I have the thought: what about making convalescent home? There are convalescent homes everywhere in the world. Think how good it would be if we had convalescent home here?"

"Yes, there's certainly no doubt about that," agreed Mr. Skælling emotionally.

Opperman himself was emotional. His upper lip was trembling, and there was a pleading look in his eyes. He sat turning his hat in his hands as though embarrassed, and while doing so he had about him something of the look of a junior clerk obtaining an interview with his boss and intending to ask for a small pay rise. This man of wealth, this consul, was far too modest. Mr. Skælling actually felt sorry for him and tried to help him along. "Well, and now you're perhaps thinking of starting an appeal, Mr. Opperman . . . ?"

"Yes, no, I wanted first to say that now my house, my villa, is standing empty after my poor Alice's death, and I not need it any more, and it is so big and roomy that it could almost be used for a start if you think so, Editor. And then we could make appeal, yes, and then I would put my name on list of contributors to give 50,000 kroner, that is what I have thought."

Mr. Skælling brought his hands together with a loud smack. He was thunderstruck.

"And then the convalescent home could be called The Alice Opperman Memorial Home in memory of my wife. Or simply Alice House."

"The Alice Opperman Memorial Home," said Mr Skæll-

ing. His voice was breaking with emotion. "No, now you must . . . Excuse me a moment, Consul Opperman, I must tell my wife about this straight away. I can't wait. Maja – just you listen. What do you say to this?"

Maja simply burst into tears when she heard of Opperman's plan.

"And then people are so nasty to you," she said, holding his hand tight.

"What you mean nasty?" asked Opperman smiling.

"No one's nasty to Opperman," her husband corrected her.

"No," agreed Opperman. "Almost everyone is so kind. But, Editor, perhaps you will write a little about it so it can be organised and the appeal be started, yes? You need not mention my name."

"You'll not be able to avoid *that*, at least," laughed the editor. "And why should you, in any case?"

"My hat, Maja," said Mr. Skælling to his wife when they were on their own again. "*That*'s what I call a gesture. And the touching thing about it is that he's doing it to honour and sustain the memory of his wife. He must have been *terribly* fond of her, after all."

Maja nodded and dried her eyes.

"There is simply *no* denying that that sort of thing comes from the bottom of the heart," Mr. Skælling went on. "Where the Devil should it come from otherwise? Oh, sorry, that was an unfortunate way of putting it, but quite honestly, I'm just a little exhausted as well. He knows how to give, that Opperman. We must do something for him. He must be honoured. *He*'s the one who ought to get a knighthood, not Solomon Olsen, for what has Solomon ever done for the public good? He's looked after his own interests, that's what he's done, and he's a master at it. But I will certainly drop a hint to the Governor when the occasion arises."

The look in Mr. Skælling's eyes became scornful, almost cruel, and in a tone of profound contempt he said: "And

then what about our little cynical friend the doctor with all his malicious quibbles about religious clichés and worms being chopped to pieces. He suddenly seems strangely insignificant, doesn't he, Maja?"

Mr. Skælling fumbled for his cigar box and his hand was trembling as he lit a cigar. "My word, Opperman shall not only have the back page tomorrow, but the front page, too. It's a pity we haven't got a block with his photograph. Or his wife's, eh? Or the house . . . that lovely old home of theirs, which now . . . By God, I think I'll write that front page now straight away. At last there's something pleasant to write about . . . something other than war and murder and shipwrecks and tragedies, but, the Devil take me, something great and cheerful. Almost like in the old days."

Mr. Skælling, the editor, took out his writing pad. He put down his cigar and, without thinking, whistled a bit of the Luxembourg Waltz.

# 4

Rather hesitantly, the weather had turned mild. Late, veiled sunrises gradually evolved into an indeterminate haze of smoke and evening twilight without any real daytime transition.

Due to circumstances, Mrs. Lundegaard had closed her boarding house, and Myklebust and Thygesen were now homeless. Well, homeless and homeless . . . In reality they could perfectly well lodge at Marselius's hostelry, The Welcome Hotel, but it was a confused, semi-military place. In that case the Gokstad Ship was better; there they found peace and quiet to play the guitar and live their lives undisturbed. And then they could go out for a short sail before the wind or drift about at will, or they could tie up their ship in some lonely bay along the shore of the fjord. And fry a piece of steak. What a splendid way of living. Beer never tastes better than with a good piece of steak, and *snaps* never tastes better than with a good steak and a beer. And never do steak, beer and *snaps* taste as good as when consumed on an overcast evening in a forgotten little inlet to the sound of lapping water.

Occasionally they would go ashore and do their shopping, buying food, tobacco, blankets, jerseys, everything the heart could desire, and Myklebust had as much money as a basilisk has scales. The military canteen provided them with drink. As one of the allies, Myklebust was of course friends with the entire military establishment, including Captain Gilgud.

The cabin was too cramped, but they managed to extend it and build in new cupboards and roomy bunks with spring mattresses. Nothing is more delightful than thus lying hidden and forgotten and sipping a dark brown scalding toddy, as spicy as tobacco juice, while the night rain patters on the deck like mice on the table when the cat's away. Or when the wind is strong and the waves are

splashing up like glass around the hull, an innocent, chaste sound that reminds one of the dawn of time.

Sometimes it would suddenly turn as bright as day in the cabin; they would look at their watches then, swear gently and think it was the end of the world, but it would only be the beam from one of the army's two searchlights, ha, ha. Occasionally, too, there would be the rumbling of guns in the depth of the night, but that was of no significance either; it was only to make sure that people didn't forget they were being watched over, at no expense to them, by a considerable military potential and its expensive equipment.

One night the air raid sirens sounded, but it was only a young lady who in a super-playful mood had fiddled with the switch. But another night they sounded again, and Myklebust, who was lying reading Rauschning's "The Revolution of Nihilism" heard that the darkness was filled with the chaotic sound of engines and the rumbling of metal, the ploughshare of death. The locust swarm of destruction had finally come, then, the swarm that hungers only to kill and to suffer death itself. It had often been envisaged and even predicted that the Cauldron, excellent wartime harbour as it was, would be destroyed by fire. But the danger passed again. Early one morning, even before the sirens had time to crow, a single bomb was dropped into the harbour from a great height. It failed to explode. Thus it is that people grope their way forward through suffering and danger and sleep and food and disgust and hope until the great moment when . . .

If, that is, it ever dawns. But hope maketh not ashamed.

One day Myklebust received a letter, not one of those insignificant Red Cross letters formulated like a telegram, but a real, tangible letter. But he could see straight away that it was from his eldest son, who was a collaborator, and he only opened it to have the signature confirm this. Then he sat down with his face twisted in pain, put the letter and envelope on the hot stove and watched the paper turn first brown and then black and finally disappear in a sooty little flame.

No bitter comments. He was a father, but first and foremost he was a patriot. The odd word from the long, well-printed letter had teased its way into his retinae as he was looking for the signature; now they germinated like evil seed in his mind: blood bonds . . . illness . . . fallen. Was that the clock that had fallen off the wall, or was it the collaborator brother who had fallen on the eastern front? Fallen . . . fallen . . . But the letter had been burned, and a good job, too. Patriots didn't read letters from collaborators.

That same day Myklebust was informed that Odd, his youngest son, was among the survivors from the minesweeper H.M.S. Hawthorne, that had been sunk by enemy action, but that he was lying wounded in hospital.

The following day – a quite unique copper-red day – the two earnest, grey-haired men, without previous agreement, made an extra big purchase of food and clothes, seamen's equipment, lifebelts, provisions for a long voyage.

"It's so as not to be bothering you all the time," said Thygesen to Masa Hansen, to whose delighted sales assistant the now analine-red sun-rise-and-set sky had imparted an extra shade of red.

"Hey, just look at this, Thyge," said Myklebust as they left with their load. He pointed to Masa Hansen's shop window.

"Oh," said Thygesen. "Heavens, has *that* ended up there after all?"

They were looking sadly at poor Jens Ferdinand Hermansen's roundabout. The cardboard ship was lying fully laden at the quayside, and jumping jacks were happily waving their arms about. But the proscenium had gone, and the inscription *The Black Cauldron* had been erased. It had been replaced with some rather clumsily written words:

### THE SHIP IS LADEN WITH:

below which there was a movable panel in which Masa Hansen at any time could blazon the goods she wanted to

advertise. Smart English leather seamen's jackets with zip fasteners. And beneath it all: Remember that goods from Masa Hansen are not only the first, but the best.

"Well, shall we tear ourselves away," said Myklebust. "Or are you perhaps waiting to see the ship blow up?"

"There was something about a button," said Thygesen. "A button that he pressed."

"Yes, I remember that," nodded Myklebust. "I've been looking for that button myself, but it's not there. They must have amputated that part of the works."

On board the "Gok" there was now a remarkable amount of activity. No question of drinking that day. Everything had to be put in its right place. The cargo had to be stowed silently and efficiently, as though under the supervision of a mate. Sails and equipment checked. Telescope. Rifle. Rockets. And there was even a chart.

Finally, after the task was successfully completed, they took a single innocent Vat 69, the colour of mahogany, almost black in the earth-brown afternoon light. A slight breeze was blowing. The barometer was rising.

"On such an evening as this," remarked Myklebust. "On such an evening as this, you know. Broad sails across the North Sea. No, I mean we could sail out to the mouth of the fjord and back. We'll have a side wind in both directions."

"I really think you mean it, Mykle," exclaimed Thygesen, betraying signs of hysterical fear. "As far as that! But what if we get stranded on an underwater rock?"

His voice became ever weaker and thinner: "Or we might catch our death of cold."

"No, but we're going to raise anchor now," said Myklebust seriously. He got up with a prolonged sigh, a sigh betokening relief and calm decision.

Soon afterwards the shield-lined ship was on its way out towards the mouth of the fjord. It was greeted with waves and shouts from the battery on the promontory: "Goodbye, Gok. Remember us to them over in Jamaica. Good luck." And the two seafarers gave a melancholy wave back and avoided smiling or looking at each other.

Out on the fjord there was a fair breeze. The Gok was on the alert and pricked its ears like a dog sensing a commotion. They passed a corvette on its way in, and more waves and shouts were exchanged.

"What's that they say?" asked Thygesen. "What's been observed four miles from land, Mykle?"

"A *plaice*," said Myklebust. "A plaice. Four miles south east of the mouth of the fjord. Heavily camouflaged."

"Keep aport, sir," came the shout. "The sunset might explode at any moment."

Myklebust, who was sitting at the rudder, bent deep and turned his face away so as to be on his own. Thygesen helped himself to a private Vat. He knew that Mykle could not tolerate the sight of young sailors. He was sitting and becoming sentimental.

He must be entertained. That *Saul*!

Thygesen let the drink take hold a little, then he took out his guitar and burst forth into a subdued and deeply felt song:

> There once lived a man demonic and grey,
> – diddledy-diddledy-dee –
> But harmless he was, so all did say,
> – diddledy-diddledy-dee –
> But sometimes his eyes would flash so bad,
> – Friends, believe my words –
> That people would say that he was mad.
> – Diddledy-diddledy-dee –

"Oh, you're wonderful," said Myklebust looking away with a misty eye. "Let's have some more. Have you made it up yourself?"

"No, it's taken from the collected works of Henrik Ibsen. Slightly adapted by Georg Brandes." Thygesen continued:

> I've seen him myself but a single time,
> – diddledy-diddledy-dee –
> White-haired he was, with laugh sublime.

– diddledy-diddledy-dee –
Hear now, I'll tell you all a tale,
– Friends, believe my words –
And if at times it seems too pale,
– Then diddledy-diddledy-dee –

One moonlight night with on-shore breeze,
– diddledy-diddledy-dee –
An English yacht the land did seize.
– diddledy-diddledy-dee –
Come help us, Terje, in our distress.
– Friends, believe my words –
Now help was nigh, I do profess.
– diddledy-diddledy-dee –

Terje leant 'gainst the towering mast,
– diddledy-diddledy-dee –
His eyes were shining all aghast,
– diddledy-diddledy-dee –
The wealthy lady was fair like spring,
– Friends, believe my words –
His fulsome praises she did sing.
– diddledy-diddledy-dee –

The waters shone, the wind did blow,
– diddledy-diddledy-dee –
And Terje stood there all aglow,
– diddledy-diddledy-dee –
White-haired he was, his laugh sublime,
– Friends, believe my words –
He seemed to stand outside of time.
– diddledy-diddledy-dee –

"More," demanded Myklebust.

"All right, but I can't remember it all just like that," said Thygesen. "Then they got married, and he became a lord and at last an admiral, bright lad he was. And then at the

very end you see him kiss the lady for a terribly long time and magnified 88 times."

"Well, that's what you can call a modernised version of *Terje Vigen*," said Myklebust. "Not a trace of romanticism left in it."

"No, it was functionalistic," Thygesen confirmed.

"Tell me . . . why was the Victorian age so *clammy* in so many ways?" said Myklebust. He stared out across the ocean. "But on the other hand, it wasn't so *evil*."

"Methinks *your* eyes are flashing bad," said Thygesen.

"Yes, but mainly at winter and rough weather," Myklebust trotted out the quotation. "But sing, Thyge, sing, man. What about something really old and *motheaten*?"

They were approaching the mouth of the fjord. It was still blowing, a gentle, friendly breeze. The sea lay before them deadly serious like a solemn cellar floor dotted with a few spots of spilt burgundy. Out on the western horizon the odd cigar glow could still be seen smouldering. But in the south-east the moon was rising. Familiar and homely, the faithful old night-light shone and filled the air with a deep melancholy scent of clean sheets and soap and evening prayer.

Thygesen tuned his guitar and struck a couple of languorous chords:

*The moon hath raised her lamp above . . .*

Myklebust set course towards the moon. There was a good breeze out here, and the Gok was making fine speed.

"Let's have something to eat now," said Thygesen when he had finished his song. "Steak or stew, or would you rather have something else, Captain?"

"No, Thyge. Time is standing quite still now. It's almost like being young again. 'The moon hath raised her lamp above!' Stew or steak? Steak, Thyge, *steak*. Big, juicy, with lashings of onions."

Soon the moonlight was spiced with the smell of onions from Thyge's frying pan.

The two men ate in ecstatic silence as the water lapped energetically and delectably around the boat. They took turns at the rudder. After the steak they served coffee with cognac and cigars. The boat was dancing madly towards the moon like a moth towards a lighted candle.

"Well, we'll finish this cigar," said Myklebust, moving energetically. "But *then*, we'll have to pull ourselves together. Aye, we'll bloody well have to pull ourselves together. We'll have to make ourselves as hard as . . . ."

"As the dentist's drill?" suggested Thygesen.

"Aye, for we're not going back. Is that agreed, Thyge? We're not going back to the Cauldron. Not at any price. That's as daft an idea as . . . as . . . ."

"As a drunk on the first day of Creation!"

"Right. Oh well, cheers to that thought. Long live the free private life on the ocean. I mean *pirate's life*, damn it."

Myklebust got up and raised a threatening fist towards the moon. "And if anyone tries to stop us, he'll get what's coming to him. We won't surrender at any price. Now I've said it."

The two men exchanged terrible glances and looked down in delight, like conspirators who suddenly realise that the dreadful deed they have planned is about to be fulfilled.

# 5

The next day, too, was a cold and red day with a sky of burnished copper. It was Opperman's day. His name in huge letters adorned the front page of The News, and old Ole the Post nodded as he recognised the round O being outlined on everyone's lips and in their sensation-rounded eyes. "Op-op-Opperman," he chanted good-naturedly, and as he went on his newspaper round he turned it into a little verse:

> Op, op, Opperman,
> Now he really, really can.

But it was not only Opperman who could. They all could: Solomon Olsen, Consul Tarnowius, Mrs. J. F. Schibbye, Olivarius Tunstein, Masa Hansen and now, finally, Pontus the watchmaker. They were all building and extending. Olivarius's little shoeshop down by the river had been jacked up and furnished with both a tower and a spire and central heating, a bomb-proof shelter and a refuse chute, and his wife was displaying herself in a fur coat and dyed hair. And up on the hillside behind Solomon Olsen's broad and solid row of gables on the other side of the inlet a palace of concrete and glass was rising, built by the gifted and much-sought-after young architect Rafael Heimdal. This was where Spurgeon Olsen was to move in together with some Icelandic beauty. Yes, *whooshssh*, there he was, just whizzing past with his dark-eyed film star in the car. And there came Opperman's enormous, well-covered van rumbling along, filled with silk pyjamas and other expensive frippery in its secretive interior. It was as big as an ordinary smallholder's cottage, filling the entire width of the street, and if you wanted to save your life you had quickly to stand back against the wall of the nearest house and hold your stomach in, or, like a well-trained monkey dart up a flight of steps, if there was one nearby.

You would soon hardly be able to exist for cars in this village; pedestrians had long ago lost all their rights and were no longer really tolerated: even the pavements were in effect reserved for cars and motorcycles, and no longer did you come across even small children who were not wielding saucepan lids between their hands and snorting like horses while, with unsympathetic and murderous eyes, they forced their way between those out-dated shanks of yours which were so ridiculously in the way everywhere.

Another nuisance that seemed to be on the increase was dogs. If you stopped and listened for a moment in this village you had to admit that the barking of dogs almost drowned the noise of traffic. There seemed to be some kind of mystical union between cars and dogs. Every car was hotly pursued by one or two furious dogs, and inside, behind the windows of the private cars, you could see other angry snouts. Thus, Tarnowius's huge alsatian went everywhere by car, its two-kilo steak-eating tongue shining pink from a great distance. Now Pjølle Schibbye, too, had got a thoroughbred dog for his car, so the fashion was catching on.

Strange: the dog, that incredibly filthy, base animal . . . nothing enjoys greater human affection. Why? . . . Because it can both play up to you and make itself seem pathetic. Like him Op-op-op, thought Ole chewing away with bitter amusement at his tobacco.

Nor did a day pass without your having to witness the heart-breaking sight of a motorcyclist or pedalcyclist driving into a lamp post, a stationary car or a shop window in a desperate but vain attempt to kick a mongrel that wanted to amputate his leg. Shortly afterwards the other two main actors in the drama would appear on the scene: the policeman, who would hand out an arrest warrant to the unfortunate victim, and the dog's owner, who with a raised stick or umbrella or axe would demand compensation for the dog, which had suffered no injury, but was calmly piddling down the policeman's leg.

Ole the Post swung his bag into a more comfortable

position on his back. Thank God he was maintaining his sense of humour; that was at least something.

He stopped at Mrs Lundegaard's house. The little sign saying "Guest House" had been taken down: Myklebust and Thygesen and that peculiar Icelander were no longer there, and the widow, who at one time had been so energetic and lively, had become lonely and thoughtful and almost beautiful. But her old hospitality was unchanged, and the little flowered *snaps* bottle came out on the table, and Ole had to go across to the door and spit out his morning chew.

Still nothing from Engilbert Thomsen. Perhaps he had fled the country. Perhaps he had chosen suicide. Perhaps he was a spy. Perhaps he was under a spell. Perhaps he was not quite right in the head, as sometimes happened with unusually bright people. It was all so complicated. But now it was already a long time since he had disappeared, and Mrs Lundegaard was beginning to settle down and resign herself to her fate, which when all was said and done was not so terrible – having a child after six years of childless marriage and scarcely two years as a widow. Financially she was all right, indeed, she was probably quite well off.

"Opperman!" she exclaimed, showing two o-shaped eyes above the paper. "A large house and 50,000 kroner. Yes, but he can afford it," she added dispassionately. "OK, he can afford it."

"Yes, let's drink to that," said Ole. "Oh, sorry, I've emptied my glass."

Mrs. Lundegaard glanced up from behind her newspaper, a glance that was half melancholy, half roguish, and poured him a fresh glass.

"Anything new otherwise?" she asked, as she went on reading. "The baker? Liva?"

"Yes, Liva's all right, sort of," Ole could inform her. "She's happy and contented, but completely dotty. Pastor Fleisch goes and visits her every day and shows her pictures. She's absolutely crazy about pictures. But Simon the baker

is still stark raving mad and they have to keep him in a strait-jacket."

"Good Lord." Mrs. Lundegaard lowered the newspaper and stared up in the air for a moment. "And what about the bun sect?"

"Oh, that's strictly forbidden now, and Markus and Benedikt are still in gaol accused of attempted murder. So that put an end to it, obviously. . ."

Ole sat playing thoughtfully with his empty glass. "And Captain Gilgud's wedding with Borghild Tarnowius . . ."

Mrs. Lundegaard looked up quickly and gave a youthful smile as she filled the glass for the third time. "Oh, Ole . . . really? Are they really serious, then?"

"Yes, they're supposed to be getting married the day before Christmas Eve. But, hmmm. But well, you mustn't believe everything you hear," said Ole, emptying the glass as though in distraction.

Mrs. Lundegaard's eyes had become sharp with curiosity. "No, you mustn't, must you, Ole?," she said imperiously.

"Cheers, sorry, I forgot to say it, but it's too late now, but . . . no thank you, no thank you . . . oh, thank you!"

Mrs. Lundegaard nervously replaced the cork in the bottle and said in a cold, commanding tone: "Well, and *then* what, Ole?"

"They say she's got herself into trouble again. But not with . . . the Captain. Enough said."

Mrs. Lundegaard shrugged her shoulders slightly and drew in her lower lip: "Well, I *never* heard anything like it . . ."

Ole quickly emptied the fourth and irrevocably last glass; he must get on, for people were dying to get their newspapers and read about Opperman . . .

Out on the fjord an armed trawler was on its way in. On its heels followed the Gok, without sails, and with two sailors on board. The trawler was towing the strange little Viking ship. What could that mean?

A moment later a crowd formed on the quayside. What was going on? People were whispering to each other,

smiling, frowning and shrugging their shoulders. It was Thygesen and Myklebust. They had been up to something and were being taken before Inspector Hansen for interrogation. Smuggling? Espionage?

People were busy guessing throughout the day, and the most unbelievable rumours buzzed around like flickering subtitles to a film: They had been in contact with enemy submarines by means of a secret transmitter. They had murdered the Icelander because he knew too much and sunk his body out at sea.

But no one knew anything for certain, for it was kept secret. A military secret.

Mr. Skælling, the editor, had, however, via Consul Tarnowius obtained some authentic information. Of a strictly private nature, of course, the Consul having obtained it from his son-in-law-to-be, Captain Gilgud. It was unique.

"Good God," he groaned. "Life still has its humorous aspects, Maja! Those two day-dreamers have been intercepted by the patrol boat far out to sea, making south as fast as their sails would let them. The crew hailed them and signalled to them to stop, because they're not allowed to leave the fjord without permission, and in fact they fired a warning shot at them ... but no, it was no use, they simply sailed on, and when the ship came up alongside them they completely lost control of themselves and *shot* at it with a rifle. Luckily they didn't hit anyone. It was Myklebust who fired the shot. 'We won't surrender at any price,' he shouted. Just think, he was completely out of his mind, that nice old man. 'You can pulverise us with your guns, but you shan't take us alive,' he shouted."

Mr. Skælling held on to his stomach. "And just imagine," he said, choking with laughter as he sat down: "All the time Myklebust stood there threatening them like some furious latter-day Francis Drake, the other idiot was firing *distress signals!*"